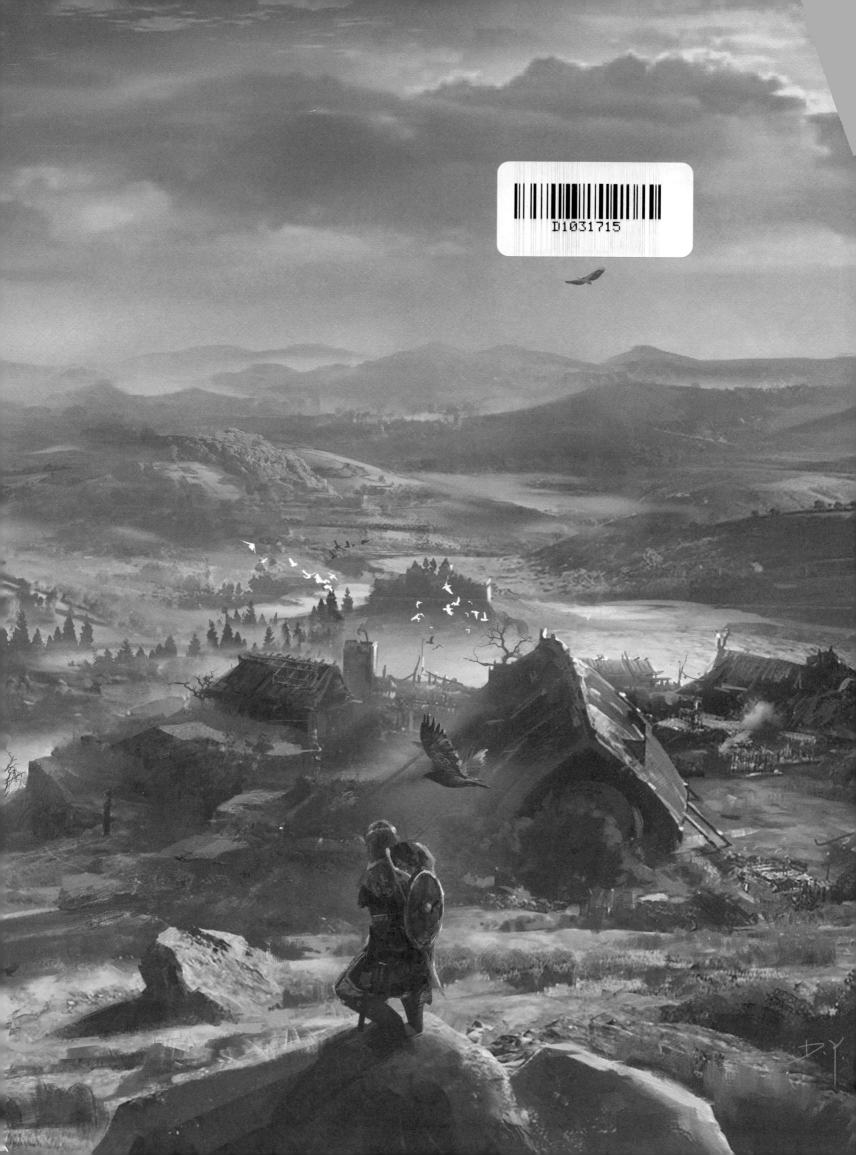

THE ART OF
ASSASSIN'S CREED
VALHALLA

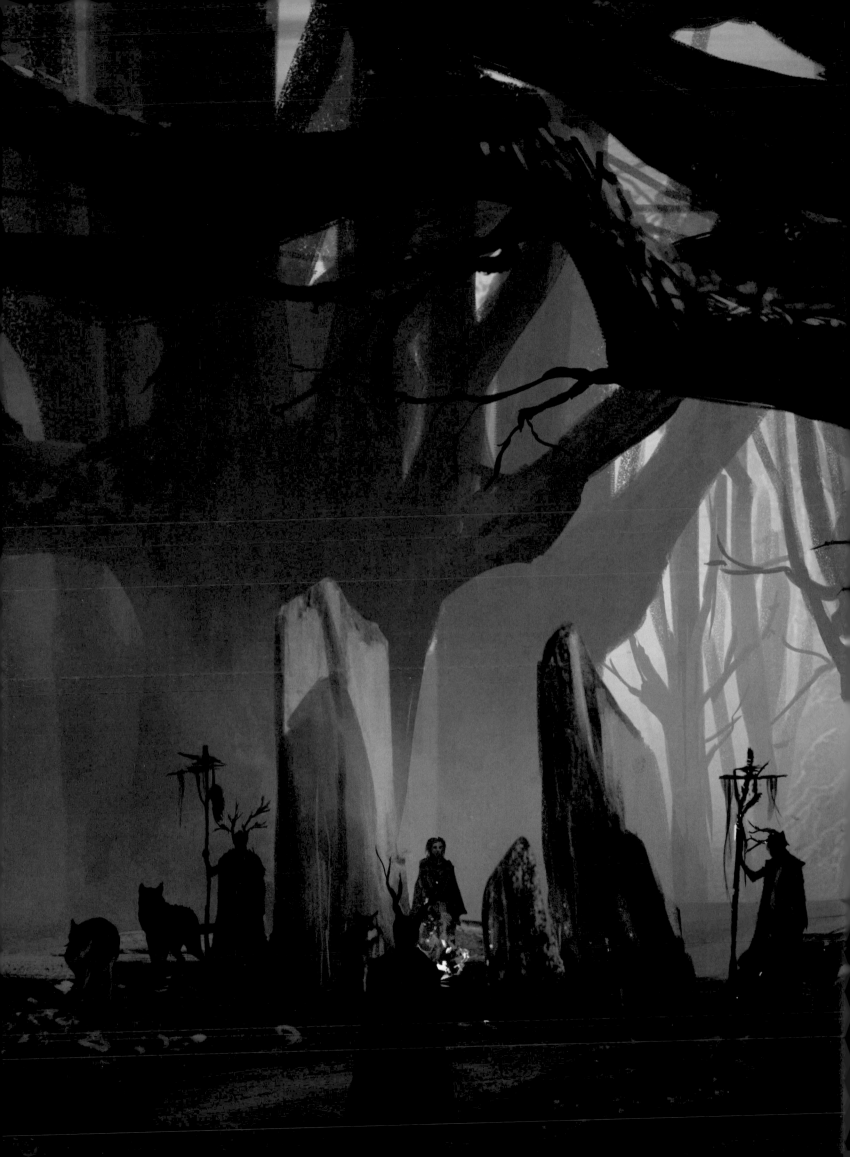

THE ART OF
ASSASSIN'S CREED
VALHALLA

FOREWORD BY
RAPHAËL LACOSTE

DARK HORSE BOOKS

PRESIDENT AND PUBLISHER // **MIKE RICHARDSON**

EDITOR // **IAN TUCKER**

ASSOCIATE EDITOR // **BRETT ISRAEL**

DESIGNER // **SARAH TERRY**

DIGITAL ART TECHNICIAN // **ALLYSON HALLER**

THE ART OF ASSASSIN'S CREED VALHALLA

Published by Dark Horse Books
A division of Dark Horse Comics LLC
10956 SE Main Street | Milwaukie, OR 97222

DarkHorse.com
First edition: November 2020
Ebook ISBN 978-1-50671-932-0
Hardcover ISBN 978-1-50671-931-3

Deluxe edition: November 2020
ISBN 978-1-50672-045-6

10 9 8 7 6 5 4 3 2 1
Printed in China

Library of Congress Cataloging-in-Publication Data

Names: Tucker, Ian (Editor), editor.
Title: The art of Assassin's Creed Valhalla / editor, Ian Tucker.
Description: Milwaukie, OR : Dark Horse Books, [2020] | Summary: "The Assassin's Creed series is renowned for its skillful blend of historical fiction, epic environments, and exciting action. This art book offers an insider's look at first title in the franchise to explore Norse culture and the Viking invasion of England in the 9th century. Featuring iconic artworks ranging from stunning settings to brutal weapons, as well as developer insights, this is a must-have for any Assassin's Creed fan and art lover alike"-- Provided by publisher.
Identifiers: LCCN 2020015235 | ISBN 9781506719313 (hardcover) | ISBN 9781506719320 (ebook)
Subjects: LCSH: Video games--Design. | Video games in art.
Classification: LCC GV1469.37 .A623 2020 | DDC 794.8--dc23
LC record available at https://lccn.loc.gov/2020015235

PAGE 1: ART BY MARTIN DESCHAMBAULT
PAGES 2–3: ART BY RAPHAËL LACOSTE
PAGES 4–5: ART BY MARTIN DESCHAMBAULT
PAGES 6–7: ART BY RAPHAËL LACOSTE

CONTENTS

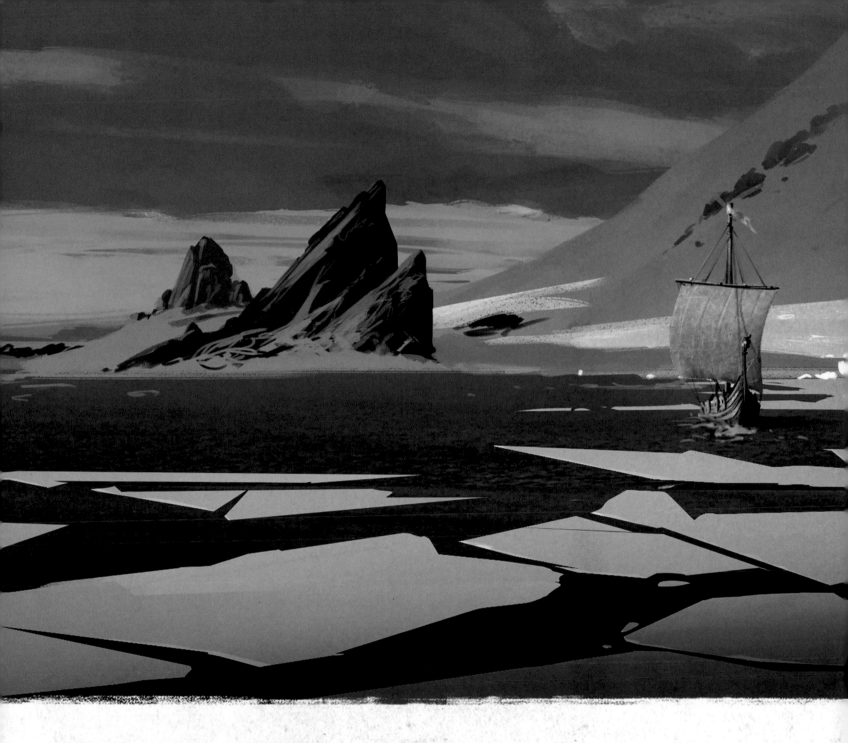

FOREWORD

The beauty of untouched nature and majestic open landscapes has always filled me with a sense of wonder. It triggers my love for travel and adventure, and stimulates my curiosity.

The world of *Assassin's Creed Valhalla* may not feature as many landmarks and architectural structures as previous *Assassin's Creed* games, but I strongly feel that it showcases the most diverse natural scenery we have ever created for the franchise. From the snowy high peaks and precipitous fjords of Norway to the lush rolling hills of East Mercia, through the mystical forest of Puzzlewood, the arid hills of Shropshire, and the foggy wetlands of East Anglia . . . this journey will be a memorable one.

Before going into production, we had the opportunity to visit England, Denmark, and the beautiful Lofoten Islands in Norway. The memories and photographs from that field trip guided the creation of our illustrations. Our aim was to craft memorable moments for the players, reminiscent of those we had experienced during our travels, and to bring them on an epic journey through a fascinating open world.

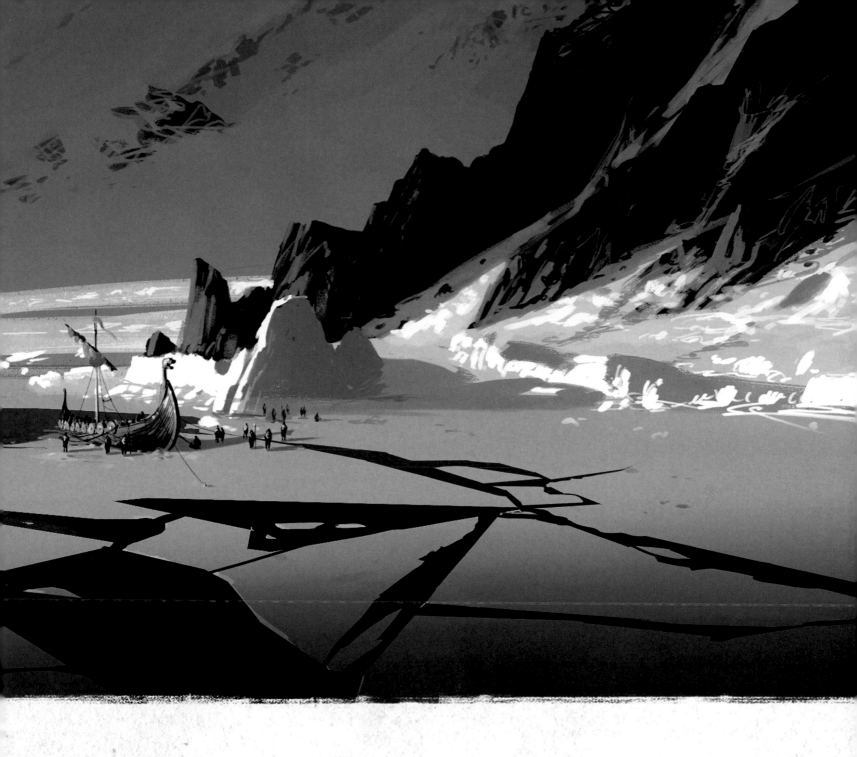

As an art director or visual artist, it is very important to focus on the overall impression you want to convey throughout the world, rather than getting lost in too many small descriptive elements. Our world is not a literal re-creation of reality. In fact, our objective is to design grandiose settings that would evoke emotions for our players. We strive to challenge ourselves to build worlds that can provide pure escapism. In the last three years spent working on this game, we've been committed to bringing the most interesting world to life for our players to explore.

Very early during the game's conception, I decided to help the player locate themselves in the world of *Assassin's Creed Valhalla* by establishing distinct atmospheres and color palettes for our different biomes. This led us to assign a static season to each region, which greatly impacted the visual direction of the game. A frigid winter serves as the backdrop for Norway and Northumbria, while Mercia is set in a vibrant fall, and Wessex, a lush summer. This helps the player to keep a mental map of the world but also to discover new lands with an interesting feeling of change.

Additionally, the contrast between the lost, epic ancient Roman architecture and the modest buildings of the ninth century creates a unique and mysterious atmosphere. The resonance of the past is everywhere, and this keeps players intrigued as they journey through the game.

I am very happy to embark on this adventure with you. Art is meant to be shared, and I am grateful for the opportunity to showcase our work through this book. I am proud of our talented teams and what we've accomplished!

As a great friend and artist told me once, "It's no small task building universes. It's a dedication of a lifetime."

—Raphaël Lacoste, June 2020, Montréal, Canada

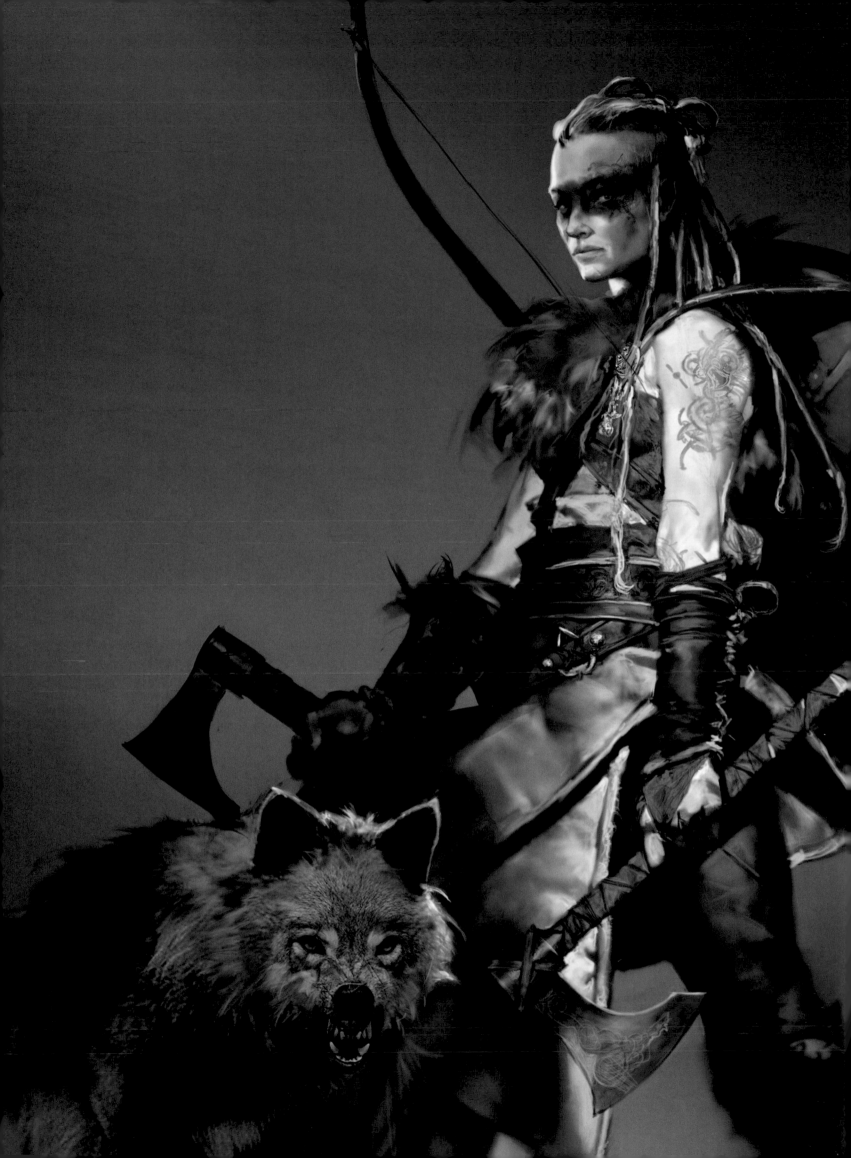

CHAPTER ONE

CHARACTERS

EIVOR

Raised as a warrior, Eivor of the Raven clan is a fearless Viking who leaves Norway to subdue England and build a thriving settlement for the clan. Playable as female or male, both versions of the character convey similar personality traits, wear the same outfit, and have comparable physical features.

"*Assassin's Creed Valhalla* has been designed to deliver the Viking experience within the *Assassin's Creed* world," says senior art director Raphaël Lacoste. "Eivor's character design needed to achieve a specific goal: we wanted to move away from the established Assassin visual archetype and create a true Viking character."

Eivor's final design only contains subtle elements that would hint to their Assassin background, like the red sash and the hooded cloak.

ART BY REMKO TROOST

ART BY YELIM KIM

ART BY REMKO TROOST

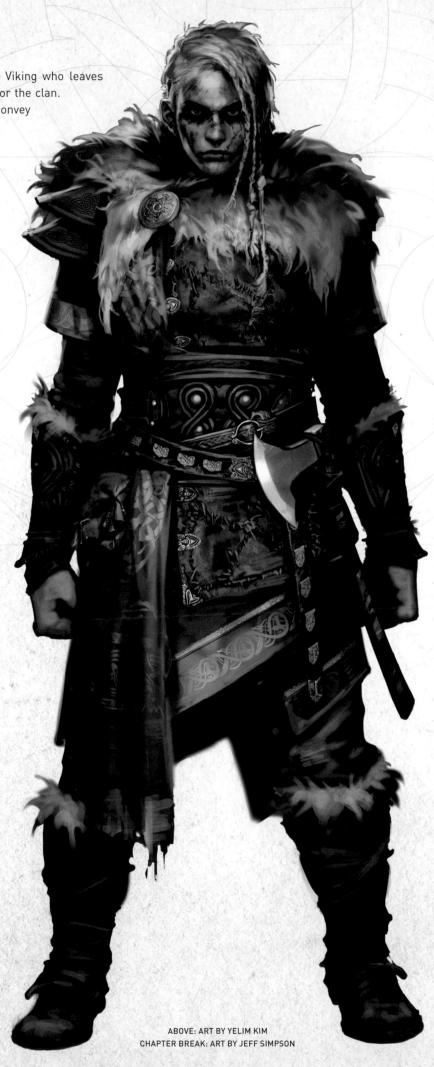

ART BY REMKO TROOST

"This Hidden Blade is a gift brought back by Eivor's brother Sigurd from his travels to the Abbasid Caliphate. Its design is inspired by the beautiful craftsmanship of the Abbasids."—RAPHAËL LACOSTE

ABOVE: ART BY YELIM KIM
CHAPTER BREAK: ART BY JEFF SIMPSON

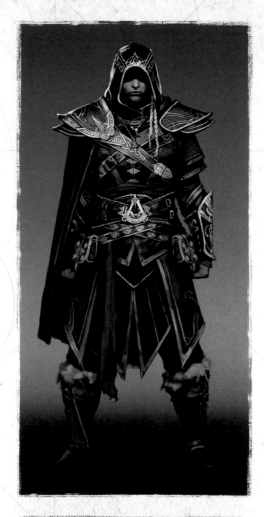

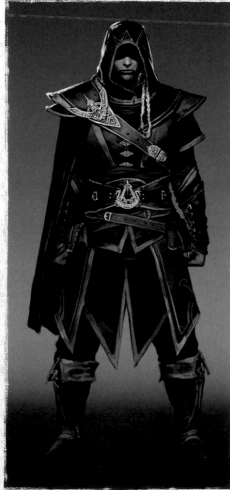

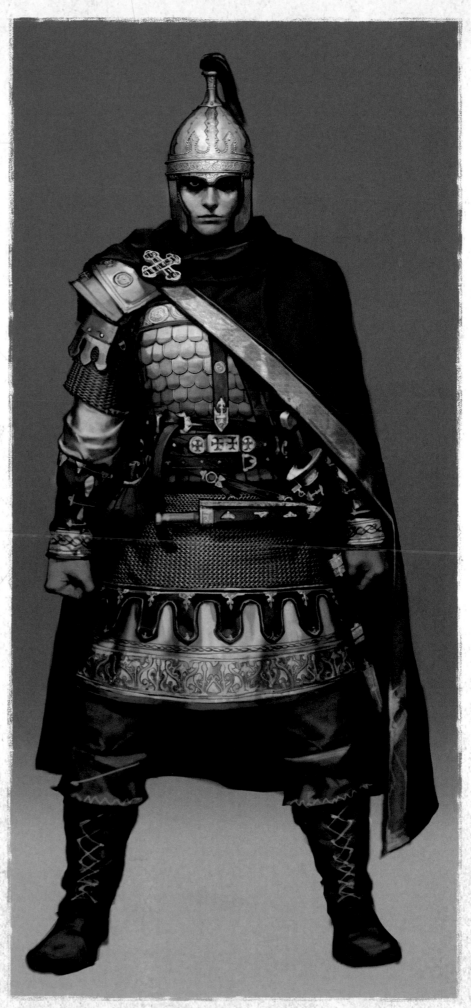

"Customization is a very important element in our game, and we designed various outfits for Eivor," says Lacoste. Each outfit expresses a unique theme—be it rooted in a specific historical era or in one of the different Viking factions. There are even outfits inspired by Norse mythology.

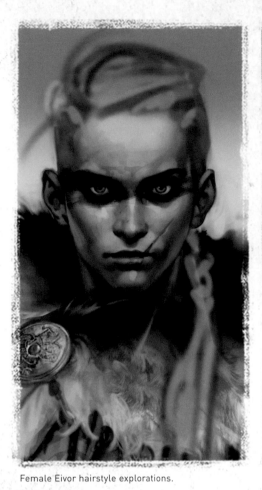
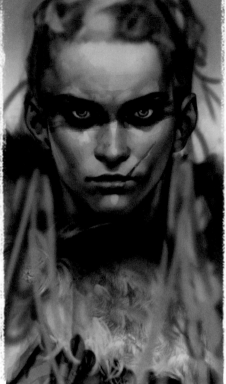
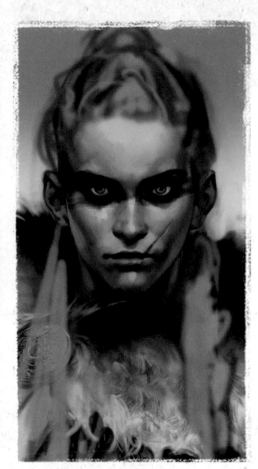

Female Eivor hairstyle explorations.

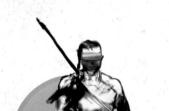
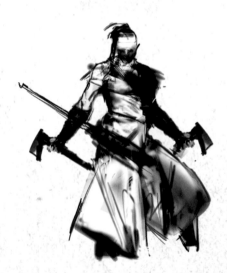
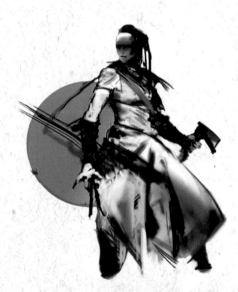

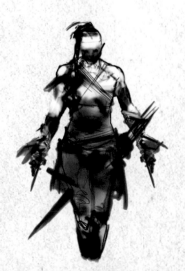

"Eivor is a skilled warrior and strategist—and is also stubbornly independent," says concept artist Yelim Kim. "We looked at lots of different pop culture references as we developed Eivor, but one that gave me clear direction was when creative director Ashraf mentioned the tank fight scene from the original 1995 version of *Ghost in the Shell* during one of our early meetings." Eivor is a leader indeed, never hesitating to risk anything for their clan—even though the consequences could be self destructive.

"Before designing details, the most important thing is always composition," says Lacoste. "This is why we first spend time working on shapes and silhouettes before moving ahead with details. Lines first—less is more." This information is essential when development reaches production in 3D, allowing the artists to more accurately describe specific character details to the character modelers.

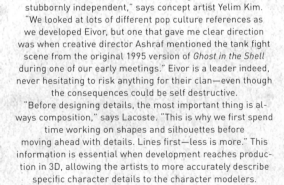
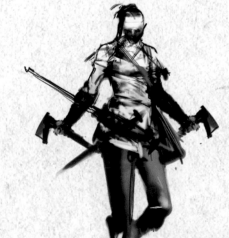

ABOVE AND RIGHT PAGE: ART BY JEFF SIMPSON

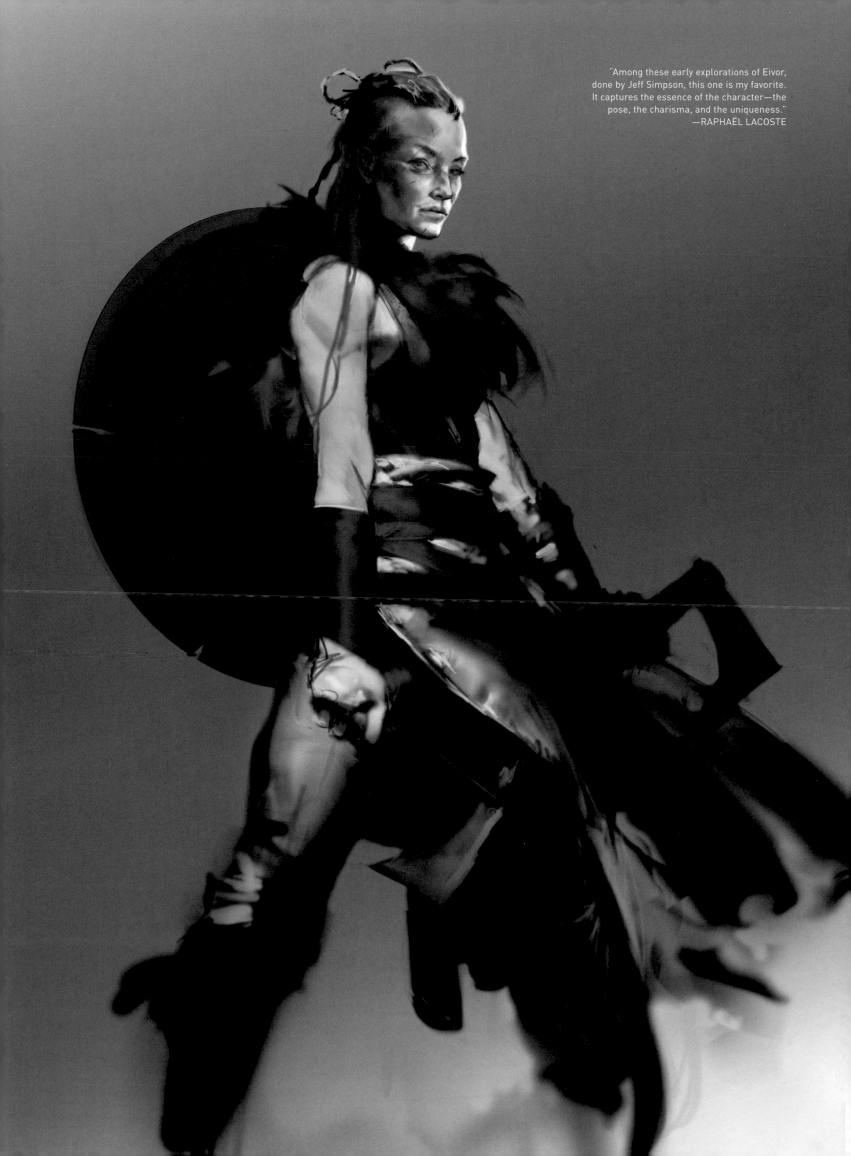

"Among these early explorations of Eivor, done by Jeff Simpson, this one is my favorite. It captures the essence of the character—the pose, the charisma, and the uniqueness."
—RAPHAËL LACOSTE

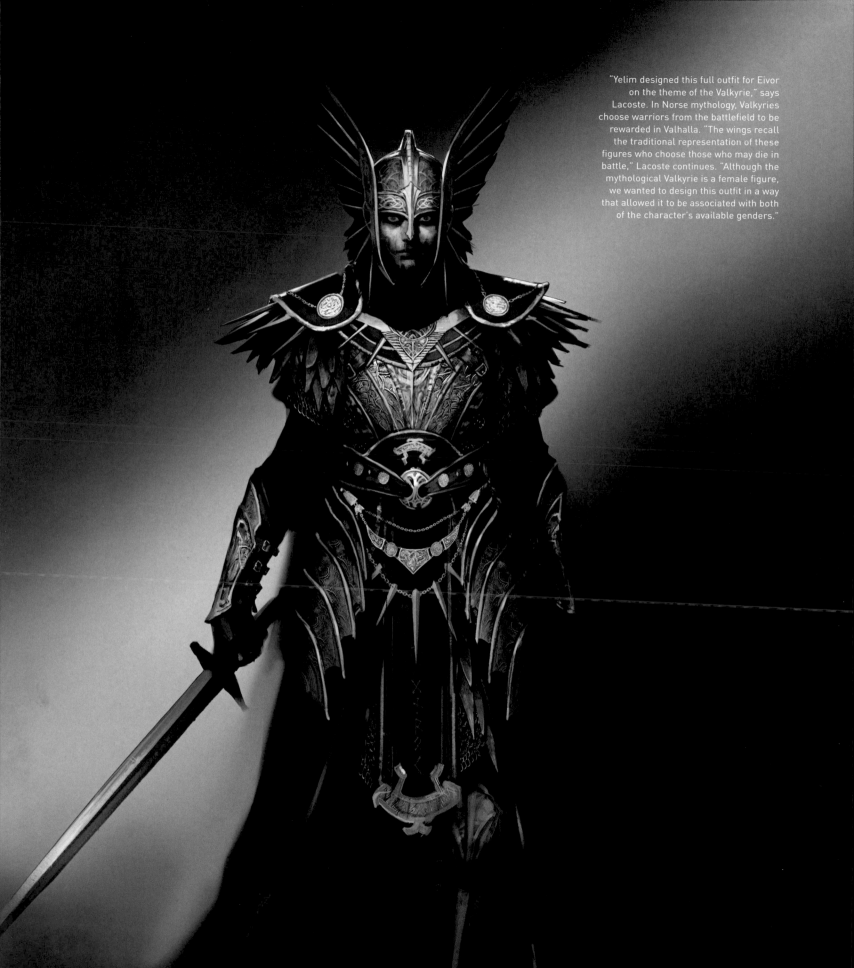

"Yelim designed this full outfit for Eivor on the theme of the Valkyrie," says Lacoste. In Norse mythology, Valkyries choose warriors from the battlefield to be rewarded in Valhalla. "The wings recall the traditional representation of these figures who choose those who may die in battle," Lacoste continues. "Although the mythological Valkyrie is a female figure, we wanted to design this outfit in a way that allowed it to be associated with both of the character's available genders."

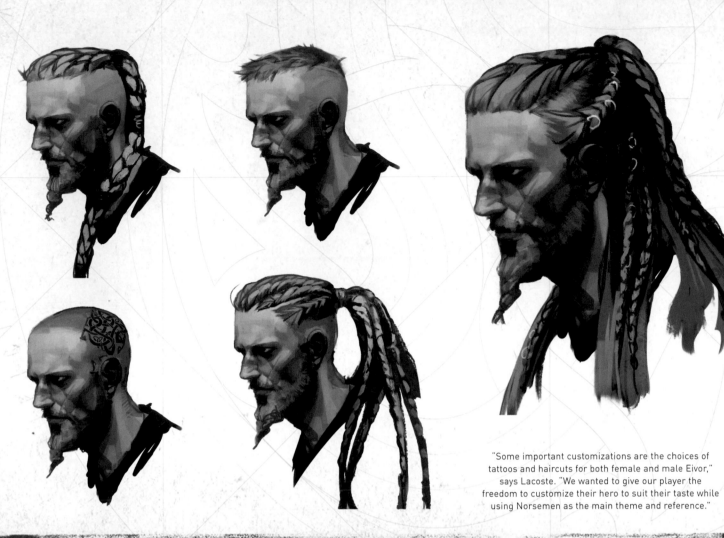

"Some important customizations are the choices of tattoos and haircuts for both female and male Eivor," says Lacoste. "We wanted to give our player the freedom to customize their hero to suit their taste while using Norsemen as the main theme and reference."

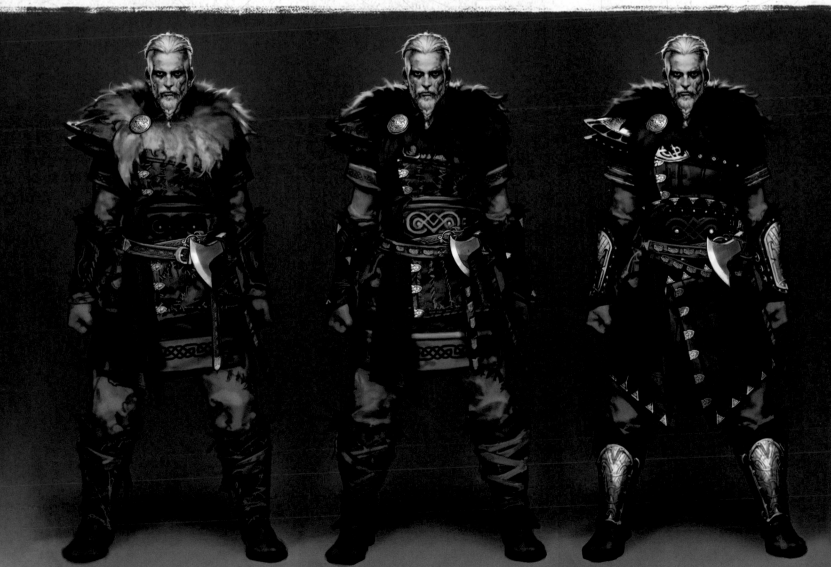

"Almost all our outfits have several levels. Here, from left to right, we have the Common, Epic, and Legendary outfits." —RAPHAËL LACOSTE

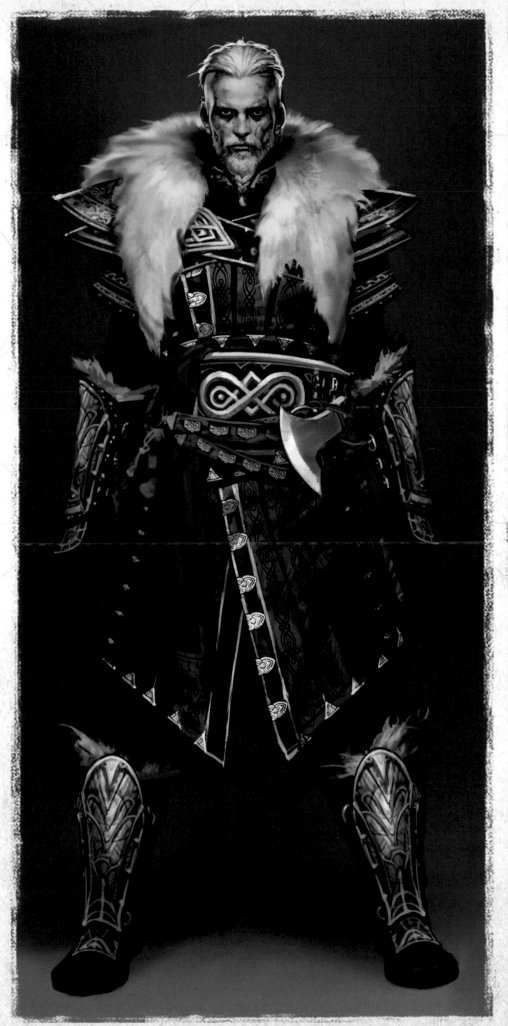

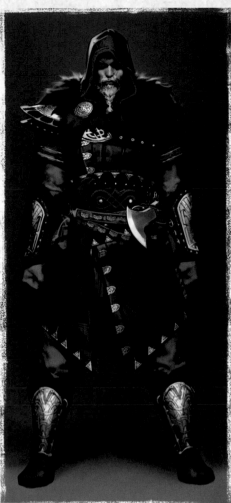

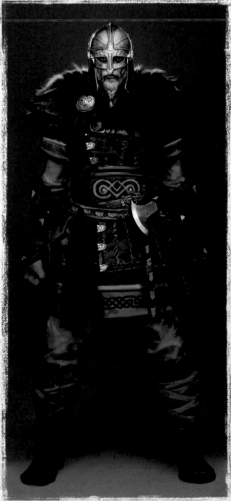

"This is the Mythical outfit. We spend lots of time designing outfits to ensure that they make great rewards for our players."—RAPHAËL LACOSTE

THESE PAGES: ART BY YELIM KIM

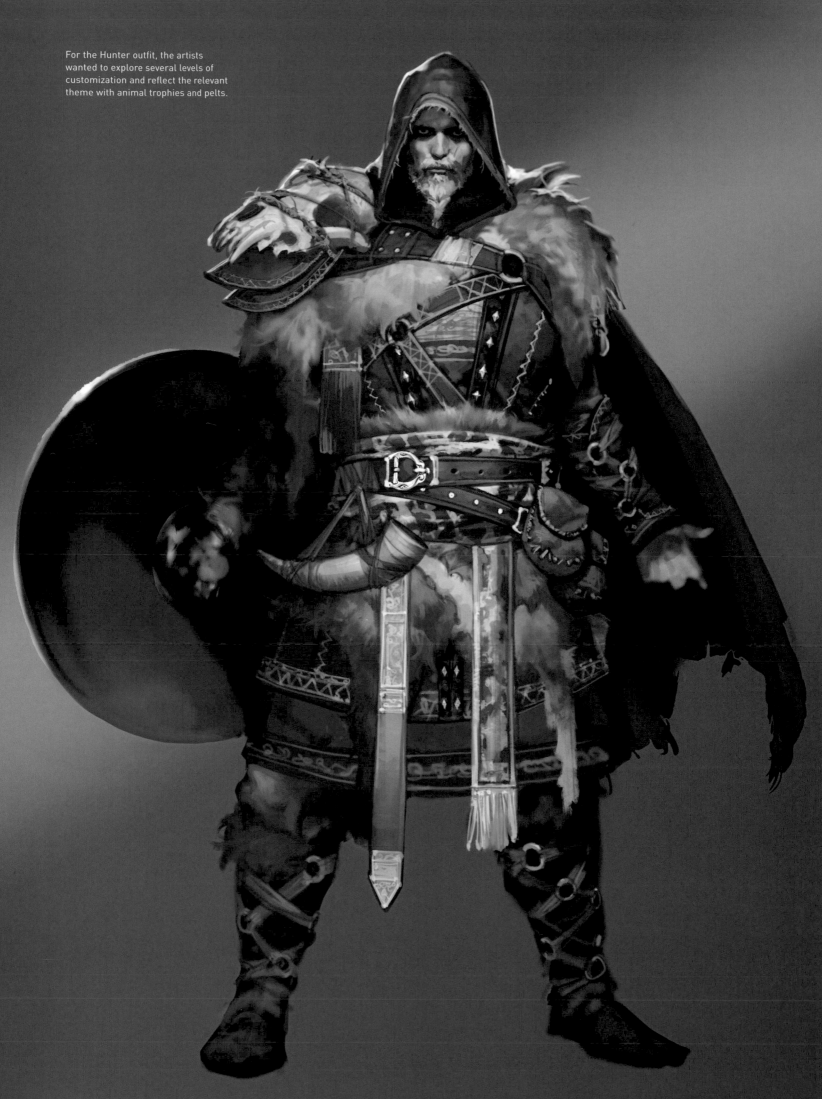

For the Hunter outfit, the artists wanted to explore several levels of customization and reflect the relevant theme with animal trophies and pelts.

ART BY YELIM KIM

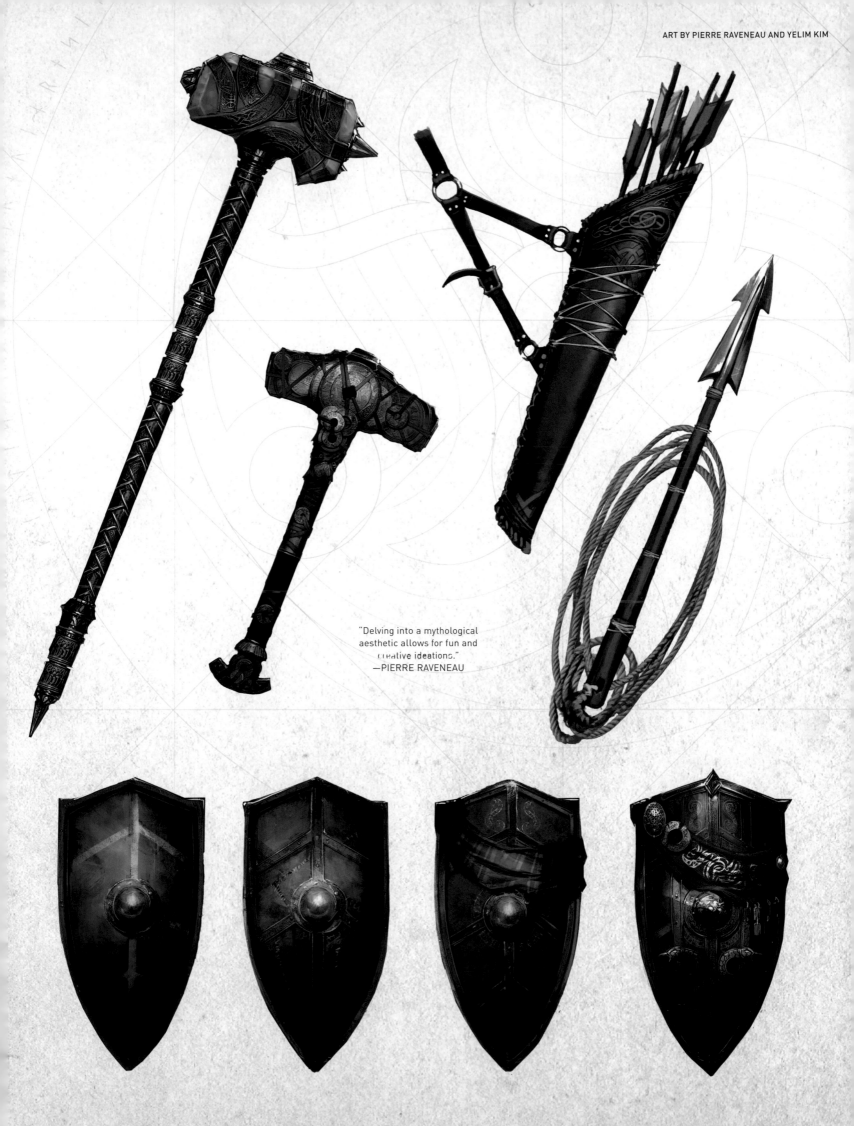

"Delving into a mythological aesthetic allows for fun and creative ideations."
—PIERRE RAVENEAU

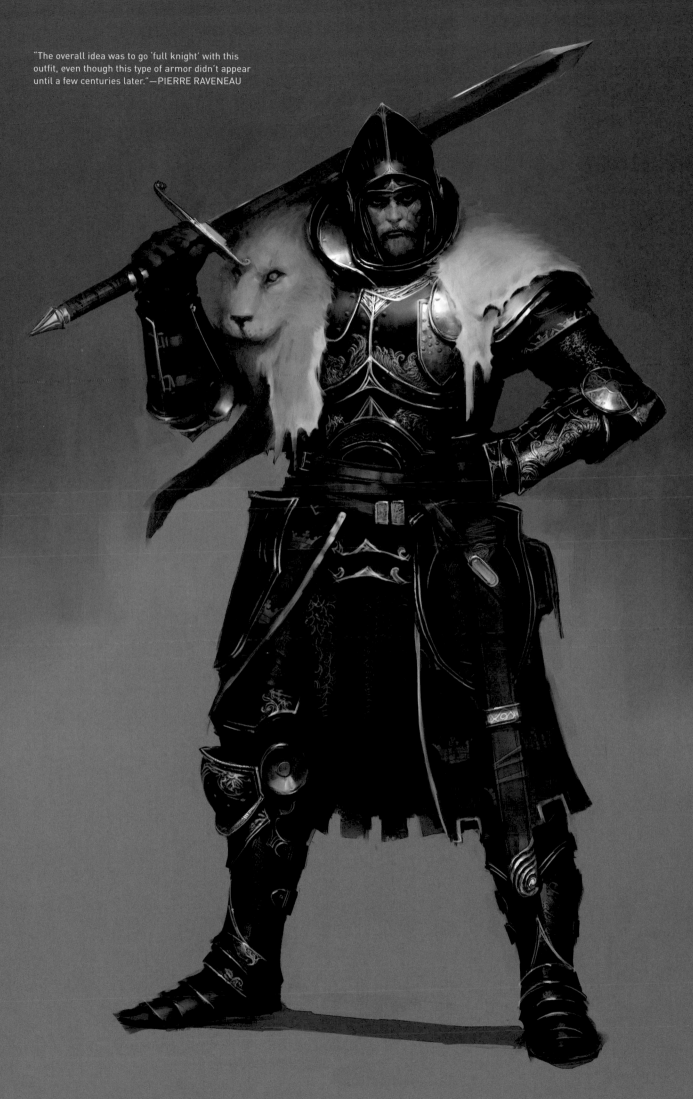

"The overall idea was to go 'full knight' with this outfit, even though this type of armor didn't appear until a few centuries later." —PIERRE RAVENEAU

ART BY PIERRE RAVENEAU

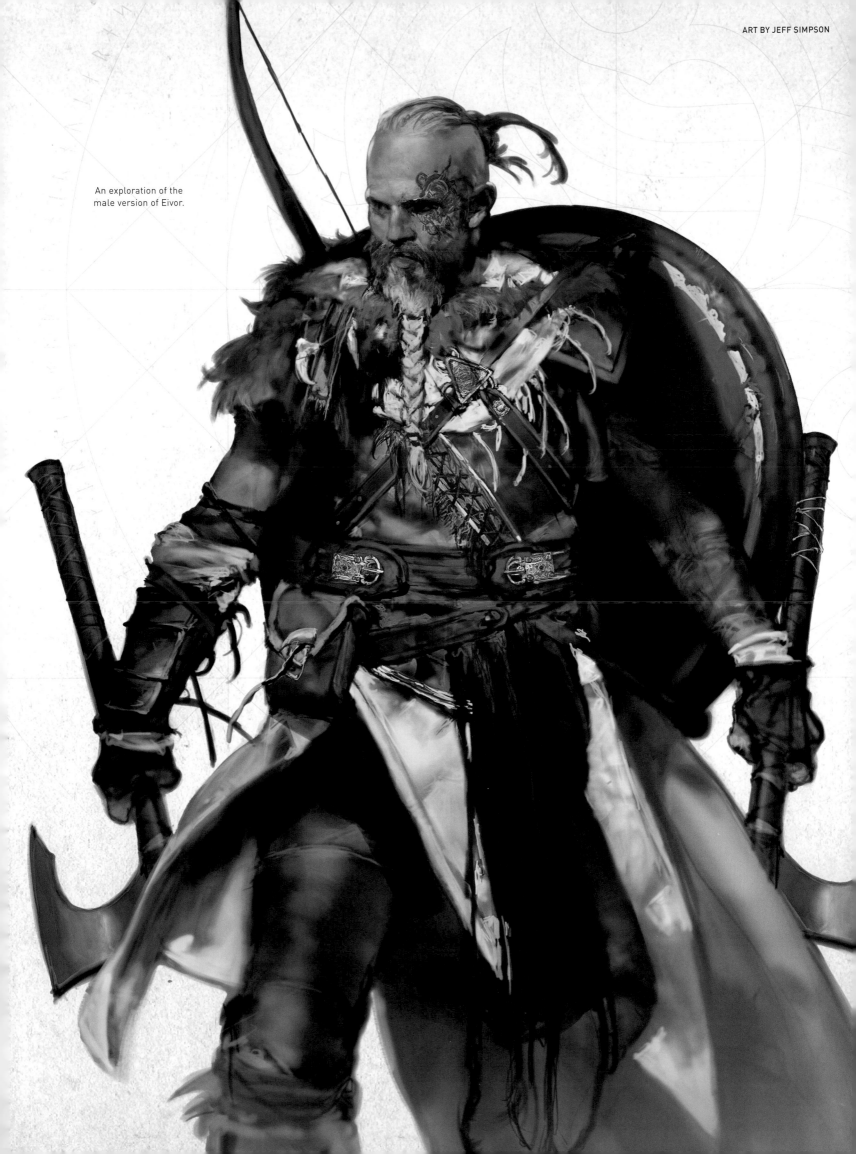

An exploration of the male version of Eivor.

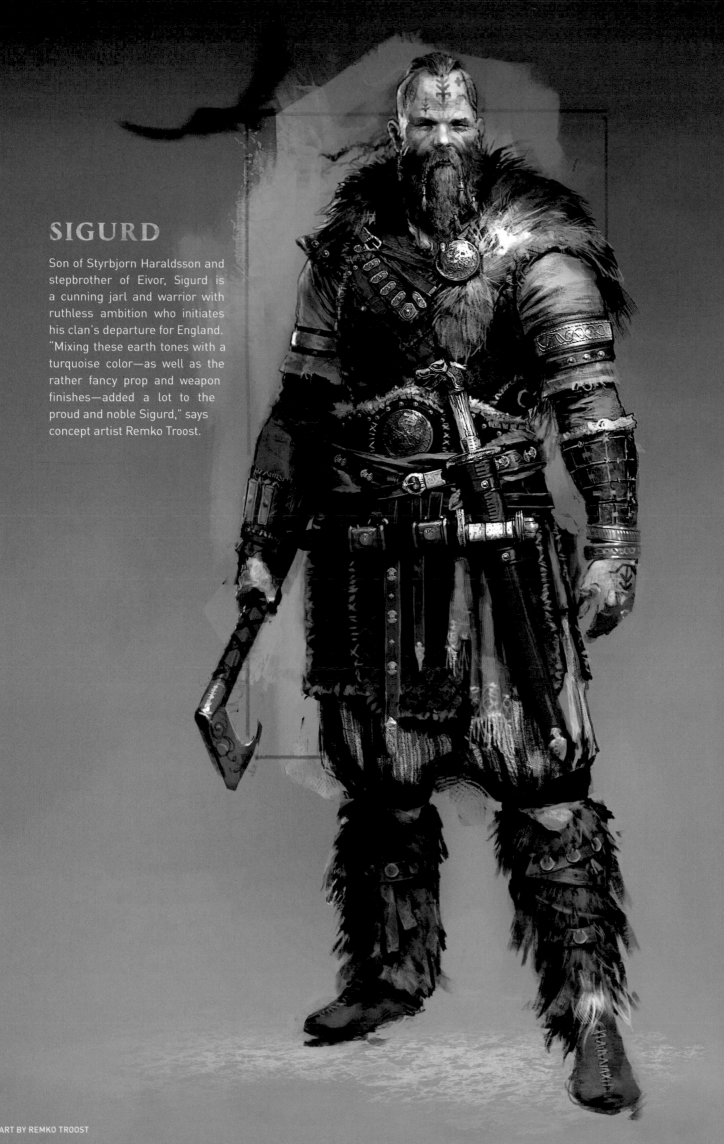

SIGURD

Son of Styrbjorn Haraldsson and stepbrother of Eivor, Sigurd is a cunning jarl and warrior with ruthless ambition who initiates his clan's departure for England. "Mixing these earth tones with a turquoise color—as well as the rather fancy prop and weapon finishes—added a lot to the proud and noble Sigurd," says concept artist Remko Troost.

RANDVI

"Randvi is the clan's chief of war strategy, Sigurd's wife, and Eivor's trusted friend and adviser," says Yelim Kim. "She is not a raider anymore; now she spends her time planning her clan's actions in the war room of the settlement. As a strategist, Randvi does not dress in a warrior's outfit, but neither does she wear the typical women's clothing of her time."

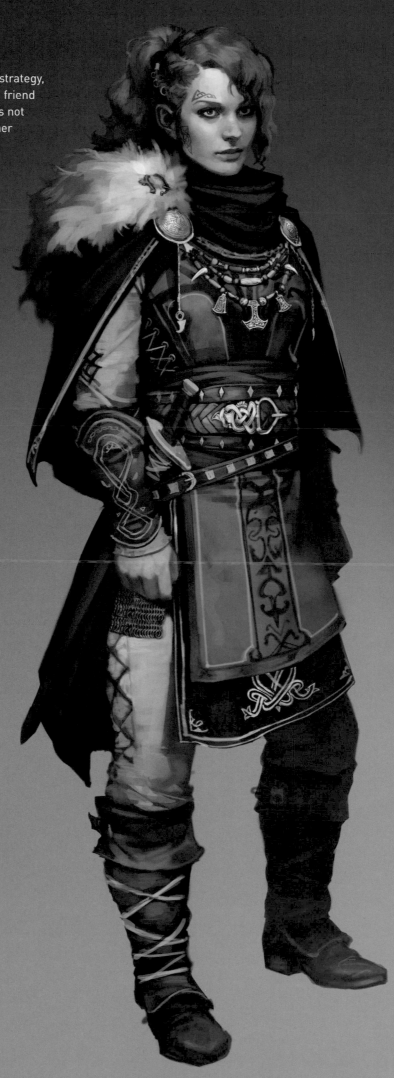

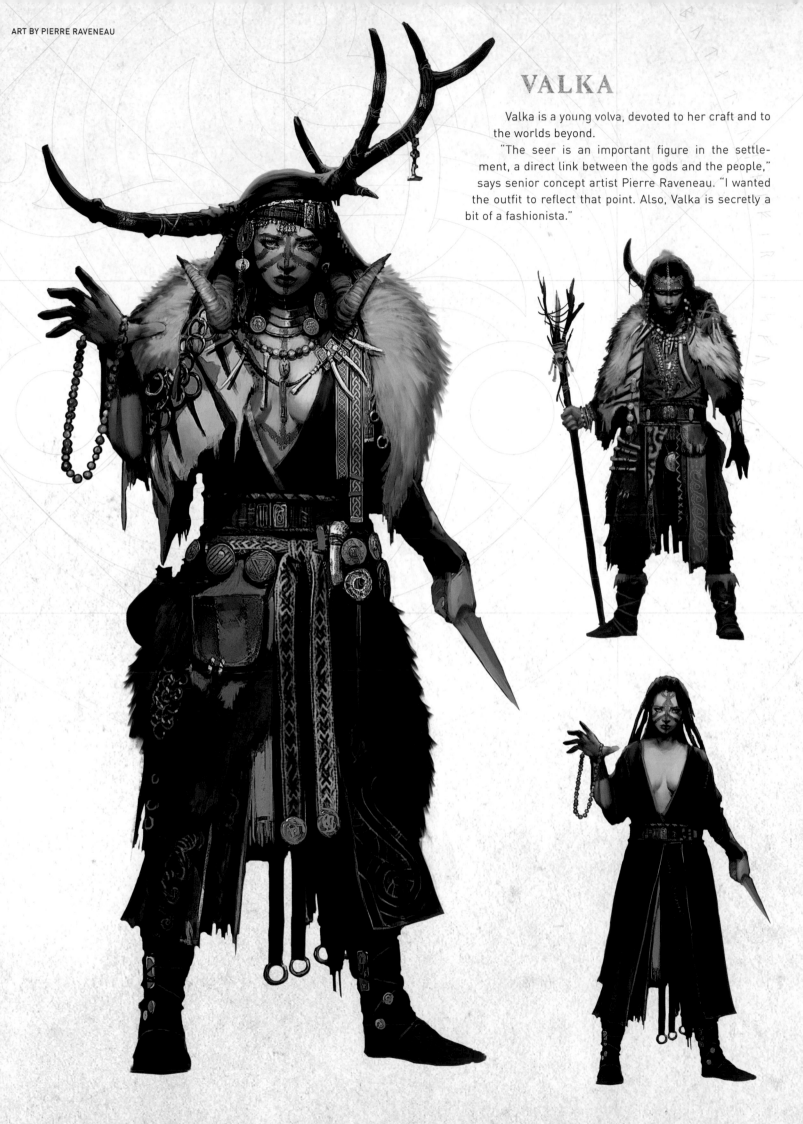

VALKA

Valka is a young volva, devoted to her craft and to the worlds beyond.

"The seer is an important figure in the settlement, a direct link between the gods and the people," says senior concept artist Pierre Raveneau. "I wanted the outfit to reflect that point. Also, Valka is secretly a bit of a fashionista."

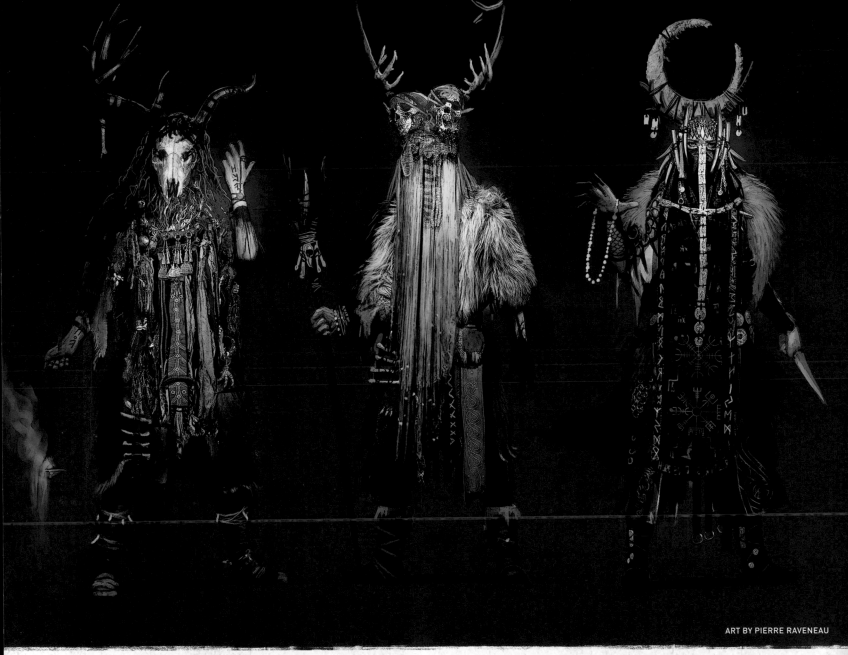

ART BY PIERRE RAVENEAU

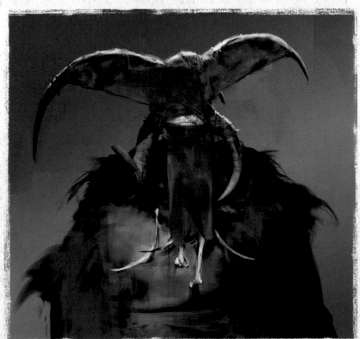

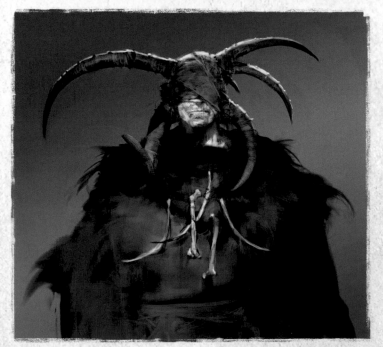

ART BY JEFF SIMPSON

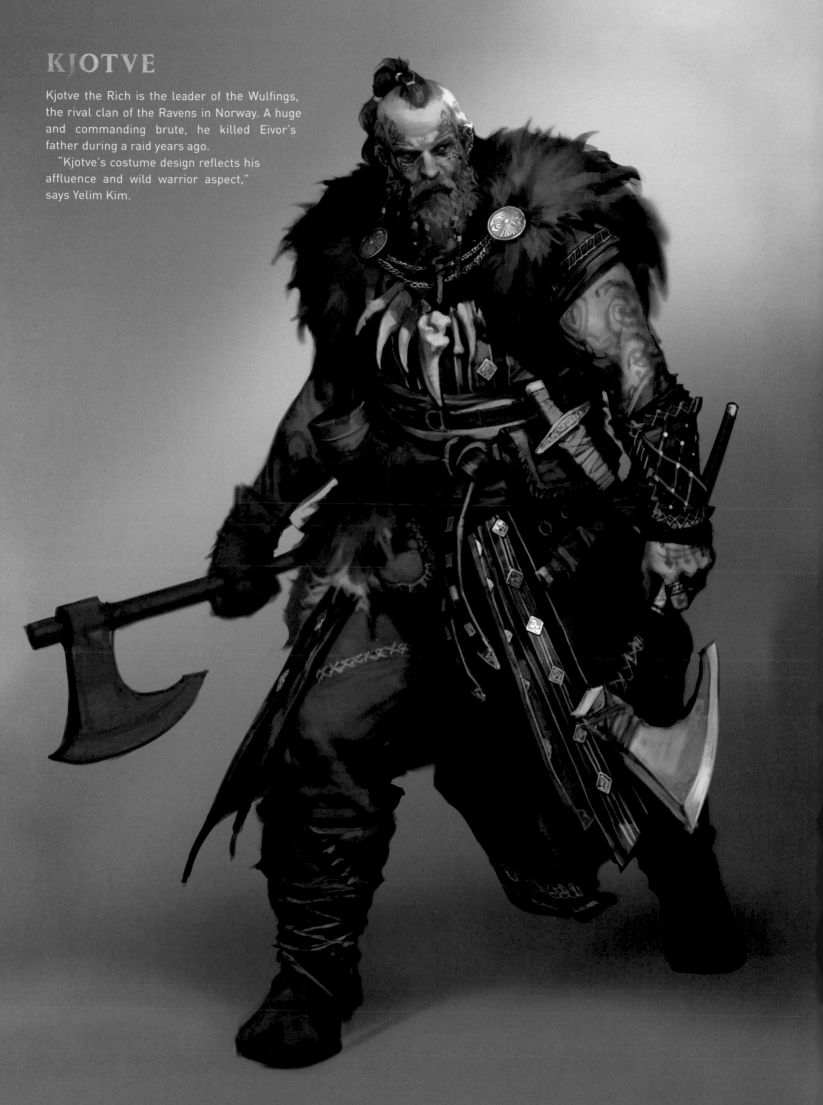

KJOTVE

Kjotve the Rich is the leader of the Wulfings, the rival clan of the Ravens in Norway. A huge and commanding brute, he killed Eivor's father during a raid years ago.

"Kjotve's costume design reflects his affluence and wild warrior aspect," says Yelim Kim.

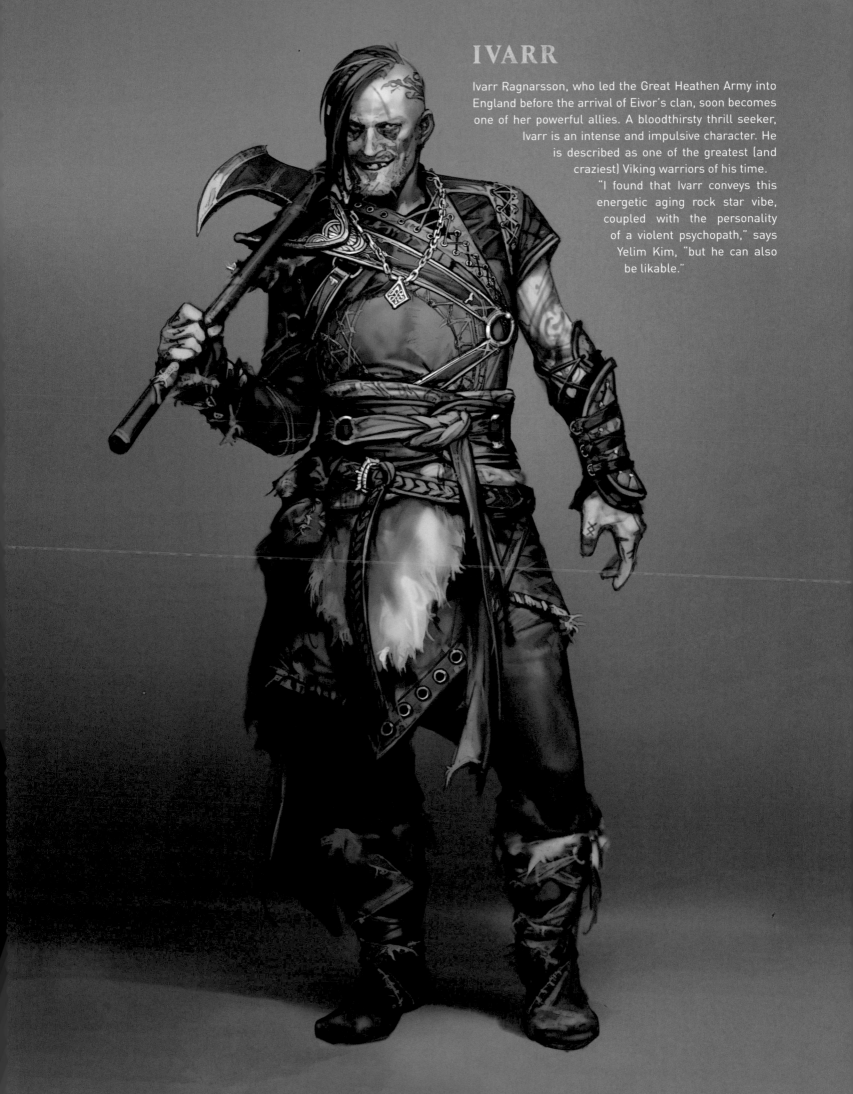

IVARR

Ivarr Ragnarsson, who led the Great Heathen Army into England before the arrival of Eivor's clan, soon becomes one of her powerful allies. A bloodthirsty thrill seeker, Ivarr is an intense and impulsive character. He is described as one of the greatest (and craziest) Viking warriors of his time.

"I found that Ivarr conveys this energetic aging rock star vibe, coupled with the personality of a violent psychopath," says Yelim Kim, "but he can also be likable."

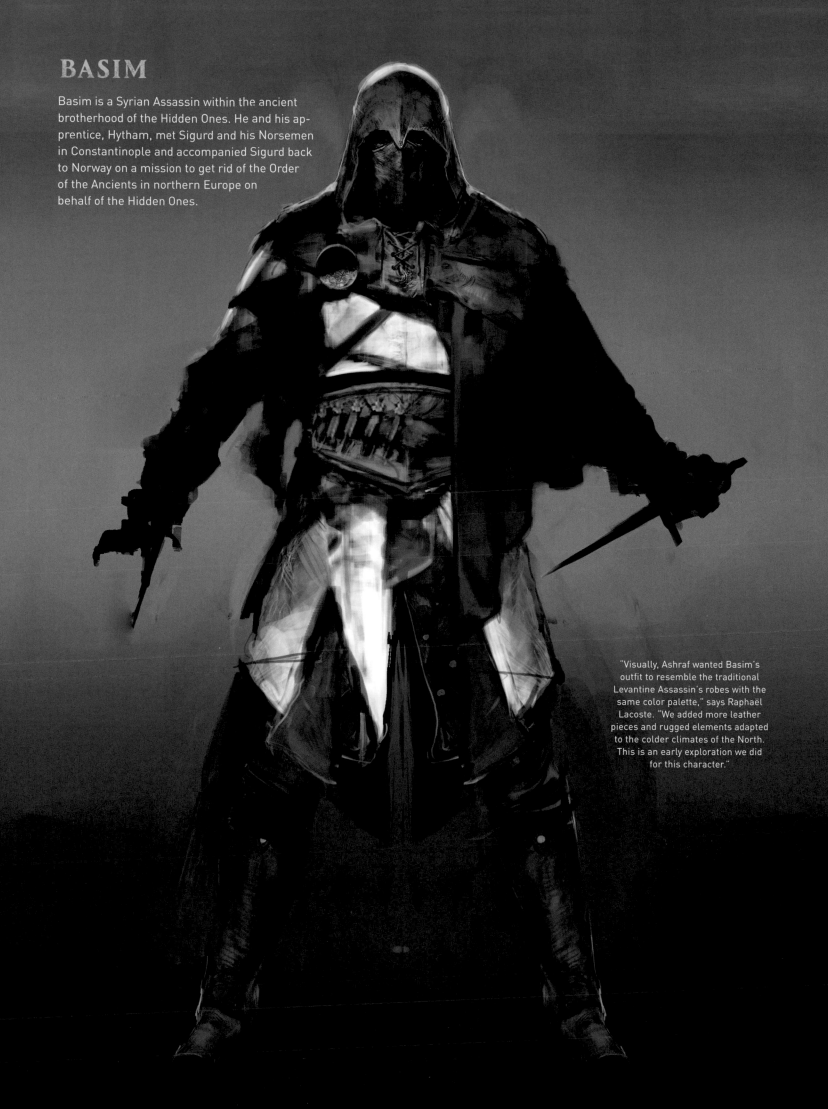

BASIM

Basim is a Syrian Assassin within the ancient brotherhood of the Hidden Ones. He and his apprentice, Hytham, met Sigurd and his Norsemen in Constantinople and accompanied Sigurd back to Norway on a mission to get rid of the Order of the Ancients in northern Europe on behalf of the Hidden Ones.

"Visually, Ashraf wanted Basim's outfit to resemble the traditional Levantine Assassin's robes with the same color palette," says Raphaël Lacoste. "We added more leather pieces and rugged elements adapted to the colder climates of the North. This is an early exploration we did for this character."

ART BY JEFF SIMPSON

HYTHAM

Hytham is Basim's young apprentice. Dedicated to the cause of the Hidden Ones, he abhors the Order of the Ancients and their strict, hierarchical worldview. He is helping Eivor locate their members in England. As an apprentice, Hytham has not earned his red sash yet, for the sash is solely reserved for the rank of Mentor.

"For Hytham, I tried pretty straightforward shapes and less shading in order to focus on his simple design."—REMKO TROOST

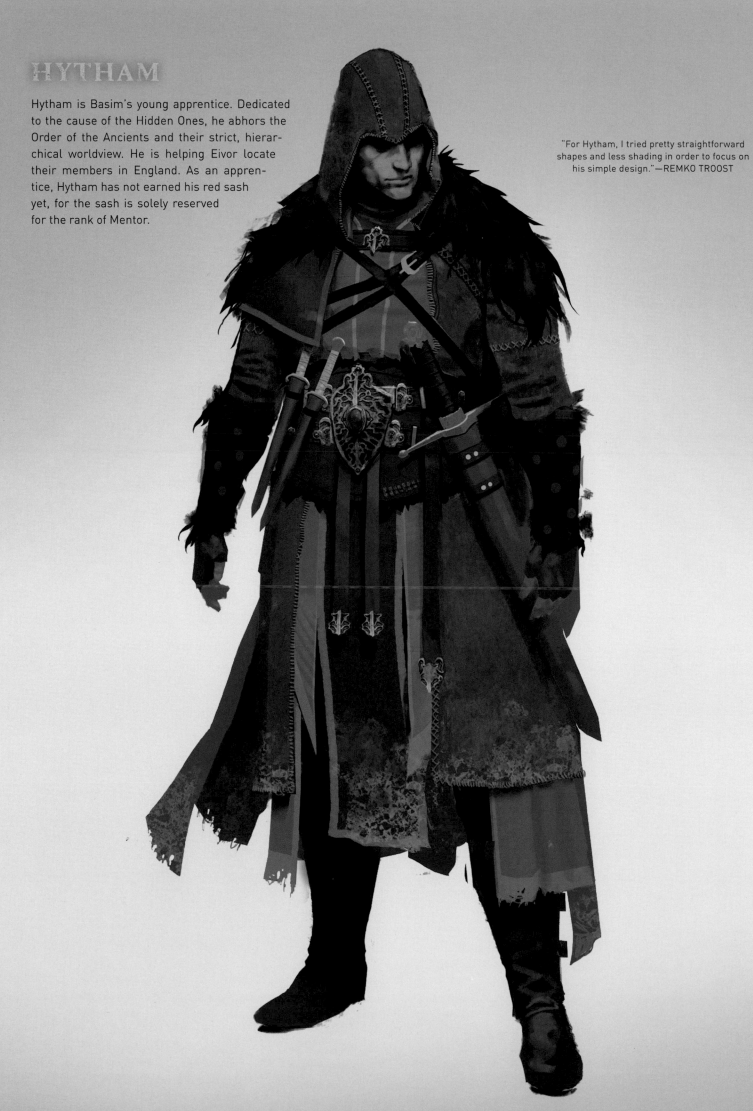

ART BY REMKO TROOST

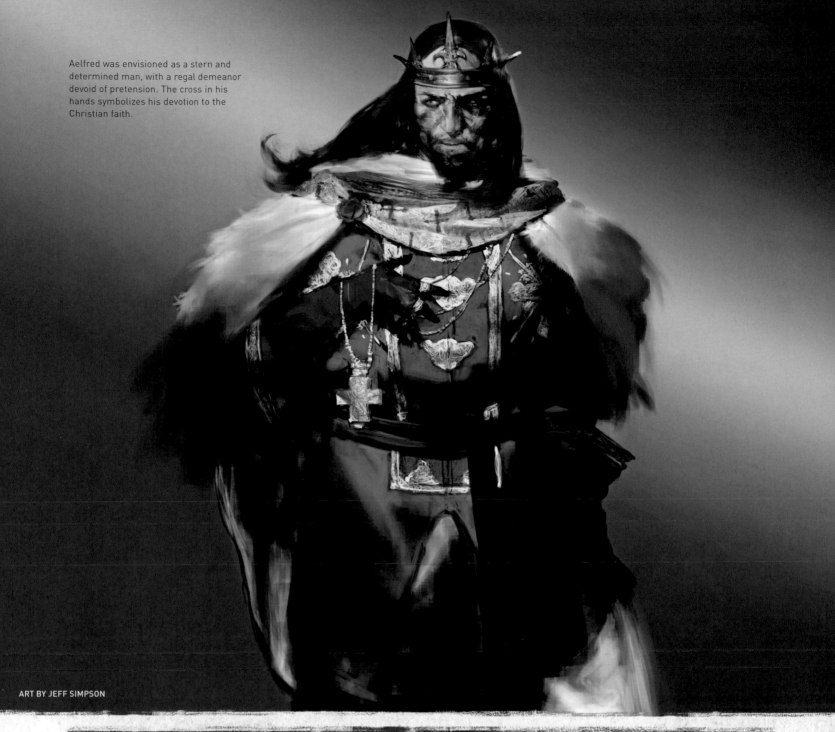

Aelfred was envisioned as a stern and determined man, with a regal demeanor devoid of pretension. The cross in his hands symbolizes his devotion to the Christian faith.

ART BY JEFF SIMPSON

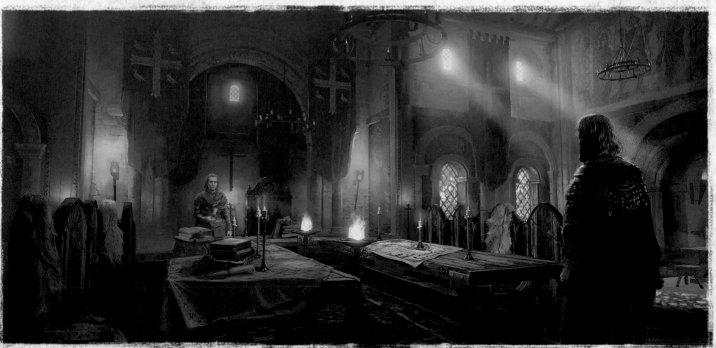

"King Aelfred declares war on the Vikings." —EDDIE BENNUN

ART BY EDDIE BENNUN

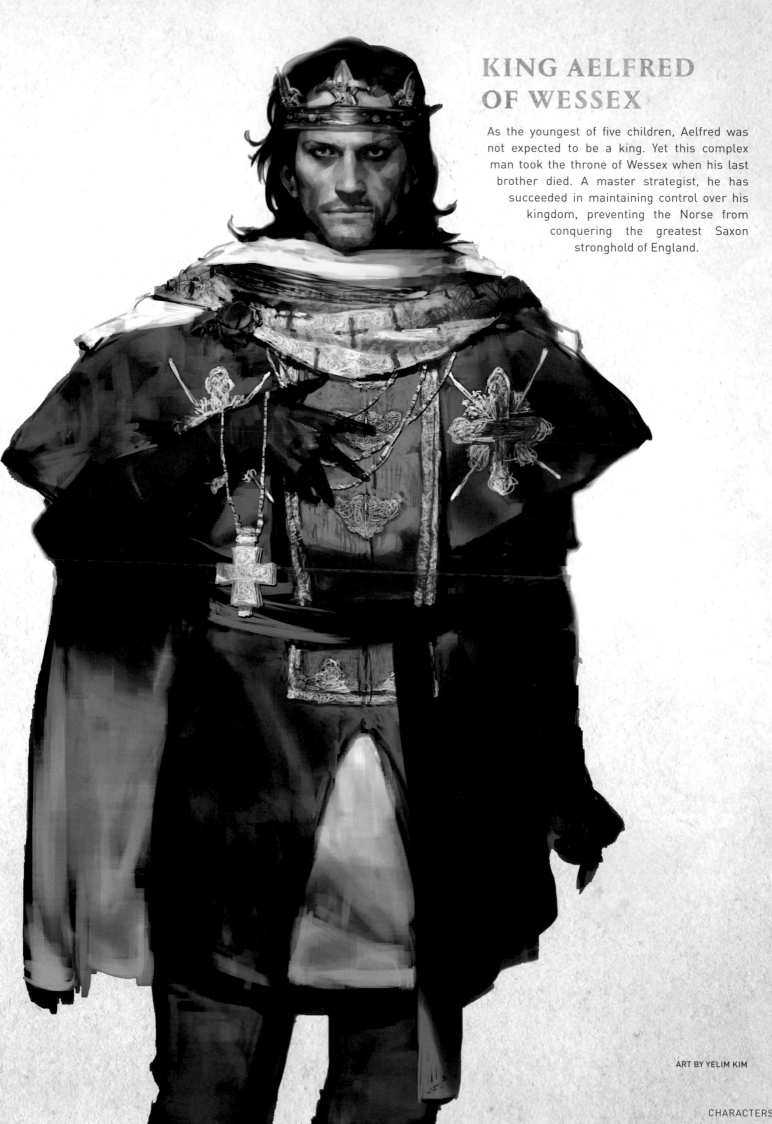

KING AELFRED OF WESSEX

As the youngest of five children, Aelfred was not expected to be a king. Yet this complex man took the throne of Wessex when his last brother died. A master strategist, he has succeeded in maintaining control over his kingdom, preventing the Norse from conquering the greatest Saxon stronghold of England.

ART BY YELIM KIM

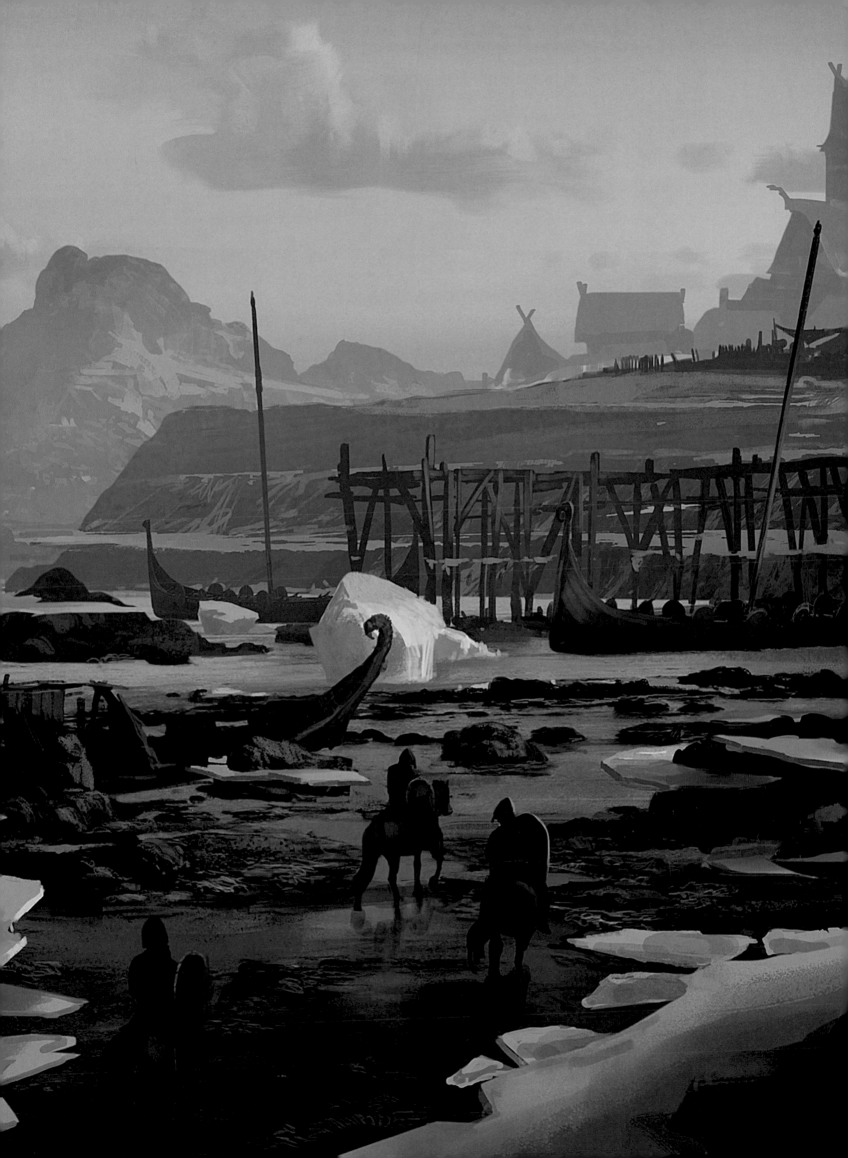

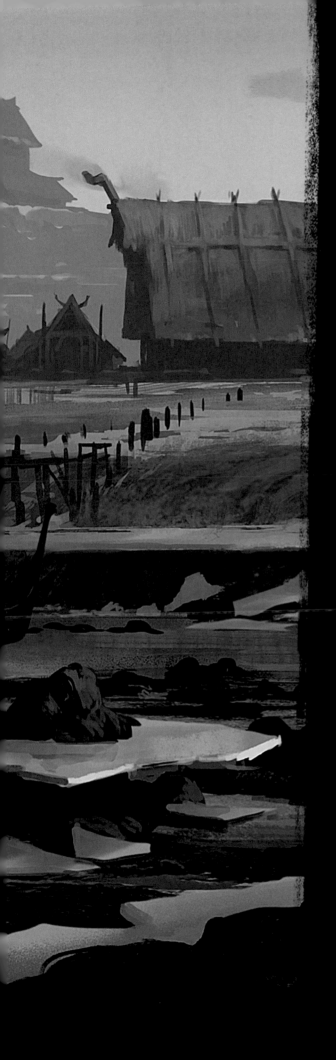

CHAPTER TWO

NORWAY

A BEAUTIFUL AND UNFORGIVING LAND

"After Egypt and ancient Greece, Norway offers a fresh new setting for our players," says Raphaël Lacoste. "We were very excited to bring this world to life. During our scouting trip, we took a lot of pictures, recorded sounds, went for hikes in the Lofoten Islands, and made sure we had a lot of inspirational material for the team. This setting is a bold contrast to those in the previous games. The landscapes, atmospheres, and lights of the northern lands are so different from our previous worlds; it was a great opportunity for the team to experiment with new visual directions."

During the challenging and rewarding journey through these unforgiving lands, the player will discover high mountains, fjords, forests, open waters, wild animals . . . and enemies. The weather is always changing—certain areas will even be hit by snowstorms—and the world will always feel different, as it's experienced during various times of day. Norway offers otherworldly and grandiose landscapes that will be extremely memorable in *Assassin's Creed Valhalla*.

THESE PAGES AND CHAPTER BREAK: ART BY MARTIN DESCHAMBAULT

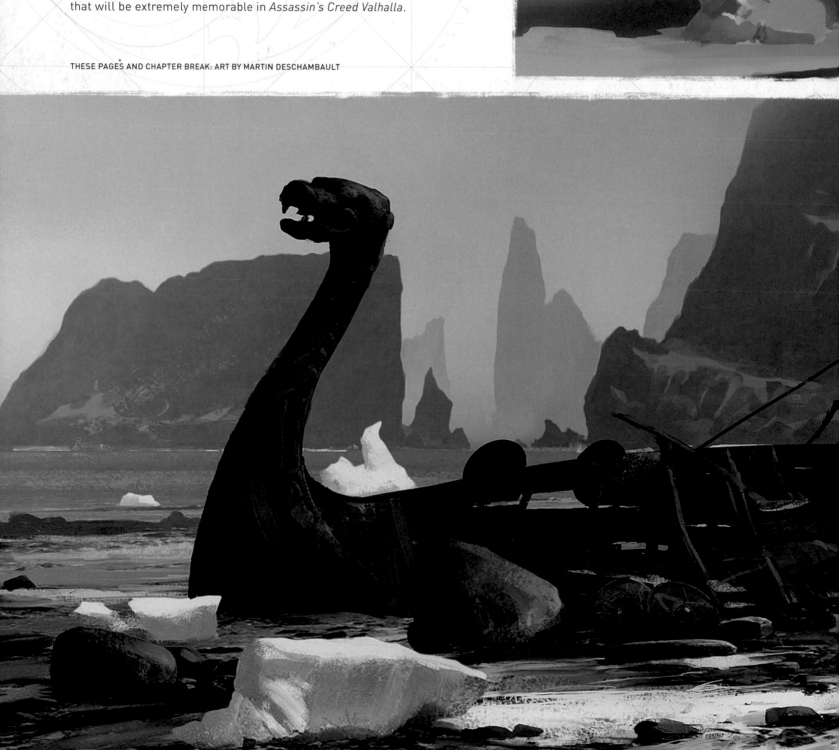

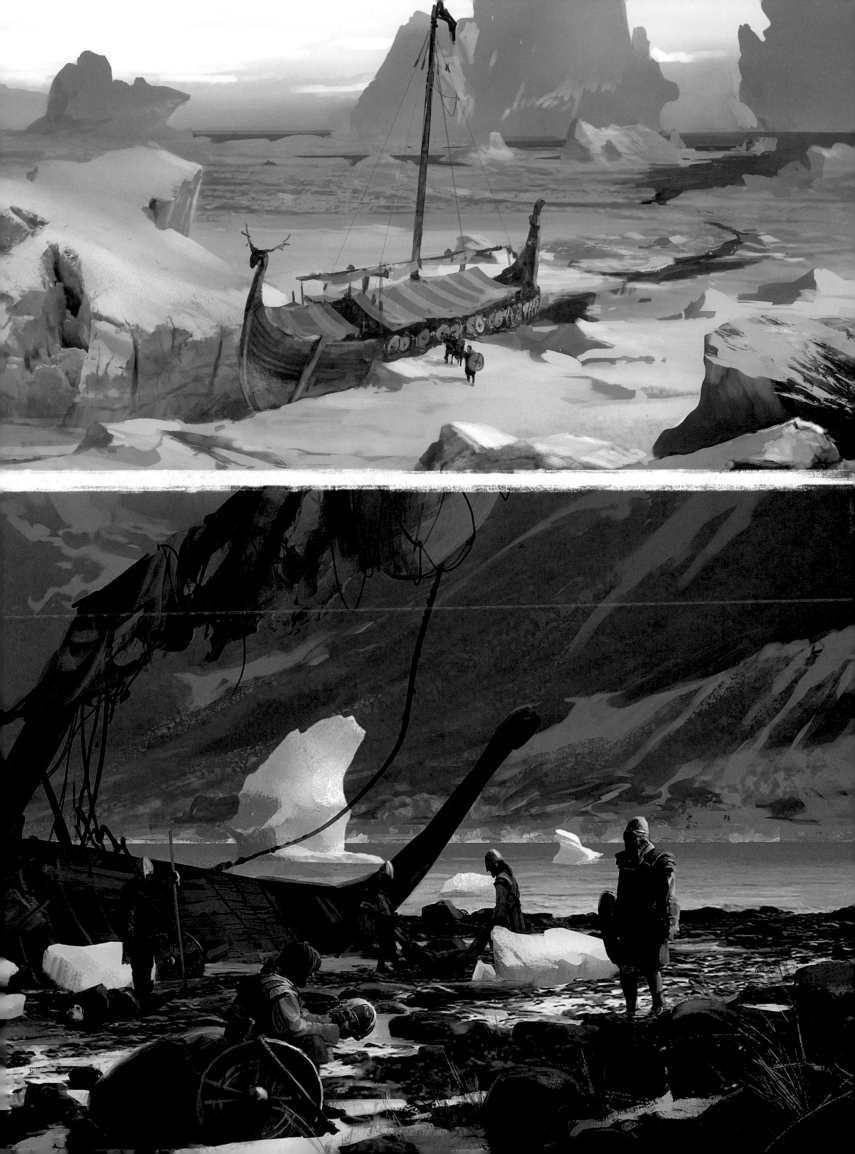

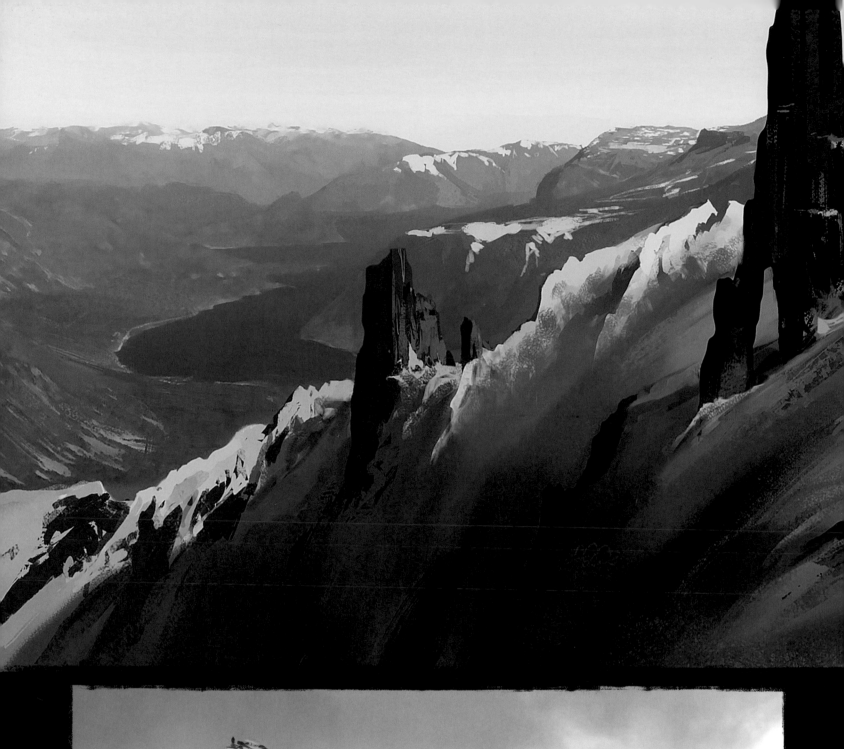

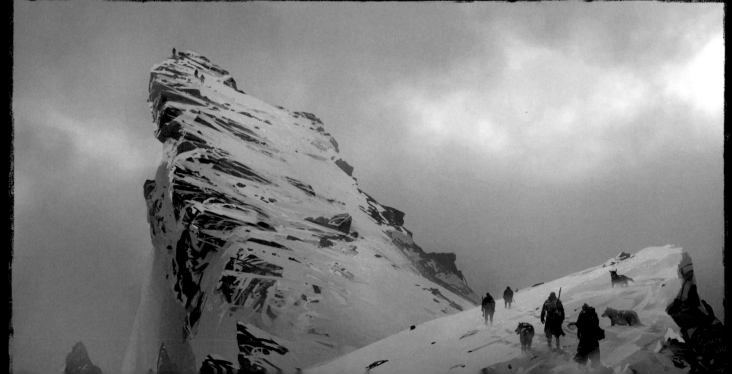

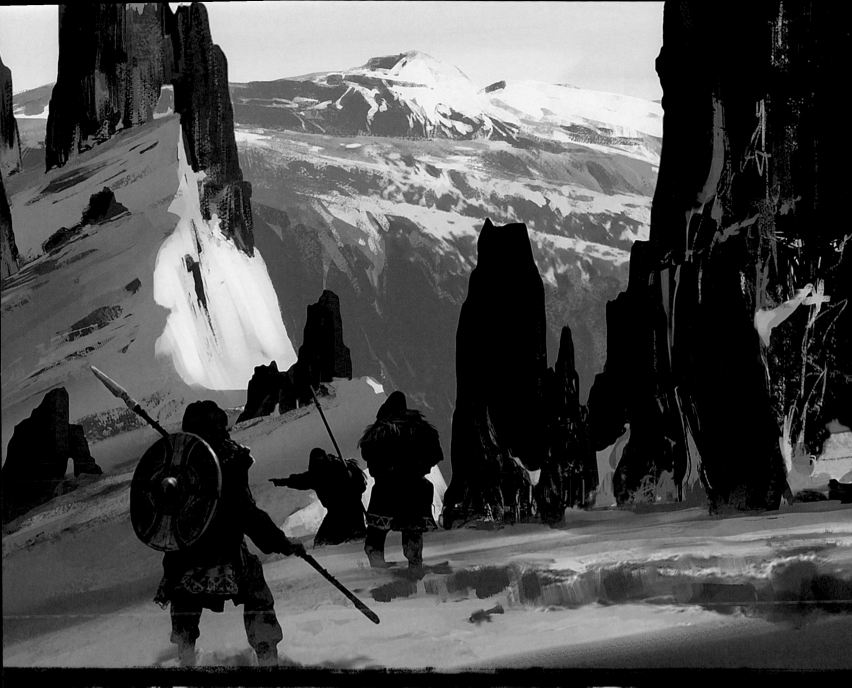

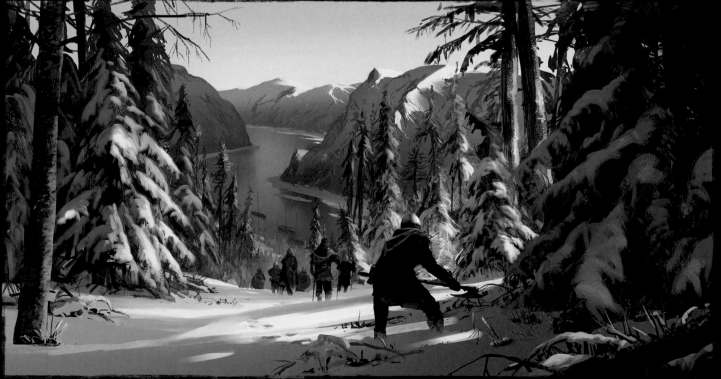

TOP AND BOTTOM RIGHT: ART BY MARTIN DESCHAMBAULT; BOTTOM LEFT: ART BY RAPHAËL LACOSTE

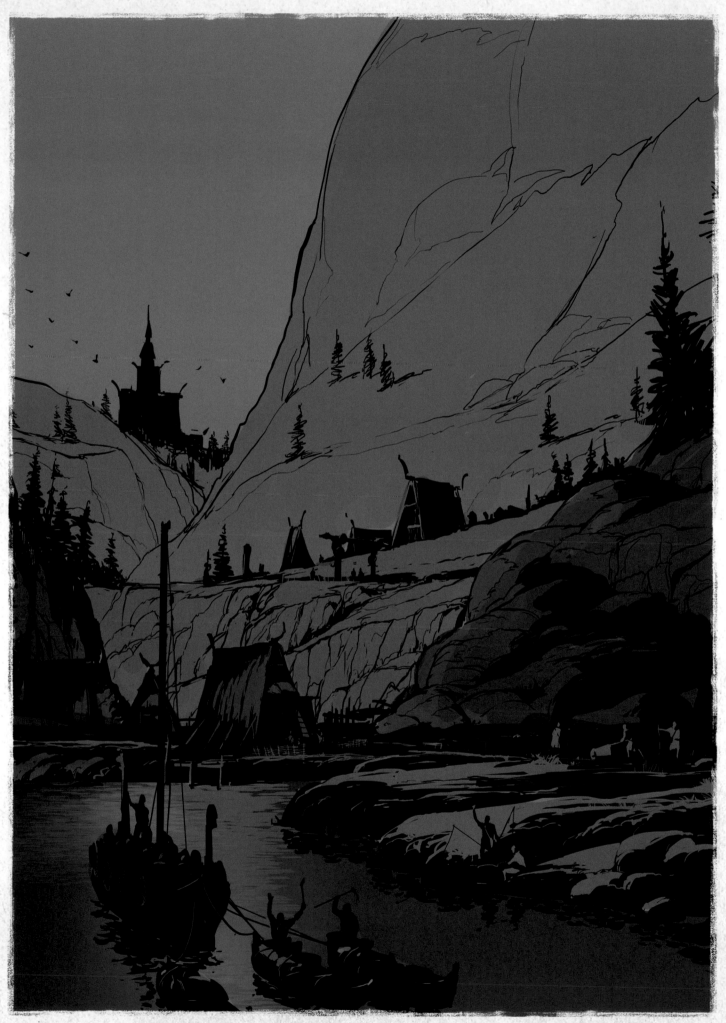

A black-and-white sketch of a Norwegian fjord.

ART BY MARTIN DESCHAMBAULT

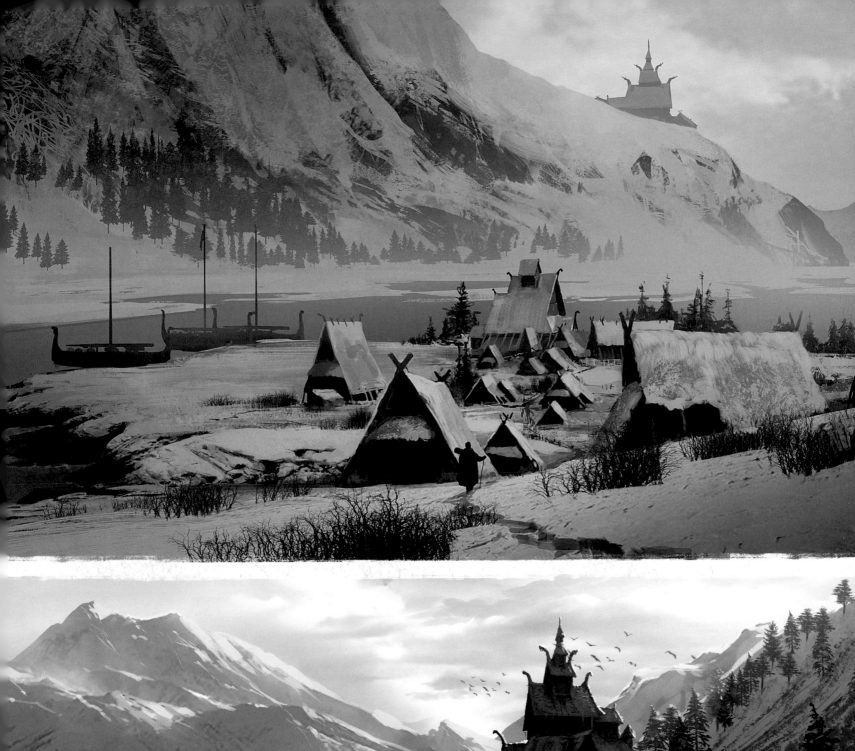

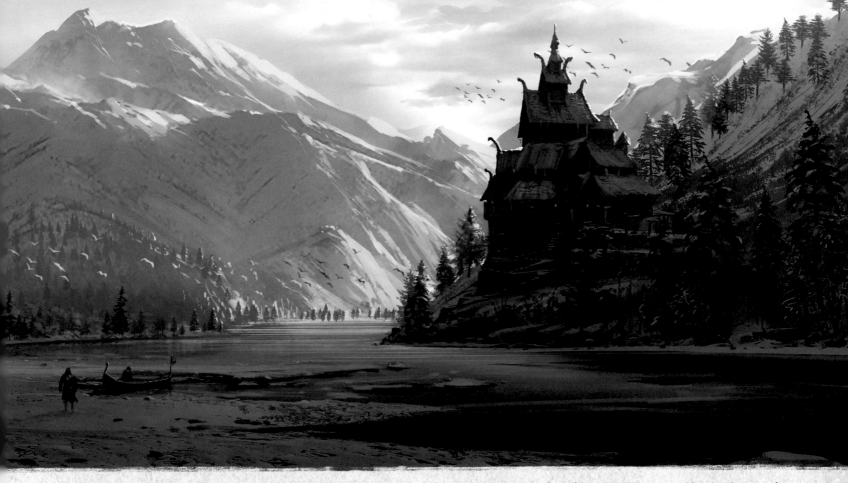

"In the bottom image, I wanted to create an iconic vista that showcases the beauty of Norway's wooden churches (or *hof*), blended with nature and framing the entry of a grand Norwegian fjord."—RAPHAËL LACOSTE

TOP: ART BY MARTIN DESCHAMBAULT; BOTTOM: ART BY RAPHAËL LACOSTE

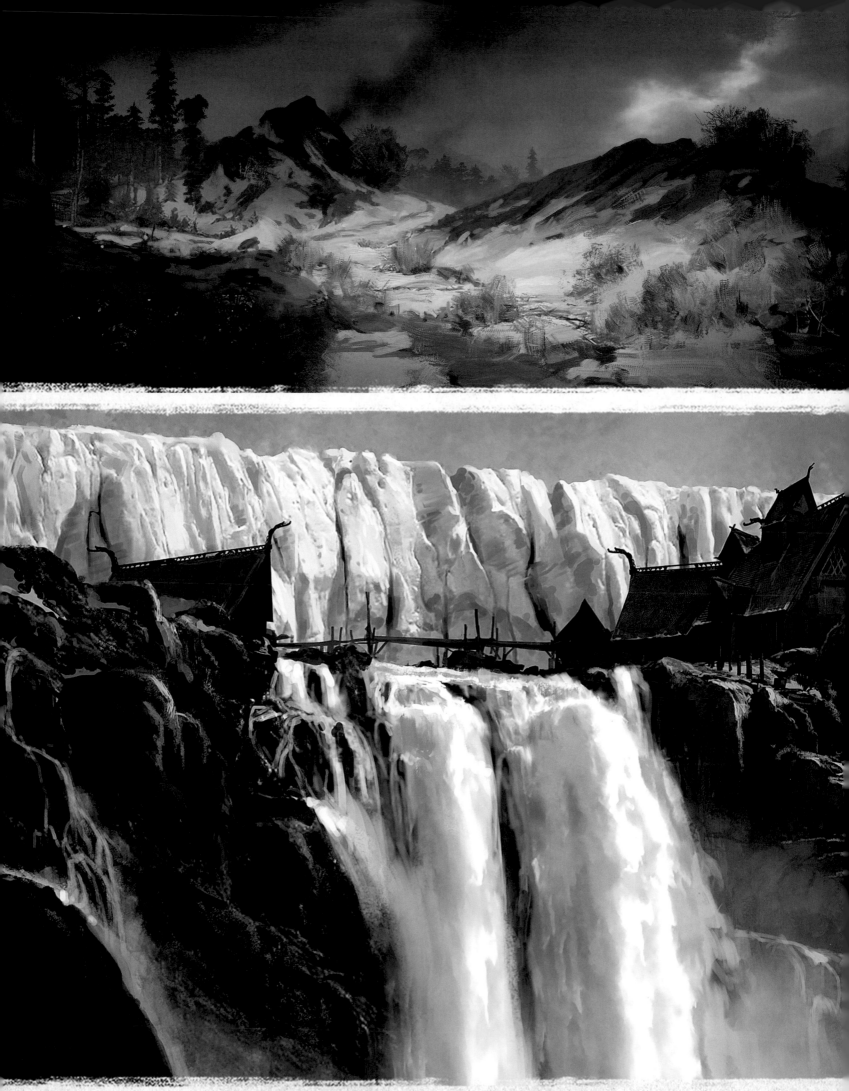

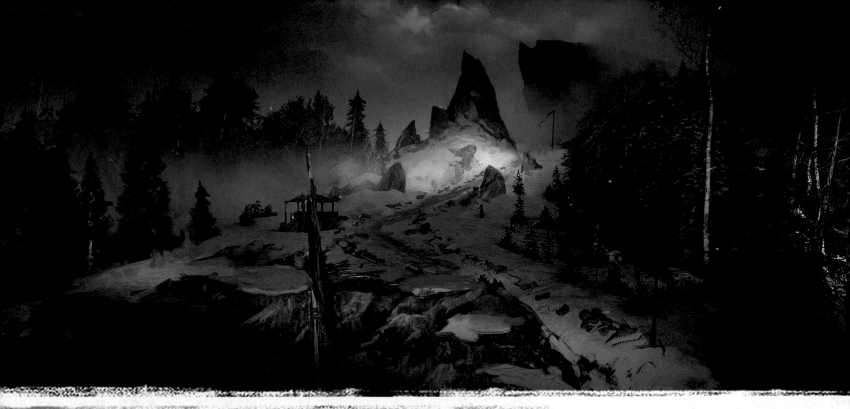

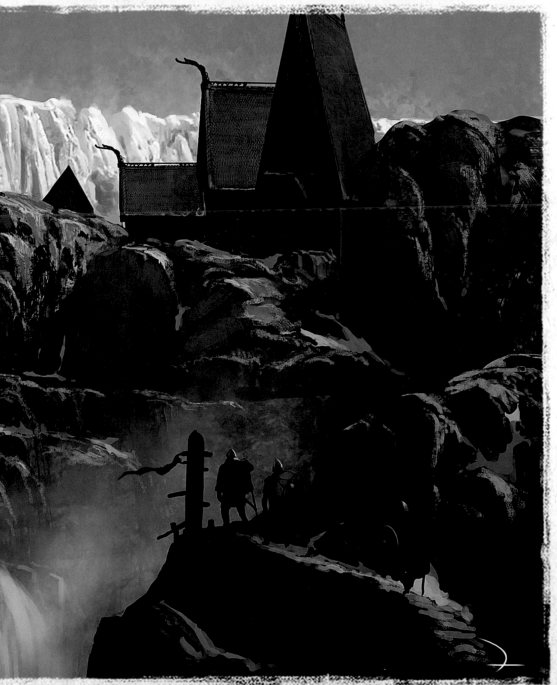

"The two images above were paint-overs of screenshots that were done during the last few months of the production," says Gilles Beloeil. "The idea was to design in a more interesting way the path for the opening of the game, because it is important to make the path very clear and good looking at the same time. We had to take extra care with this part of the world."

"Creating an interesting world for a game doesn't mean it has to be realistic," says Lacoste. "We always work hard to find a good balance between credibility and creativity to offer the best opportunities to our players, making sure we trigger curiosity, constant interest, and fun."

TOP: ART BY GILLES BELOEIL
BOTTOM: ART BY MARTIN DESCHAMBAULT

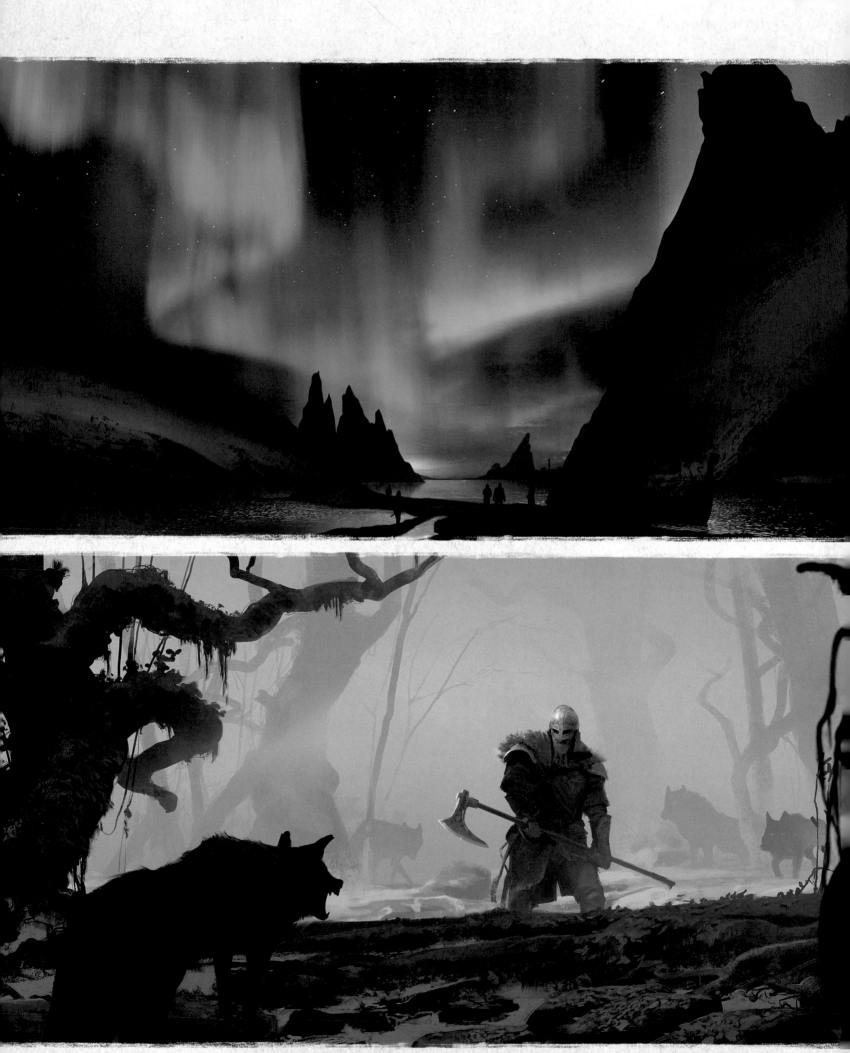

"The northern lights brought a very unique flavor to our nights in Norway. When we traveled there for our scouting trip, we were lucky enough to see them. It was memorable and moving."—RAPHAËL LACOSTE

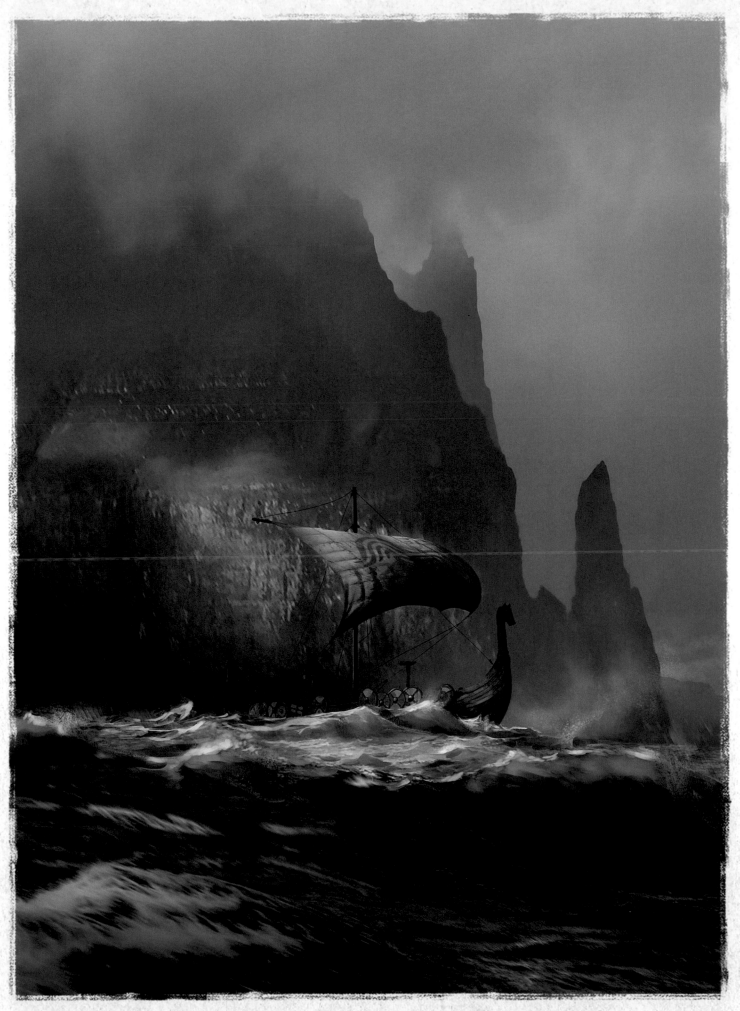

"Exploring Norway with our drakkar offers a very different perspective on exploration," says Lacoste. In *Assassin's Creed Valhalla*, the player not only can access the fjords from above by climbing mountains, but also can navigate in open waters and rivers to raid different locations with their crew.

THESE PAGES: ART BY MARTIN DESCHAMBAULT

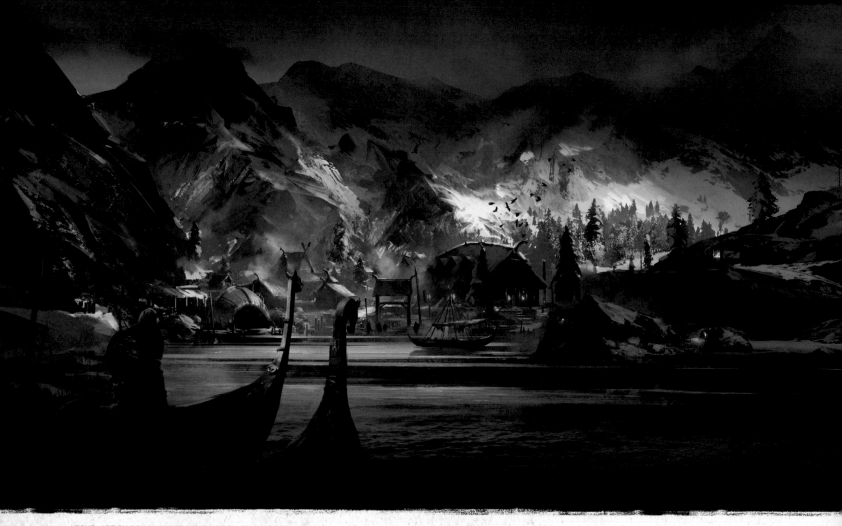

ABOVE: ART BY DONGLU YU; BELOW: ART BY JEAN-CLAUDE GOLVIN

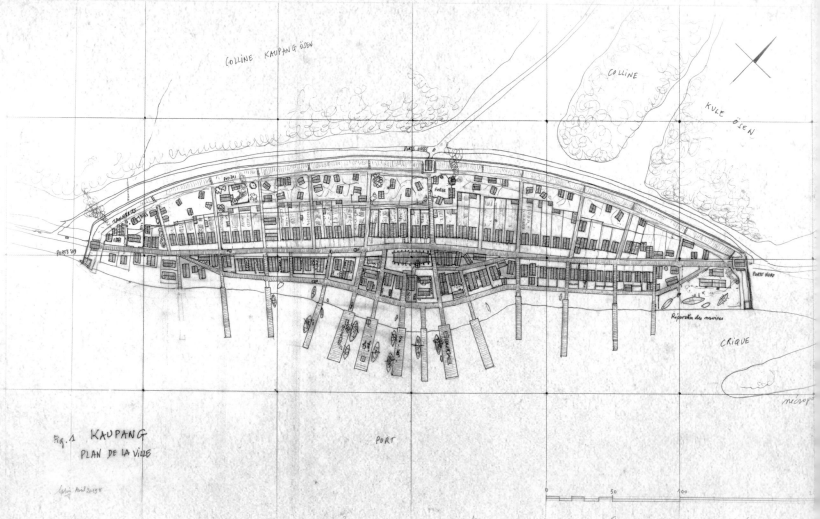

Fig. 1 KAUPANG
PLAN DE LA VILLE

"Jean-Claude Golvin worked with us on *Assassin's Creed Origins* and joined us again to share his historic and artistic knowledge. He did this map of Kaupang, an ancient Viking town, to give us an example of settlements and village layouts from this time period."—RAPHAËL LACOSTE

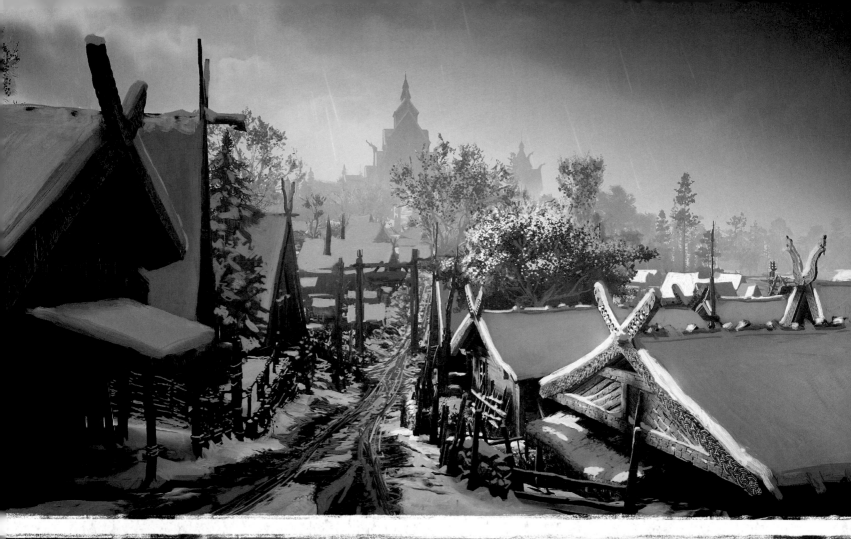

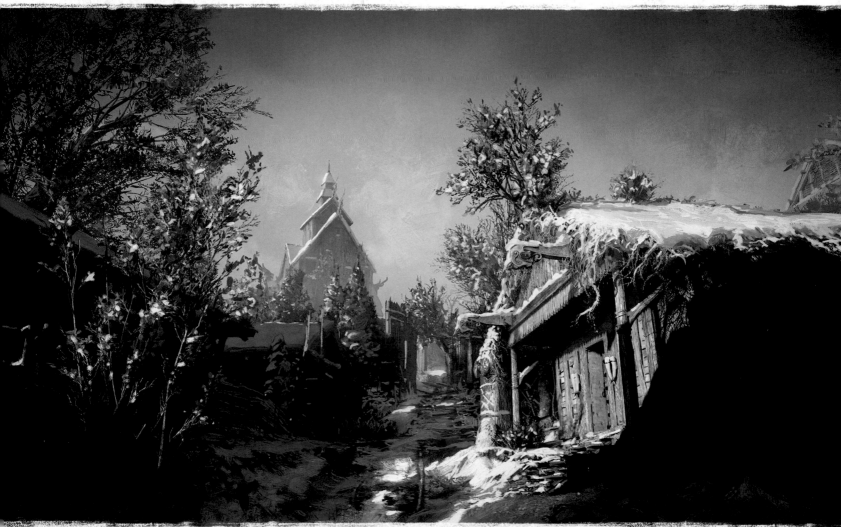

"Raphaël wanted these two paint-over concepts to be more colorful than they had been originally. They had to look cold in terms of temperature but warm in terms of ambiance." —GILLES BELOEIL

THIS PAGE: ART BY GILLES BELOEIL

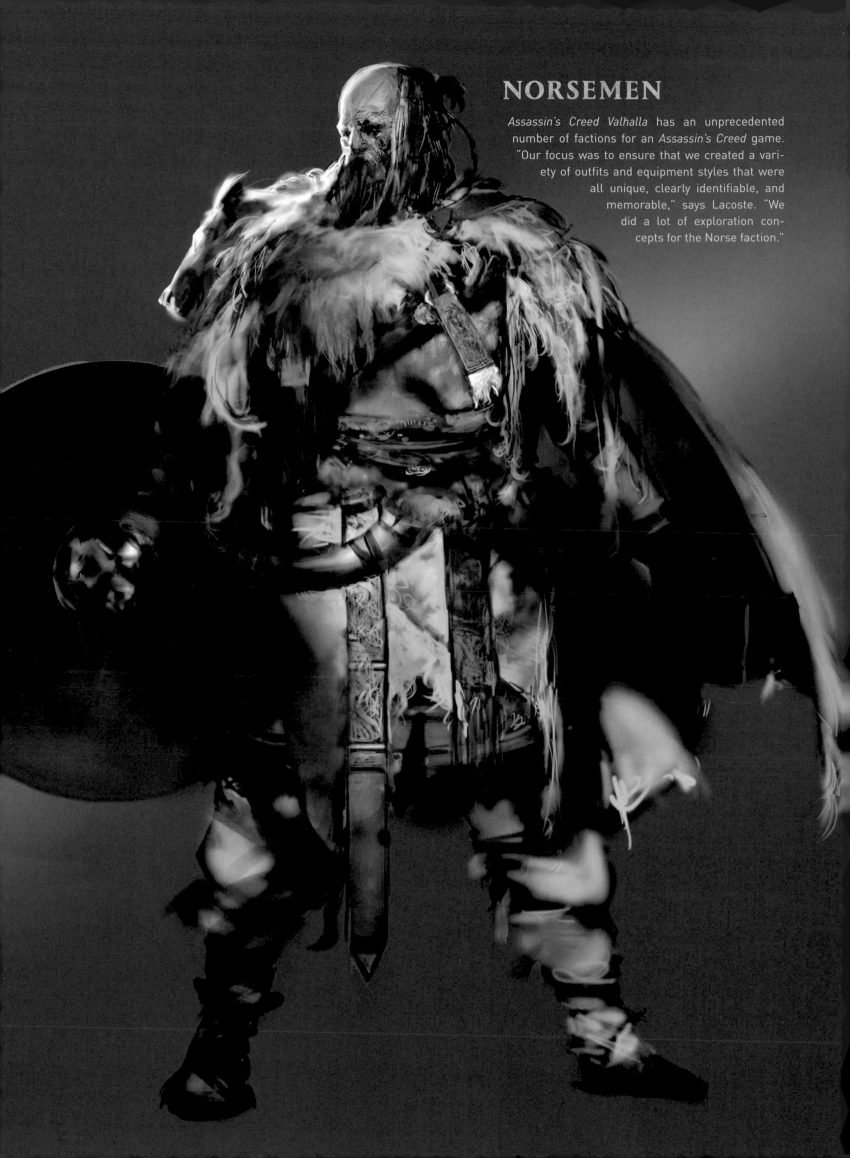

NORSEMEN

Assassin's Creed Valhalla has an unprecedented number of factions for an *Assassin's Creed* game. "Our focus was to ensure that we created a variety of outfits and equipment styles that were all unique, clearly identifiable, and memorable," says Lacoste. "We did a lot of exploration concepts for the Norse faction."

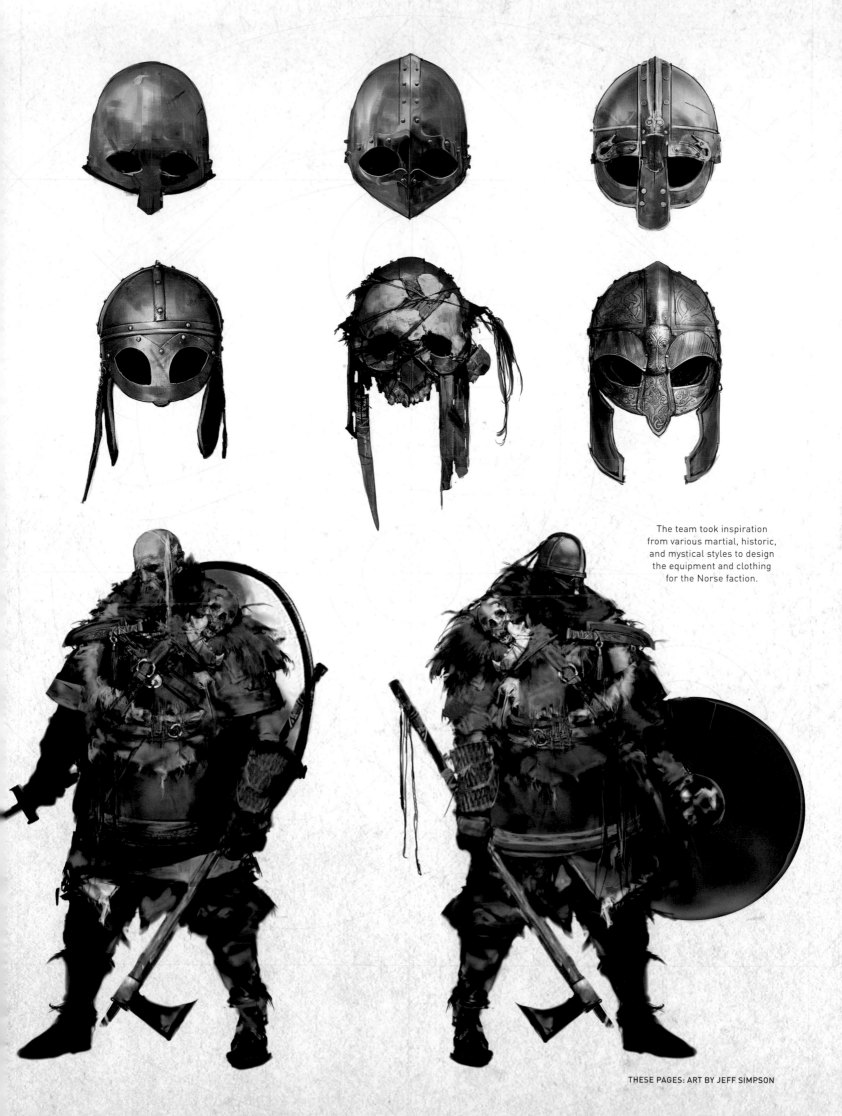

The team took inspiration from various martial, historic, and mystical styles to design the equipment and clothing for the Norse faction.

THESE PAGES: ART BY JEFF SIMPSON

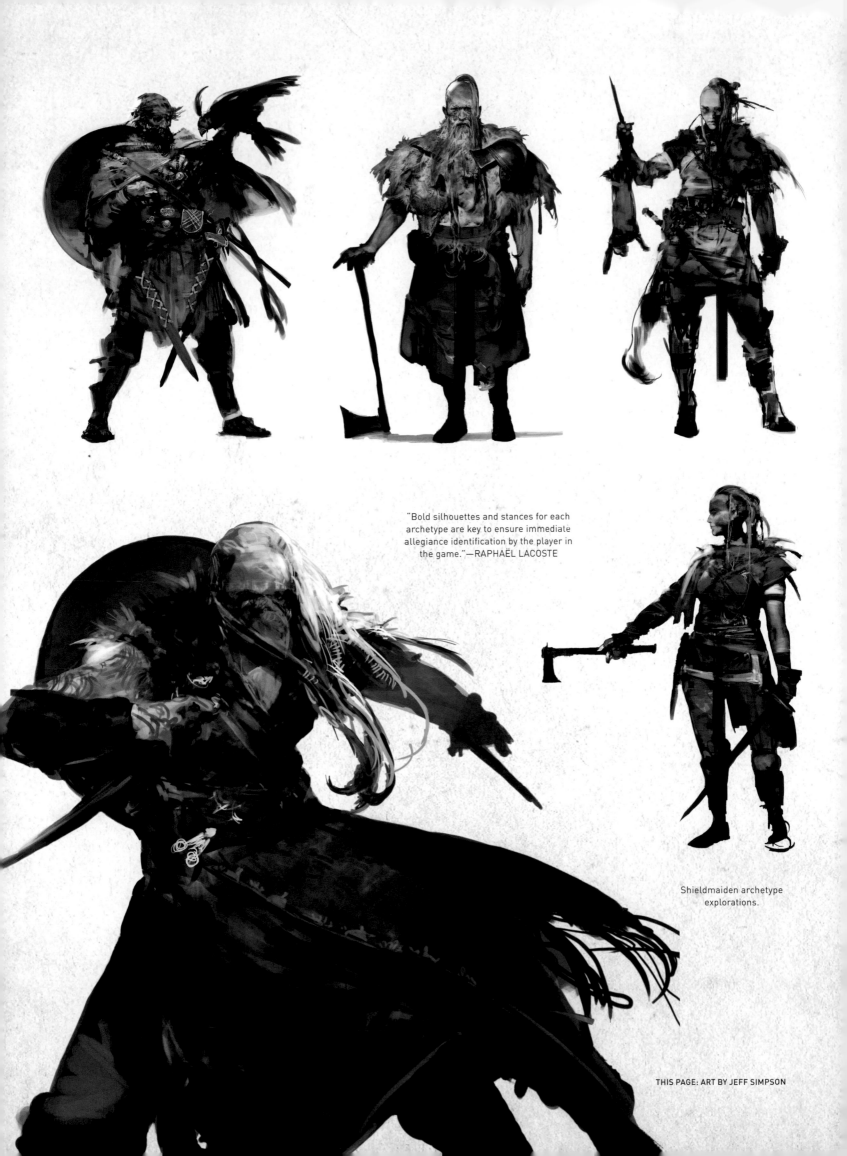

"Bold silhouettes and stances for each archetype are key to ensure immediate allegiance identification by the player in the game."—RAPHAËL LACOSTE

Shieldmaiden archetype explorations.

THIS PAGE: ART BY JEFF SIMPSON

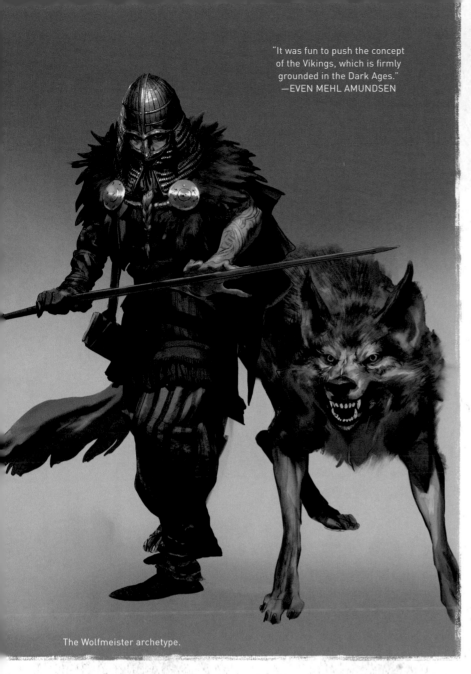

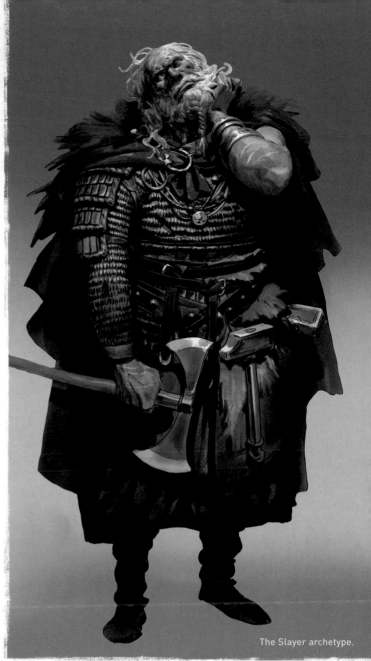

"It was fun to push the concept of the Vikings, which is firmly grounded in the Dark Ages."
—EVEN MEHL AMUNDSEN

"kick-ass' mentality."
—EVEN MEHL AMUNDSEN

The Wolfmeister archetype.

The Slayer archetype.

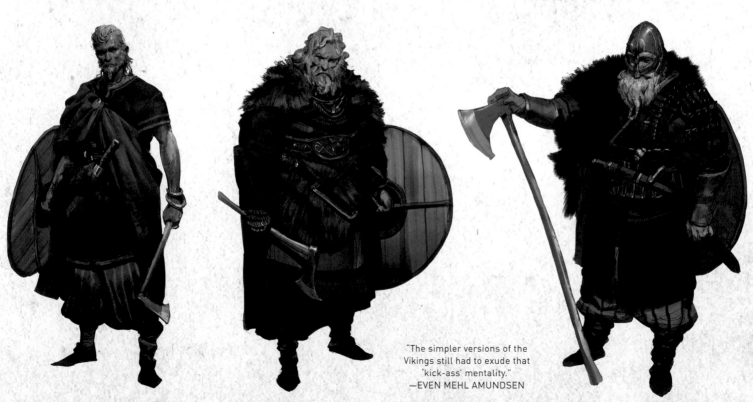

"The simpler versions of the Vikings still had to exude that 'kick-ass' mentality."
—EVEN MEHL AMUNDSEN

THIS PAGE: ART BY EVEN MEHL AMUNDSEN

WEAPONS

The team's goal for the weapons was to capture the brutality of the era while encouraging plenty of freedom for player expression. "The Viking invasion provided a vast playground where we could create iconic designs that incorporated both Norse and Saxon elements, focusing on their traditions, myths, and technologies," says art director Dann Yeau Choong Yap.

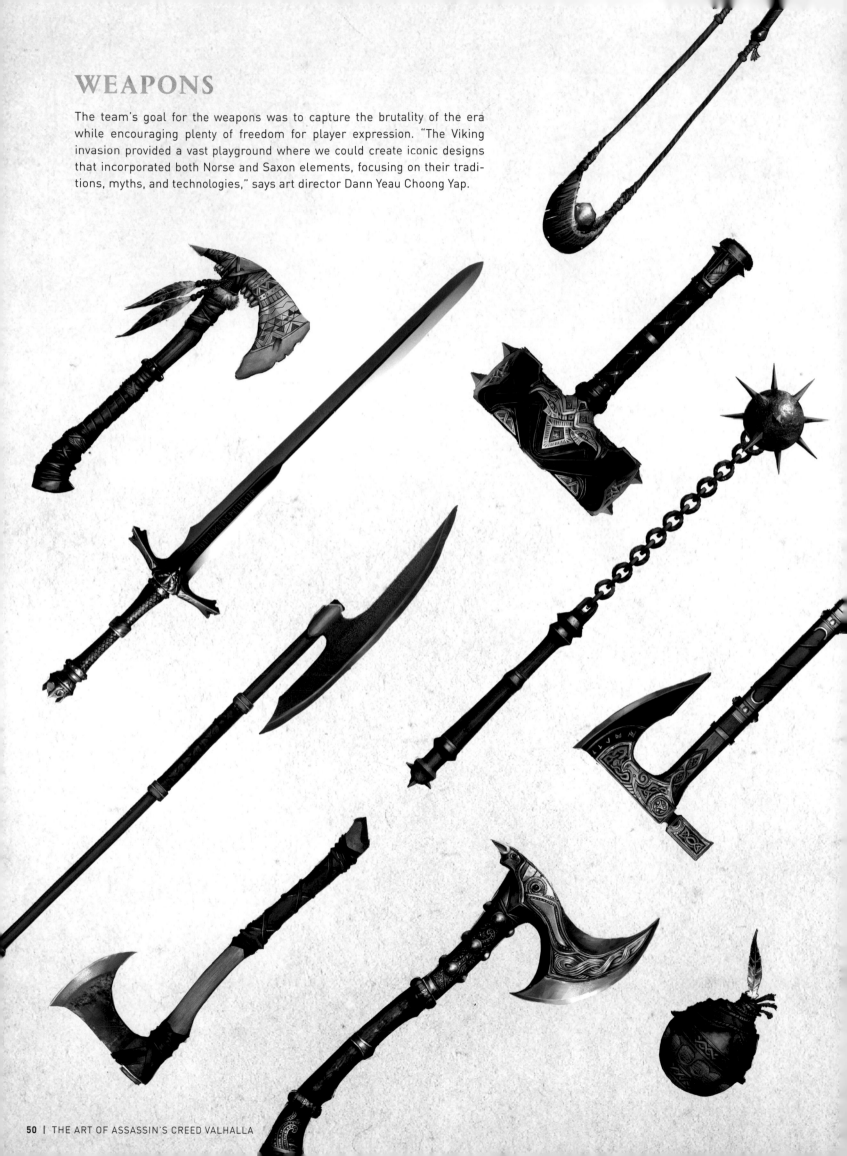

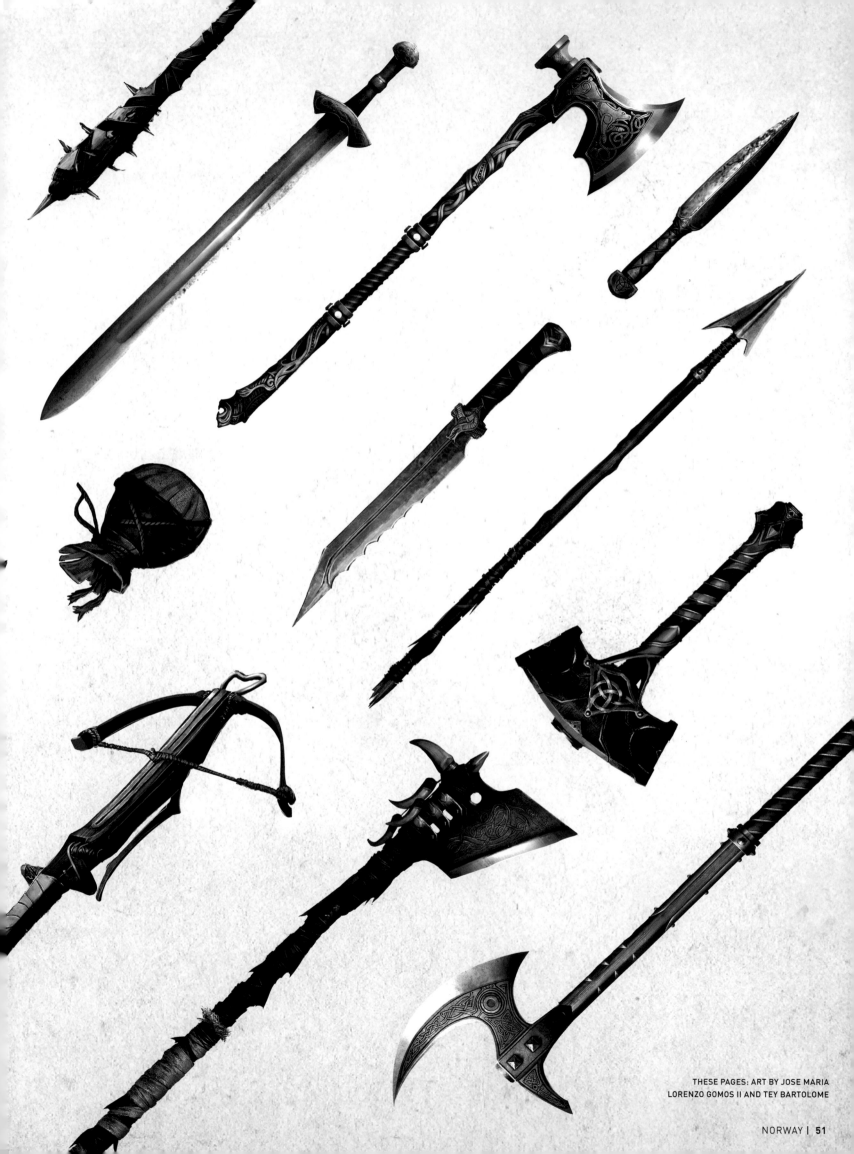

THESE PAGES: ART BY JOSE MARIA
LORENZO GOMOS II AND TEY BARTOLOME

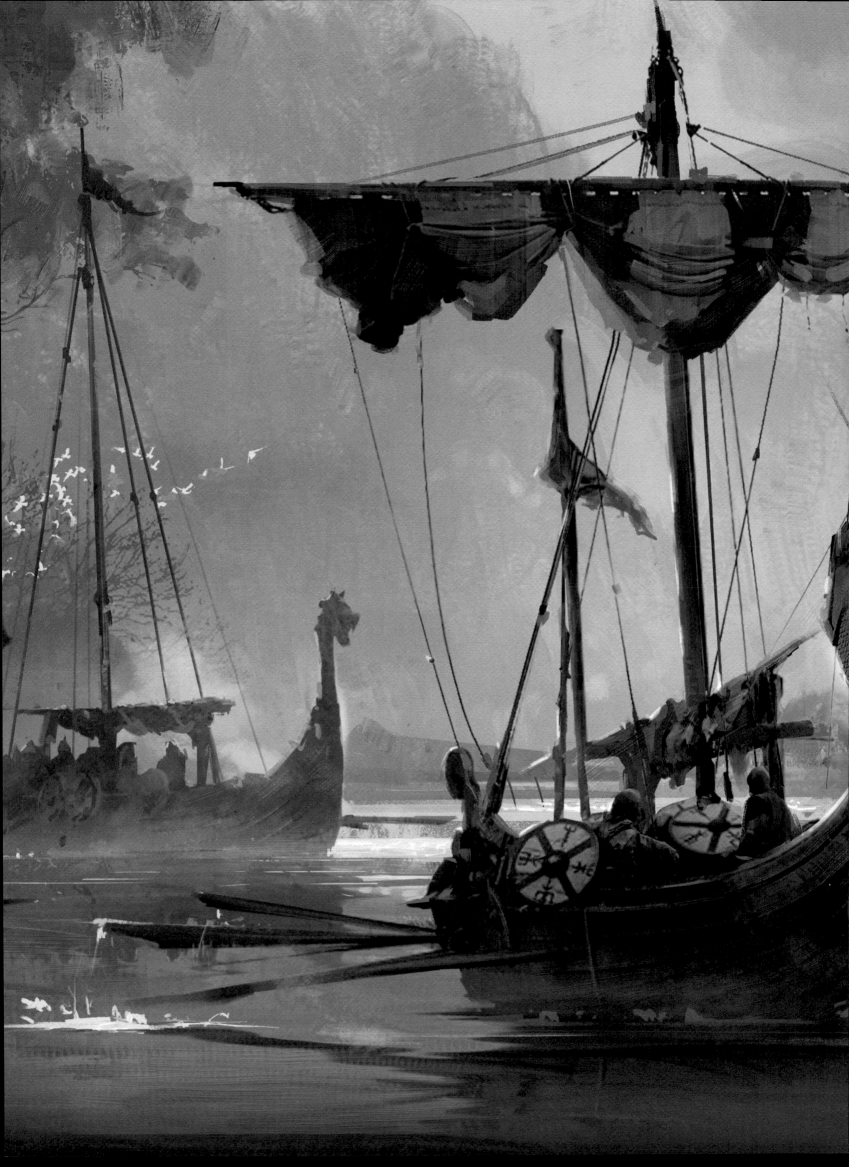

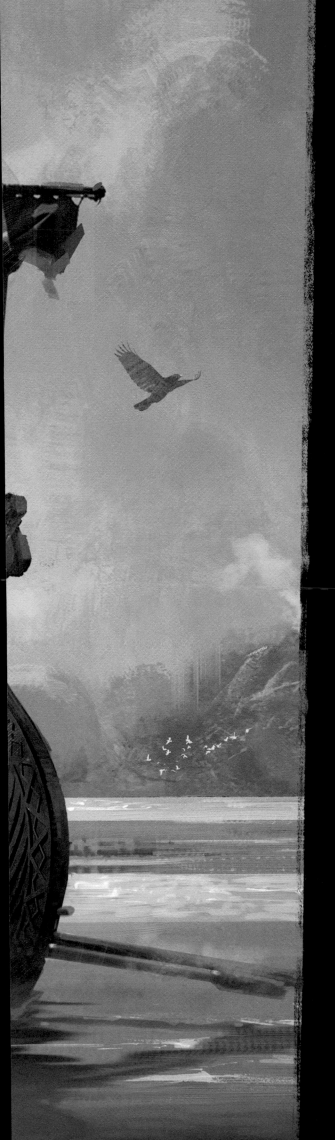

CHAPTER THREE

VIKING VOYAGER

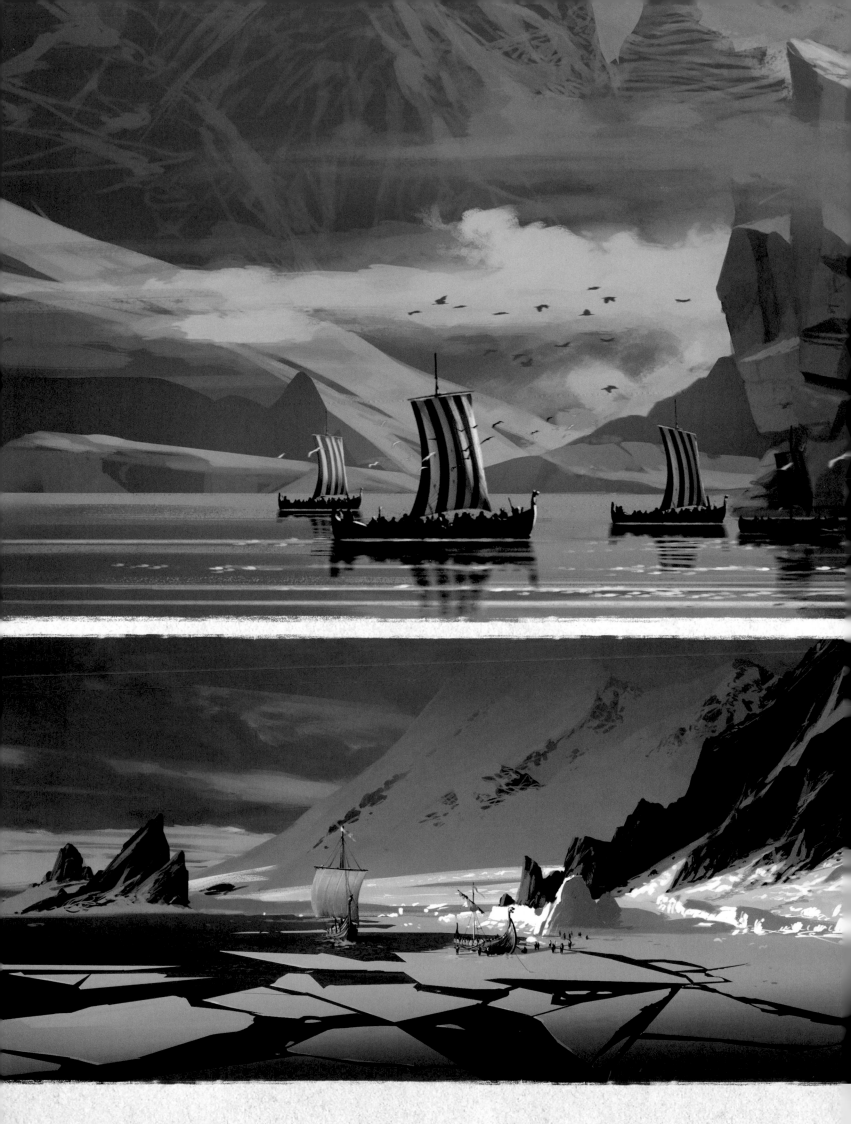

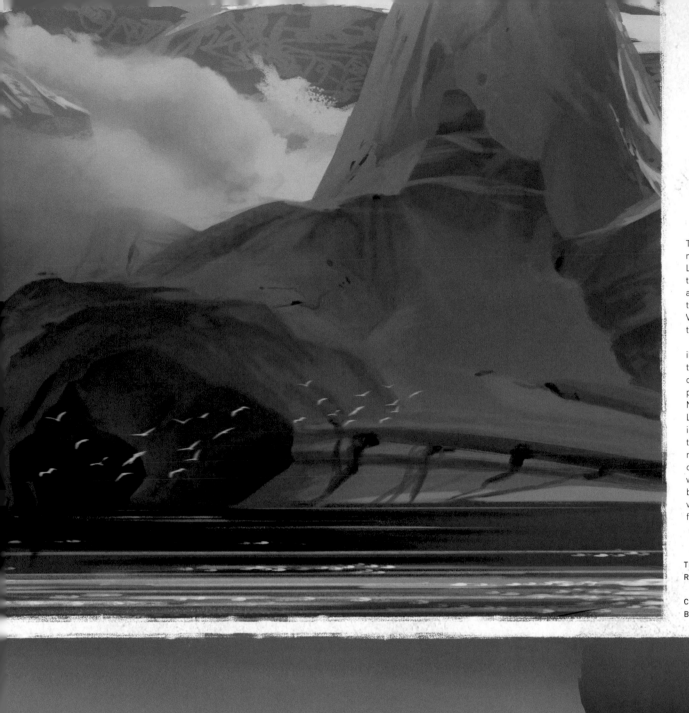

The Norse were
master shipbuilders.
Longships were used
to raid settlements but
also for long-distance
trade. This helped the
Vikings travel all over
the world.

"I wanted these
illustrations to show
the beauty and variety
of the landscapes the
player will discover in
Norway," says Raphaël
Lacoste. "It was
interesting to illustrate
the icy waters and epic
rock compositions we
could re-create in this
world. We made sure to
bring an unforgettable
visual treatment to our
first territories."

THESE PAGES: ART BY
RAPHAËL LACOSTE

CHAPTER BREAK: ART
BY DONGLU YU

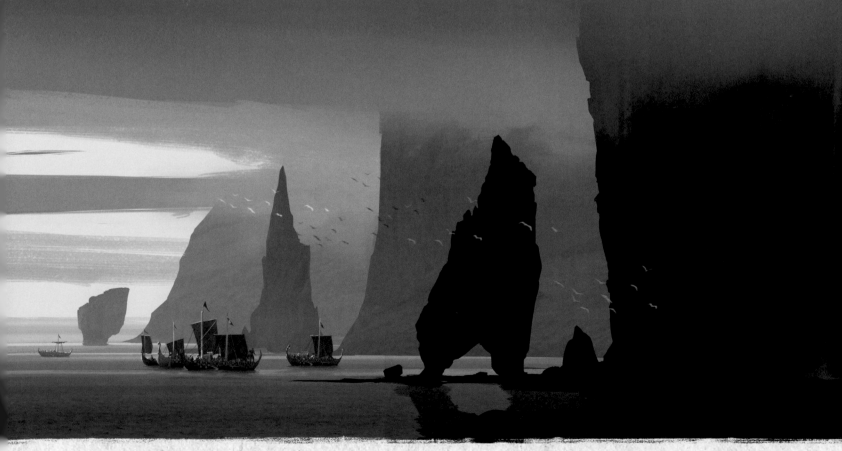

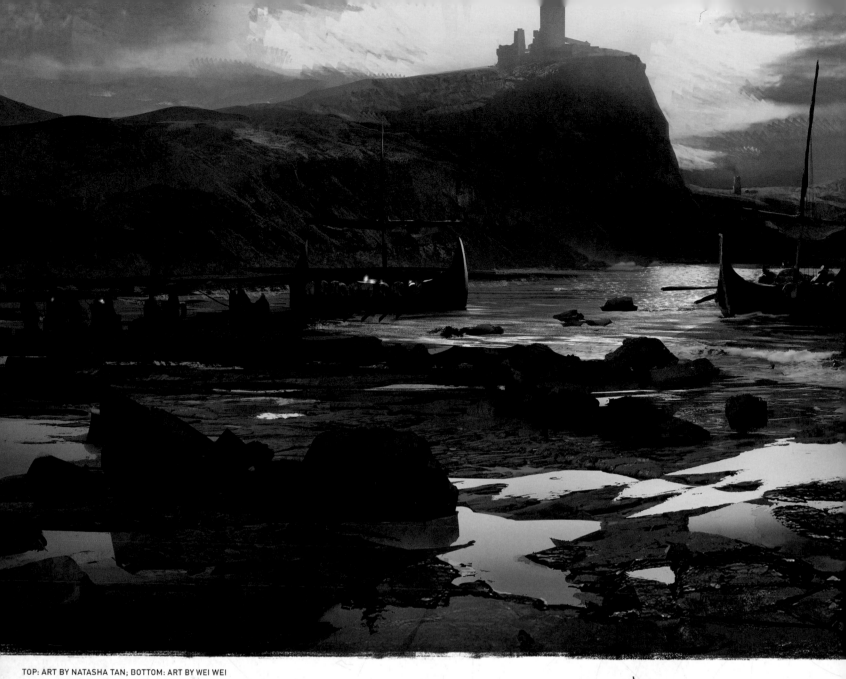

TOP: ART BY NATASHA TAN; BOTTOM: ART BY WEI WEI

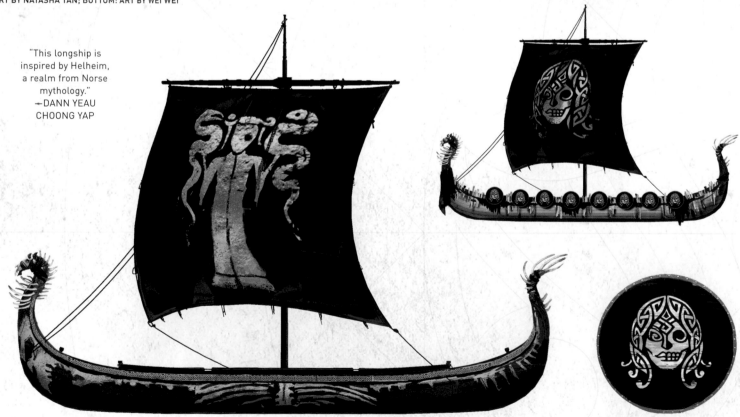

"This longship is inspired by Helheim, a realm from Norse mythology."
→DANN YEAU CHOONG YAP

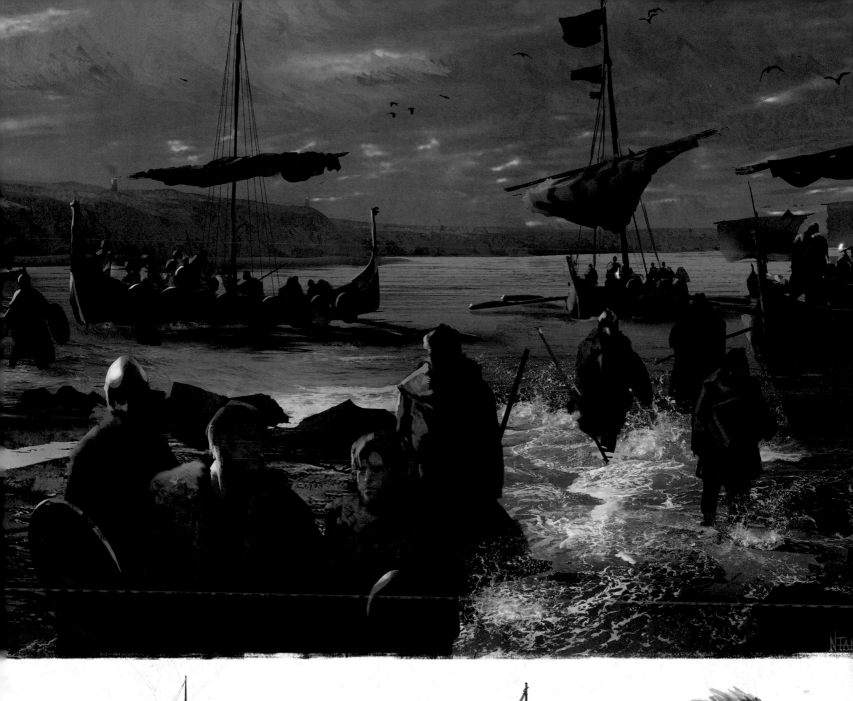

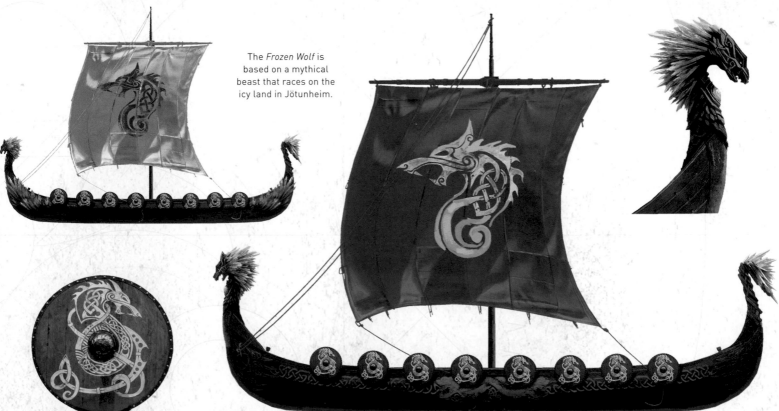

The *Frozen Wolf* is based on a mythical beast that races on the icy land in Jötunheim.

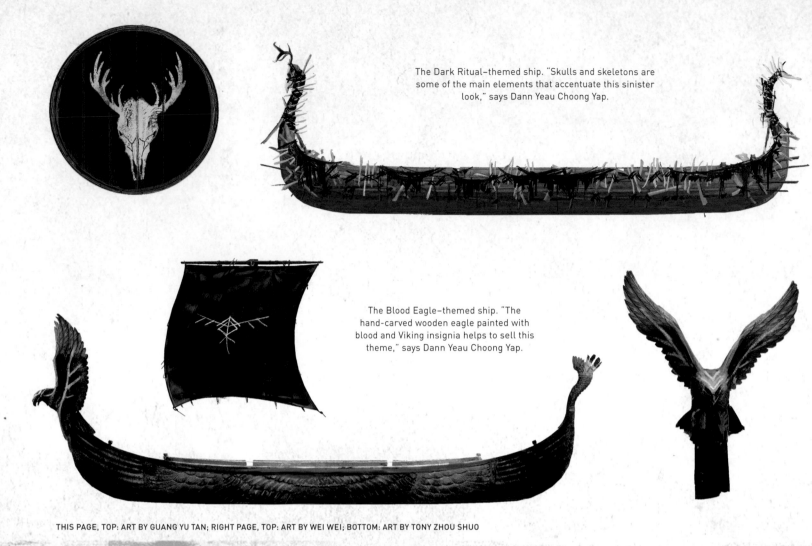

The Dark Ritual–themed ship. "Skulls and skeletons are some of the main elements that accentuate this sinister look," says Dann Yeau Choong Yap.

The Blood Eagle–themed ship. "The hand-carved wooden eagle painted with blood and Viking insignia helps to sell this theme," says Dann Yeau Choong Yap.

THIS PAGE, TOP: ART BY GUANG YU TAN; RIGHT PAGE, TOP: ART BY WEI WEI; BOTTOM: ART BY TONY ZHOU SHUO

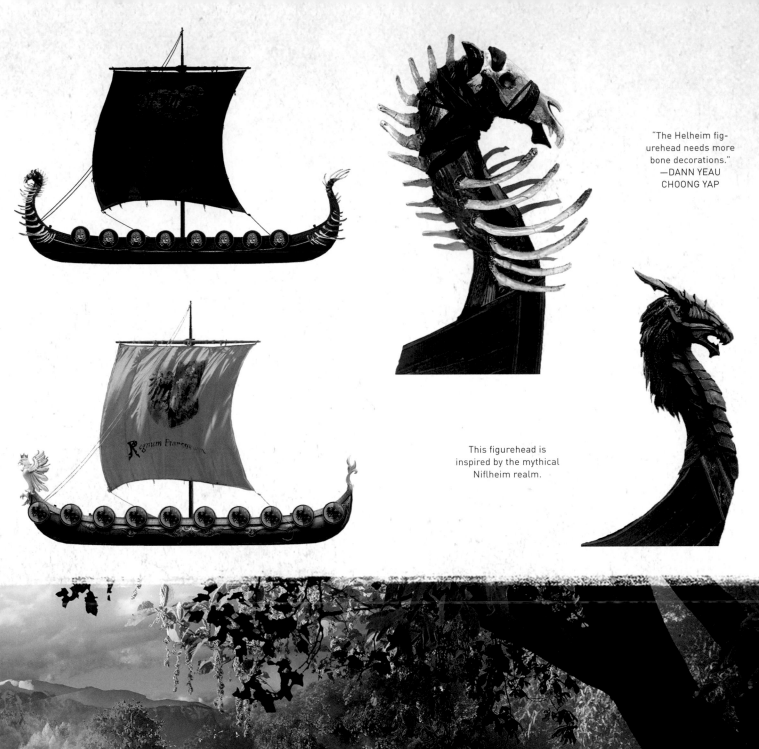

"The Helheim fig-
urehead needs more
bone decorations."
—DANN YEAU
CHOONG YAP

This figurehead is
inspired by the mythical
Niflheim realm.

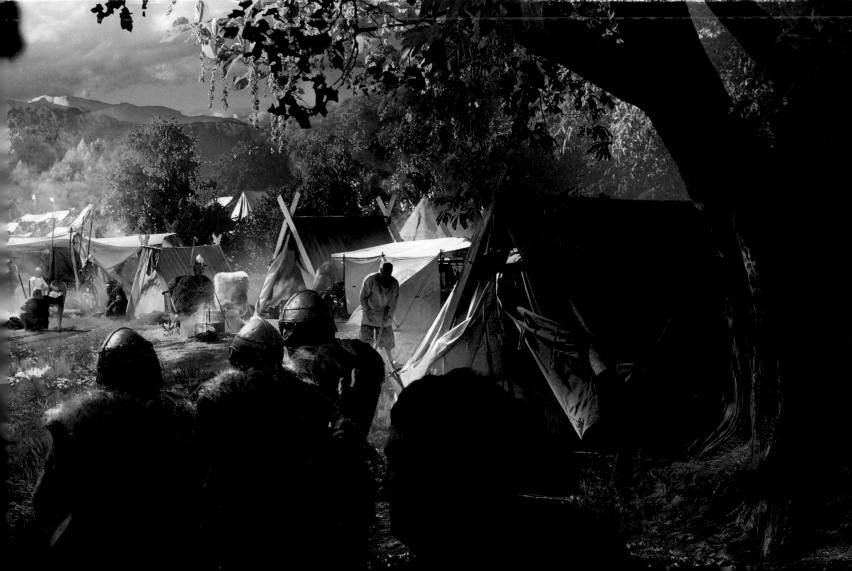

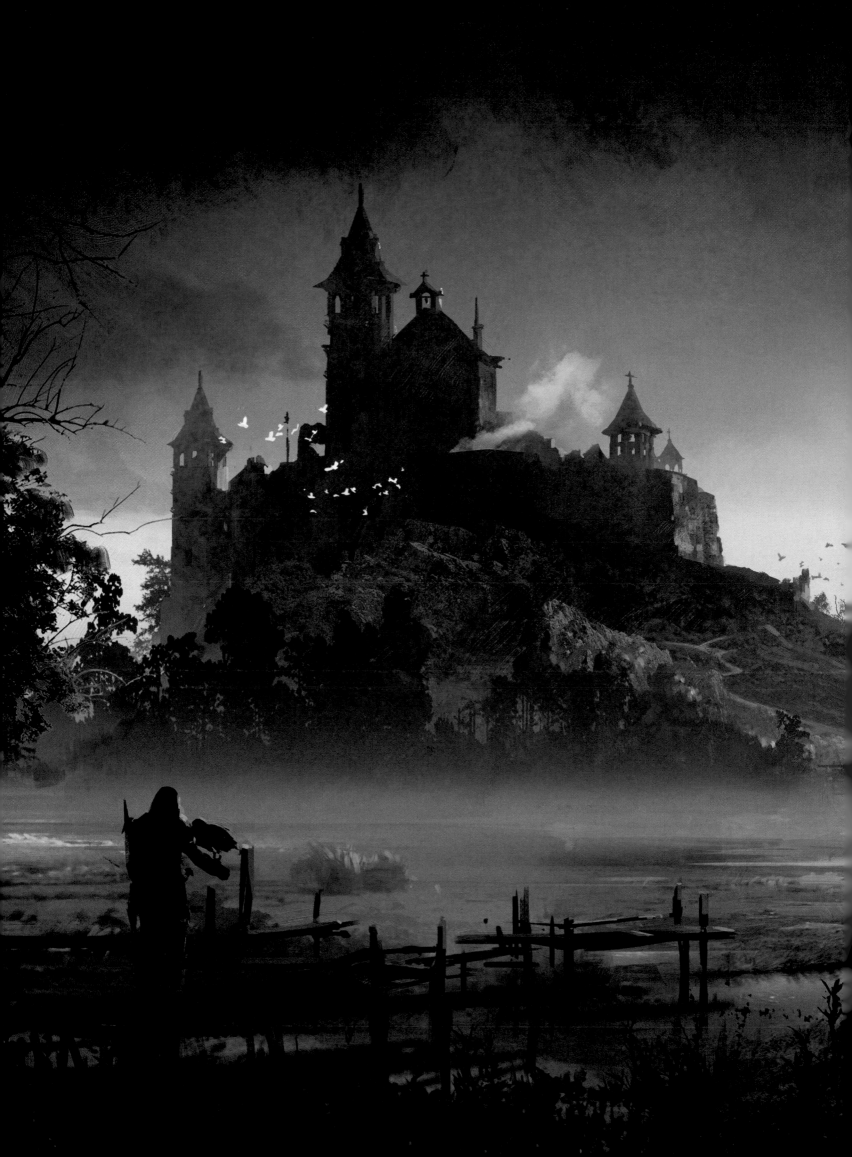

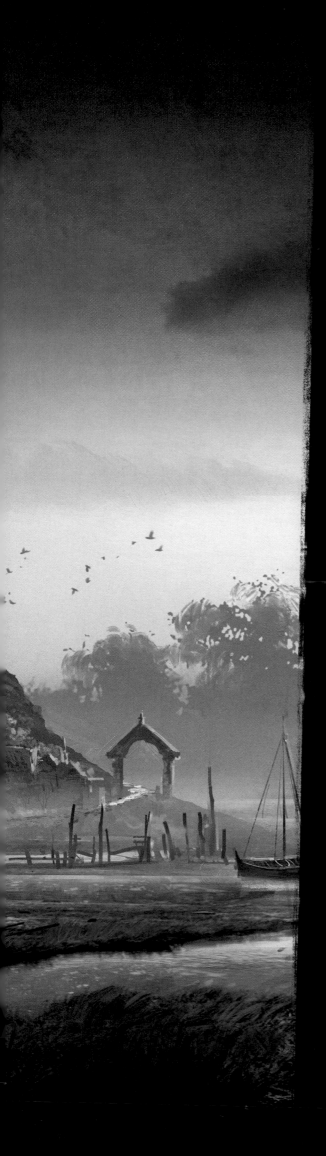

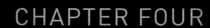

EAST MERCIA AND THE SETTLEMENT

RAVENSTHORPE

Eivor's settlement, Ravensthorpe, is based on the *Assassin's Creed* team's historical research and is intended to provide players with an authentic Viking experience. Improving and defending the settlement and taking care of its inhabitants is a primary goal in *Assassin's Creed Valhalla*.

"The settlement is an important part of the game, and a lot of work went into its design," says senior concept artist Gilles Beloeil. "The idea behind the concept art above was to give as much information as possible in only one image. I worked on a very high-definition file to be able to fit in as much detail as possible. The right image was created first and shows how the settlement could look once the player has completed it. The version on the left was created next. We were then able to dig into more precise details, such as the house interiors and façades. Each house has a certain theme, and we needed them to be immediately recognizable to the player while maintaining their Viking identity and a visual harmony with the rest of the settlement."

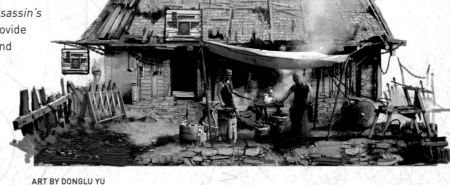

ART BY DONGLU YU

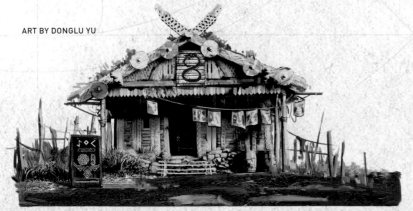

ART BY DONGLU YU

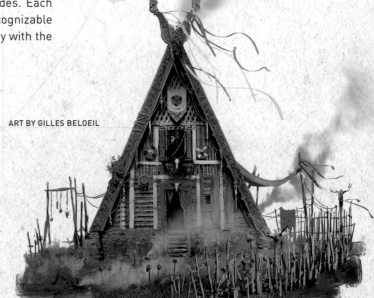

ART BY GILLES BELOEIL

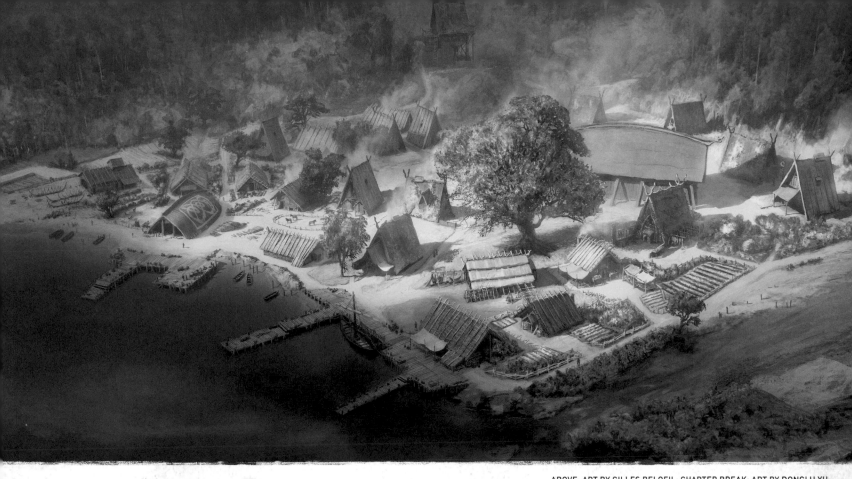

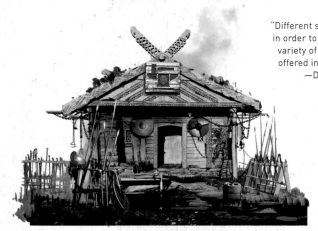

"Different shops were created in order to highlight the wide variety of services that are offered in the settlement."
—DONGLU YU

ART BY DONGLU YU

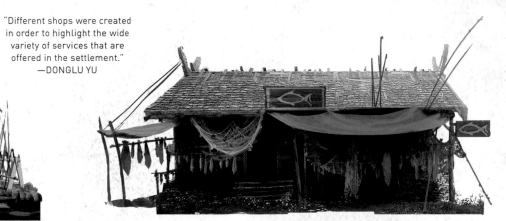

ART BY GILLES BELOEIL

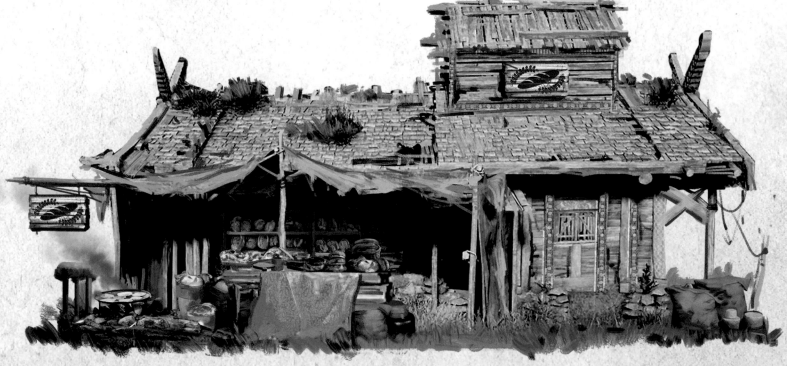

ART BY DONGLU YU

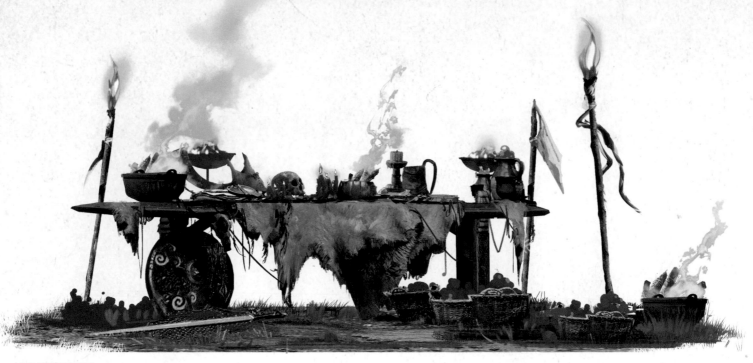

ART BY DONGLU YU

"Unique props were designed to reward players for different achievements."—DONGLU YU

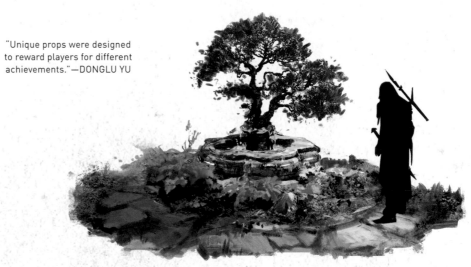

ART BY DONGLU YU

ART BY DONGLU YU

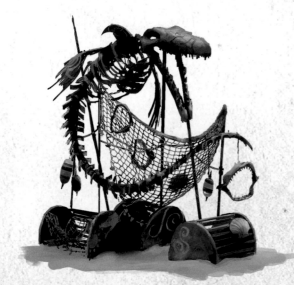

ART BY GILLES BELOEIL

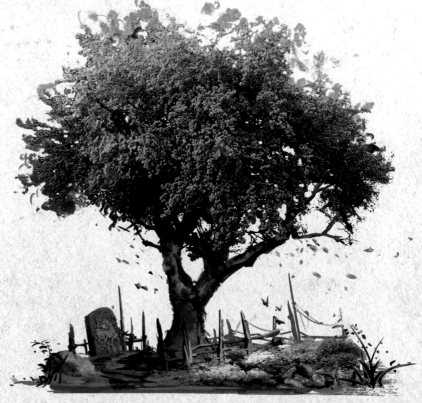

ART BY DONGLU YU

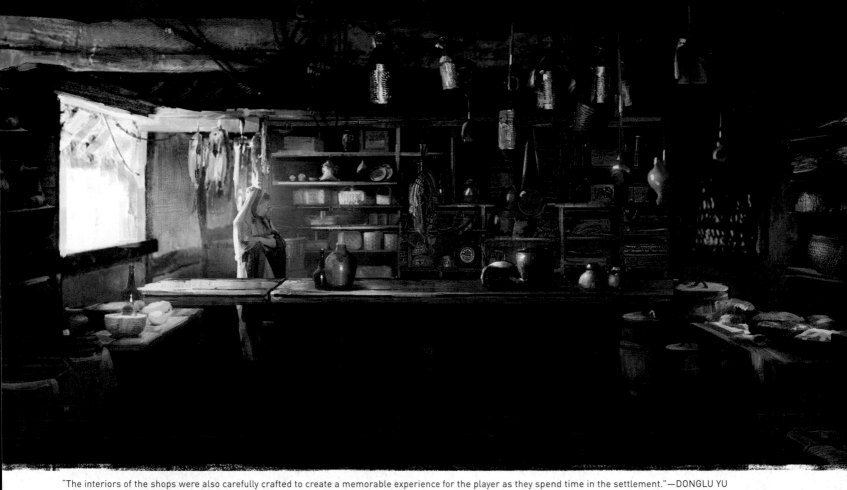

"The interiors of the shops were also carefully crafted to create a memorable experience for the player as they spend time in the settlement."—DONGLU YU

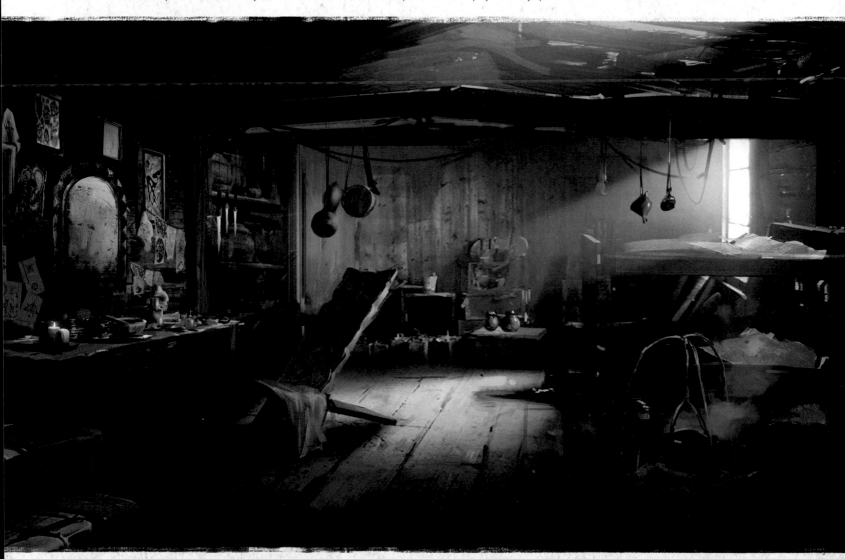

The interior of the tattoo shop.

THIS PAGE: ART BY DONGLU YU

RUINS RECLAIMED BY NATURE

"The East Mercia region, where Ravensthorpe is located, is in the heart of England," says Raphaël Lacoste. "It features a beautiful, lush autumn forest." The distinctive forest of beech and old oak trees surrounds ancient Roman structures, elements which give the region its own unique texture.

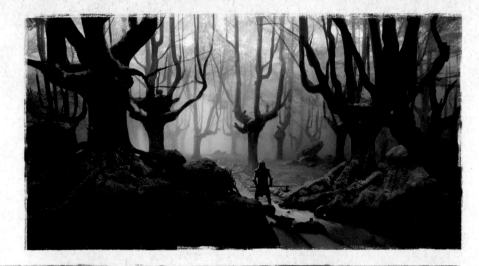

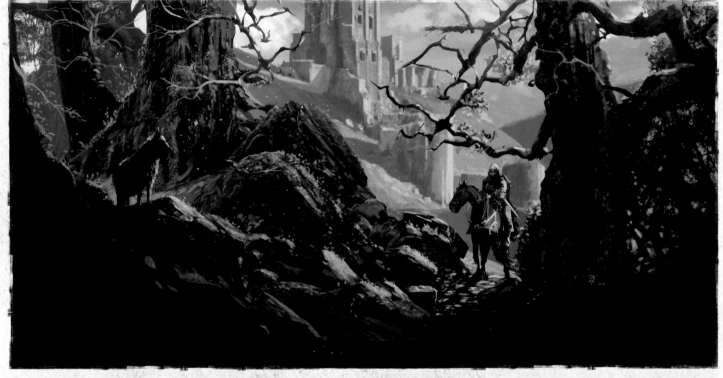

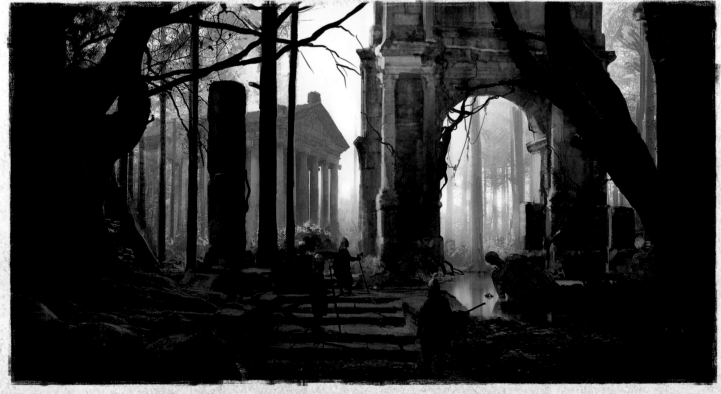

THIS PAGE, TOP AND BOTTOM: ART BY MARTIN DESCHAMBAULT; RIGHT PAGE AND THIS PAGE, MIDDLE: ART BY RAPHAËL LACOSTE

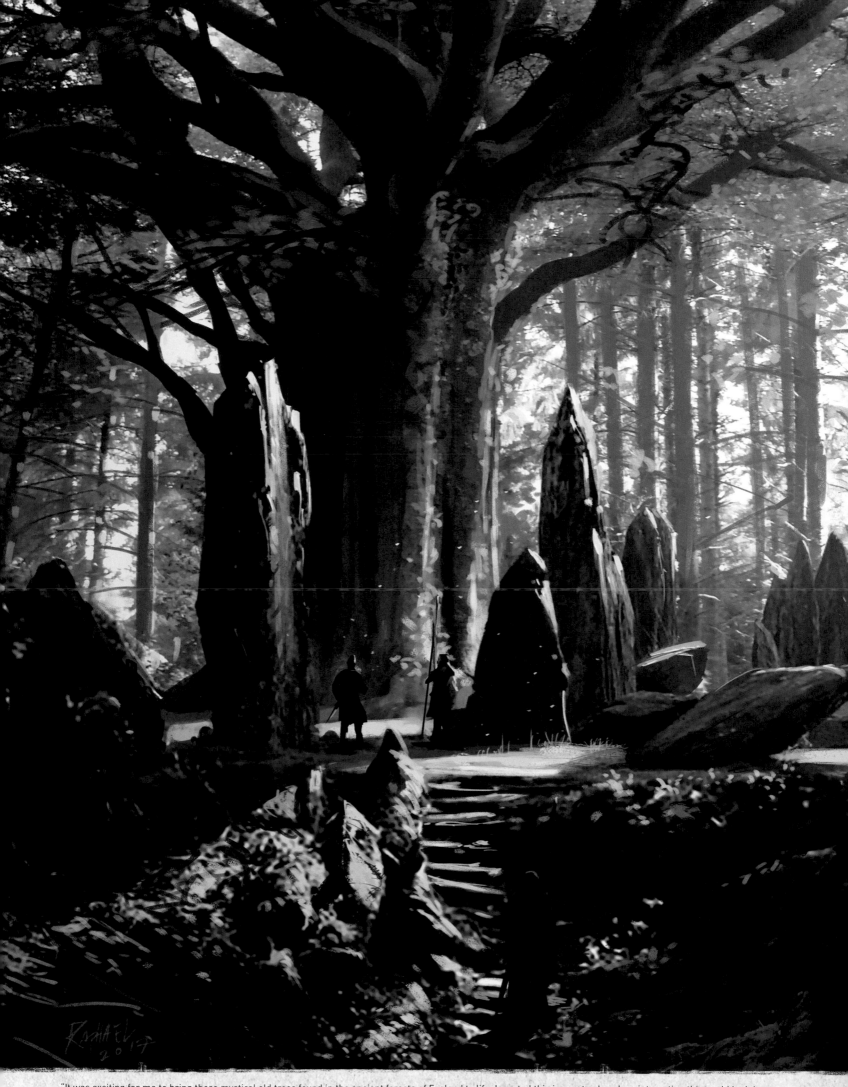

"It was exciting for me to bring these mystical old trees found in the ancient forests of England to life. I wanted this image to show how interesting this could look in the game, with a landmark beech tree near a Neolithic ceremonial site." —RAPHAËL LACOSTE

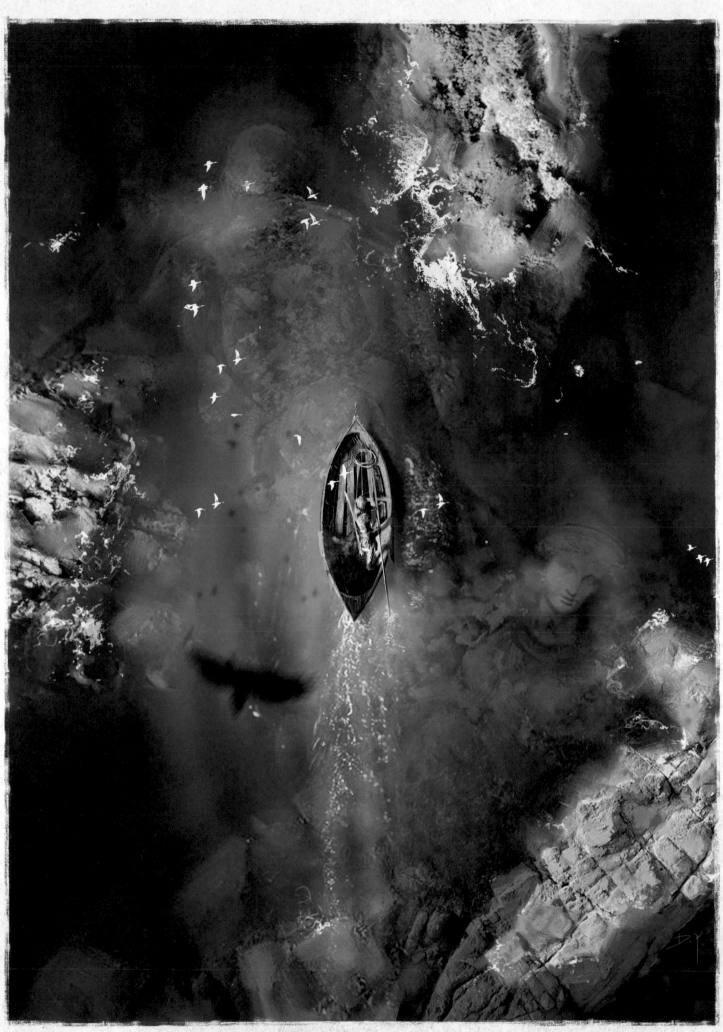

"I wanted to create an image that emphasized the lost Roman Empire's presence in the underwater areas of the game."—DONGLU YU

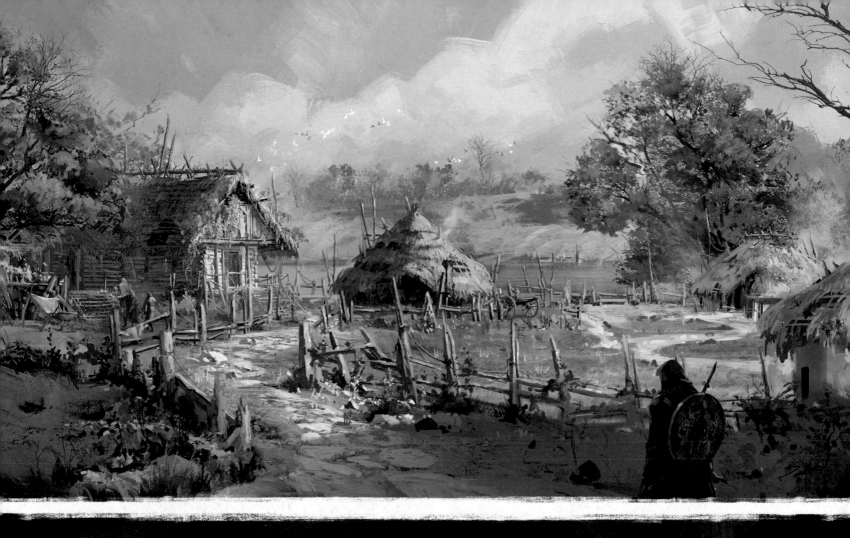

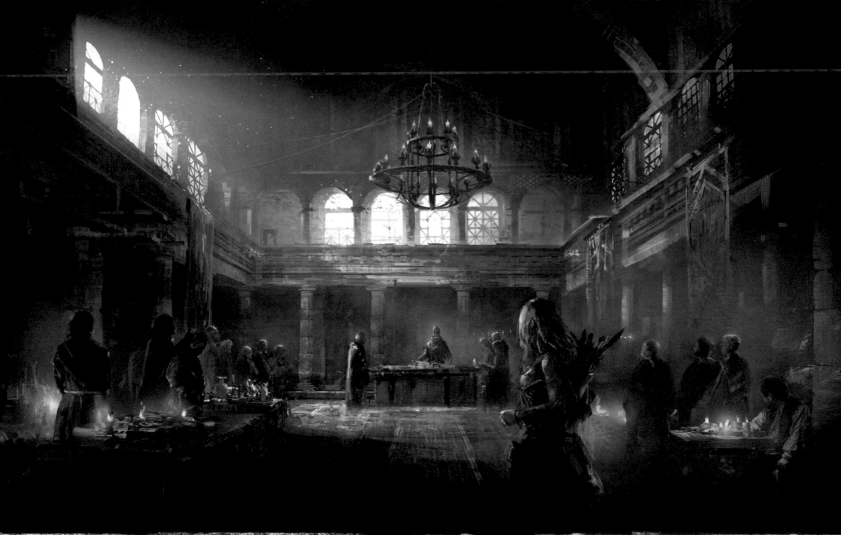

"In this interior, the warm candlelight contrasts with the blue exterior light during the confrontation between Eivor and the bishop." —DONGLU YU

THESE PAGES: ART BY DONGLU YU

LINCOLN—ROMAN ERA

This map of Lincoln during Roman times served as a reference
for the team to create the game's Anglo-Saxon version of the town.

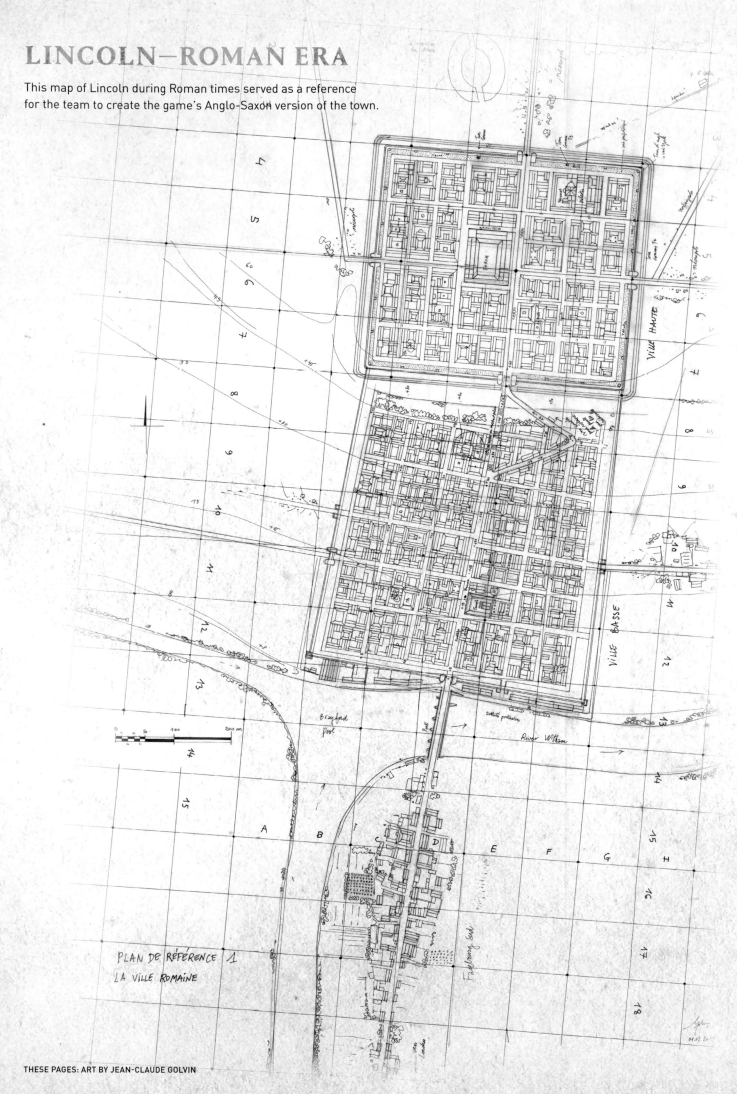

PLAN DE RÉFÉRENCE 1
LA VILLE ROMAINE

THESE PAGES: ART BY JEAN-CLAUDE GOLVIN

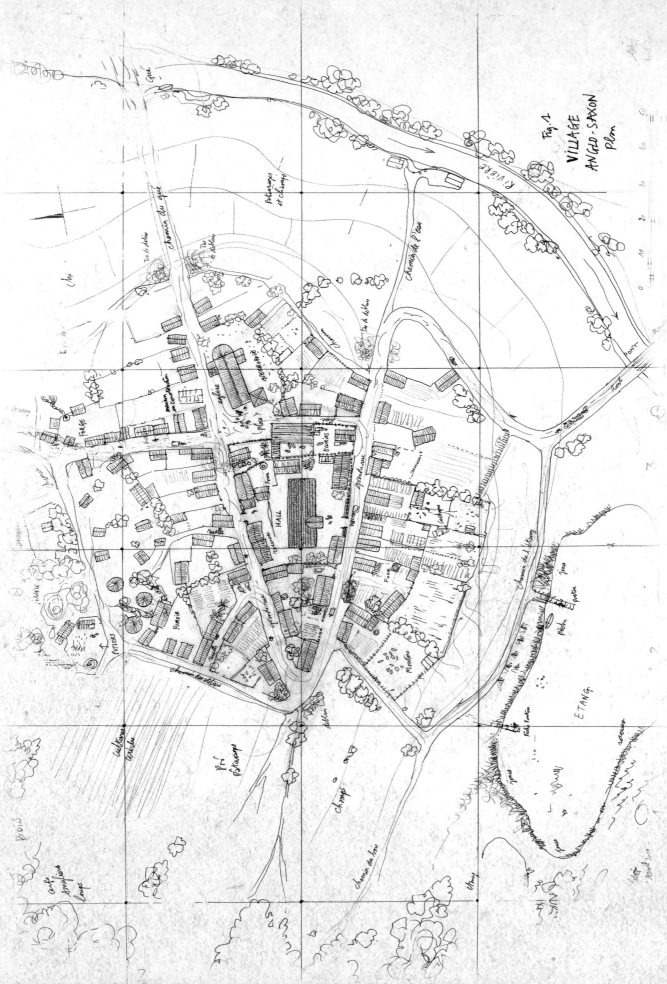

AN ANGLO-SAXON VILLAGE IN MERCIA

Jean-Claude Golvin's work allowed the team to render an authentic layout for the Anglo-Saxon towns and landscapes in the game, which were structured around the inhabitants' activities, like agriculture and livestock farming.

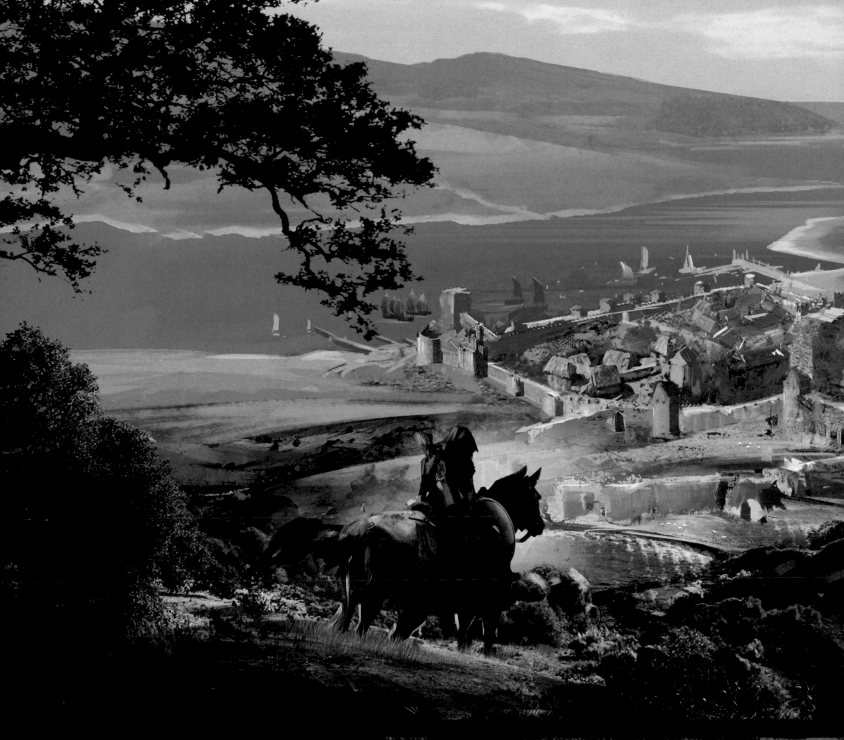

THE HEART OF LINCOLNSCIRE

The image above is from a series of concept art pieces created to represent the city of Lincoln in the region of Lincolnscire. "I needed to put thought into the surrounding landscape while also considering the level design and the juxtaposition of Roman ruins and Saxon houses," says concept artist Donglu Yu.

"In the image on the far right, I needed to design the courtyard for the Assassin bureau," says Gilles Beloeil. "We put the Assassin crest at the bottom of a Roman basin so the player could locate it and understand its purpose from above."

TOP AND BOTTOM LEFT: ART BY DONGLU YU
BOTTOM RIGHT: ART BY GILLES BELOEIL

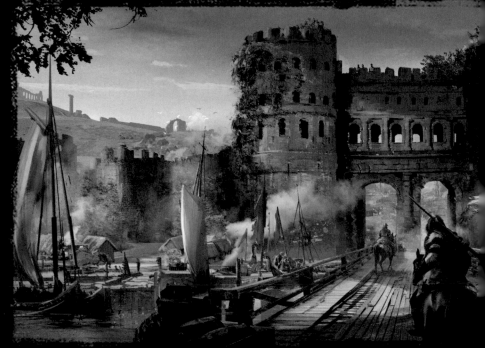

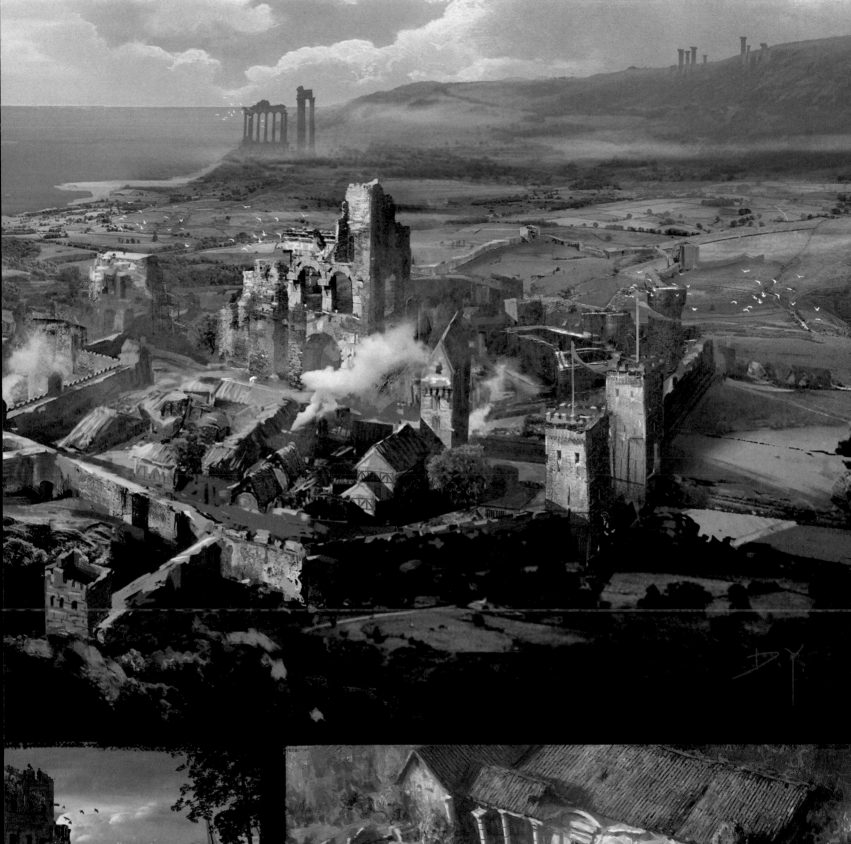

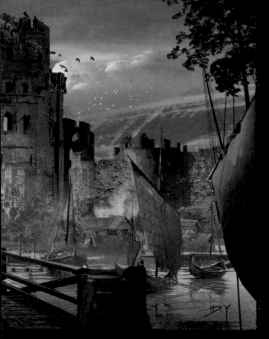

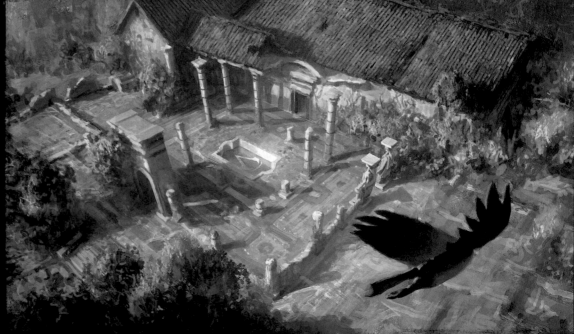

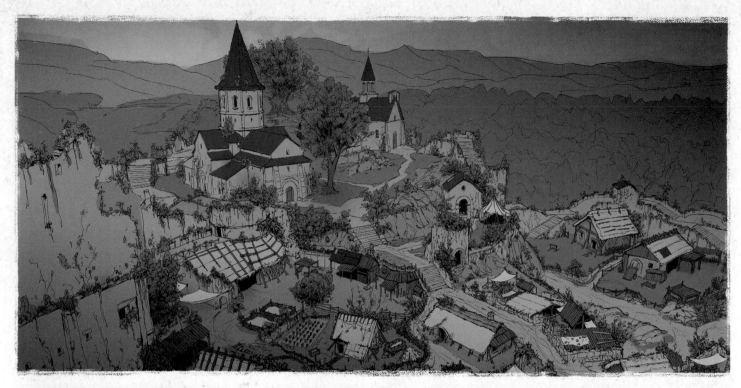

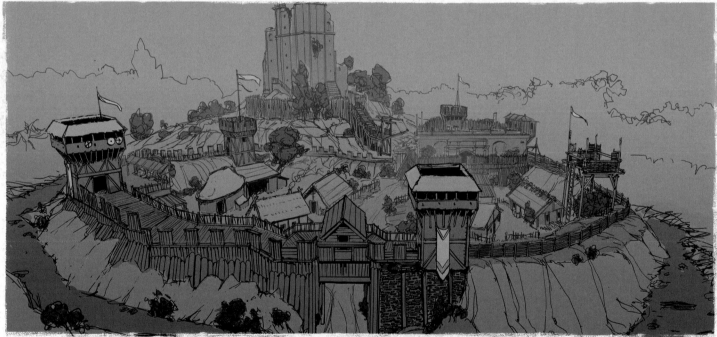

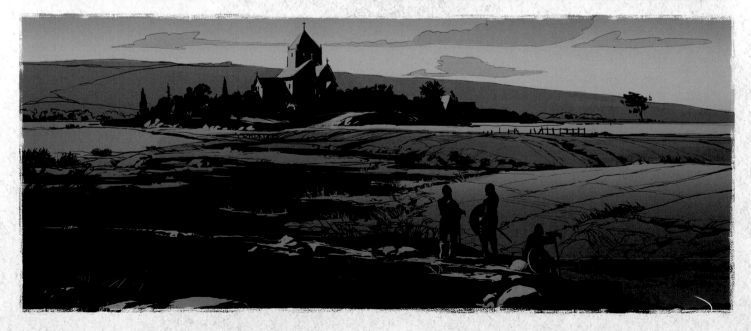

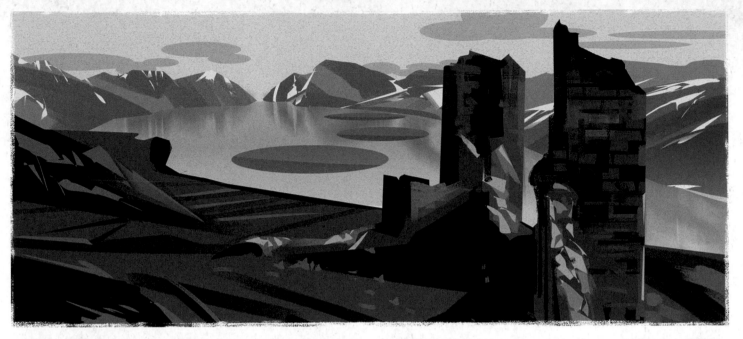

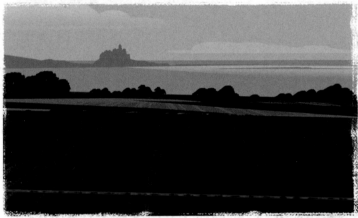

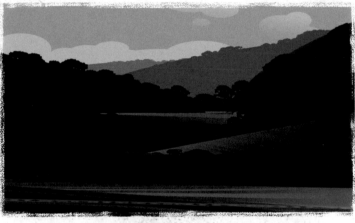

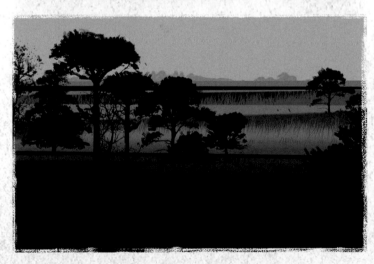

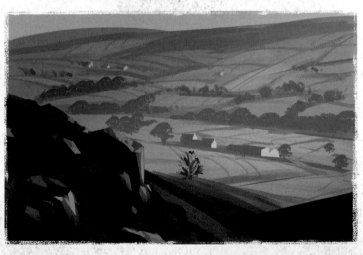

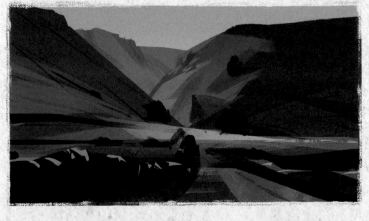

"Before adding color, lighting, and detail, we want to make sure the compositions of our landscapes, environments, and locations are varied, interesting, and memorable. This is why we always work with gray values on the first versions."—RAPHAËL LACOSTE

LEFT PAGE, TOP AND MIDDLE: ART BY GILLES BELOEIL
LEFT PAGE, BOTTOM: ART BY MARTIN DESCHAMBAULT
THIS PAGE: ART BY DONGLU YU

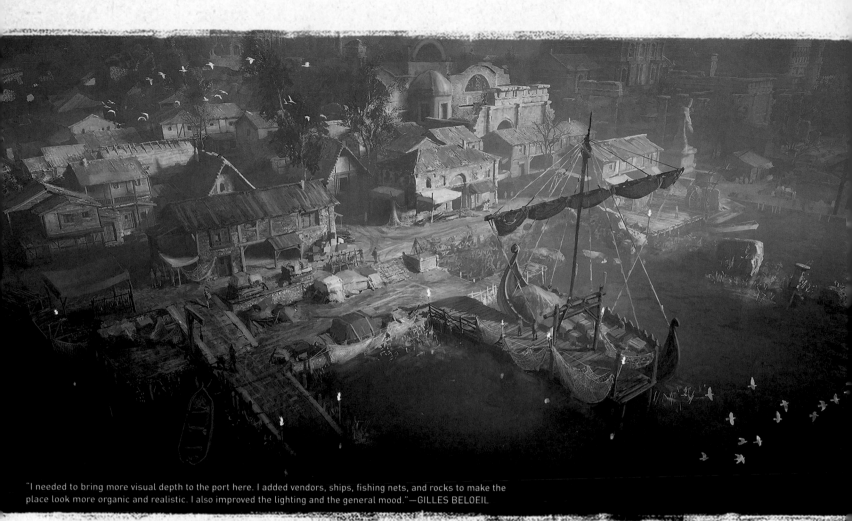

"I needed to bring more visual depth to the port here. I added vendors, ships, fishing nets, and rocks to make the place look more organic and realistic. I also improved the lighting and the general mood."—GILLES BELOEIL

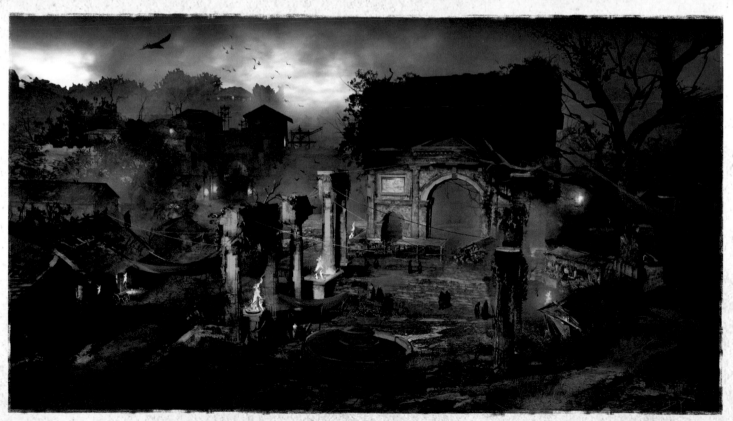

TOP: ART BY GILLES BELOEIL; BOTTOM: ART BY DONGLU YU

LUNDEN

Chaos reigns in the bustling city of Lunden when it is first discovered by the player in-game. "In contrast to the vast, colorful landscapes and cities of other locations, Lunden is desaturated and less vibrant in order to accentuate the gritty aspect of this city located on the border of East Anglia and West Mercia," says Donglu Yu.

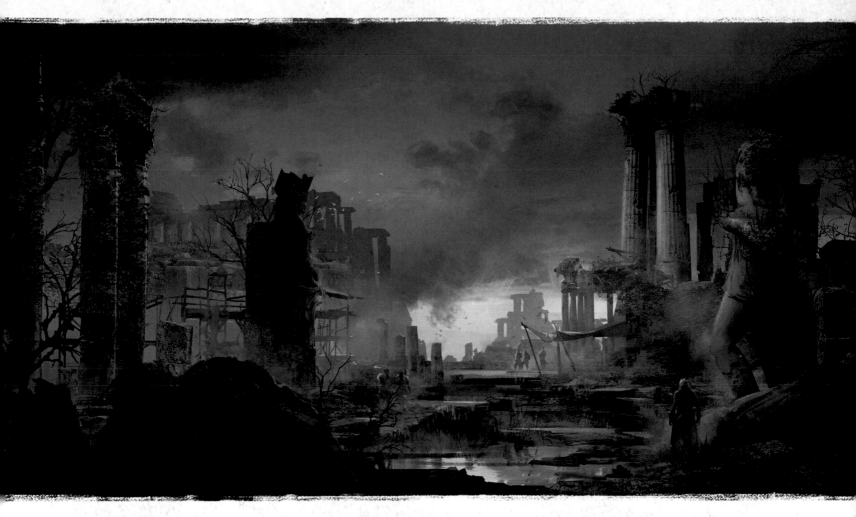

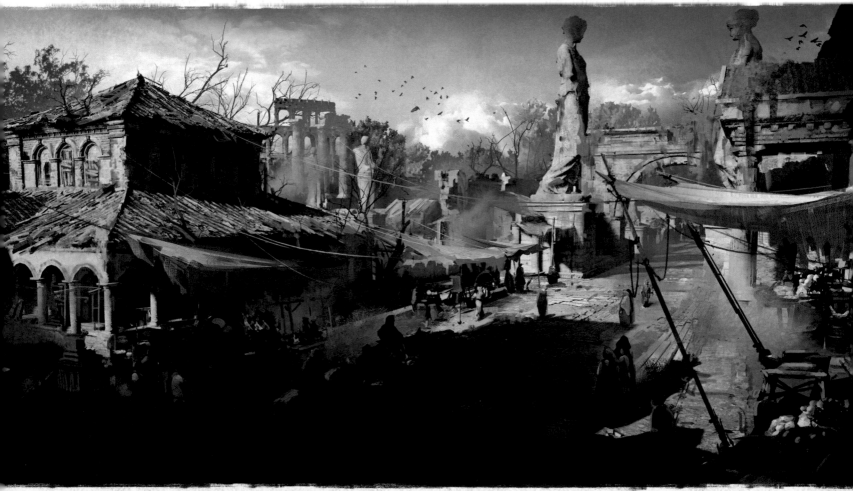

"A paint-over to dress up a street in Lunden. The addition of tents, food stands, and crowds heightens the living-and-breathing aspect of the place." —DONGLU YU

THIS PAGE: ART BY DONGLU YU

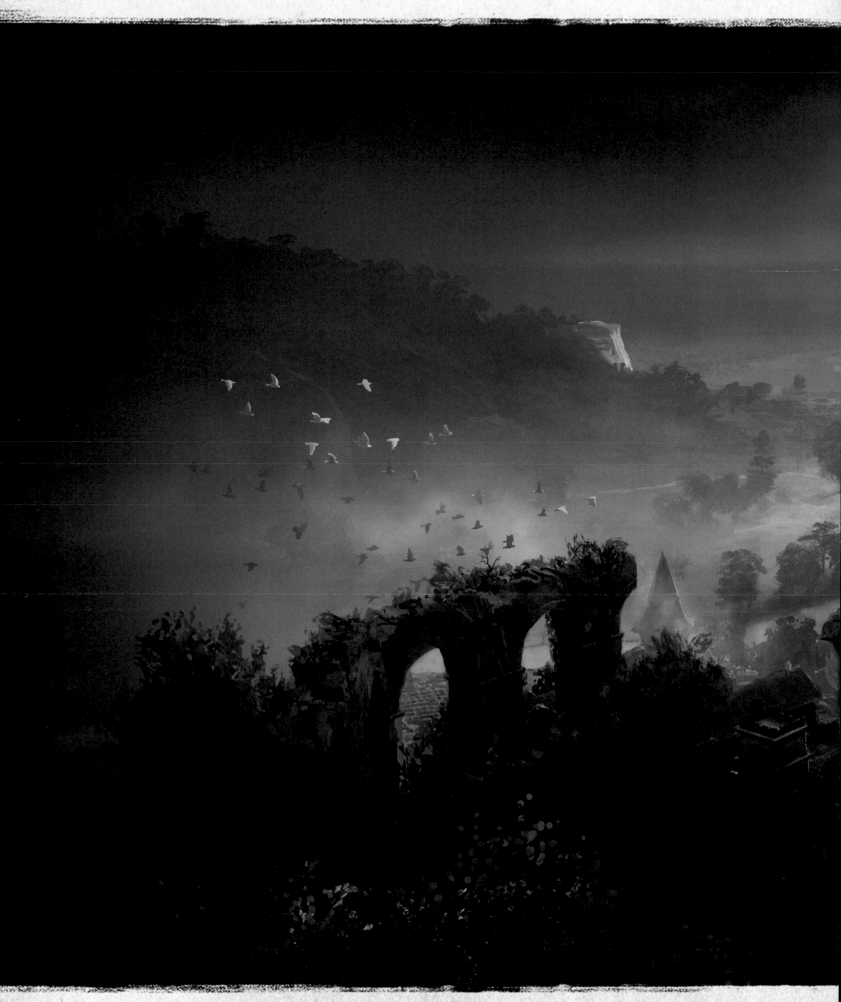

"Raphaël asked us to work on concept art of the game's vistas," says Gilles Beloeil. "This would help create a unique experience for the player when seeing England from the sky." As they developed this work, artists carefully considered mood, color, and the positions of trees and streams. "Mostly we had to play with the light and the shadows of the clouds on the ground so the landscape would exhale this visual richness," Beloeil continued. "We realized that the sky should be somber in order to push this very dramatic ambiance."

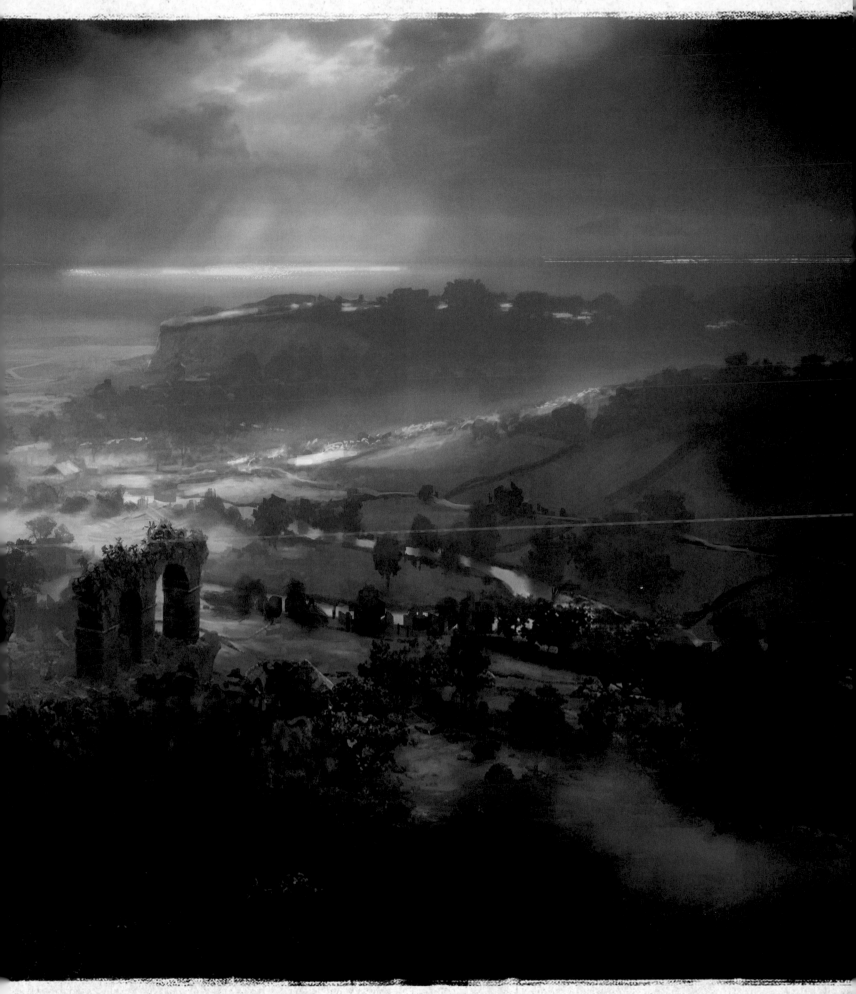

ART BY GILLES BELOEIL

BANDITS

"The challenge with the Bandit faction was to make them as much a reflection of the world as a faction in themselves," says artist Even Mehl Amundsen. "These people are broken in spirit and lacking resources, and with that you can build some pretty great archetypes; they're true underdogs."

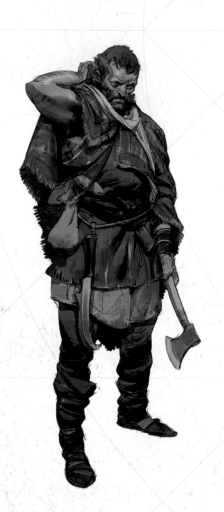

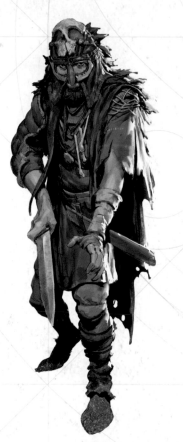

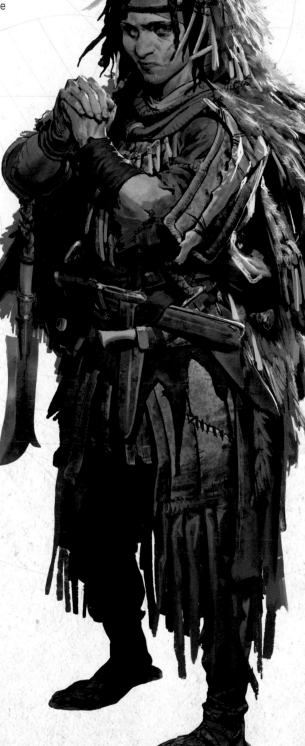

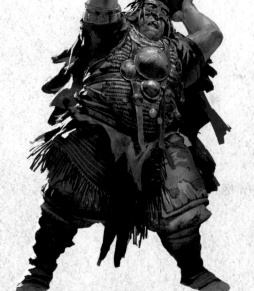

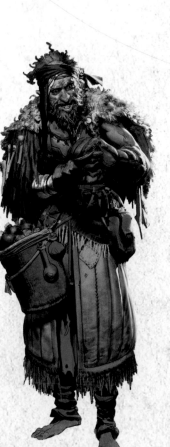

Various Bandit archetypes, including (*clockwise from top left*) two Militians, the Rogue, the Pyro, and the Destroyer. "It was fun to imagine the Rogue archetype, who explodes out from the trees and undergrowth with relentless aggression," says Amundsen.

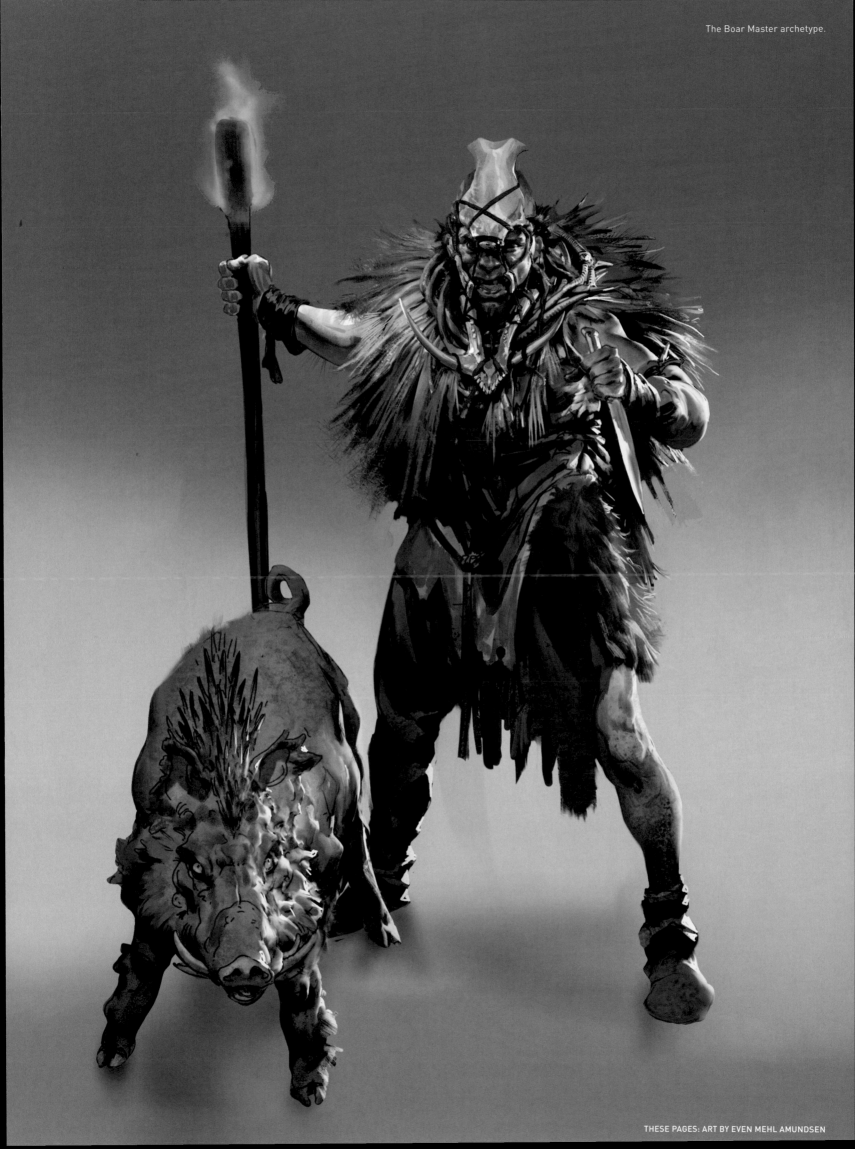

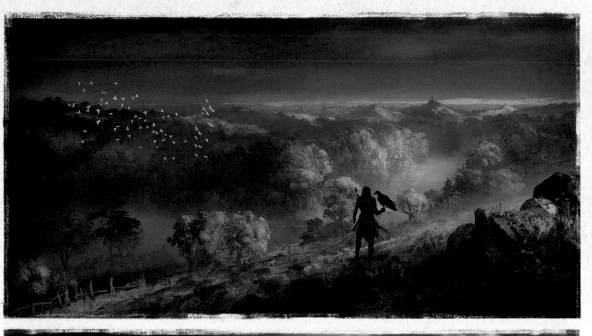

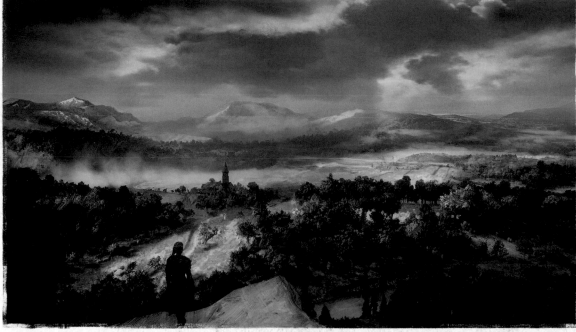

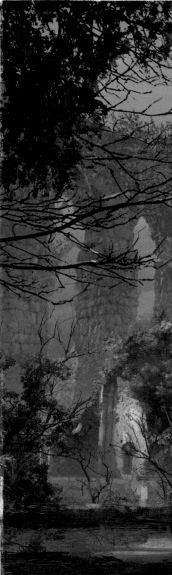

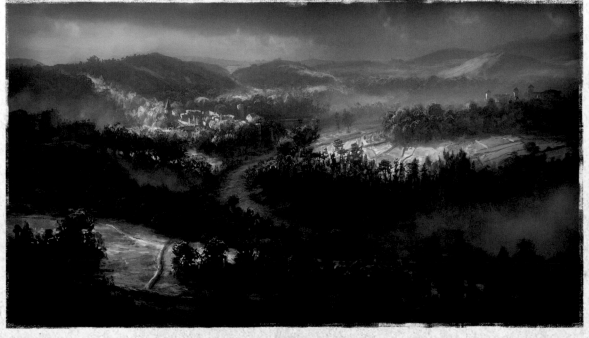

"These three images were part of the work we did on the vistas. They were especially helpful to the lighting team."—GILLES BELOEIL

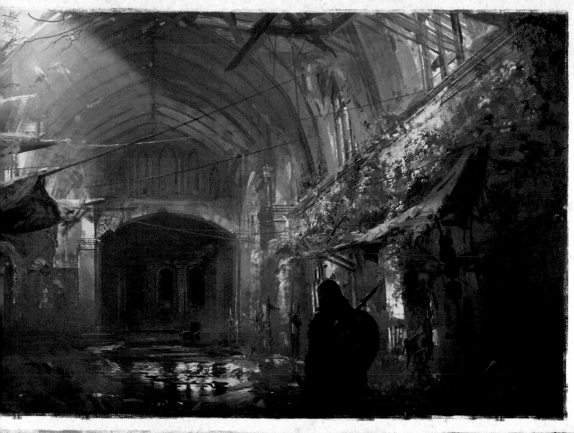

CROWLAND

"I really enjoyed creating the setting of Crowland in the Lincolnscire region," says Donglu Yu. "This is a place that perfectly showcases the post-Roman world." The ancient Roman church was covered with overgrown vegetation to create a sacred and nostalgic feeling.

FAR LEFT: ART BY GILLES BELOEIL
THIS PAGE: ART BY DONGLU YU

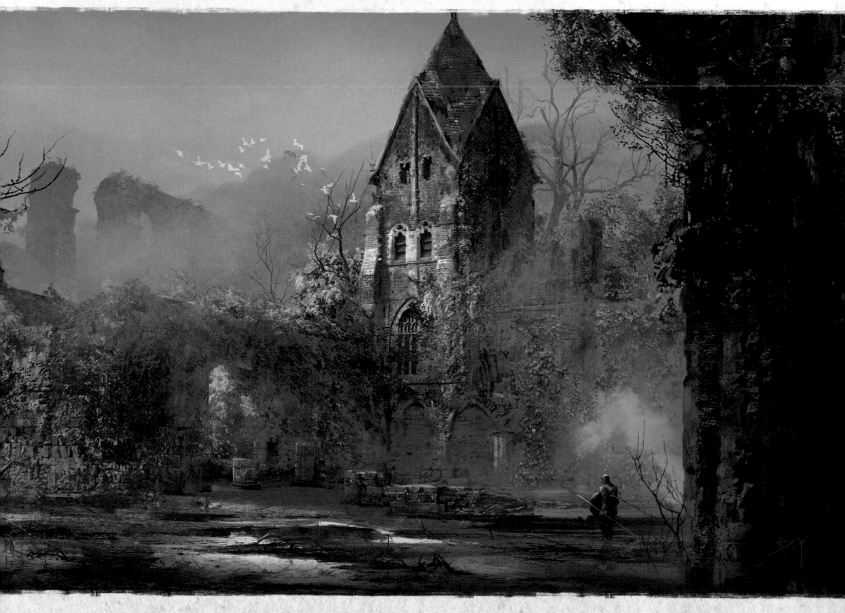

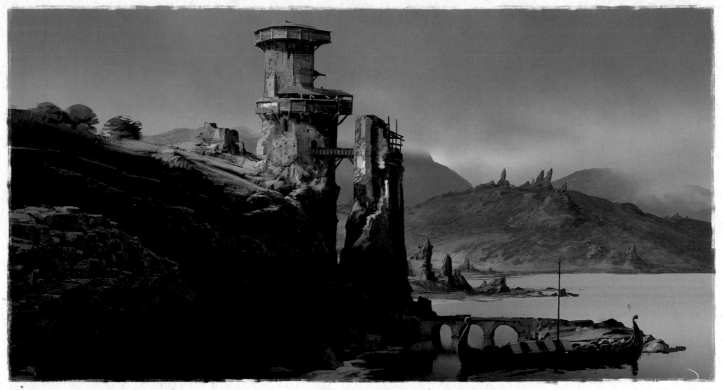

The image below is a piece of crannog village concept art, with houses on stilts and Celtic-inspired conical roofs. The player will encounter these villages in Celtic regions and swamps in the game.

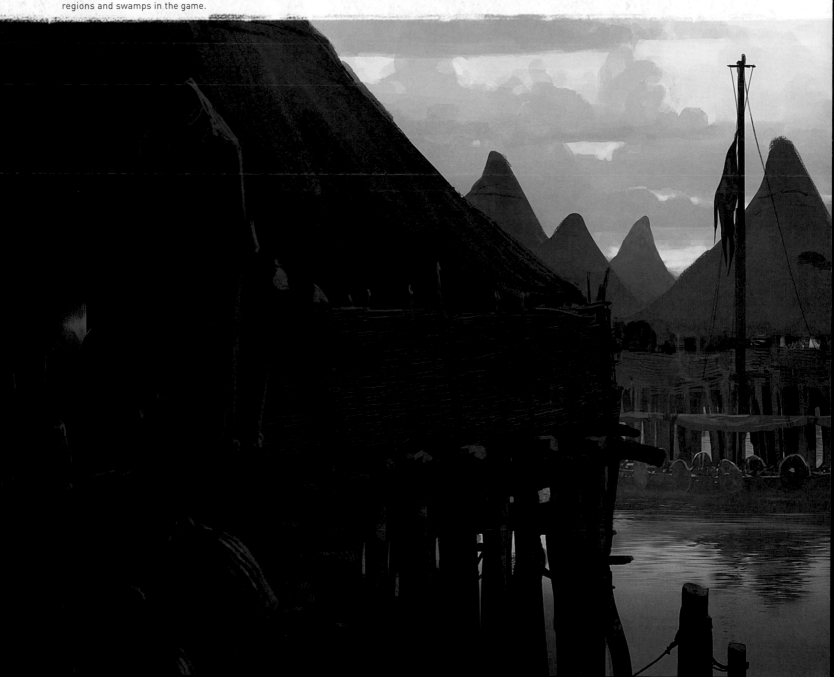

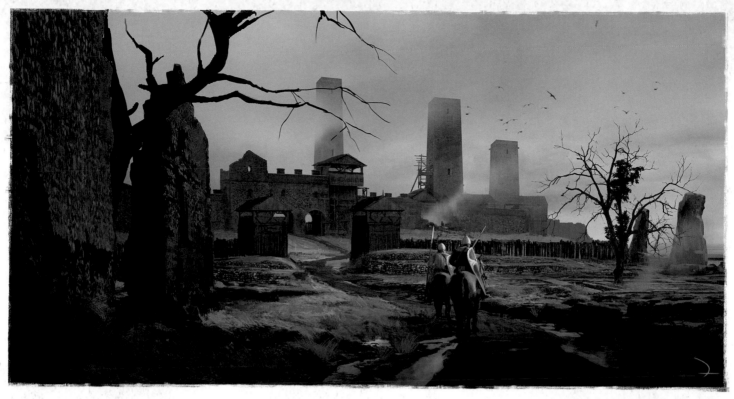

THESE PAGES: ART BY MARTIN DESCHAMBAULT

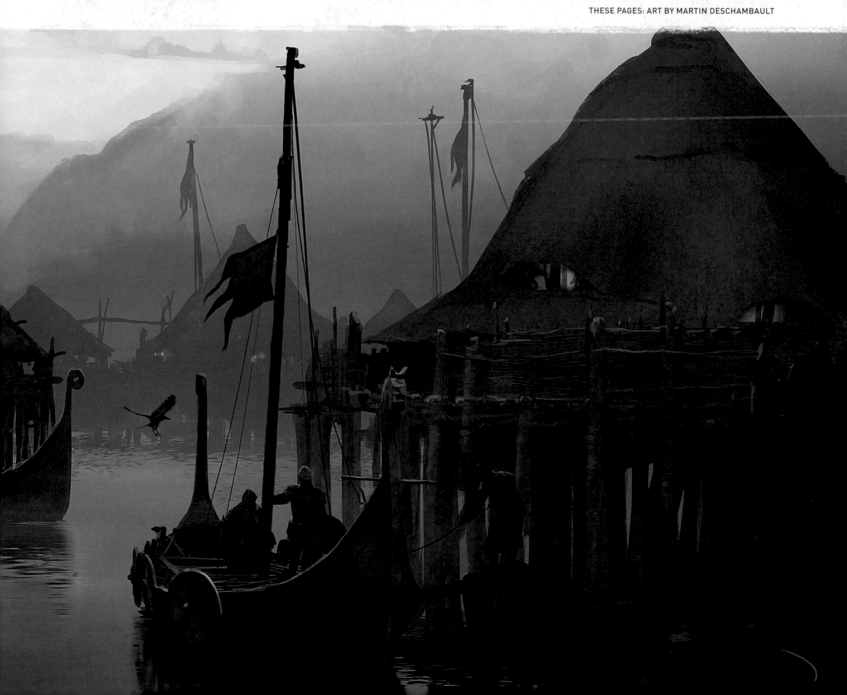

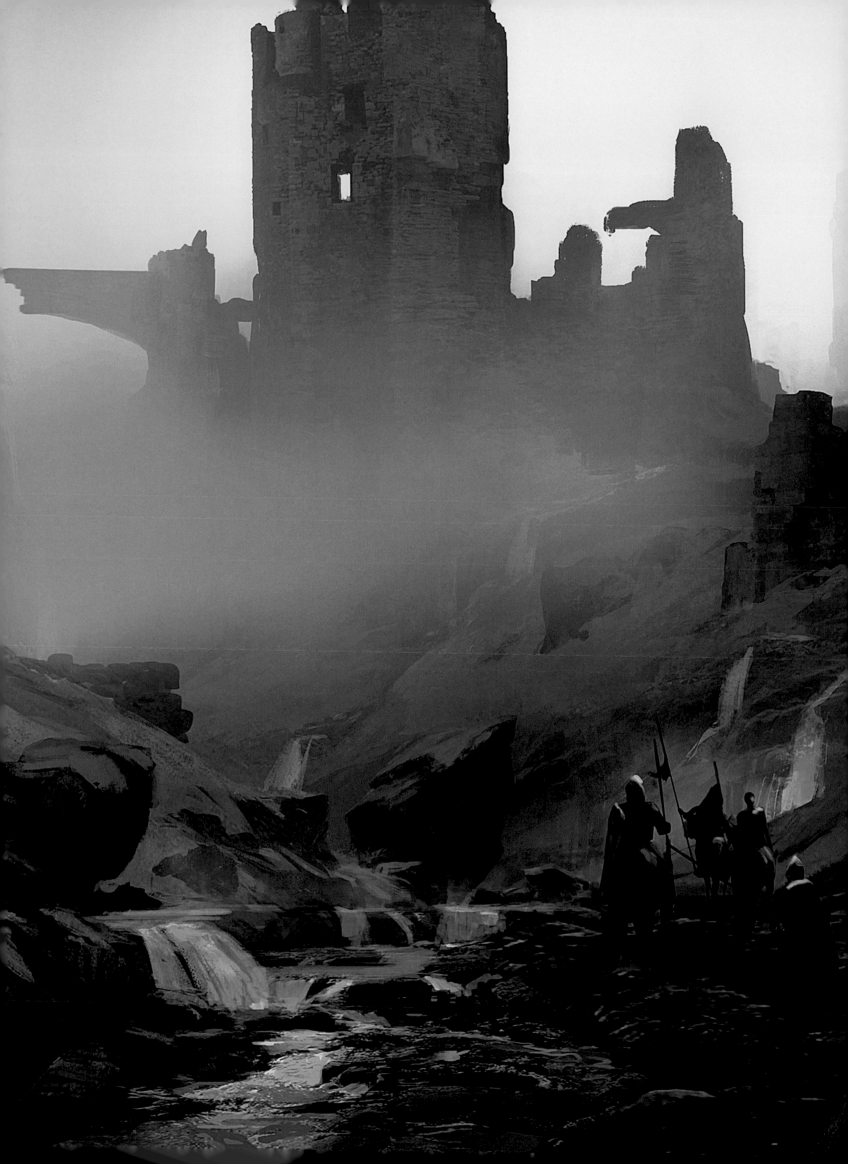

CHAPTER FIVE

WEST MERCIA

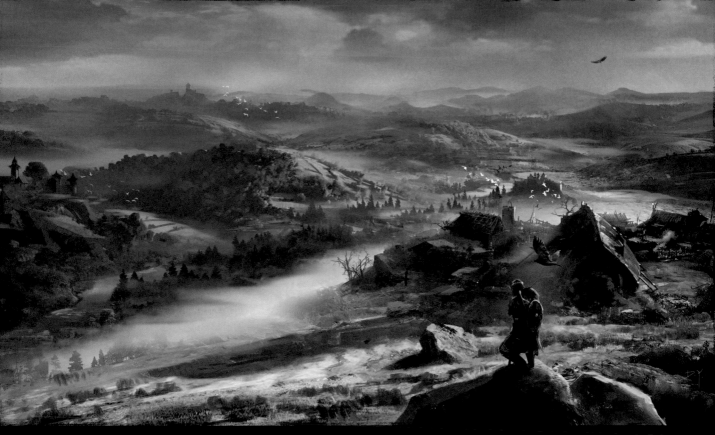

"This image showcases the vast landscape of England. The lushness of the vegetation, the blue sky behind the heavy clouds, and the rich greenery growing alongside the river were all key points for composing this scene." —DONGLU YU

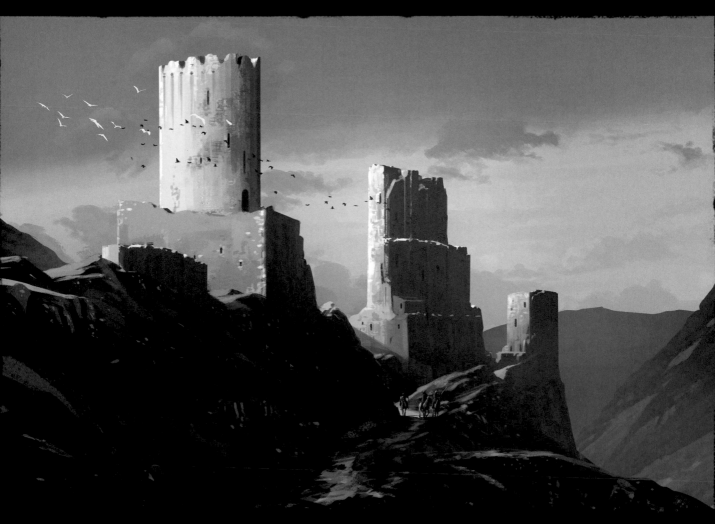

"The landscapes of West Mercia are dry and mountainous. It creates a nice contrast with the lush lands of Wessex and East Mercia. Castles and villages like brochs and crannogs were inspired by Celtic architecture and add a unique flavor to this region." —RAPHAËL LACOSTE

TOP: ART BY DONGLU YU; BOTTOM: ART BY RAPHAËL LACOSTE

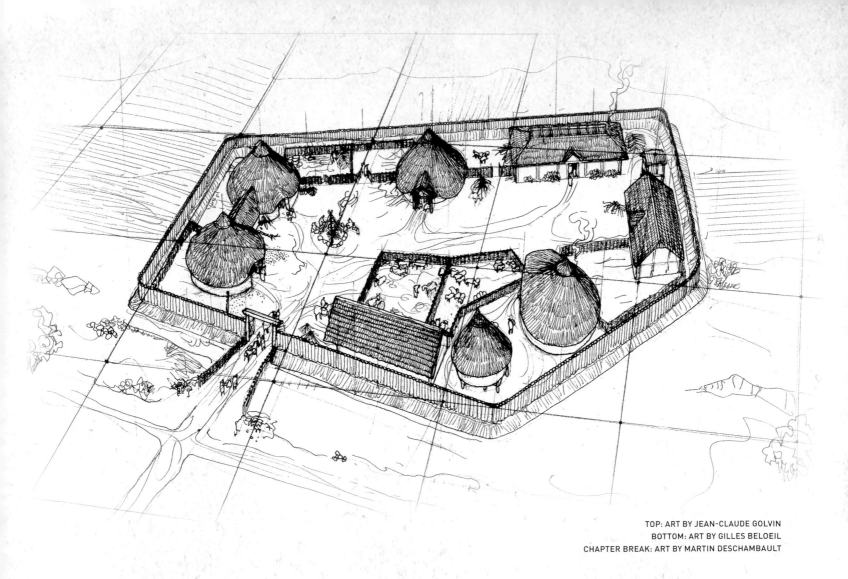

TOP: ART BY JEAN-CLAUDE GOLVIN
BOTTOM: ART BY GILLES BELOEIL
CHAPTER BREAK: ART BY MARTIN DESCHAMBAULT

CELTIC HIGHLANDS

"This is a Celtic village with different kinds of houses. I gave myself a challenge on this one by painting it with a flat front light, which meant I couldn't rely on shadows to make it look good. The shapes have a limited range of light values but a lot of variations in hues. It was difficult, but my goal was to make it look like a nineteenth-century Russian painting, because Raphaël gave us that style as a visual reference. It was fun to paint it that way."—GILLES BELOEIL

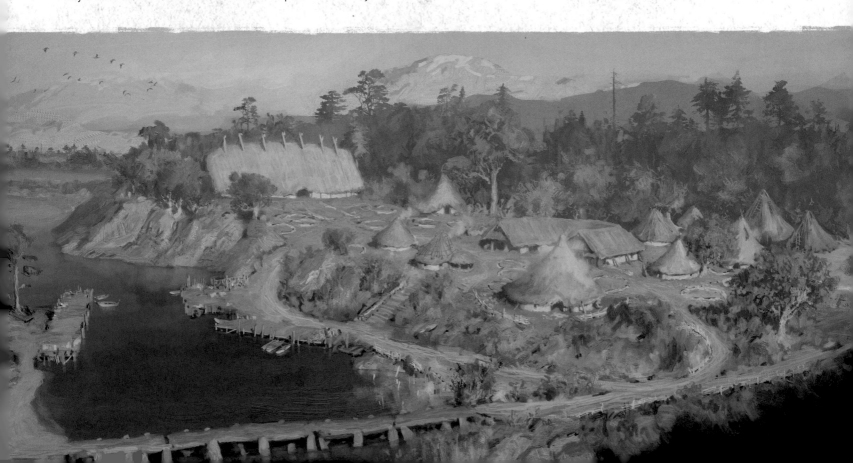

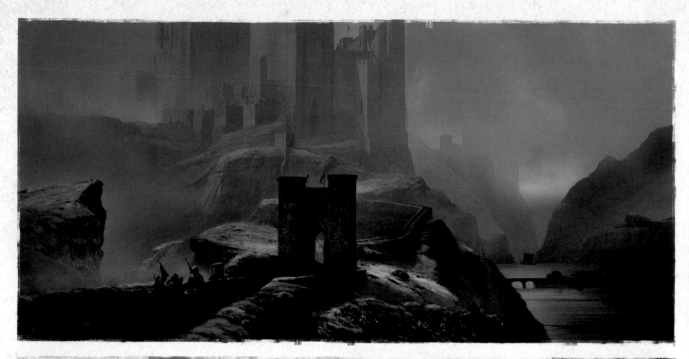

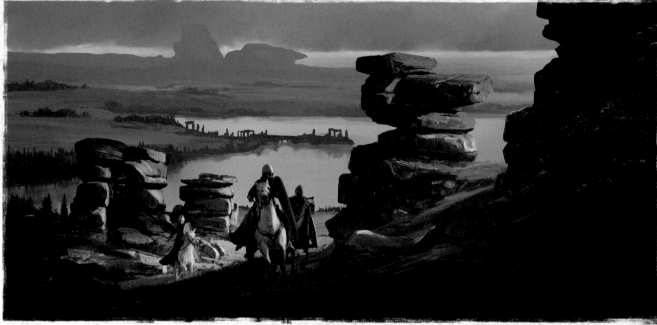

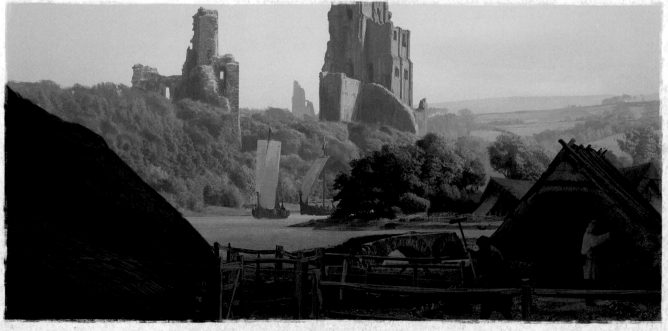

"Architecture in the Dark Ages was often limited to simple wooden walls and straw roofs, which was quite boring artistically. Luckily, large forts and

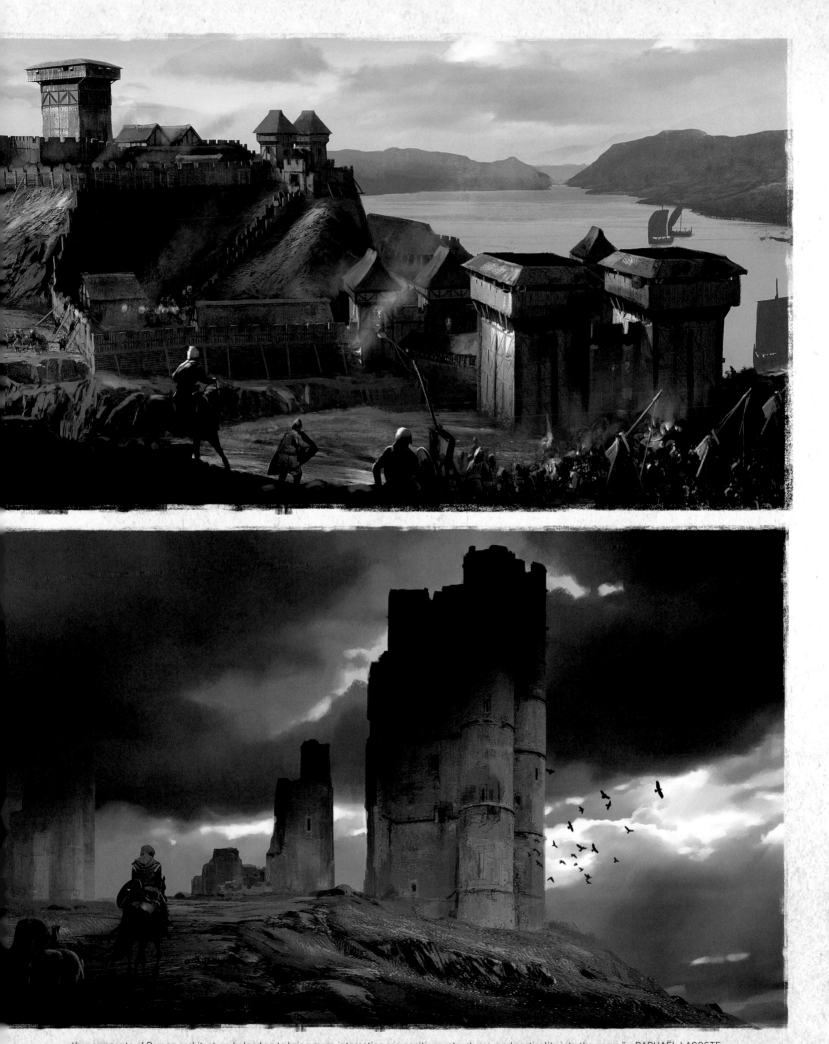

other remnants of Roman architecture helped us to bring more interesting compositions, structures, and verticality into the game." —RAPHAËL LACOSTE

THESE PAGES: ART BY MARTIN DESCHAMBAULT

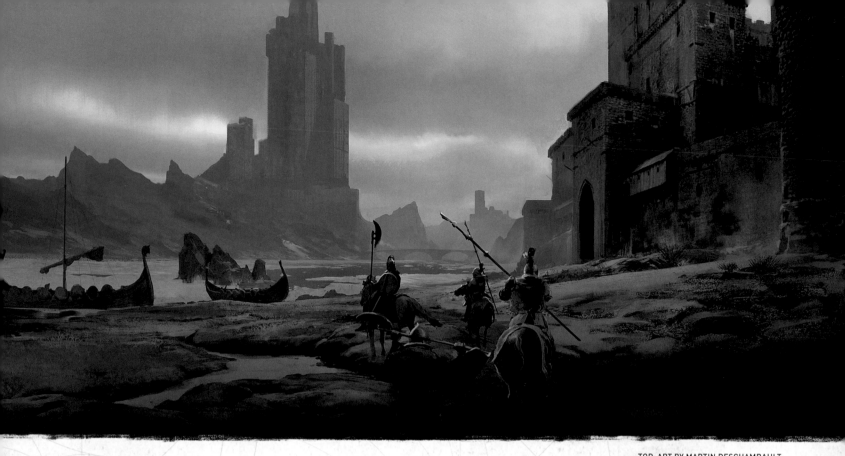

TOP: ART BY MARTIN DESCHAMBAULT
BOTTOM: ART BY EVEN MEHL AMUNDSEN

SAXONS

"The challenge for the Saxon home-team faction was to distinguish them from the Vikings, as they are historically quite similar visually," says Even Mehl Amundsen. The art team achieved this goal by exploring variations on helmets, shields, and harnesses from the region and era. "It helped to create a separate, distinct style while still having vibrant archetypes," says Amundsen.

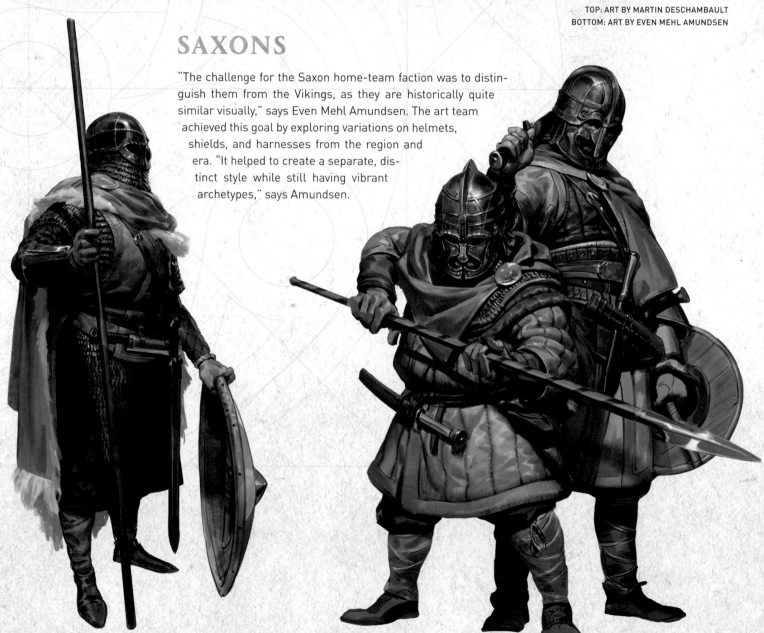

The Soldier archetype is seen on the left, and the Bondsman archetype to the right.

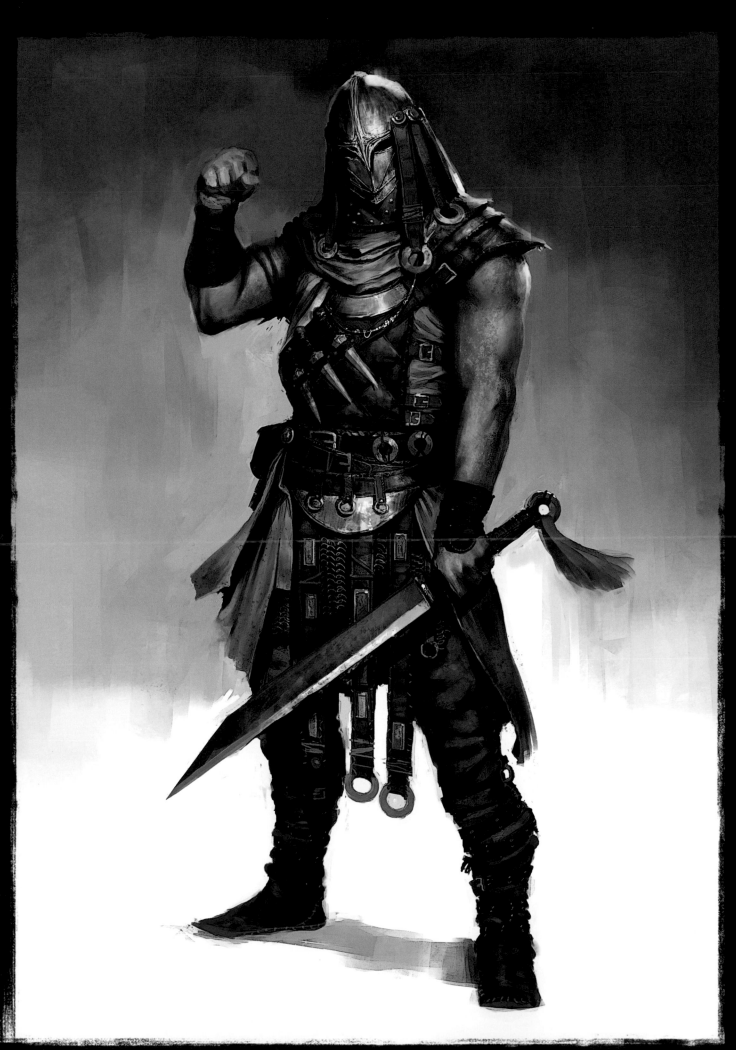

"The Reaver archetype has a design inspired by the Predator. It was fun to mix modern visual codes with ancient ones." —PIERRE RAVENEAU ART BY PIERRE RAVENEAU

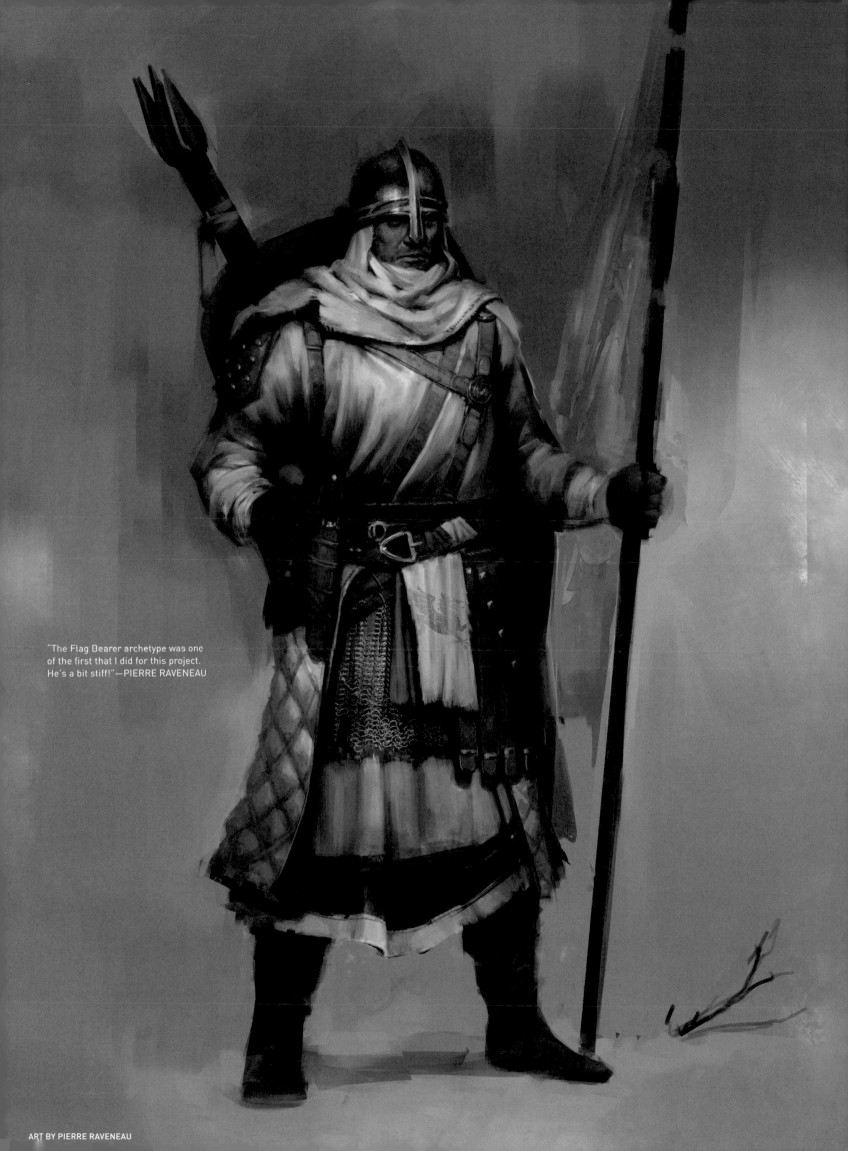

"The Flag Bearer archetype was one of the first that I did for this project. He's a bit stiff!"—PIERRE RAVENEAU

ART BY PIERRE RAVENEAU

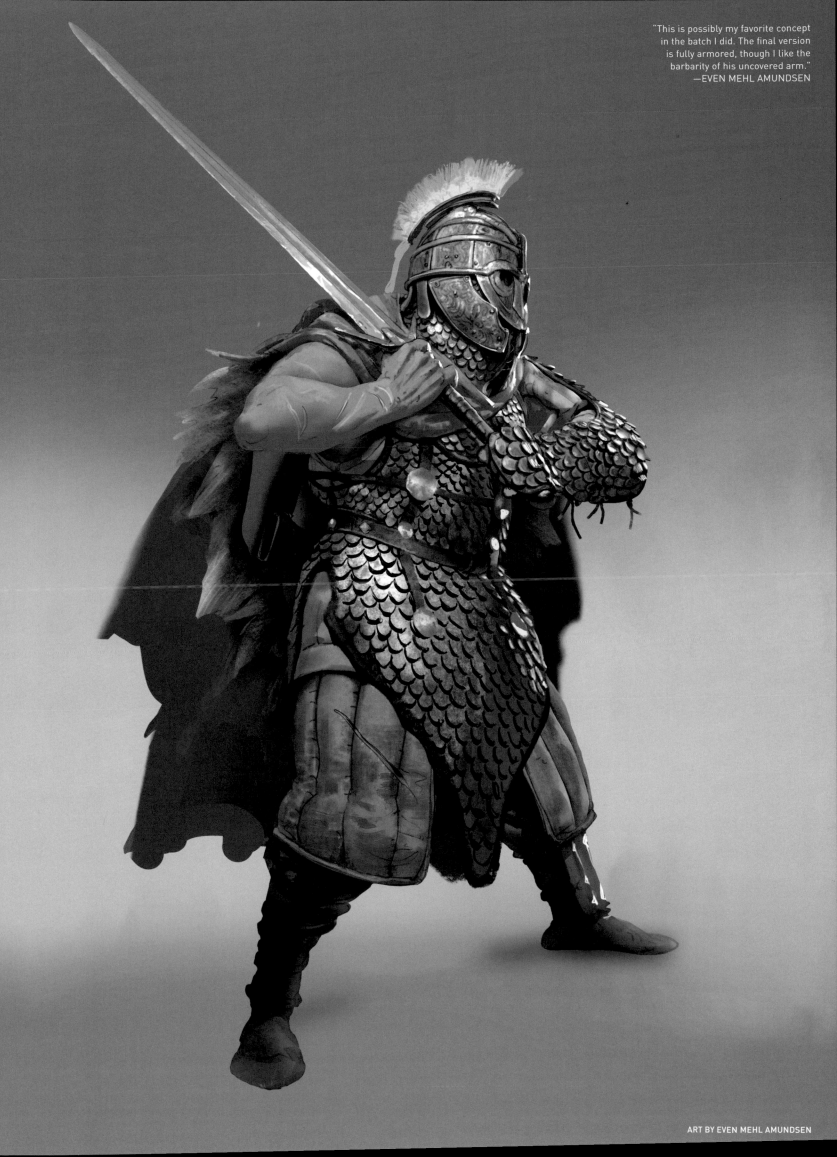

"This is possibly my favorite concept in the batch I did. The final version is fully armored, though I like the barbarity of his uncovered arm."
—EVEN MEHL AMUNDSEN

ART BY EVEN MEHL AMUNDSEN

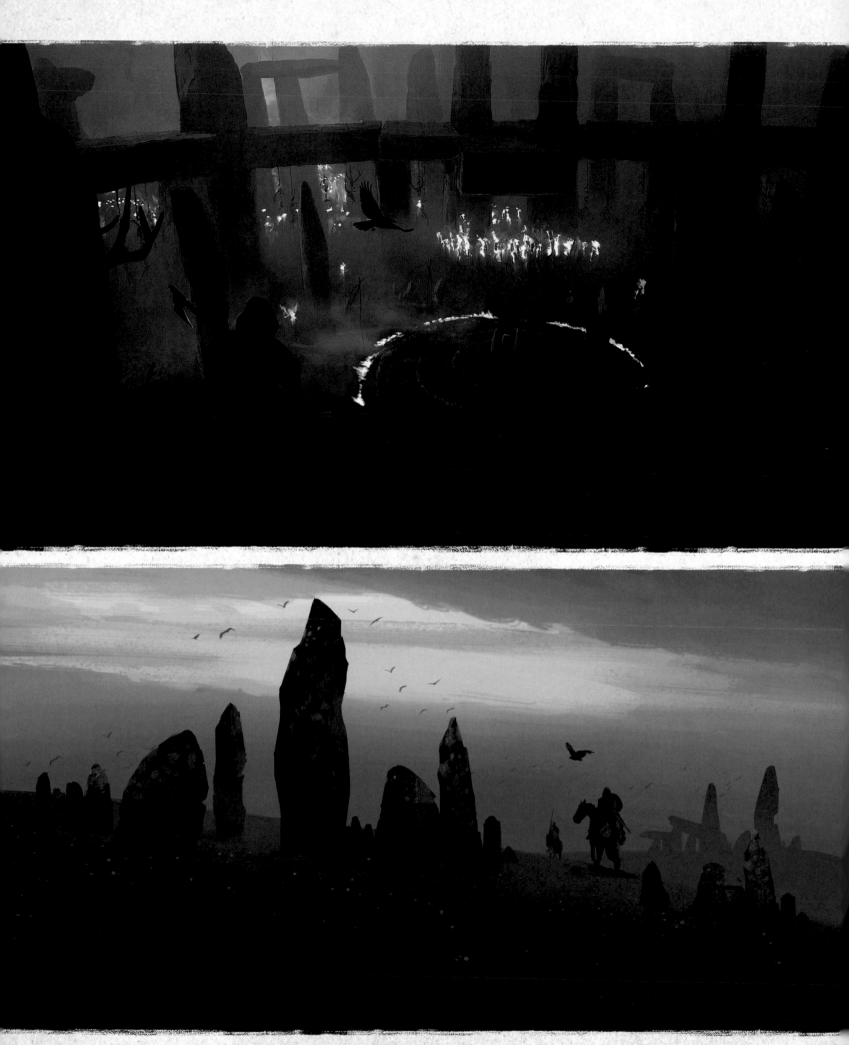

Several Neolithic standing stone sites, including Stonehenge, are featured in the game. These are truly mysterious locations imprinted with a pagan aura.

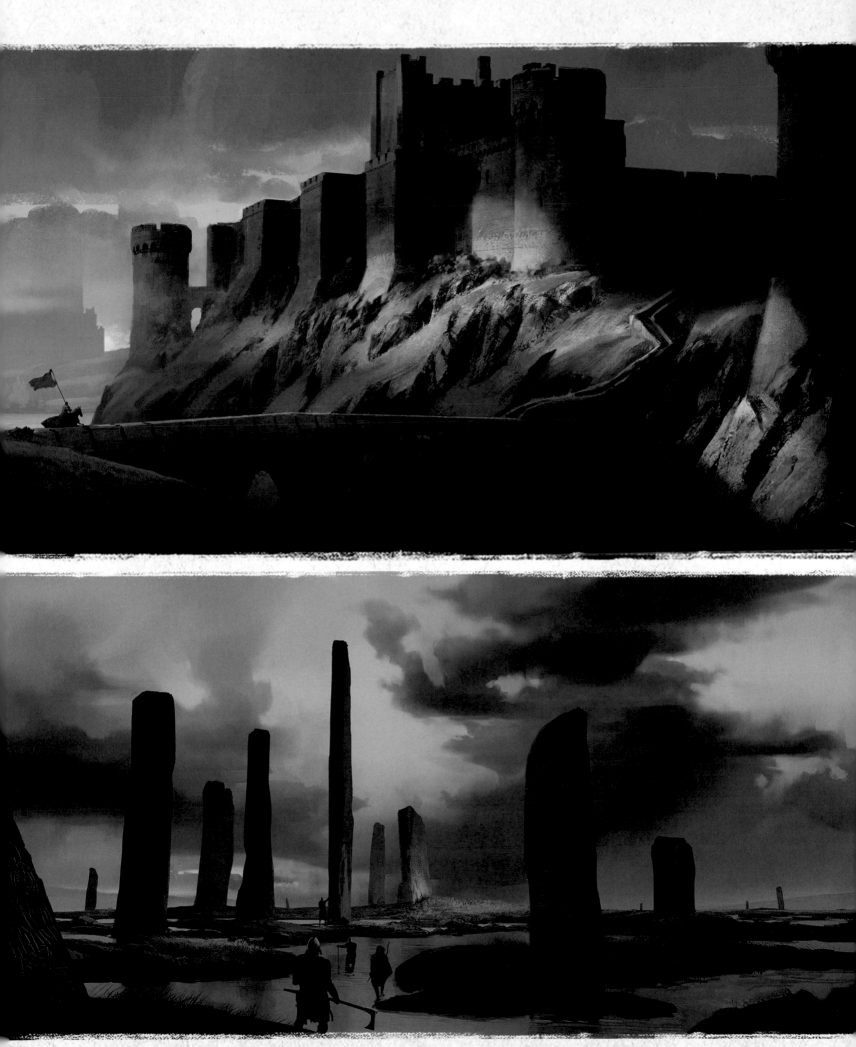

TOP ROW AND BOTTOM RIGHT: ART BY MARTIN DESCHAMBAULT; BOTTOM LEFT: ART BY RAPHAËL LACOSTE

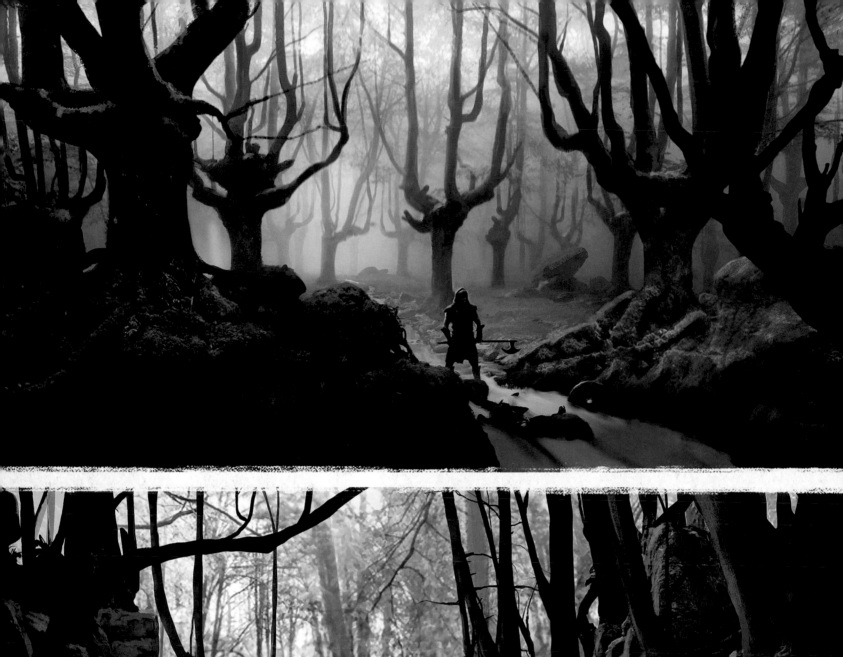

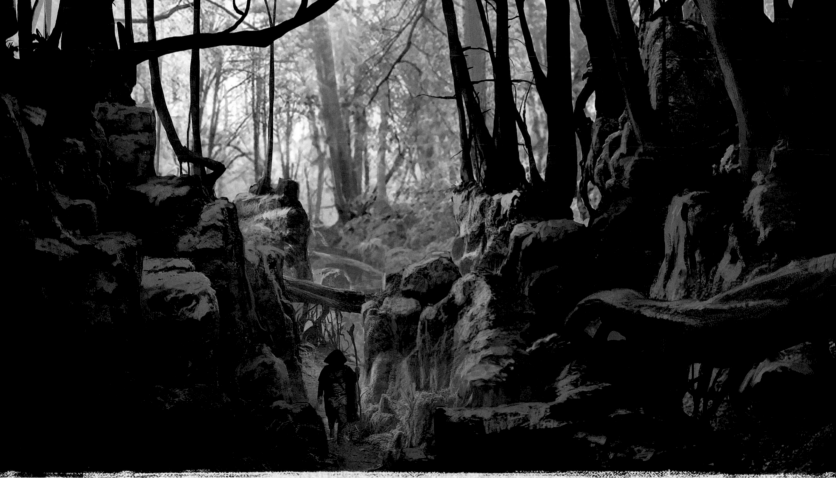

GLOWECESTRESCIRE

"The Glowecestrescire territory in West Mercia is filled with pagan traditions, mystical forests, and Celtic rituals. This part of our world offers its own vibe within our game."—RAPHAËL LACOSTE

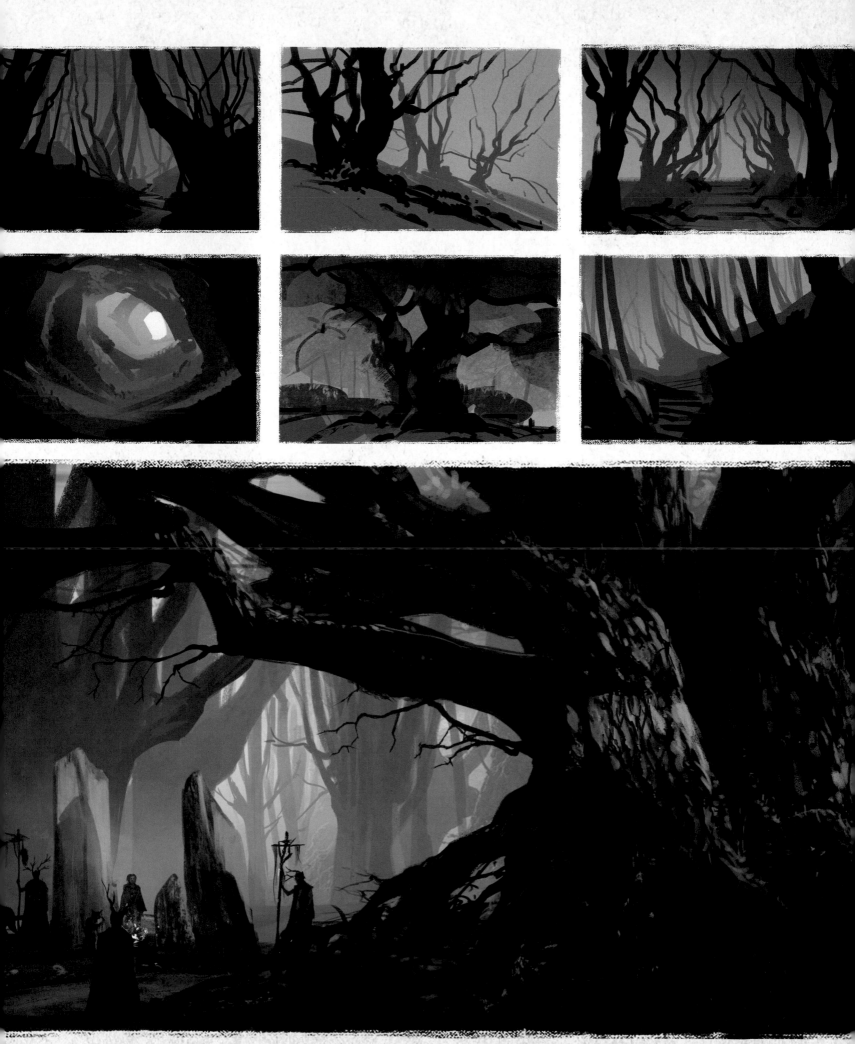

LEFT PAGE: ART BY MARTIN DESCHAMBAULT; THIS PAGE, TOP: ART BY DONGLU YU; THIS PAGE, BOTTOM: ART BY RAPHAËL LACOSTE

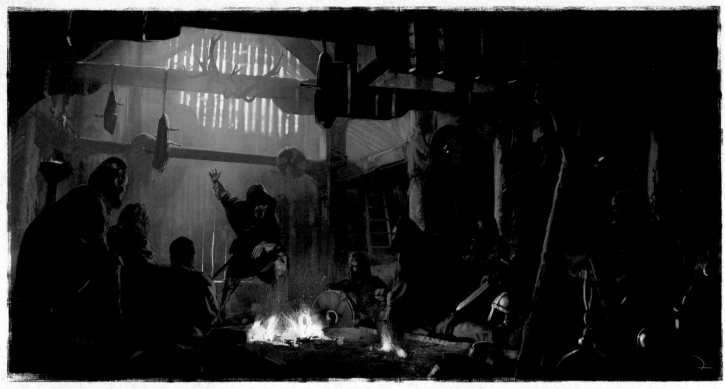

"The challenge in designing interiors is that brown tones prevail, because the one interior light source available in these times was fire. We used openings to the outside to bring exterior light in, and we added vegetation or water reflections to bring more colors to interior locations."—GILLES BELOEIL

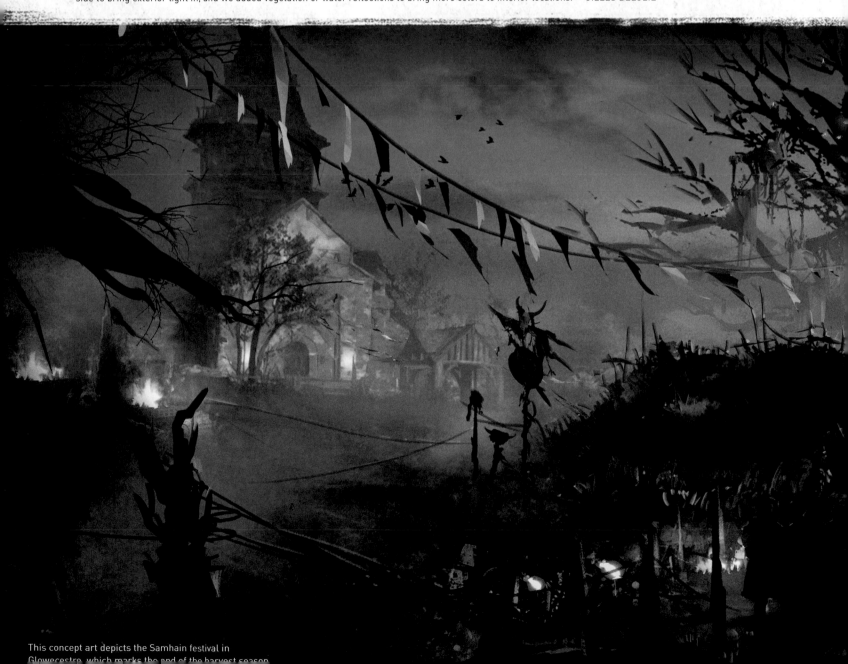

This concept art depicts the Samhain festival in
Glowecestre, which marks the end of the harvest season.

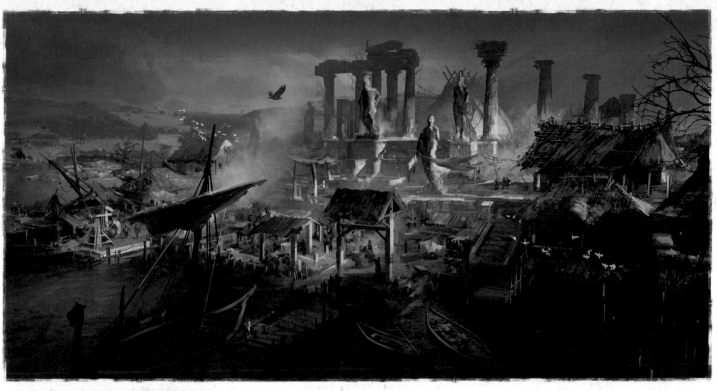

"The port of Glowecestre is vivid and colorful. We can hear boats arriving, fishermen selling the day's catch, birds chirping, and people busily loading up merchandise from the port."—DONGLU YU

LEFT PAGE, TOP: ART BY MARTIN DESCHAMBAULT
ABOVE AND BELOW: ART BY DONGLU YU

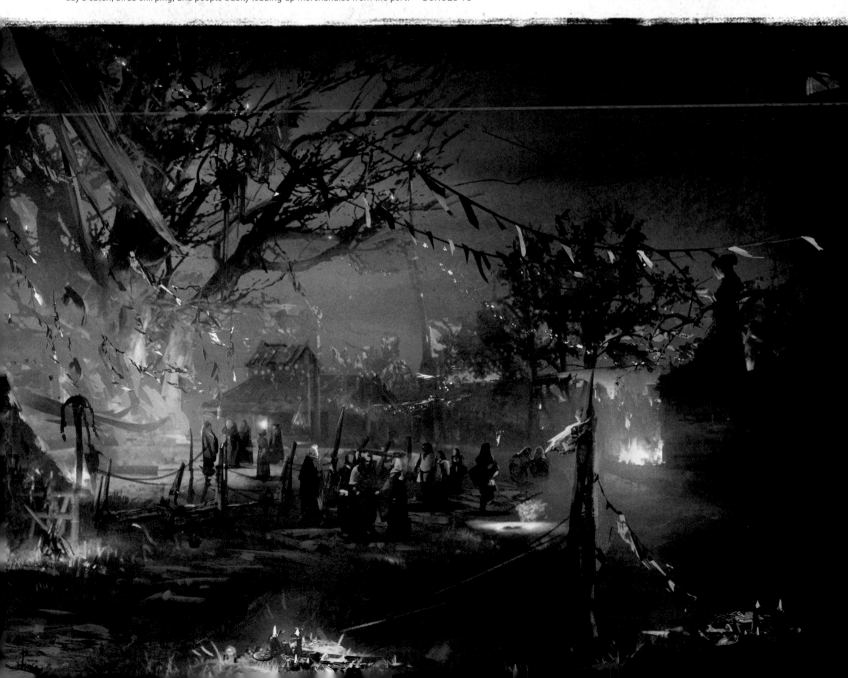

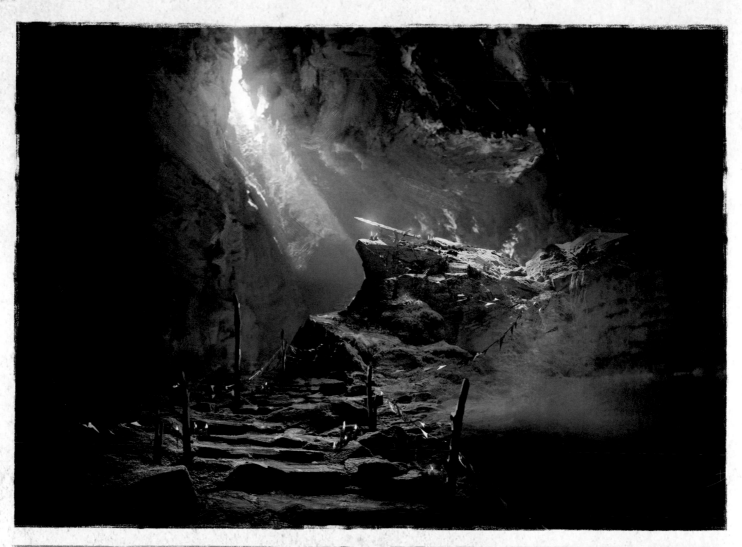

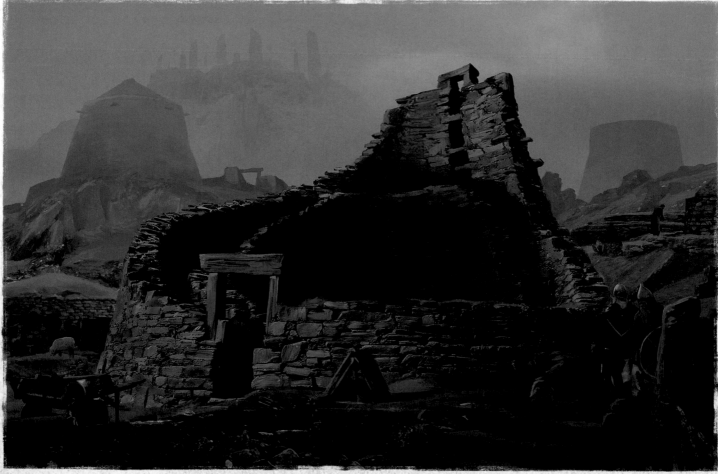

This concept art features a broch in ruins. The presence of these prehistoric circular stone towers is another example of the varied environments the player will discover in the game.

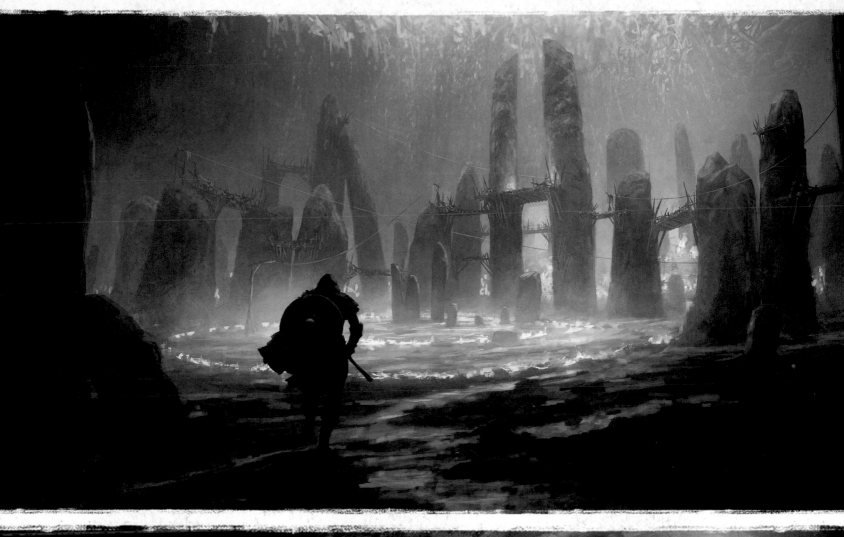

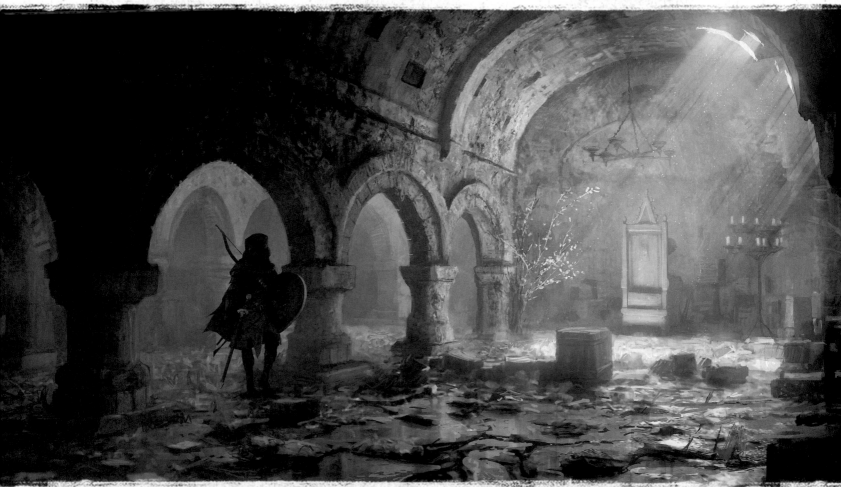

Concept art for a mysterious crypt found below a castle.

TOP LEFT: ART BY DONGLU YU; BOTTOM LEFT: ART BY MARTIN DESCHAMBAULT; THIS PAGE: ART BY GILLES BELOEIL

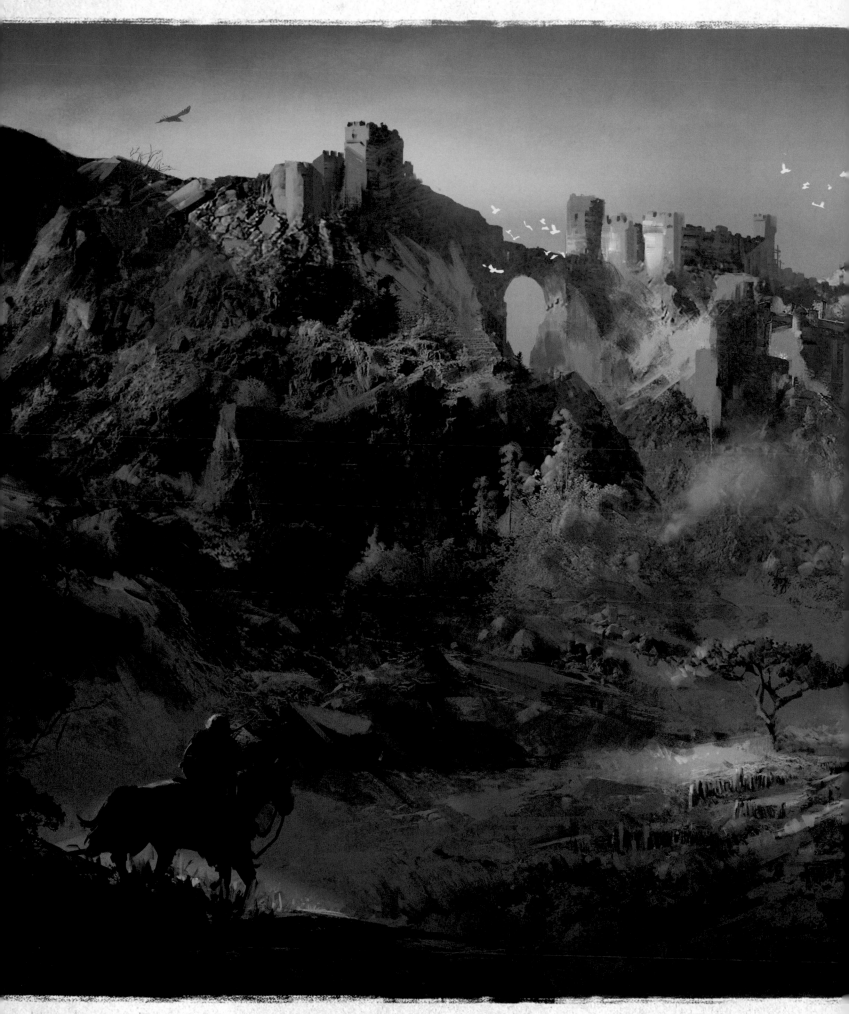

"A high-level mood piece for Trefaldwyn Castle. I was inspired by traditional paintings for this piece, leaving visible brushstrokes and paying close attention to the

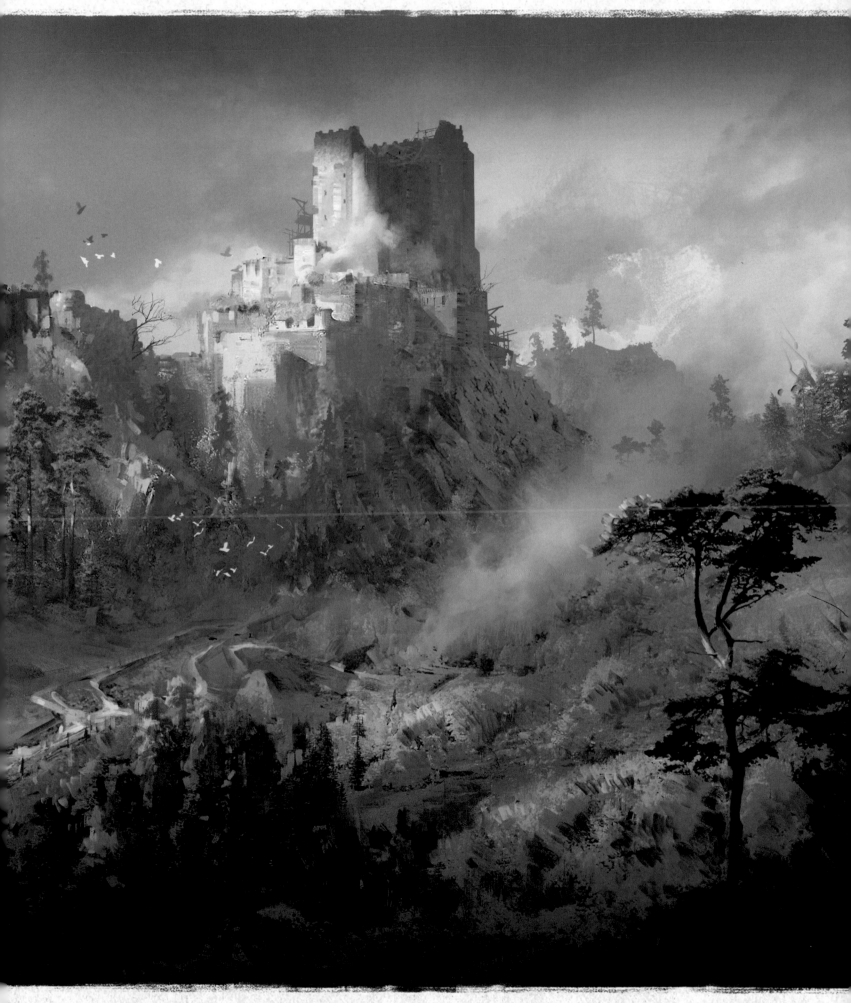

color palette." —DONGLU YU

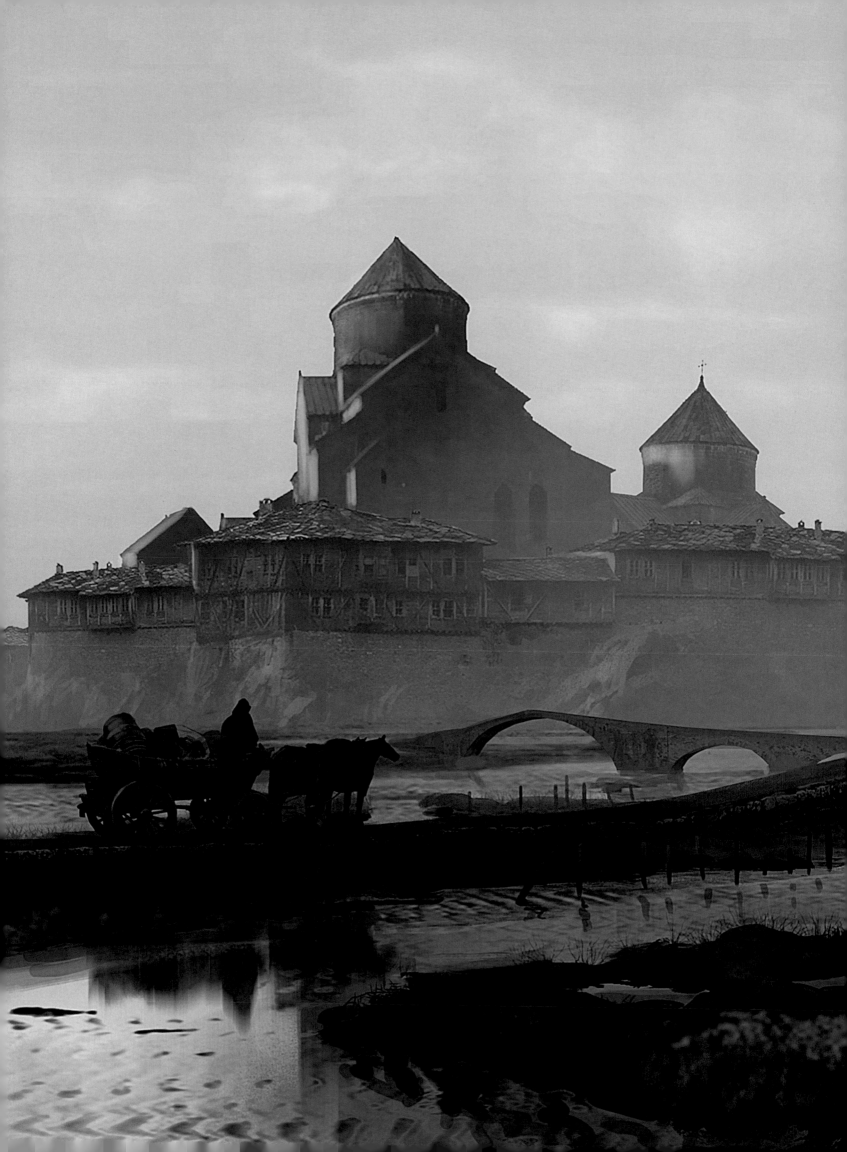

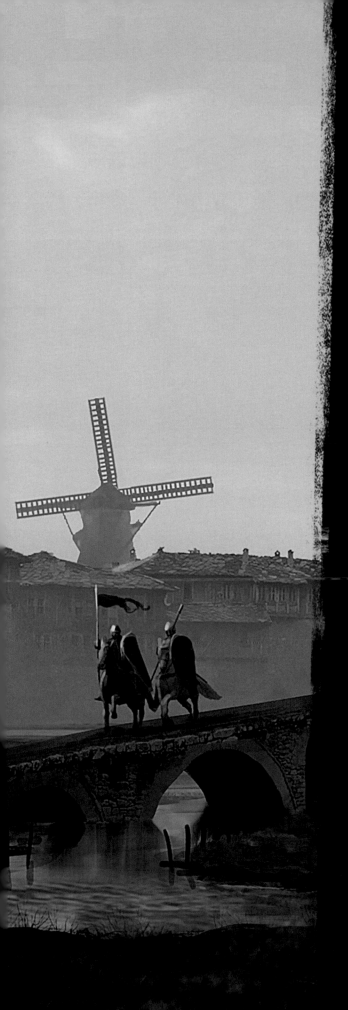

CHAPTER SIX

EAST ANGLIA

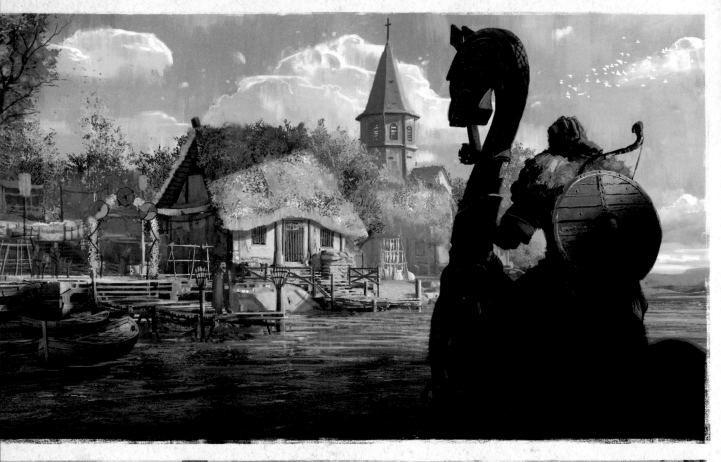

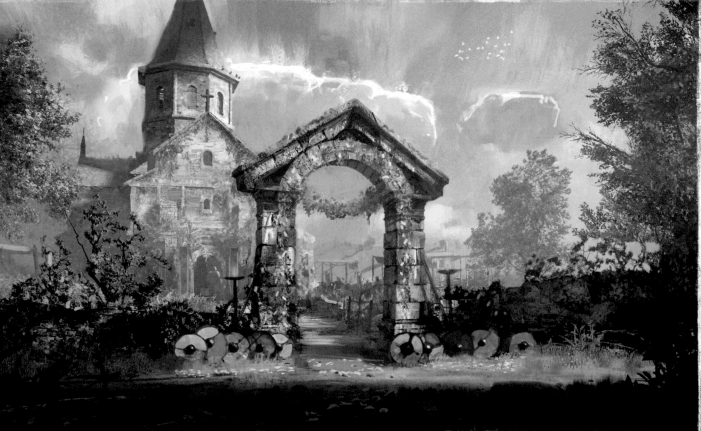

ELMENHAM

Elmenham is the home of Oswald, a Saxon noble designated to reign over East Anglia, a territory where both Saxons and Danes coexist. "The village is jubilant, and its buildings are well maintained—a big contrast to the war-torn climate that dominates in East Mercia," says Dann Yeau Choong Yap.

ABOVE AND TOP RIGHT: ART BY GABRIEL TAN; BOTTOM RIGHT: ART BY TRAVIS QIU ZHIWEI; CHAPTER BREAK: ART BY MARTIN DESCHAMBAULT

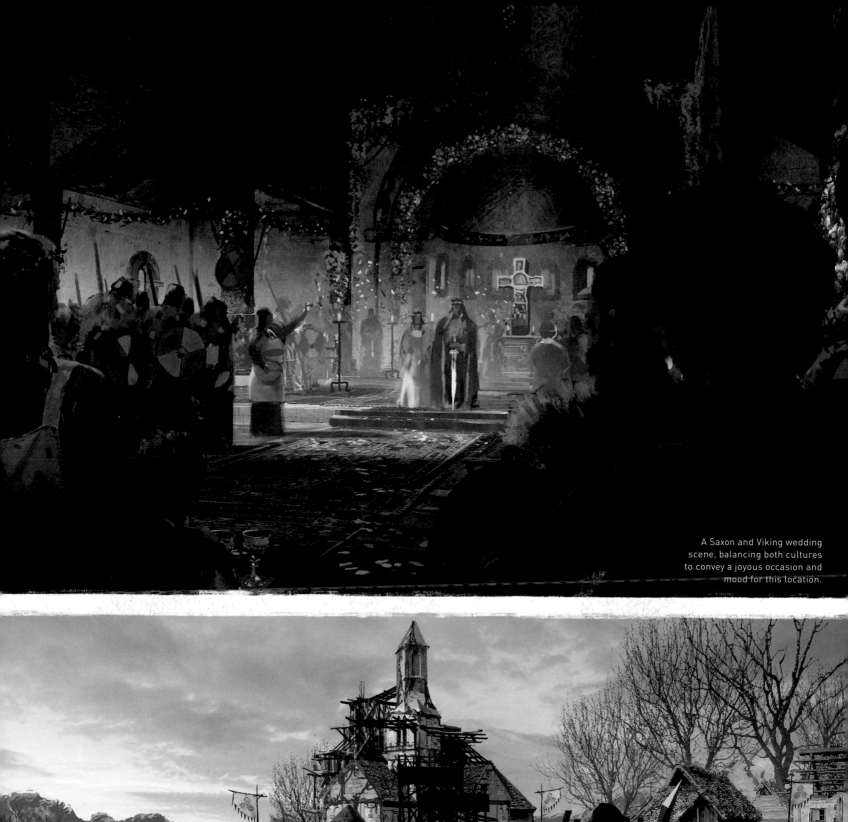

A Saxon and Viking wedding scene, balancing both cultures to convey a joyous occasion and mood for this location.

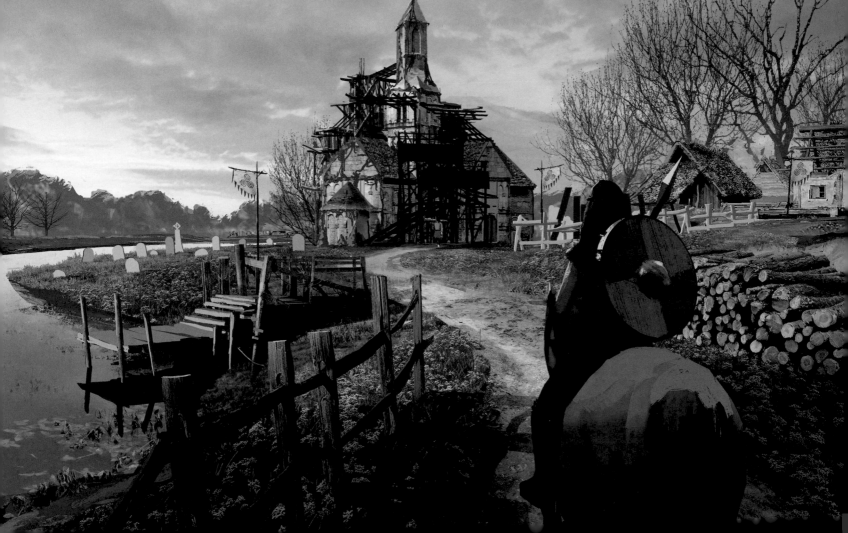

ASSAULTS

Assassin's Creed Valhalla sees the player lead Viking armies to attack enemy fortifications. Some early explorations of the assault feature are seen here. The team was challenged to strike the right atmosphere and tone during the siege of the fortresses and castles from the ocean in order to achieve believability during these sequences.

TOP: ART BY JEFF SIMPSON
BOTTOM: ART BY GABRIEL TAN

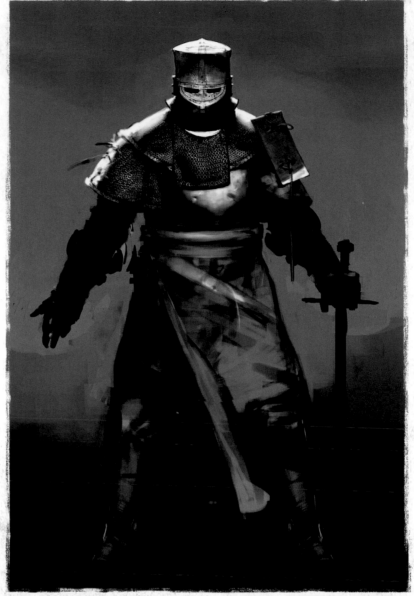

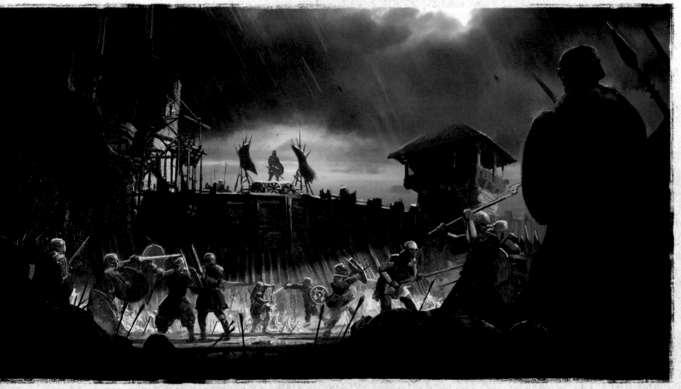

A Viking chief oversees the battle unfolding beneath the ramparts on which he stands.

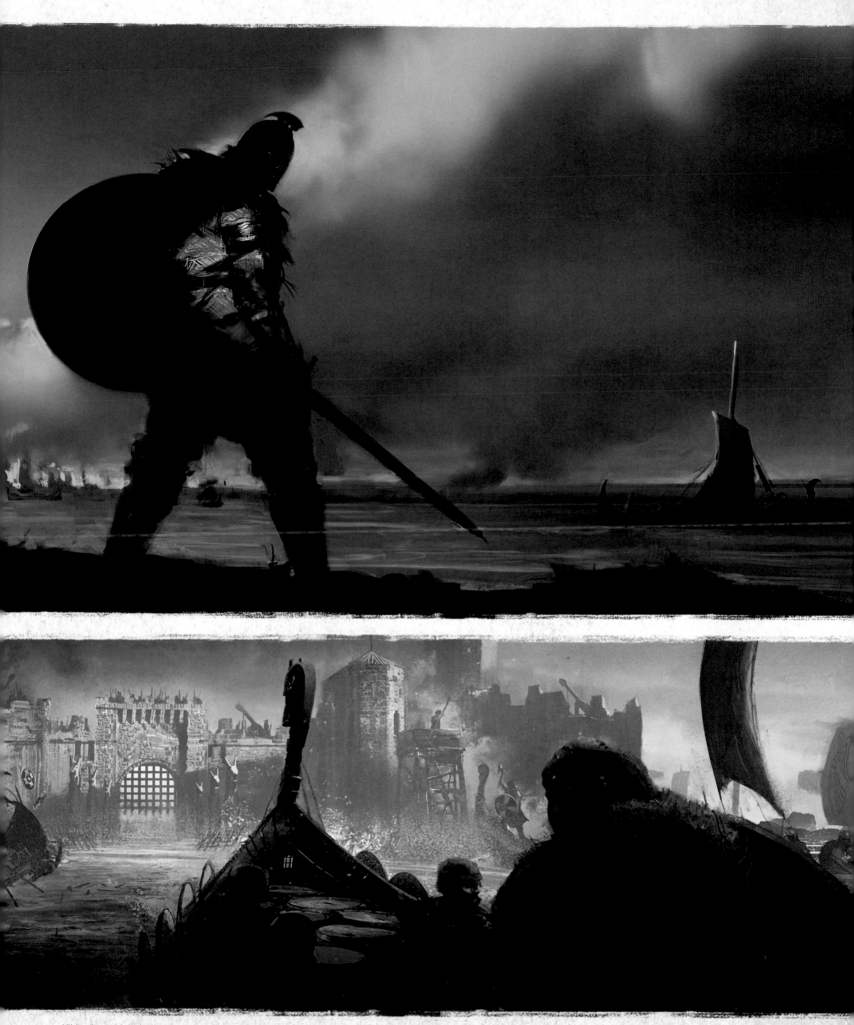

Viking longships charge toward an English fortress, laden with explosives to attempt a violent breaching maneuver.

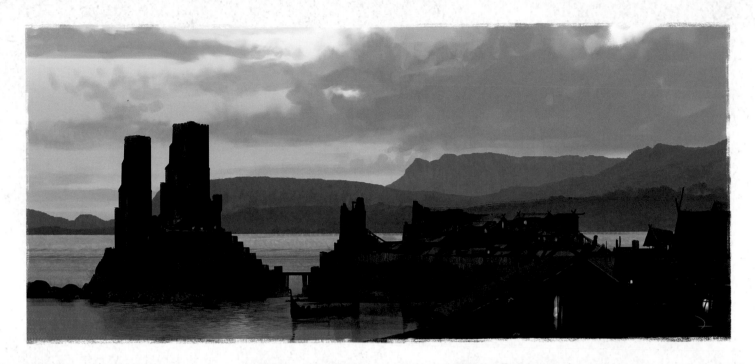

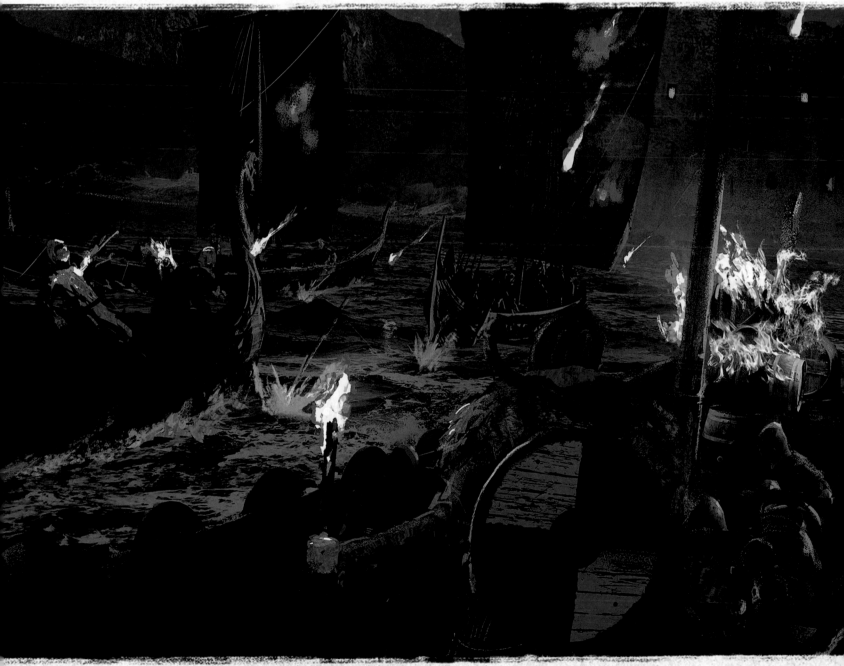

Eivor leads a nighttime Viking raid on a Burgh Castle.

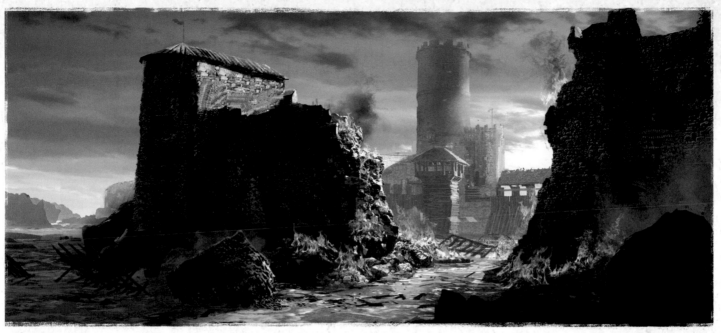

This fortress's walls lie in flaming ruins after the Vikings employed a daring tactic using a charging flaming boat and explosives.

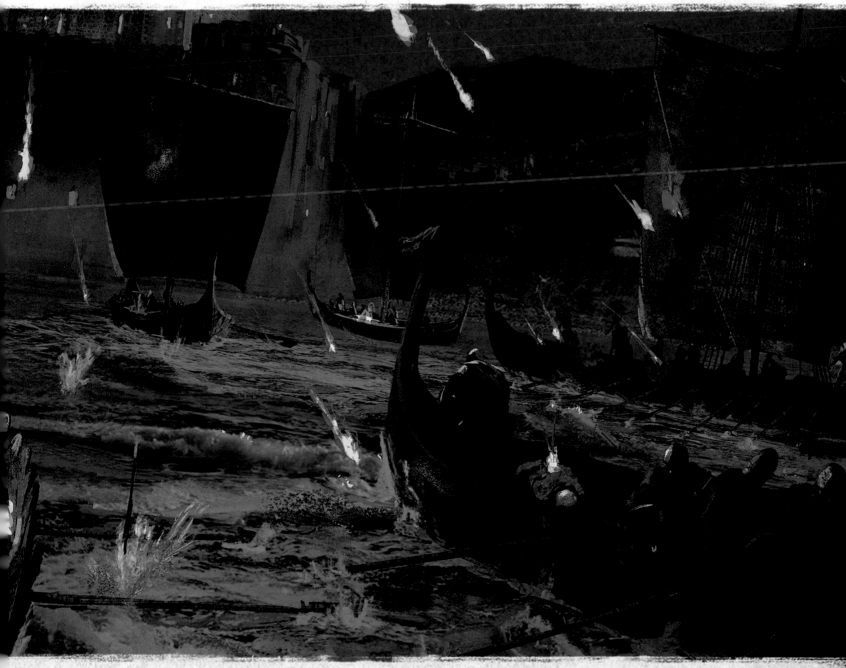

TOP LEFT: ART BY MARTIN DESCHAMBAULT; TOP RIGHT: ART BY GABRIEL TAN; BOTTOM: ART BY GUANG YU TAN

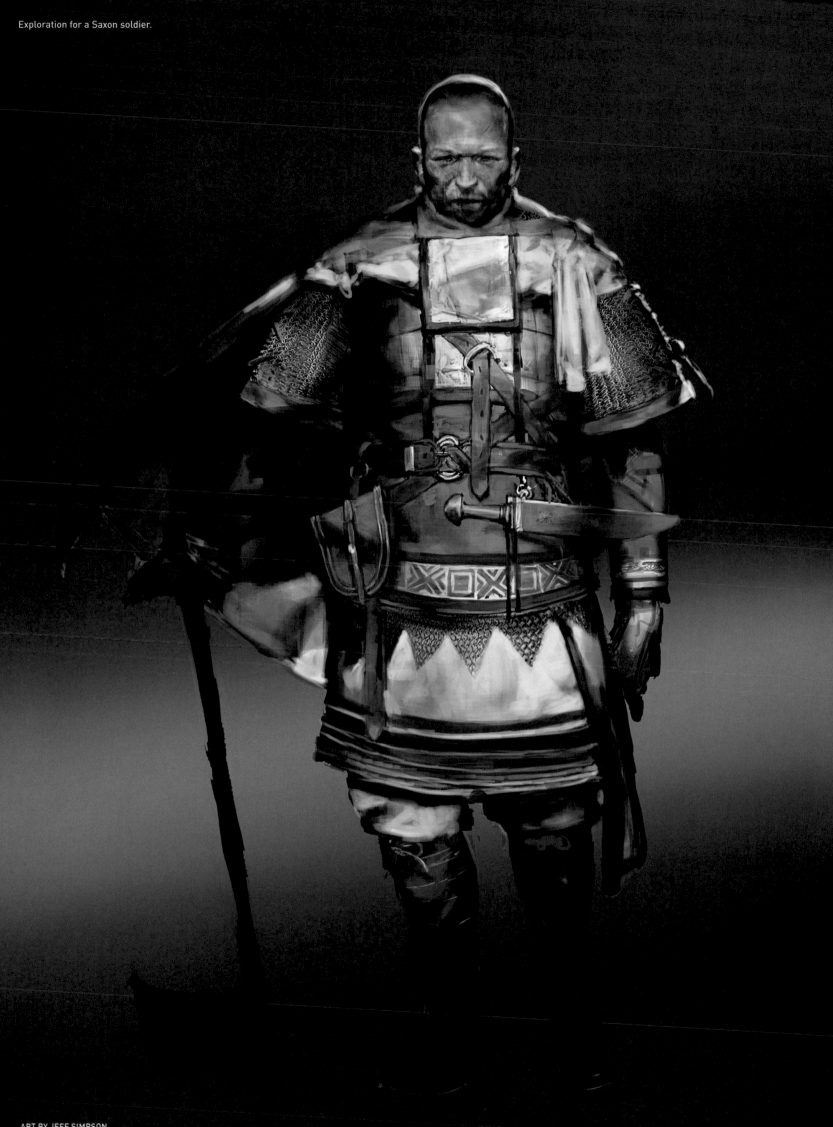

Exploration for a Saxon soldier.

ART BY JEFF SIMPSON

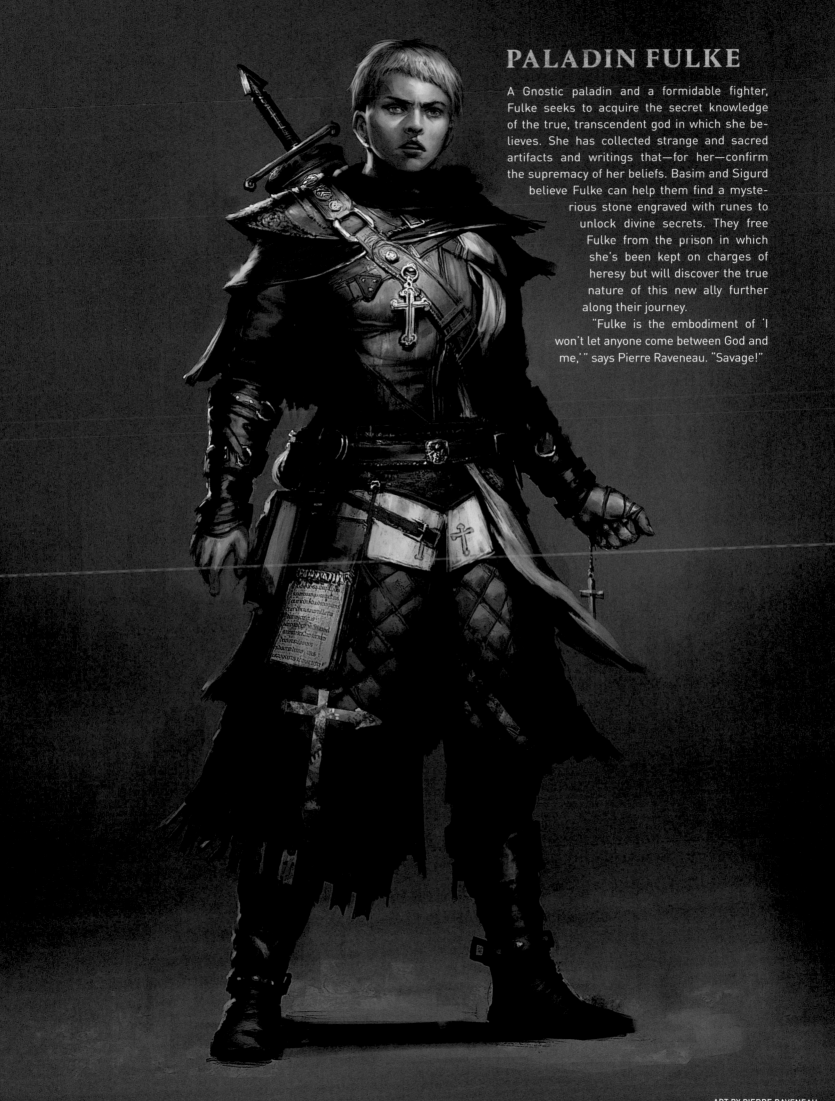

PALADIN FULKE

A Gnostic paladin and a formidable fighter, Fulke seeks to acquire the secret knowledge of the true, transcendent god in which she believes. She has collected strange and sacred artifacts and writings that—for her—confirm the supremacy of her beliefs. Basim and Sigurd believe Fulke can help them find a mysterious stone engraved with runes to unlock divine secrets. They free Fulke from the prison in which she's been kept on charges of heresy but will discover the true nature of this new ally further along their journey.

"Fulke is the embodiment of 'I won't let anyone come between God and me,'" says Pierre Raveneau. "Savage!"

ART BY PIERRE RAVENEAU

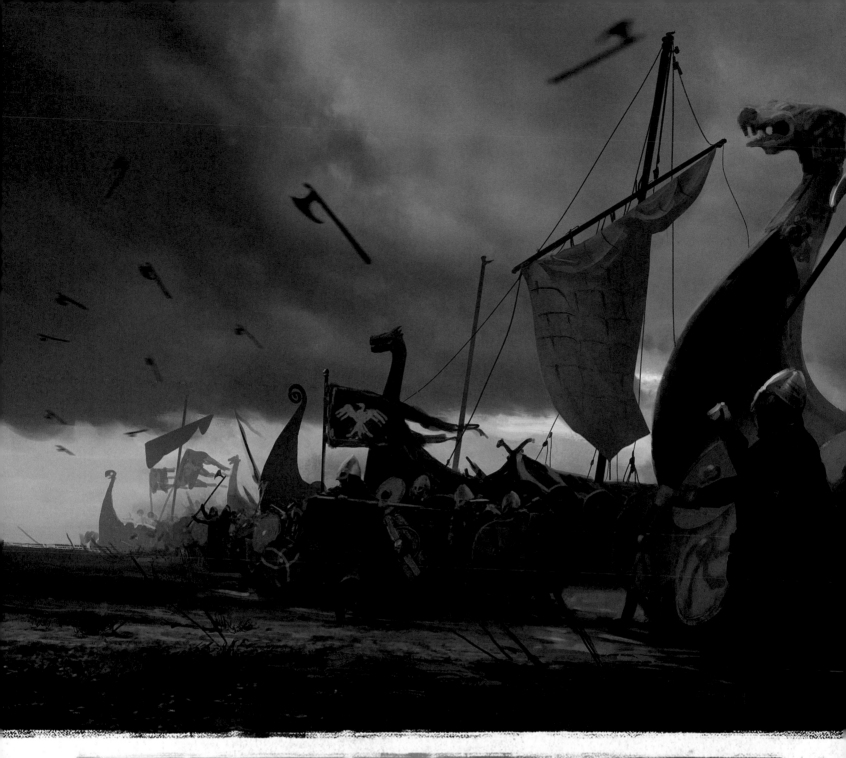

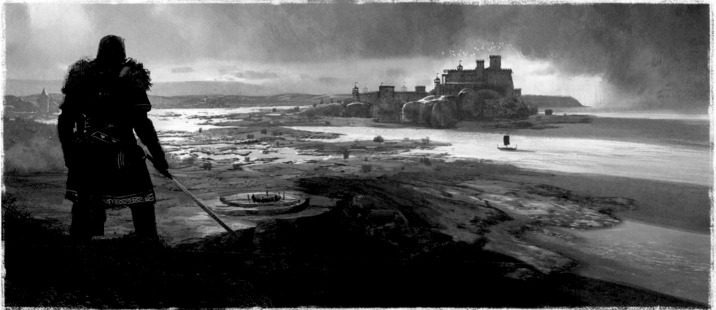

An early grand vista that explores the game's cairn feature.

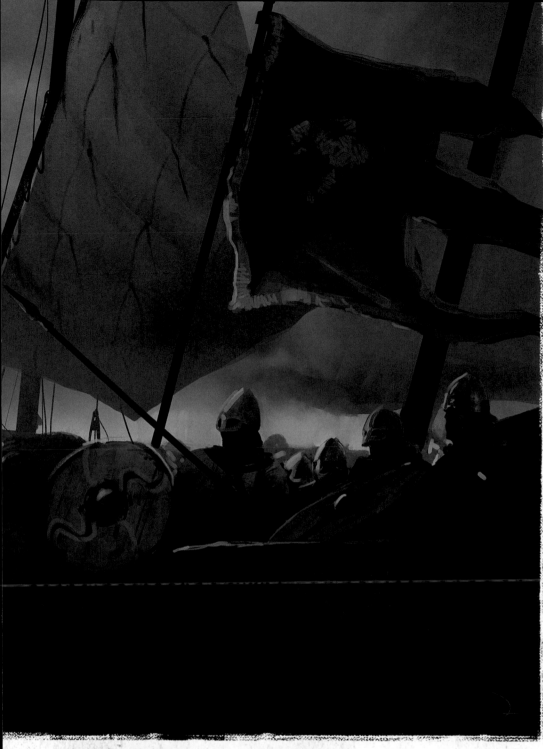

A dramatic depiction of a Viking beach landing.

TOP: ART BY MARTIN DESCHAMBAULT
BOTTOM: ART BY GABRIEL TAN

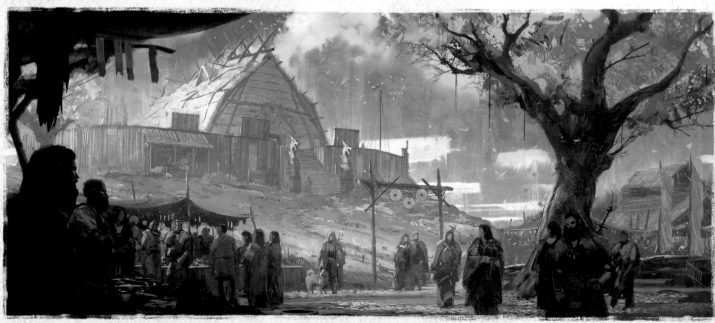

A concept of the Northwic market. The mood in the area seems to be pleasant, but trouble is approaching from over the horizon.

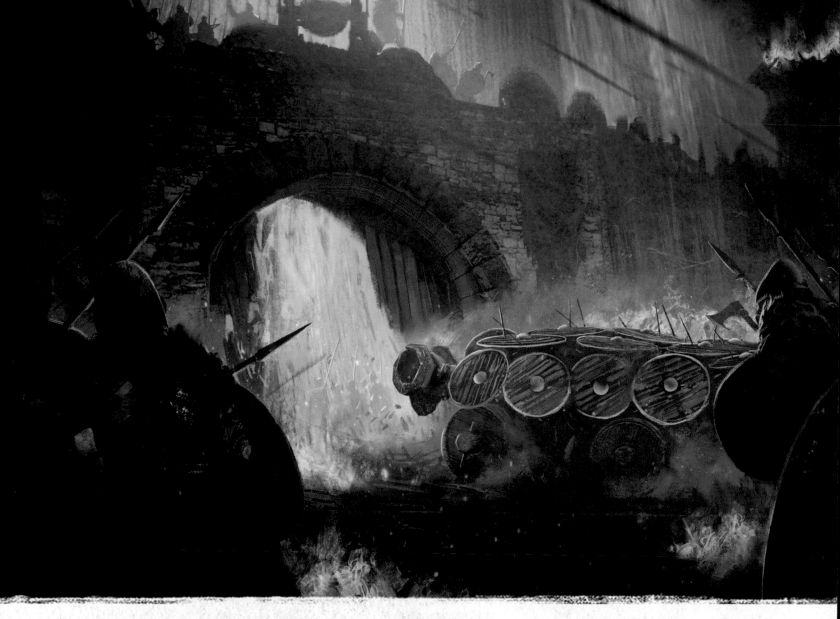

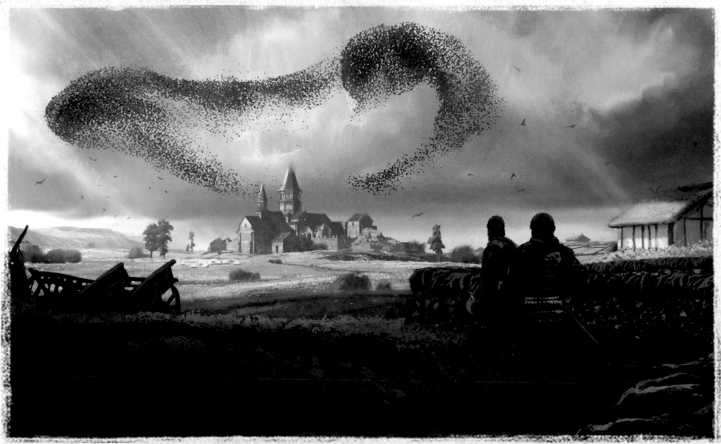

A concept piece that explores a potential gameplay feature, which would employ formations of flocking birds to guide the player to interesting locations.

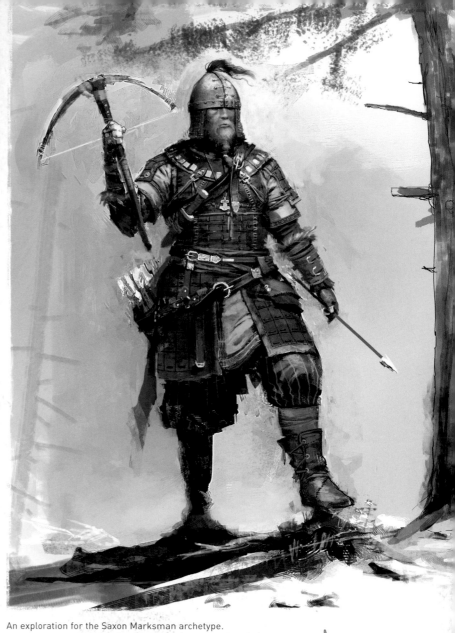

An exploration for the Saxon Marksman archetype.

Additional Saxon archetype concepts, including (*from left to right*) the Flagbearer (or Huscarl), the Noble, and the Archer.

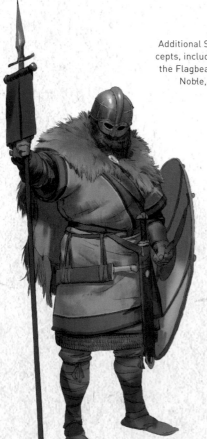

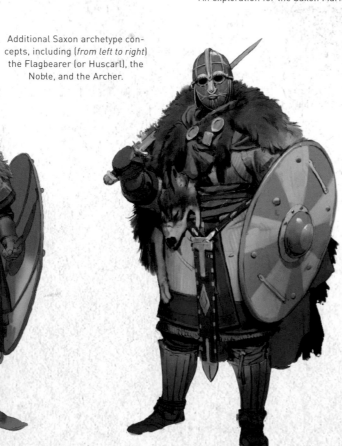

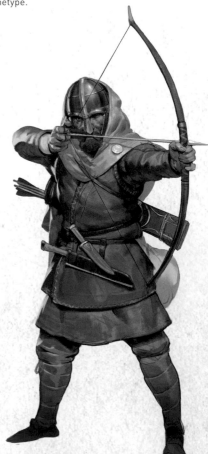

LEFT PAGE: ART BY GABRIEL TAN; TOP RIGHT: ART BY REMKO TROOST; BOTTOM RIGHT: ART BY EVEN MEHL AMUNDSEN

NORTHWIC

Eivor arrives in Northwic in the immediate aftermath of an attack by Rued's clan, causing havoc in a city where Saxons and Danes otherwise reside peacefully. The capital of East Anglia is a topographically flat town that contains the remains of a Roman coastal fort. It is built on the River Yare and surrounded by marshlands.

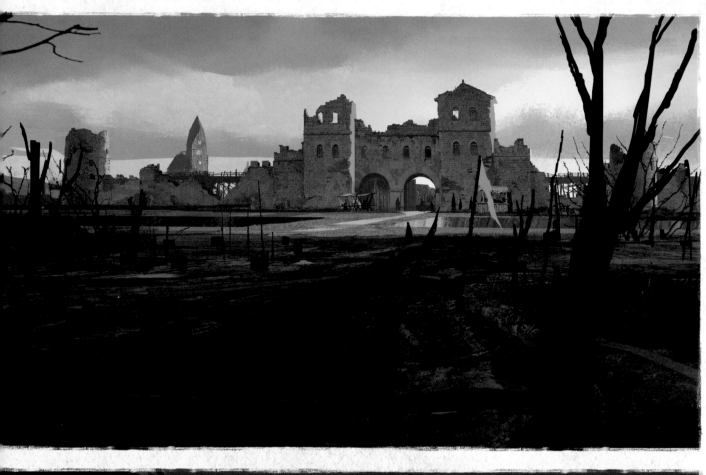

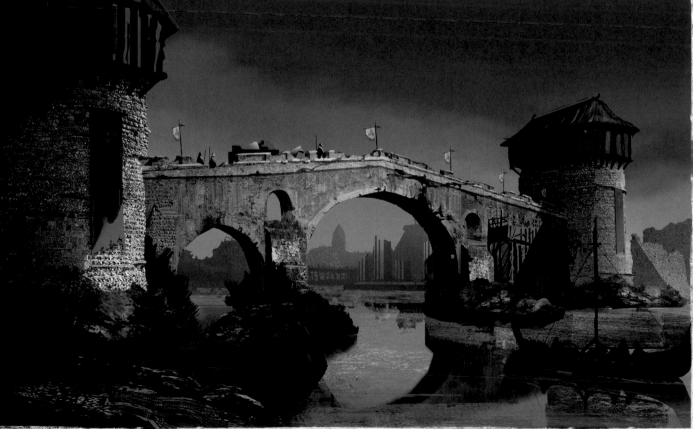

THESE PAGES : ART BY TRAVIS QIU ZHIWEI

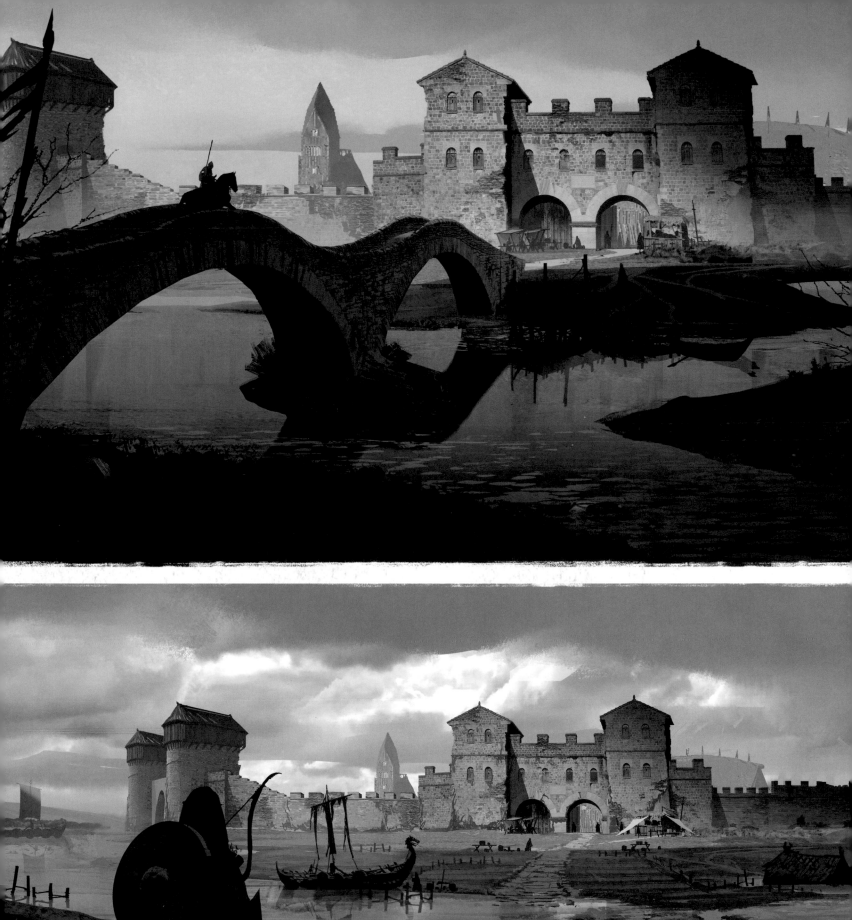

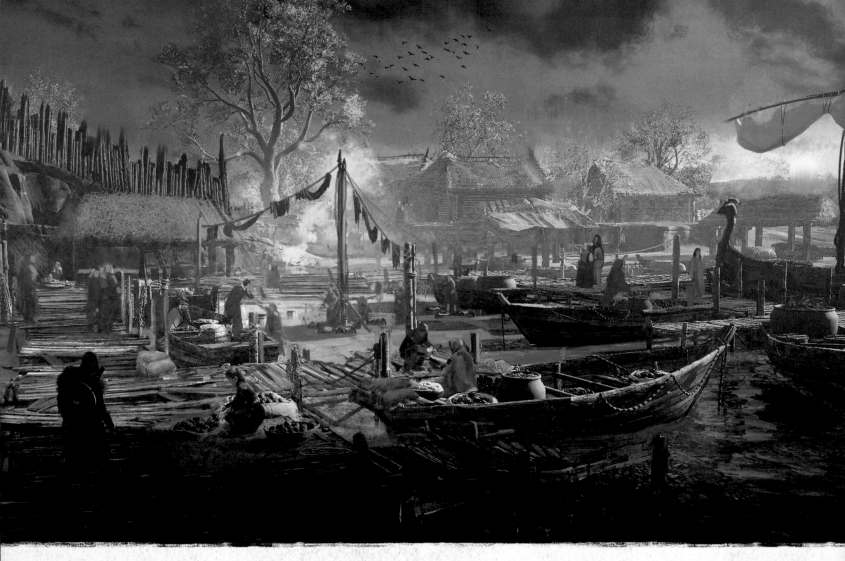

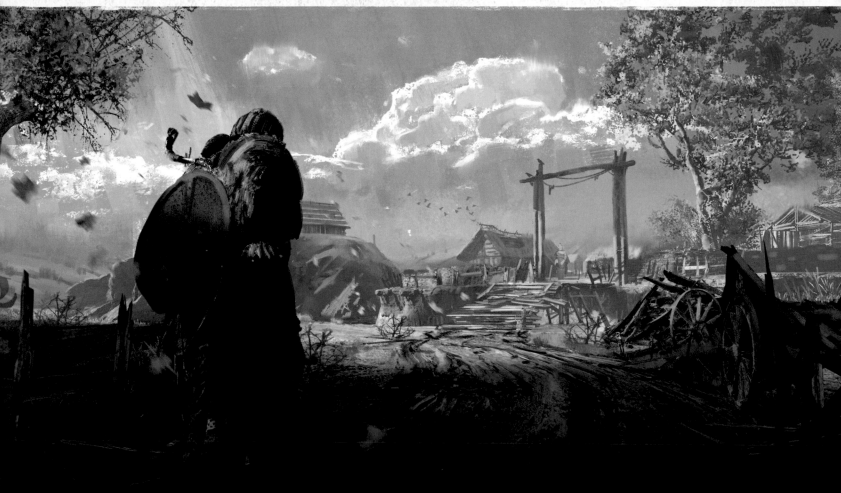

Early concepts of an impoverished fishing village that explore the area's potential layout.

THIS PAGE: ART BY GABRIEL TAN; TOP RIGHT PAGE: ART BY RAPHAËL LACOSTE
BOTTOM TWO RIGHT PAGE: ART BY MARTIN DESCHAMBAULT

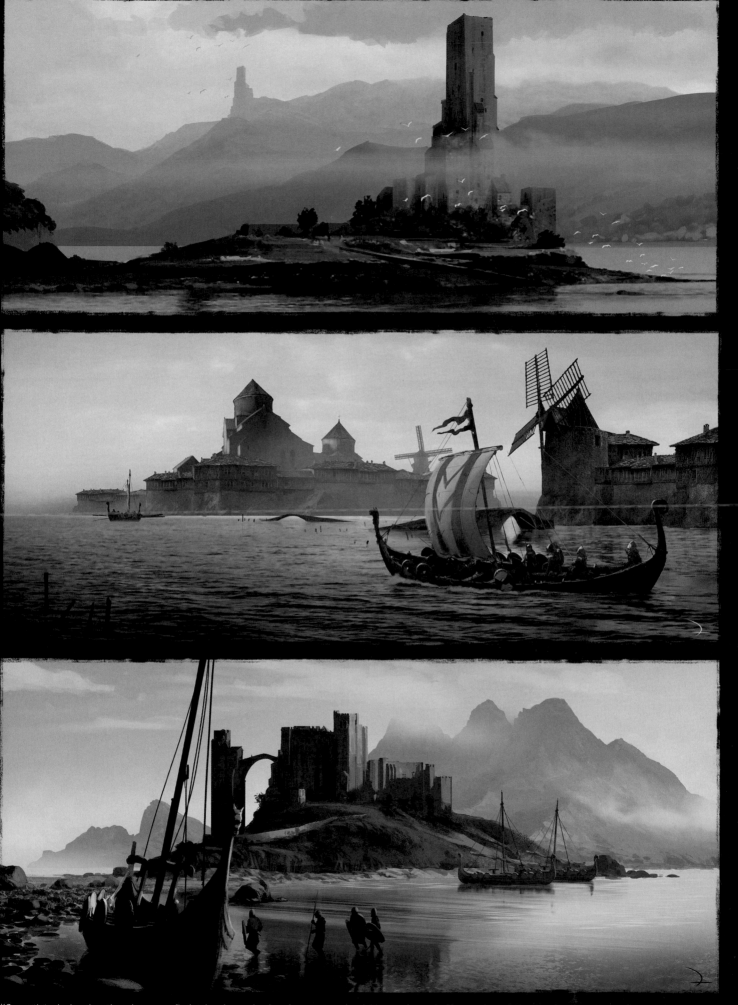

"Our artists design the otherwise empty flatland and grassland environments to be richly complemented by nearby architecture. The imposing and mysterious castles serve as the central point of interest in each piece, giving the compositions an epic feel." —RAPHAËL LACOSTE

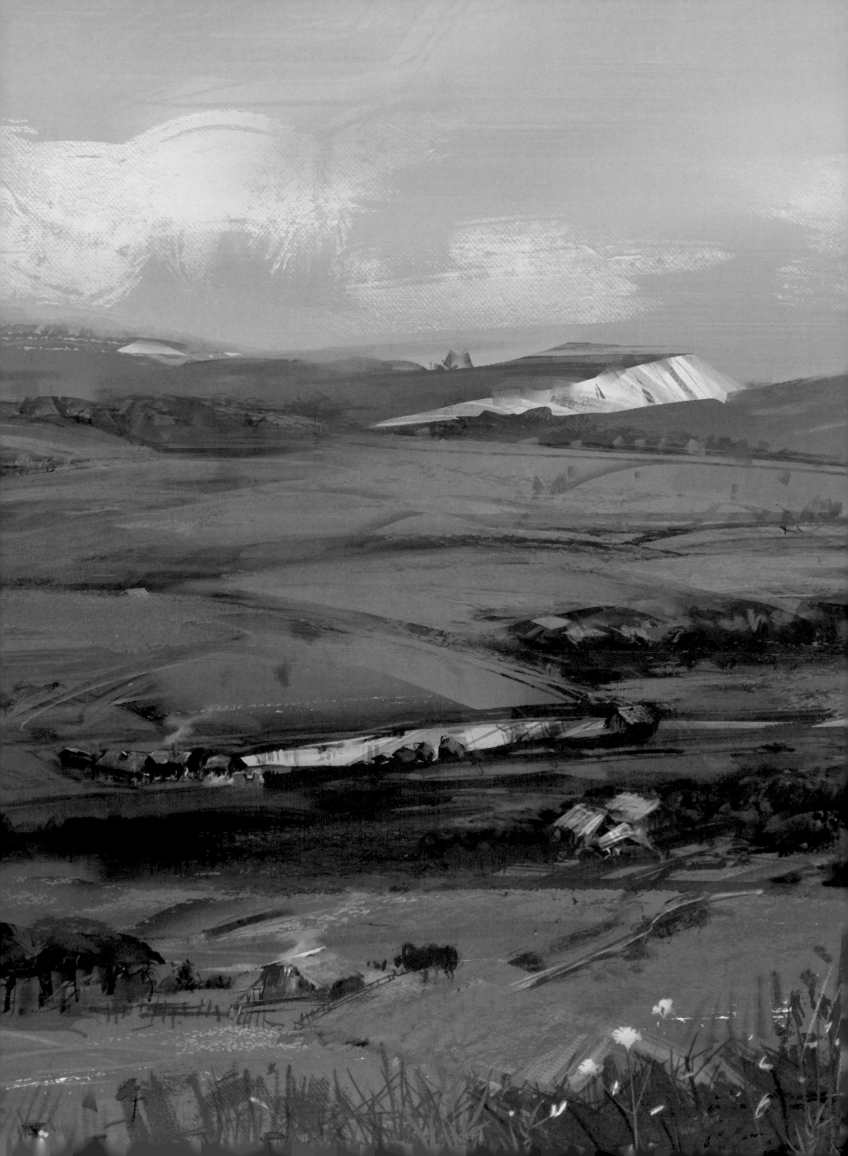

CHAPTER SEVEN

WESSEX

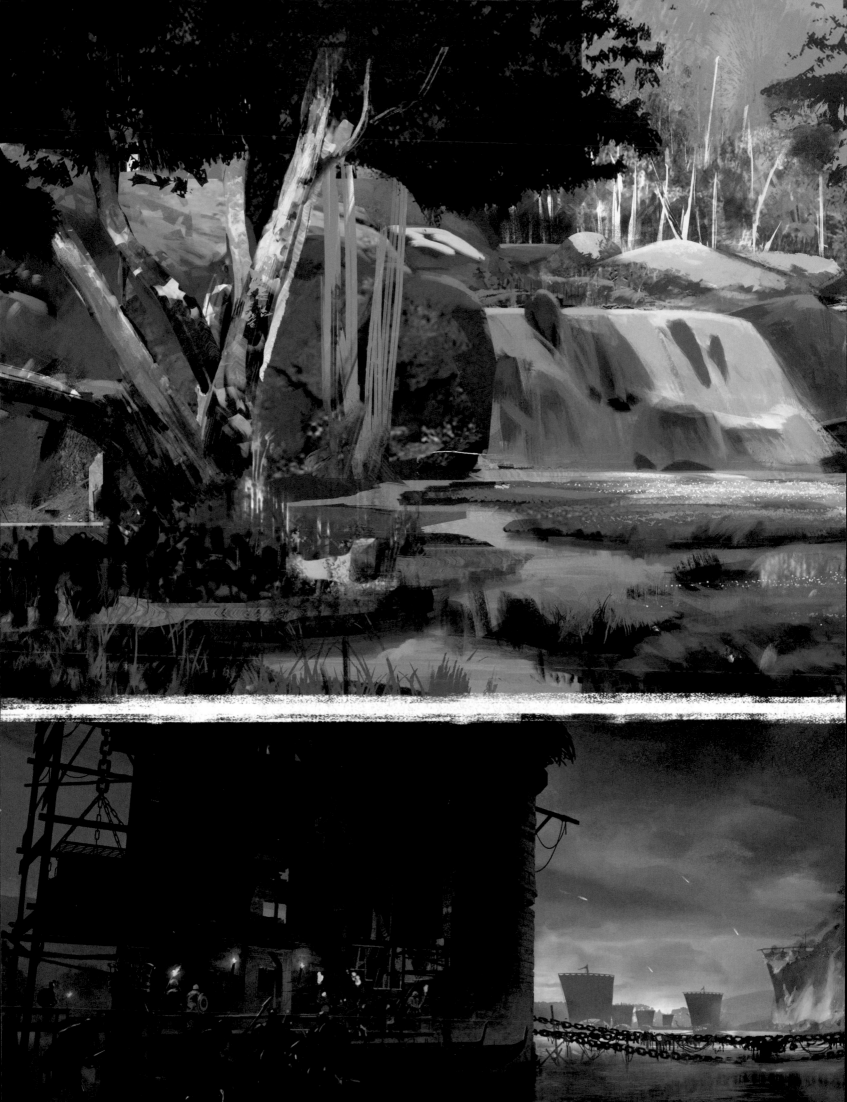

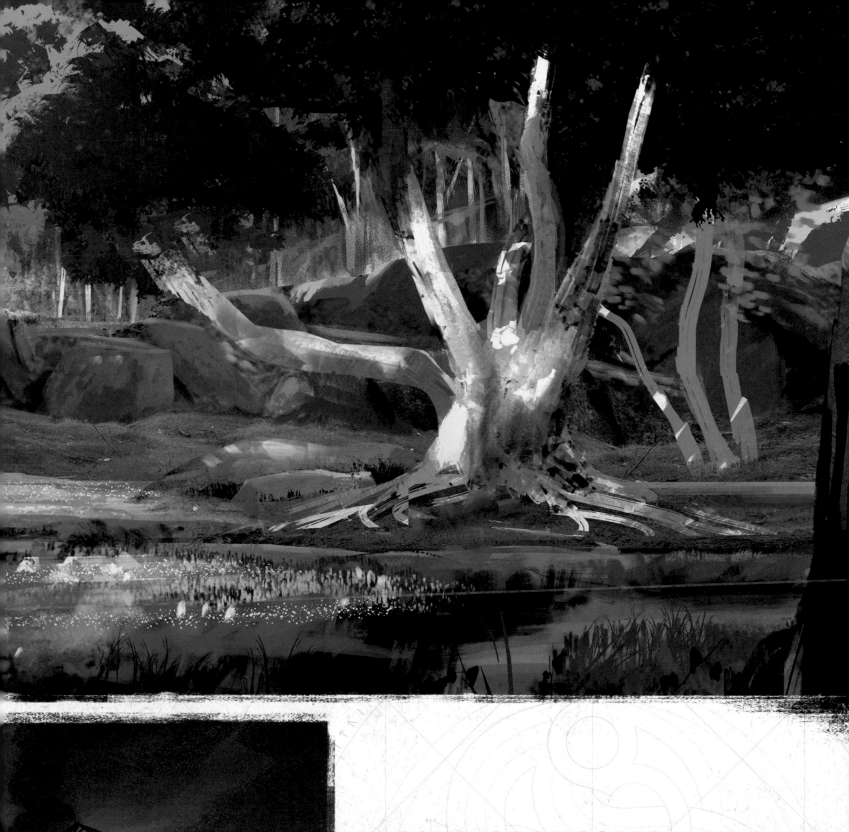

A LAND OF BUCOLIC BEAUTY AT WAR

"Wessex is a rich and vast kingdom ruled by King Aelfred, and also the last line of defense against the Vikings," says concept artist Eddie Bennun. "It's a territory where serene summer fields, mystical forests, and pretty villages and farms contrast with the cruelty of the war."

ABOVE: ART BY IGNAT KOMITOV
LEFT: ART BY PHILIP VARBANOV
CHAPTER BREAK: ART BY SABIN BOYKINOV

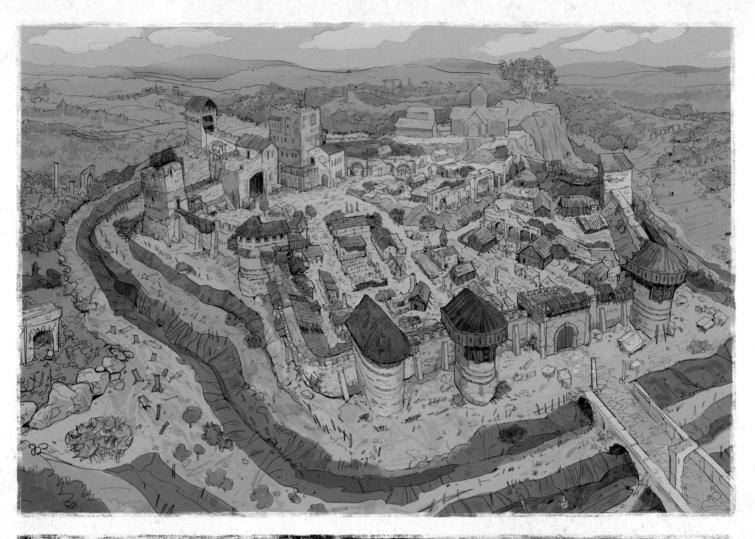

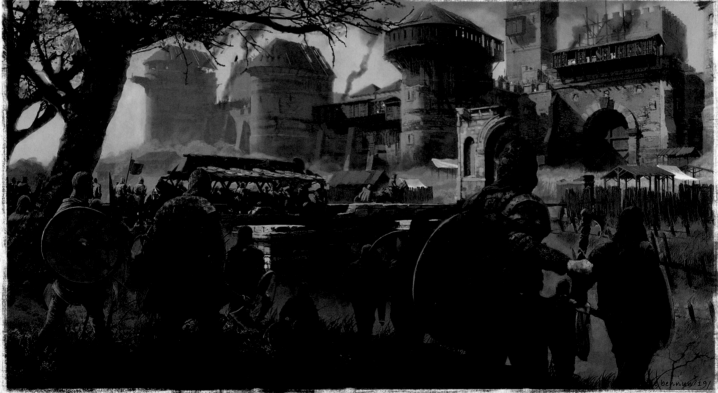

"The assaults on forts are some of the most memorable events in the game," says Bennun. "Our goal was to immerse the player in these epic battles with cinematic accuracy and realism."

TOP: ART BY SABIN BOYKINOV; BOTTOM: ART BY EDDIE BENNUN

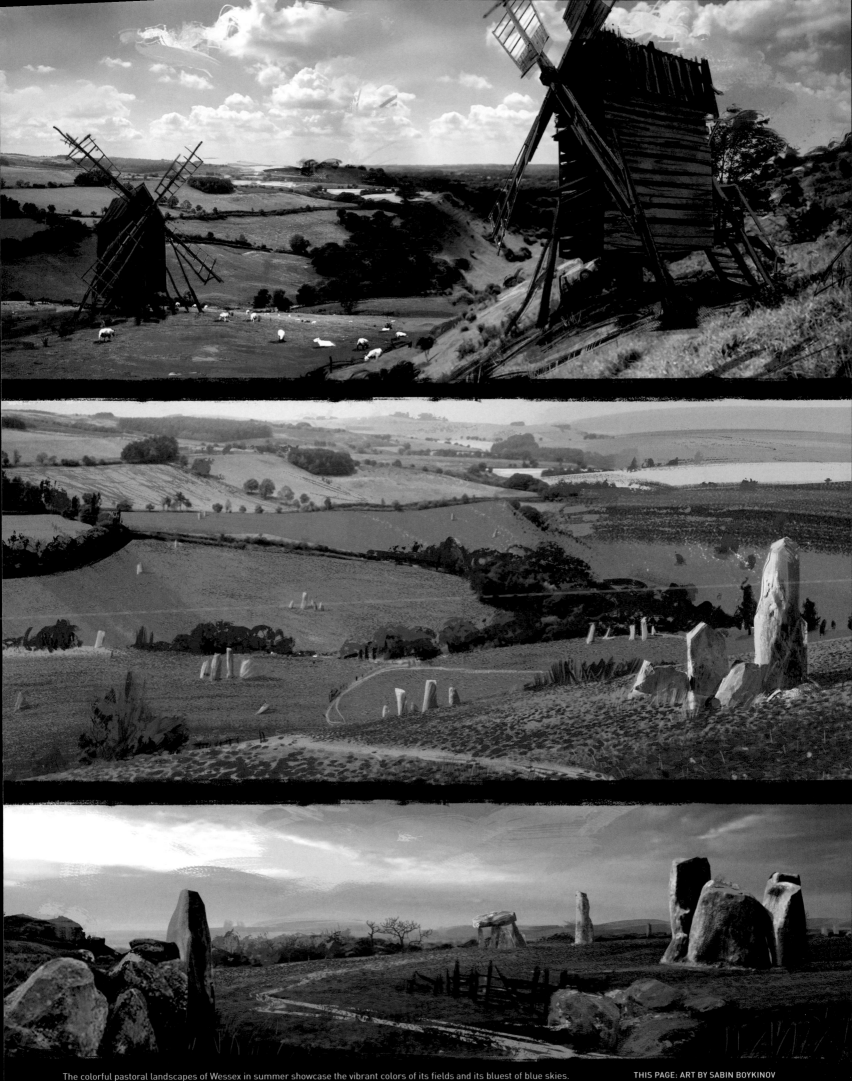

The colorful pastoral landscapes of Wessex in summer showcase the vibrant colors of its fields and its bluest of blue skies.

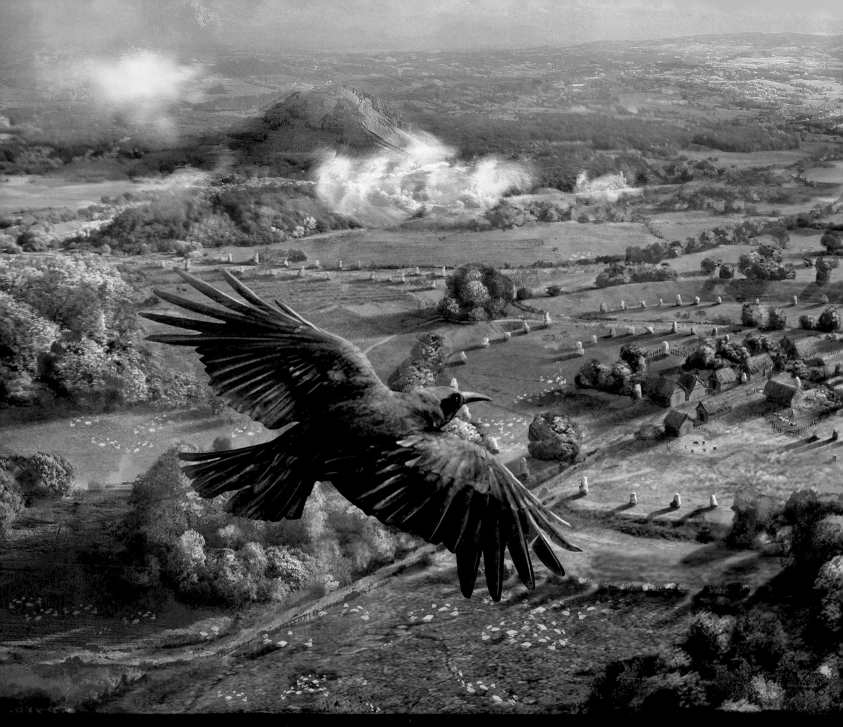

Eivor's raven, Sýnin, provides a clearer view of nearby locations and enables scouting of enemy positions. "The player can observe the beauty of *Assassin's Creed Valhalla's* universe by using the raven," says Bennun. "It was very important for the concept art to assure that the world will look consistent from both the ground and the air."

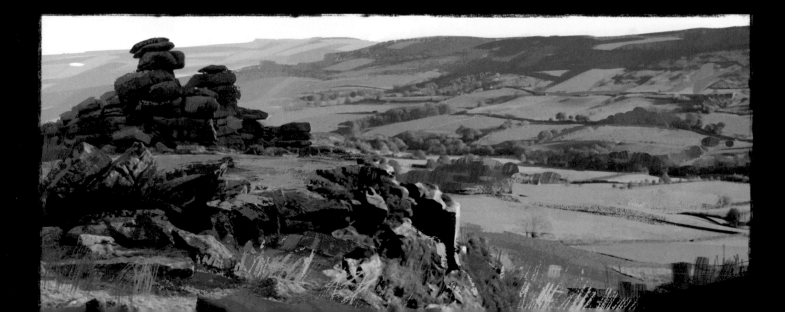

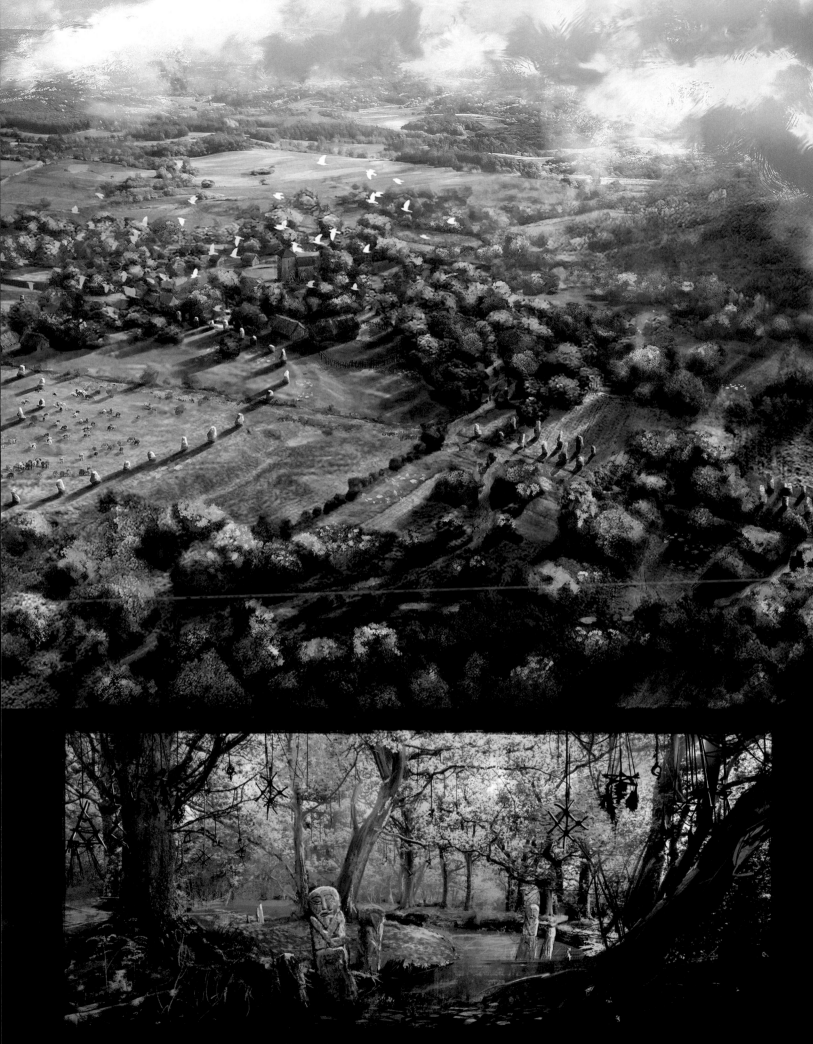

"The colorful patches of agricultural land shelter small, cozy villages, and the iconic, lonely rock formations of Dartmoor contrast with the ancient forests—all elements of the picturesque land of Wessex."—EDDIE BENNUN

TOP: ART BY DIANA KALUGINA; BOTTOM: ART BY SABIN BOYKINOV

A MIX OF CULTURES

"In addition to beautiful nature, Wessex is also home to different past and present cultures that live in a bizarre symbiosis," says Eddie Bennun. "Additionally, it hosts surprising discoveries in memorable places."

The mysterious Chichester Monastery is built on the epic ruins of an ancient Roman aqueduct. It hides secret caves and treasures under shipwrecks and in other unpredictable hidden locations . . .

THIS PAGE: ART BY IGNAT KOMITOV
RIGHT PAGE: ART BY PHILIP VARBANOV

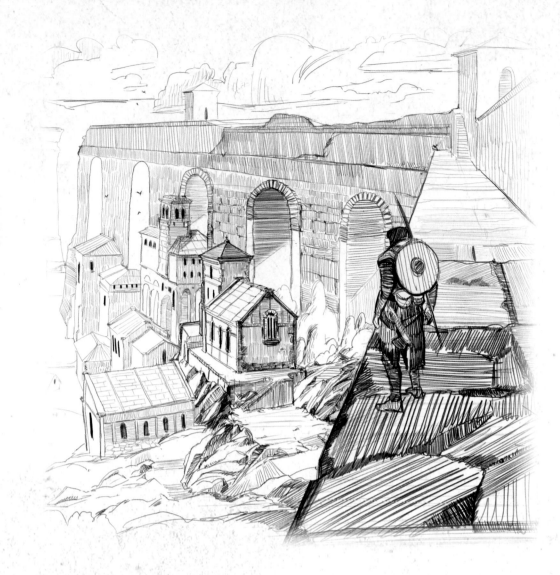

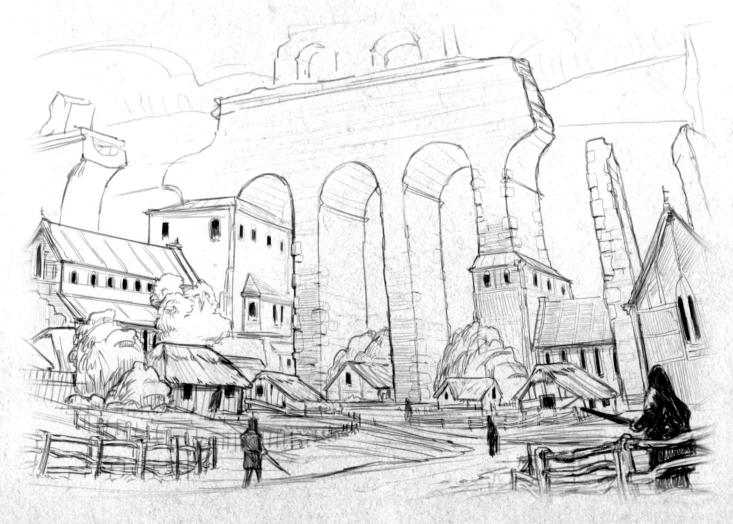

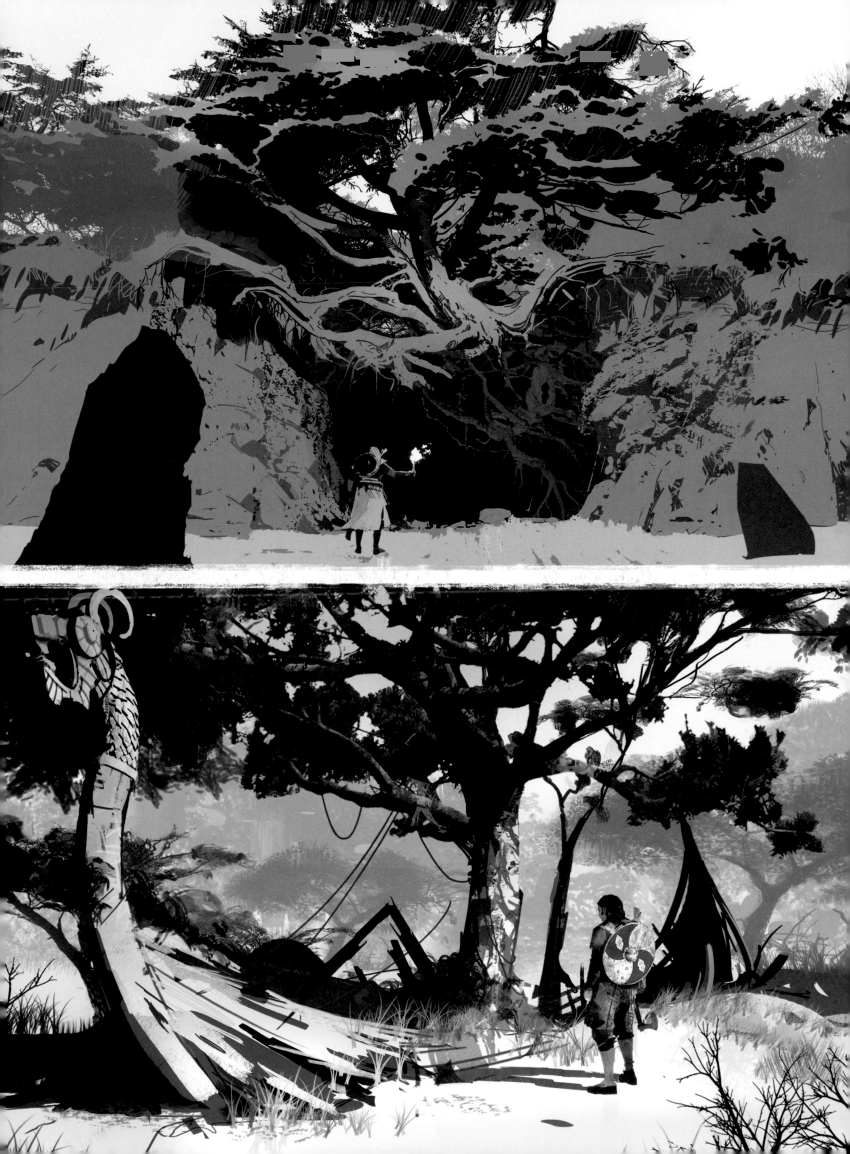

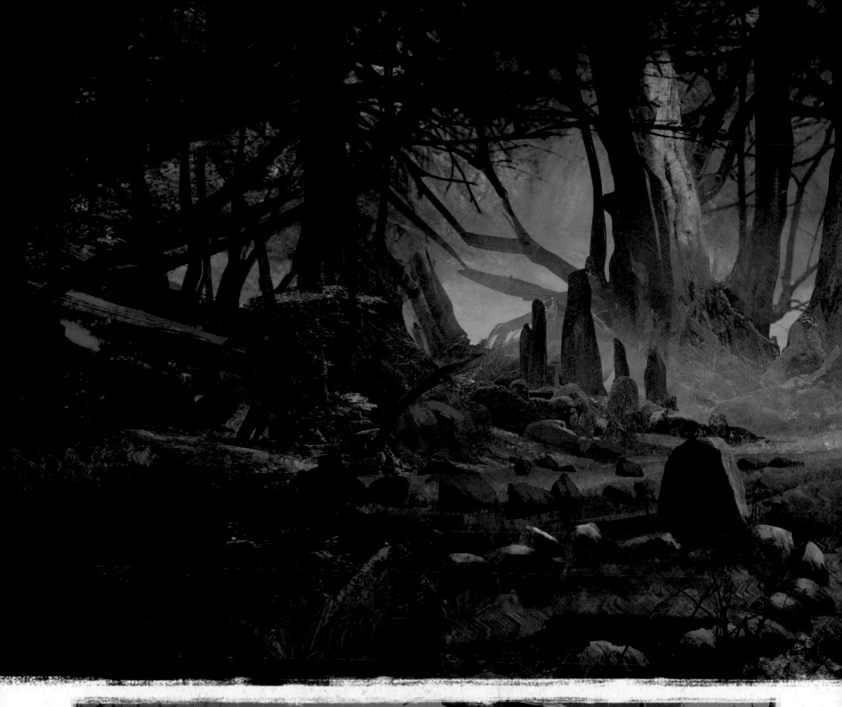

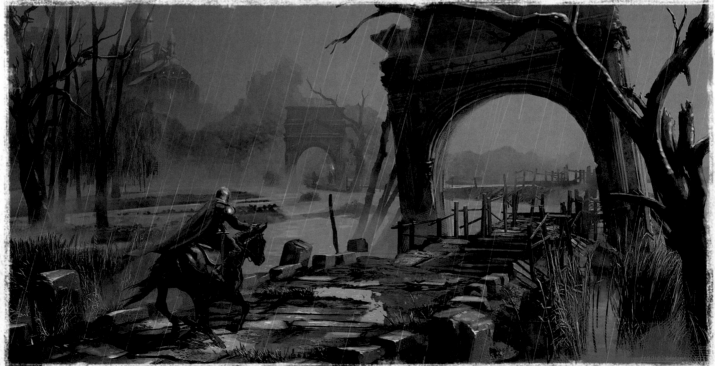

"Misty forests whisper ancient tales of haunted places. These are just a taste of what the player will find in Wessex."—EDDIE BENNUN

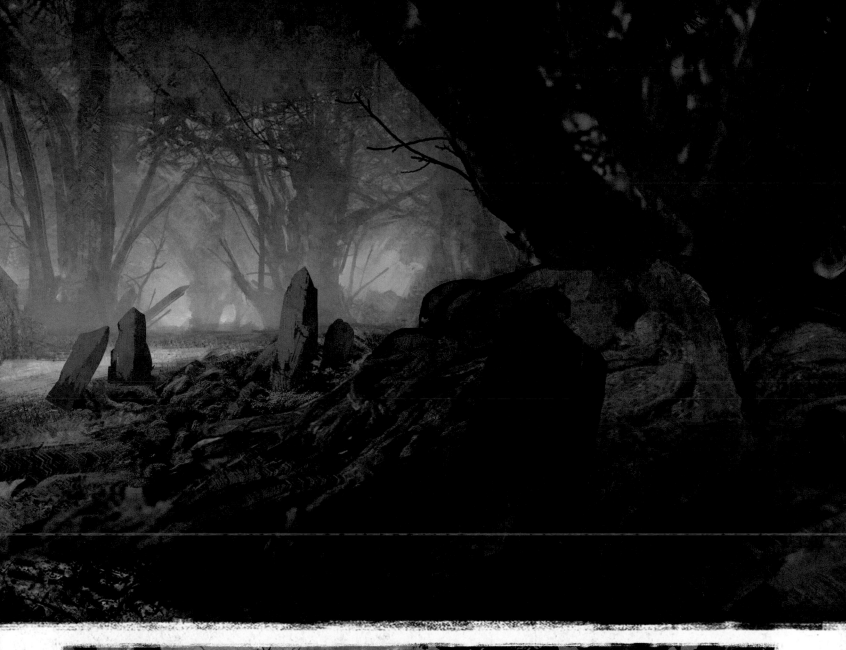

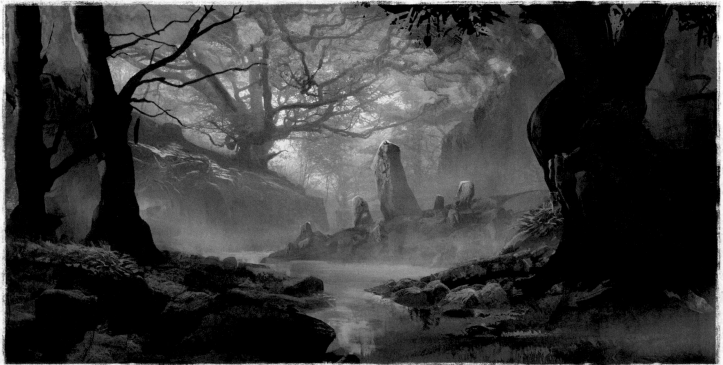

TOP AND BOTTOM RIGHT: ART BY IGNAT KOMITOV; BOTTOM LEFT: ART BY EDDIE BENNUN

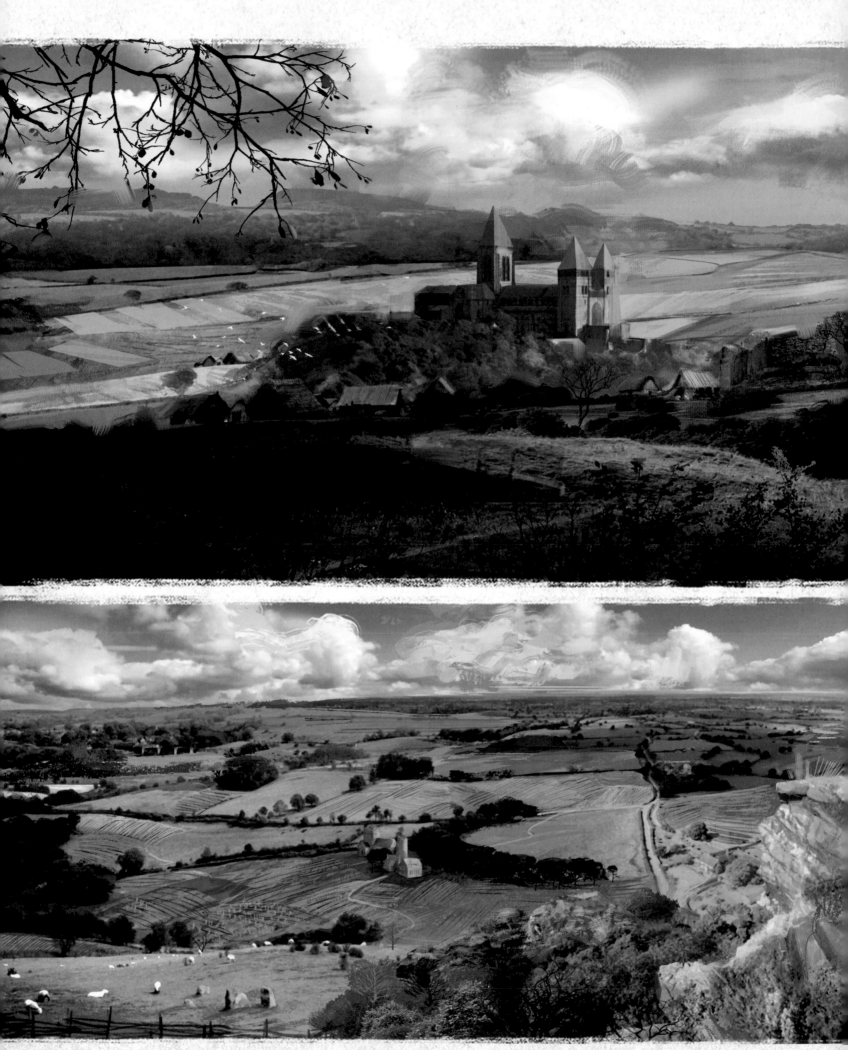

Mood and concept art for the Cent region. The artists produced various landscape explorations that show how light and weather affect the colors and atmosphere of a location.

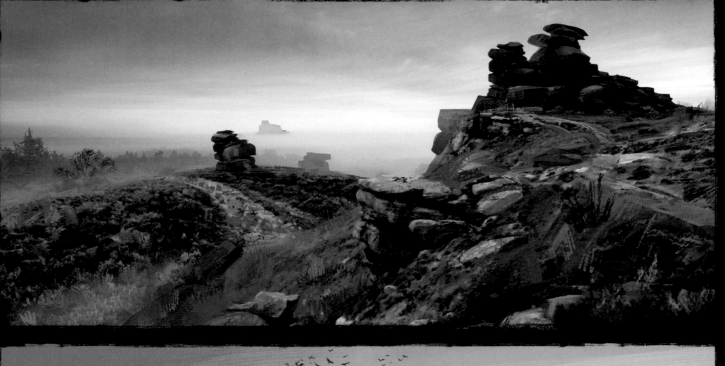

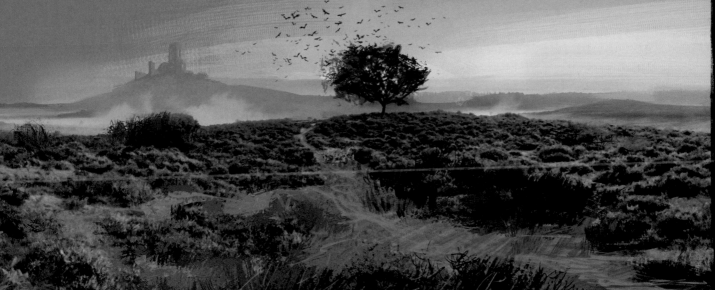

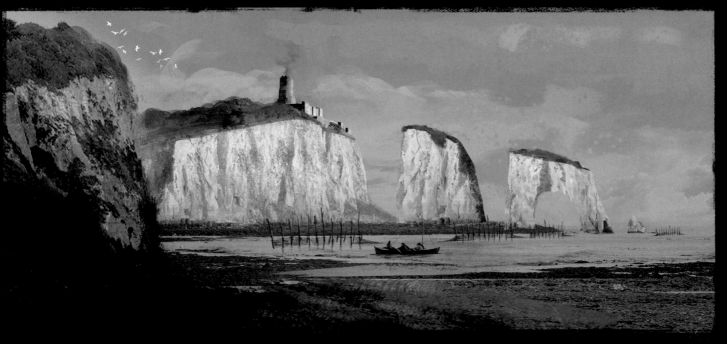

THESE PAGES: ART BY SABIN BOYKINOV

WINCESTRE

Hundreds of hours of work creating concept art and doing technical research went into the final realization of the game. "This is what it took to design the architectural crown of Wincestre— Old Minster Cathedral," says Bennun. "In the ninth century, the cathedrals were actually quite boring visually, so our goal was to make it impressive and beautiful— while still looking realistic."

THIS PAGE AND BOTTOM:
ART BY DIANA KALUGINA

RIGHT PAGE, TOP: ART BY
PHILIP VARBANOV

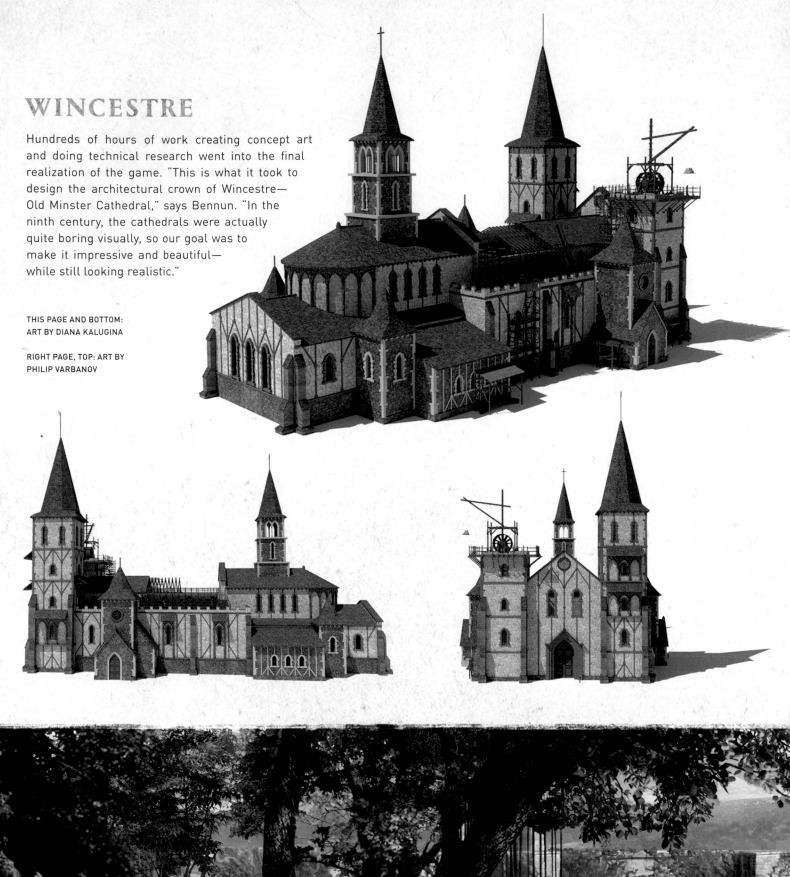

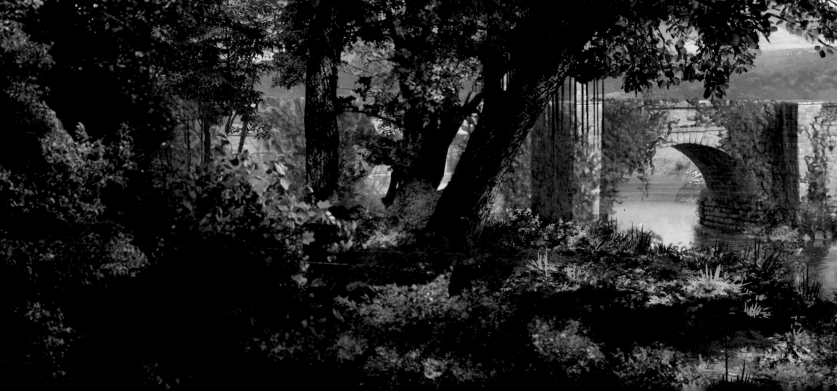

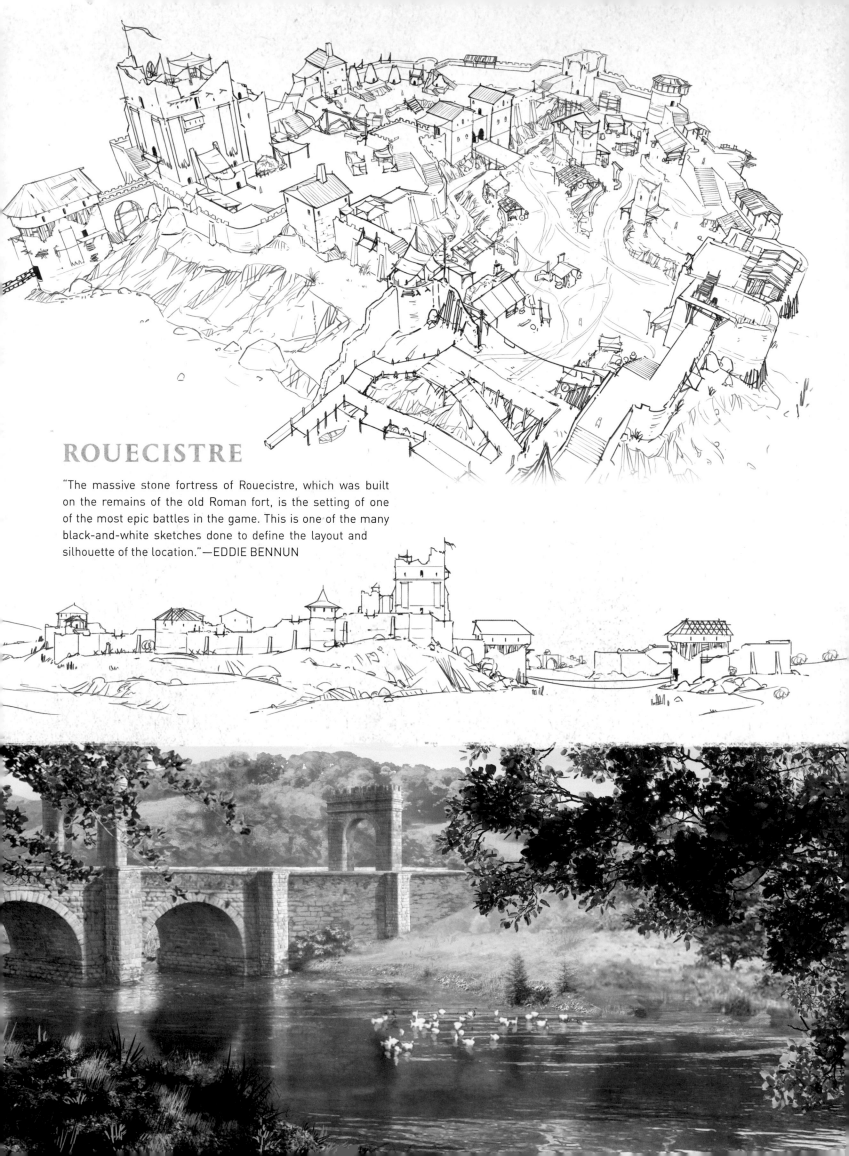

ROUECISTRE

"The massive stone fortress of Rouecistre, which was built on the remains of the old Roman fort, is the setting of one of the most epic battles in the game. This is one of the many black-and-white sketches done to define the layout and silhouette of the location." —EDDIE BENNUN

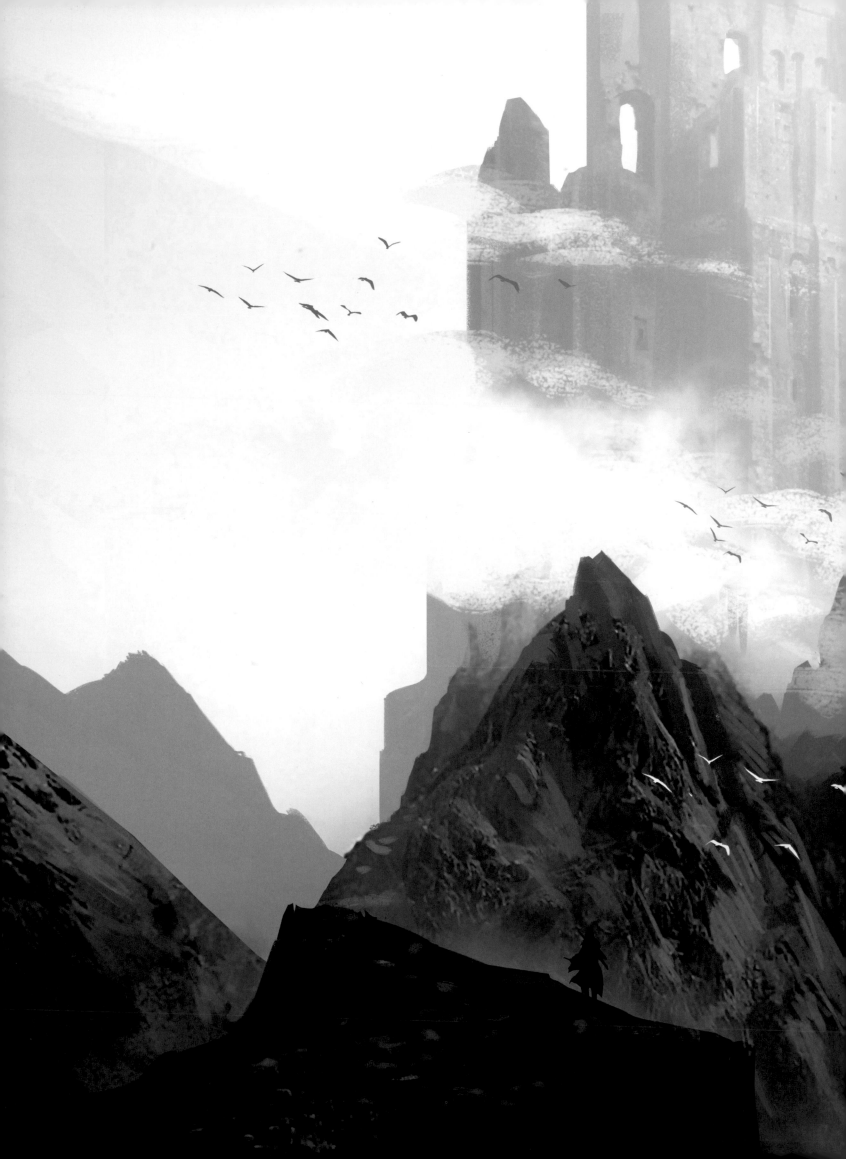

CHAPTER EIGHT

NORTHUMBRIA

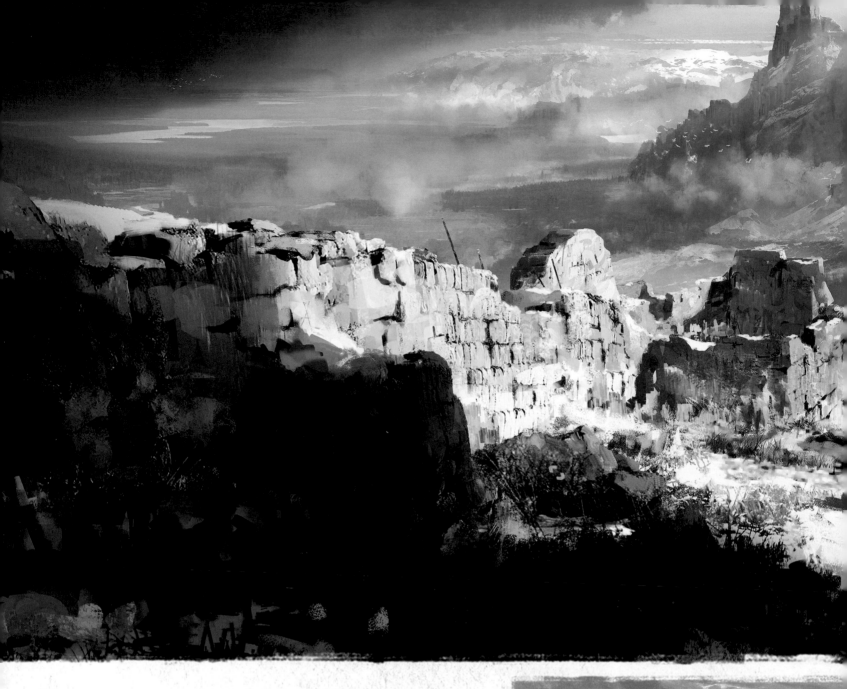

JORVIK

The capital of Northumbria, Jorvik, is ideally located at the crossing of the Ouse and Foss Rivers. With trade routes established by its Norse settlers, the city boasts traders and merchandise from all around the world.

Dann Yeau Choong Yap says of Jorvik's most iconic feature, "A mere remnant of its former glory, Hadrian's Wall continues to serve its new masters as a monumental barrier against northern invaders."

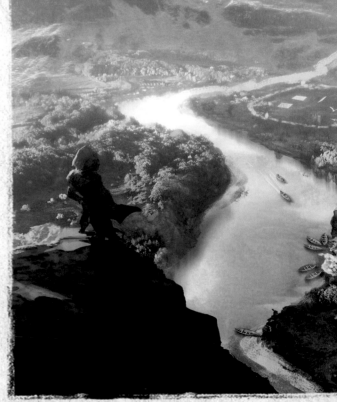

THESE PAGES: ART BY TONY ZHOU SHUO
CHAPTER BREAK: ART BY RAPHAËL LACOSTE

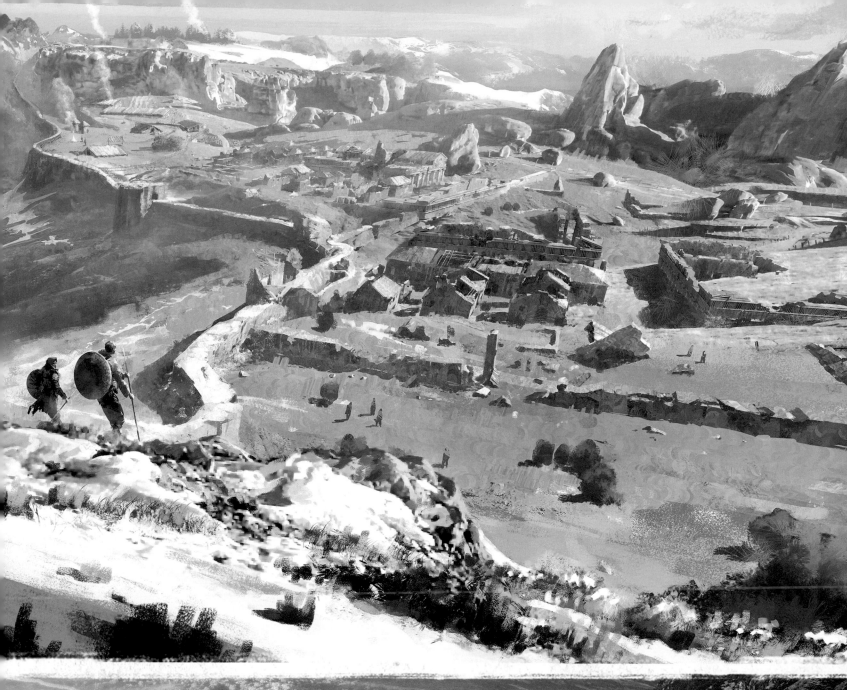

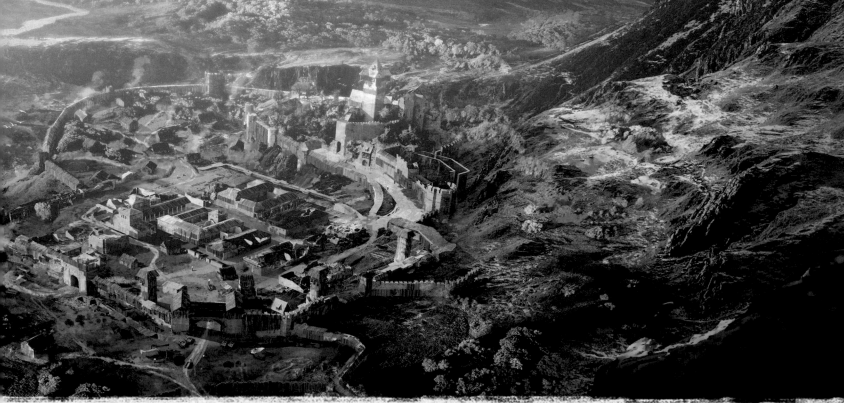

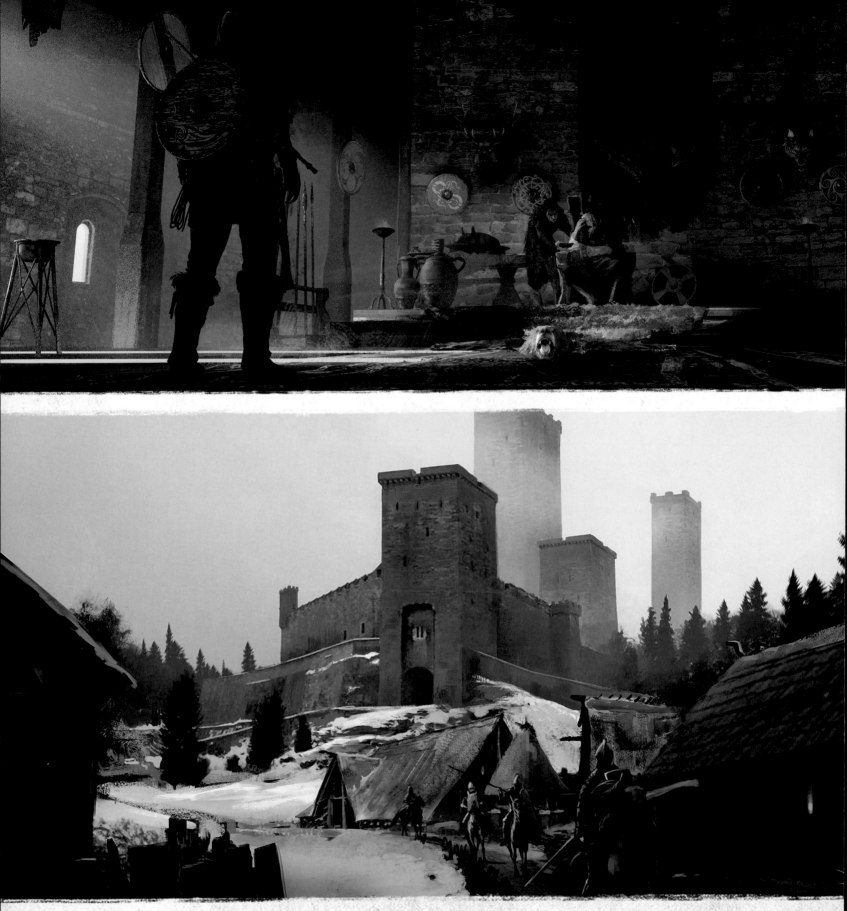

DONECAESTRE

An Anglo-Saxon burg built on the site of a Roman fort before its eventual Norse capture, Donecaestre is a strategic staging point between Northumbria and Mercia. "The stronghold serves as Halfdan's military base of operations in his fight against the invading factions. It also houses a growing Norse town within its walls," says Dann Yeau Choong Yap.

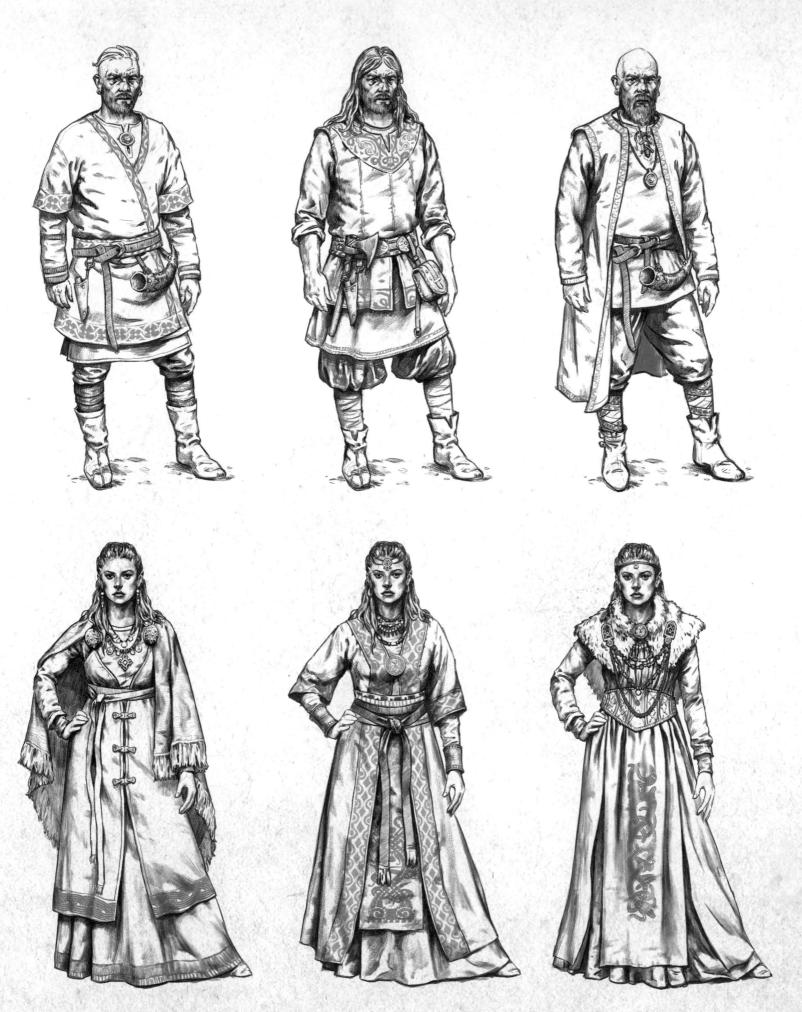

Explorations of Donecaestre civilians.

TOP LEFT: ART BY GUANG YU TAN; BOTTOM LEFT: ART BY MARTIN DESCHAMBAULT; THIS PAGE: ART BY KONSTANTIN KOSTADINOV

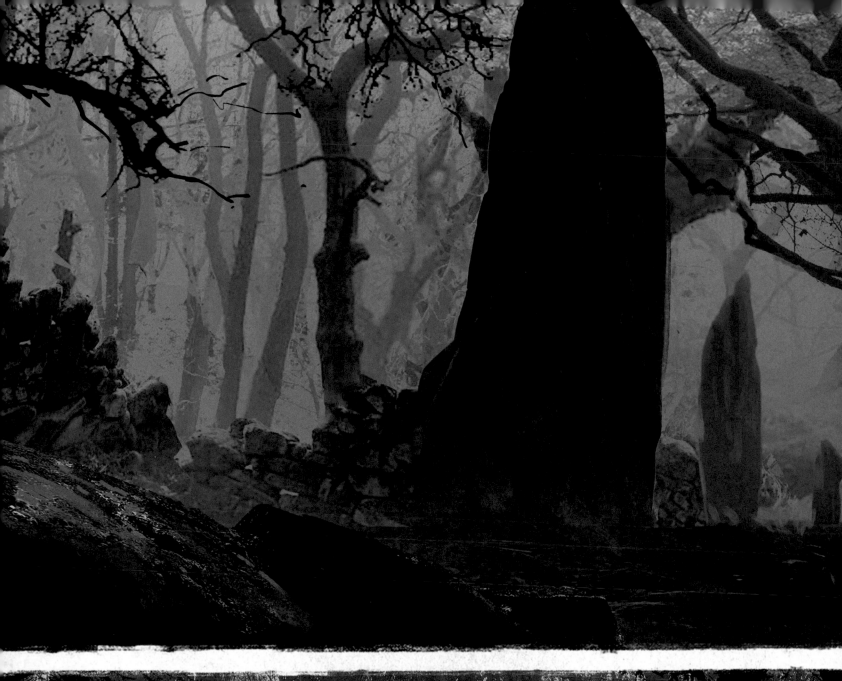

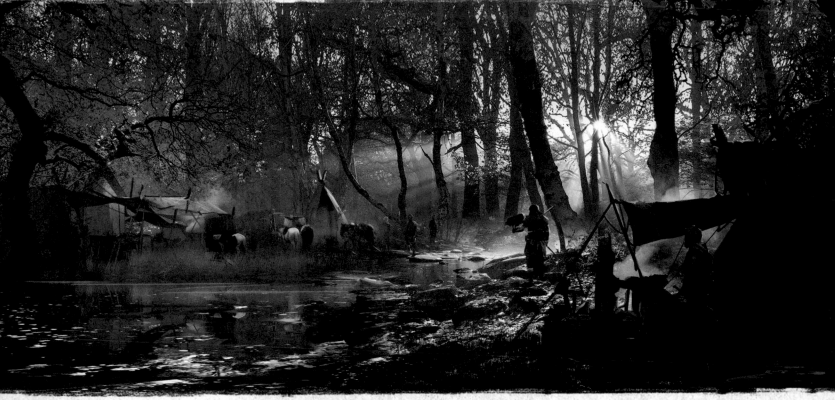

"The fall season was a highlight for the lighting team. This concept art showcases sun rays peeking through the golden fall forest." —DONGLU YU

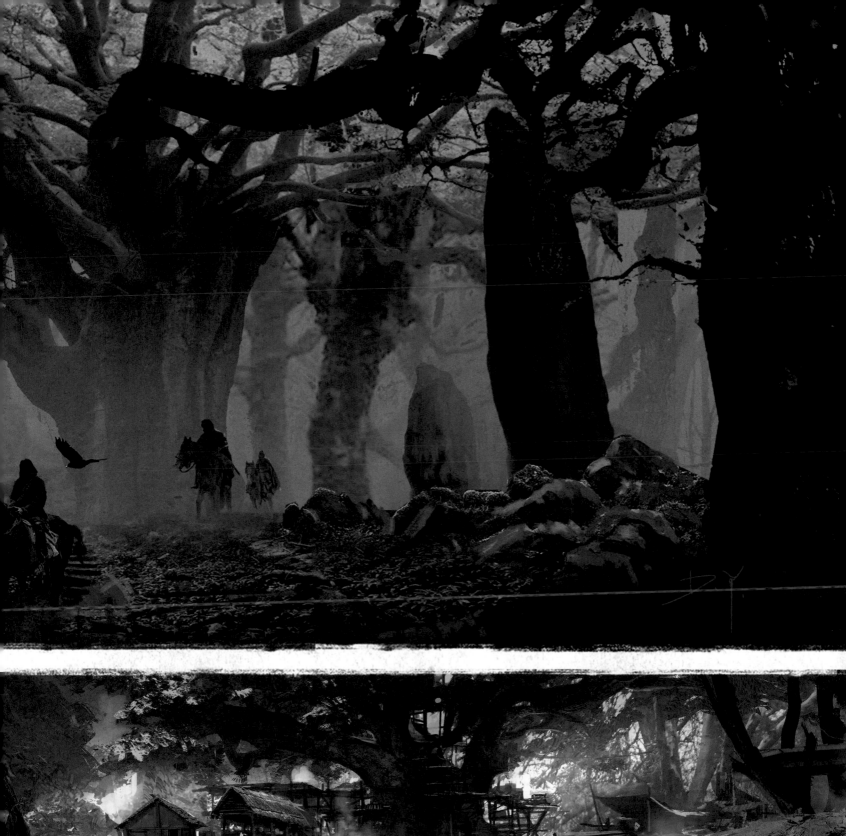

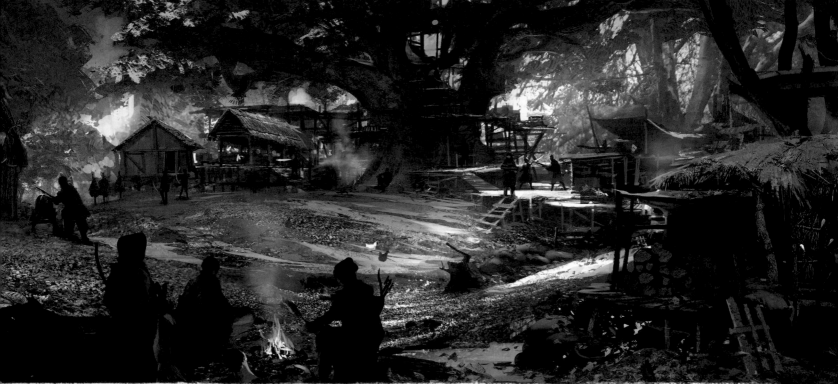

"Bandits plot their next attack in their Sherwood Forest hideout." —DANN YEAU CHOONG YAP TOP AND BOTTOM LEFT: ART BY DONGLU YU; BOTTOM RIGHT: ART BY NATASHA TAN

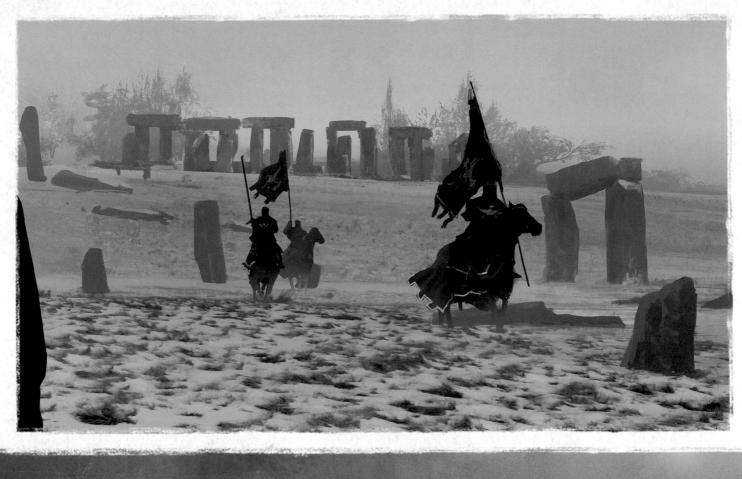

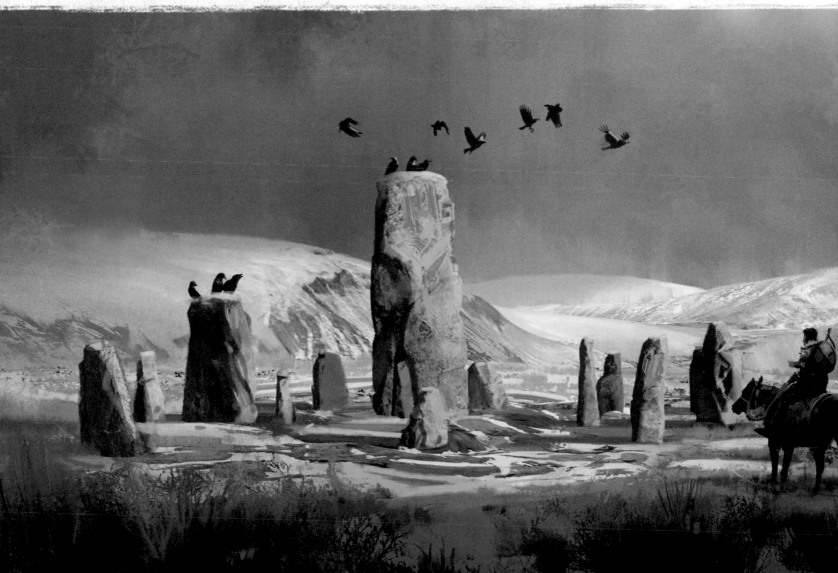

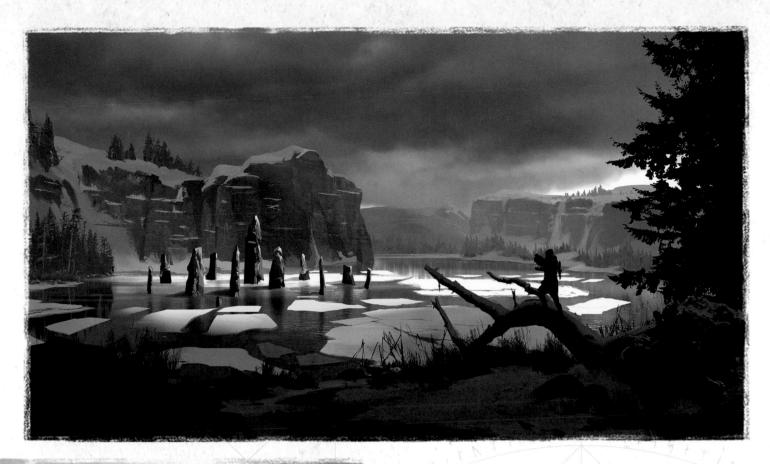

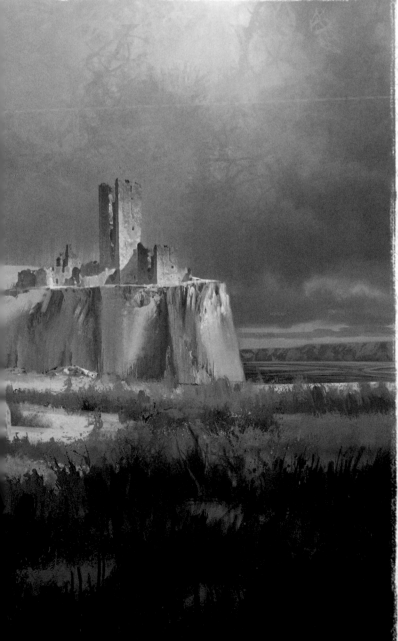

STANDING STONES

The team executed several explorations of standing stones. In the game, the player must solve puzzles involving these mysterious sites. "The challenge was to place the stones in different locations while coming up with interesting ways to identify them as puzzles by using environmental elements found in each area," says Dann Teau Choong Yap.

TOP LEFT: ART BY MARTIN DESCHAMBAULT
TOP RIGHT: ART BY WEI WEI
BOTTOM: ART BY GABRIEL TAN

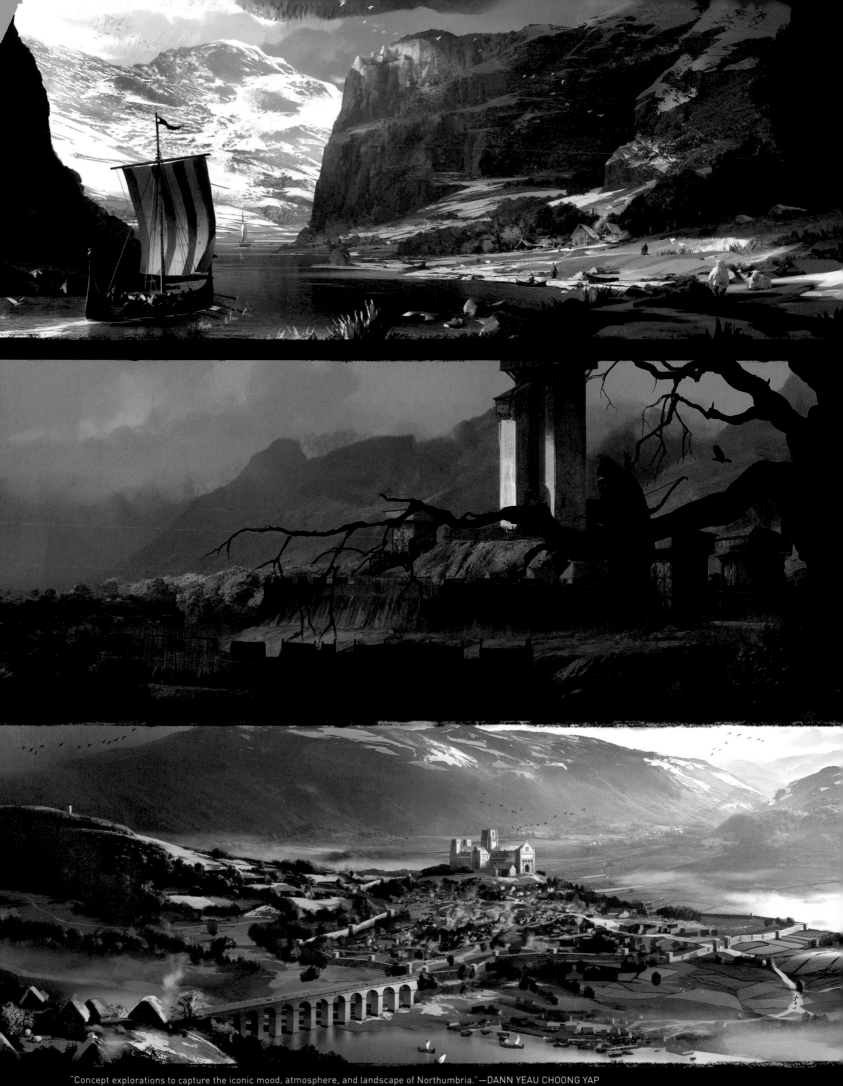

"Concept explorations to capture the iconic mood, atmosphere, and landscape of Northumbria." —DANN YEAU CHOONG YAP

THIS PAGE, TOP AND BOTTOM ART BY NATASHA TAN. MIDDLE: ART BY MARTIN DESCHAMBAULT. RIGHT PAGE, TOP AND BOTTOM: ART BY NATASHA TAN. RIGHT PAGE, MIDDLE: ART BY RAPHAËL LACOSTE.

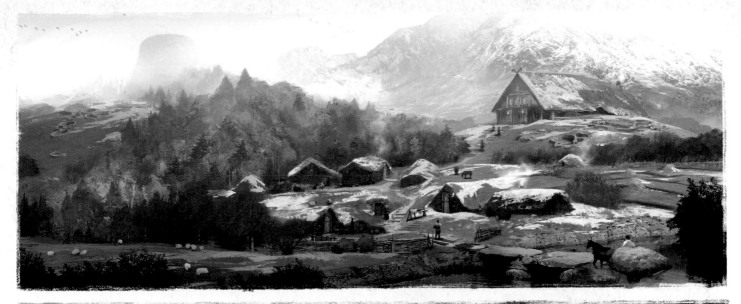

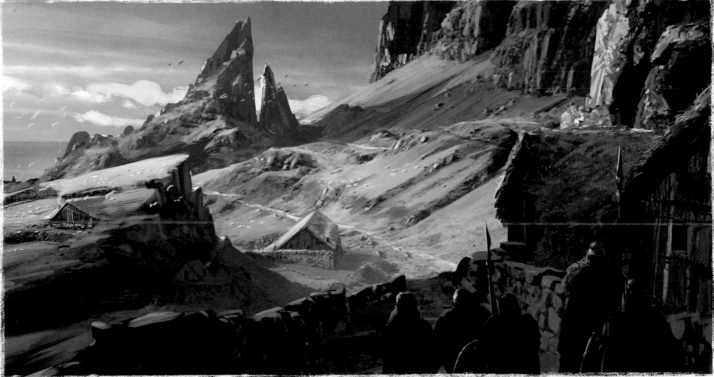

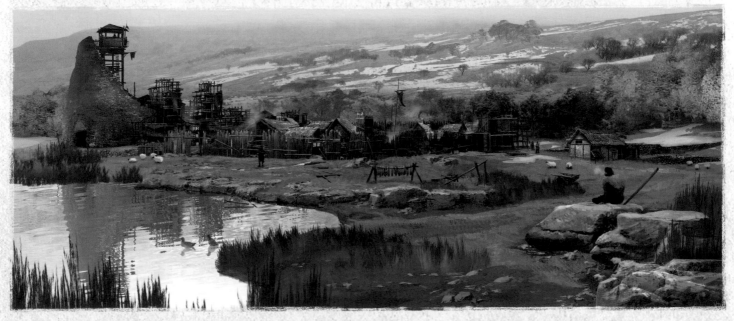

"These explorations of settlements in harsh environments capture the natural beauty of Northumbria."—DANN YEAU CHOONG YAP

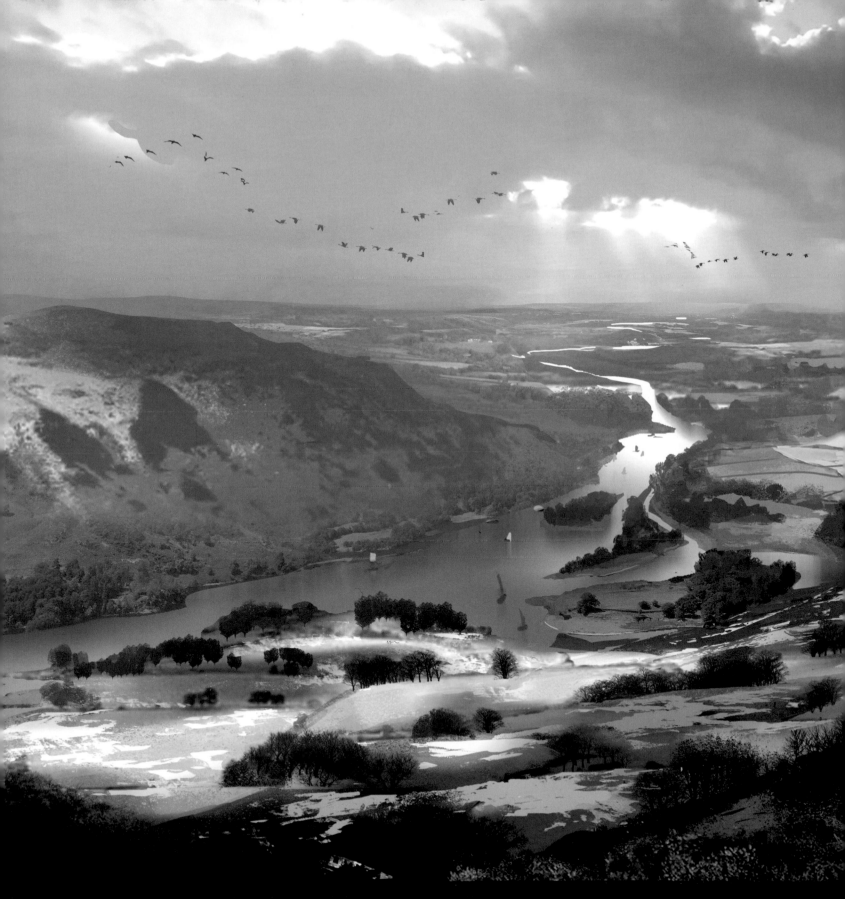

"This concept defines the overall ambiance of the Northumbria region: the open landscape, the mountain ridge, and the onset of the winter season." — RAPHAËL LACOSTE

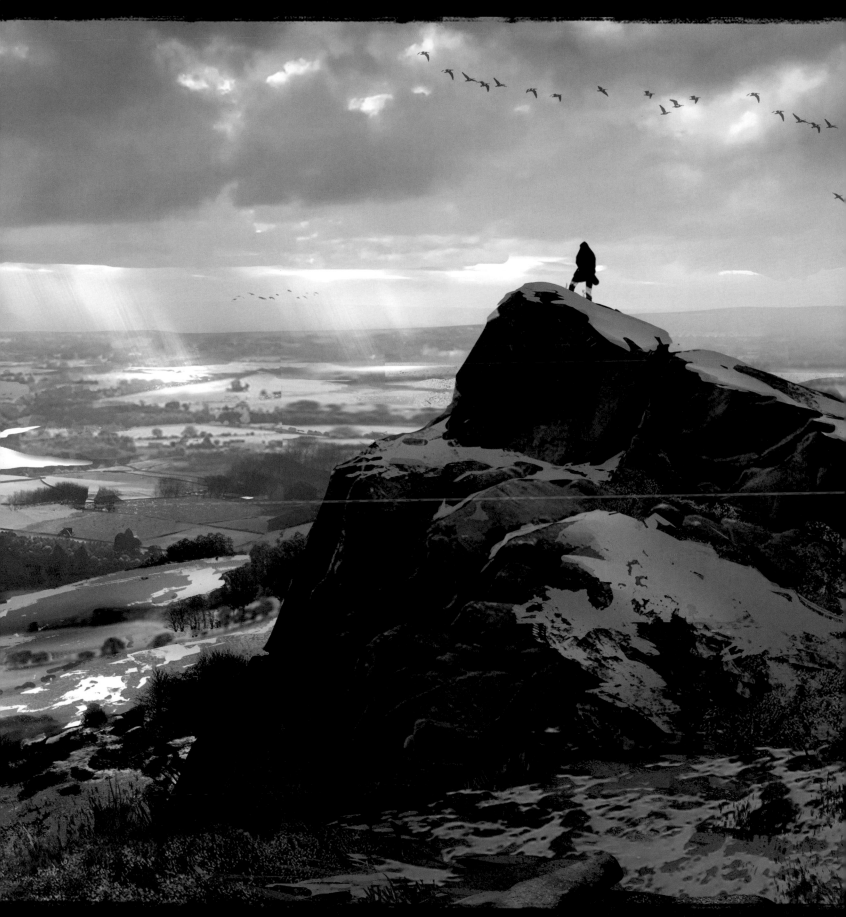

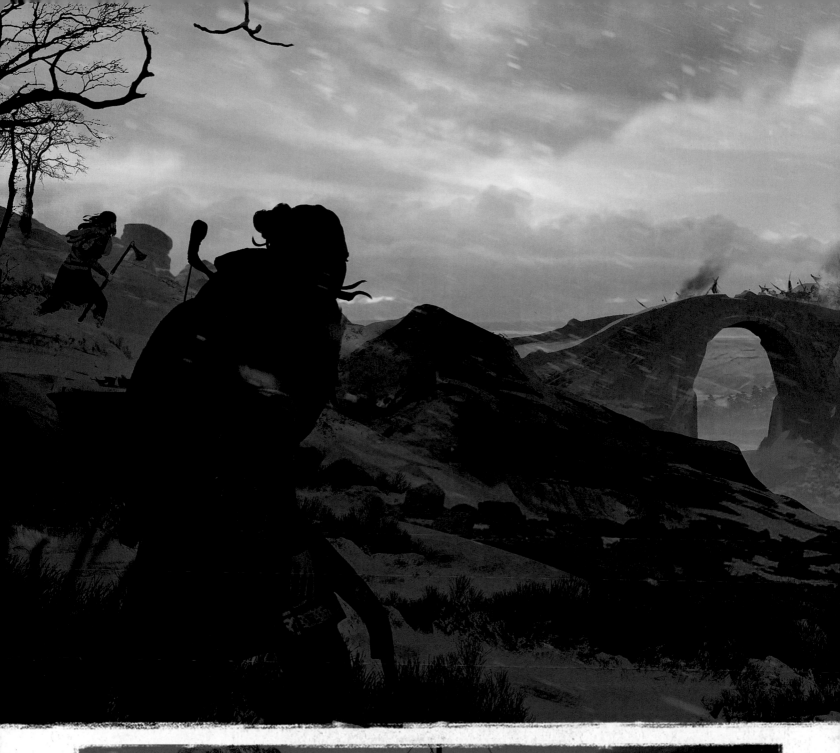

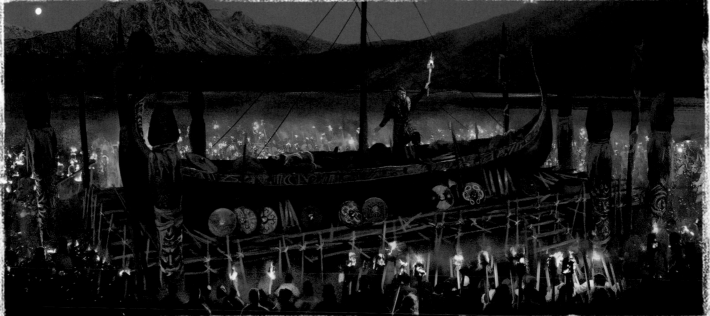

"An honorable Viking funeral that takes place during one of the quests. The deceased is placed in a boat, set on fire, and pushed off into the river."—DANN YEAU CHOONG YAP

TOP: ART BY TEY BARTOLOME; BOTTOM: ART BY GUANG YU TAN

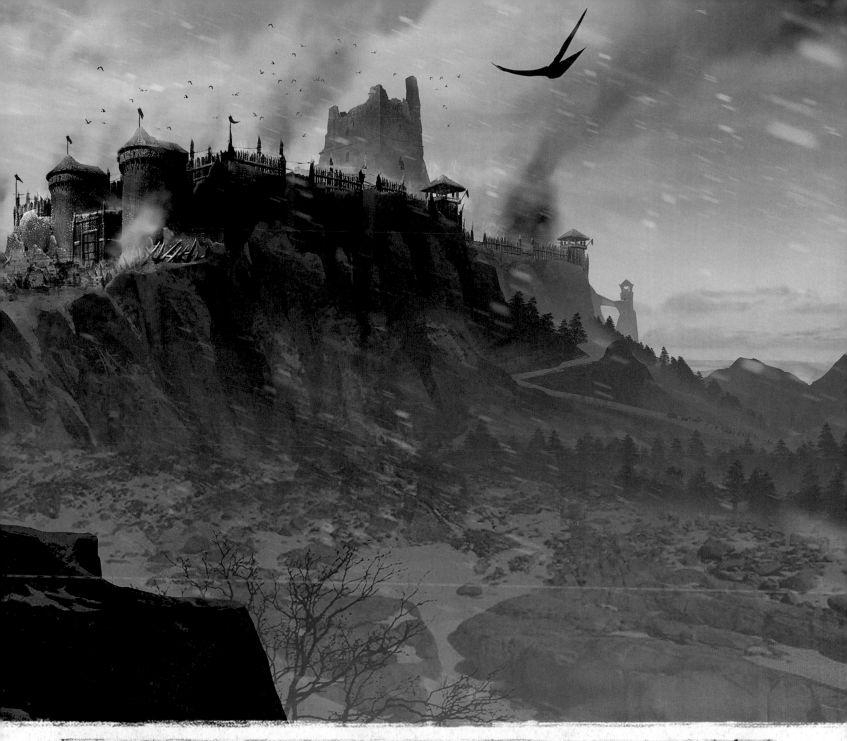

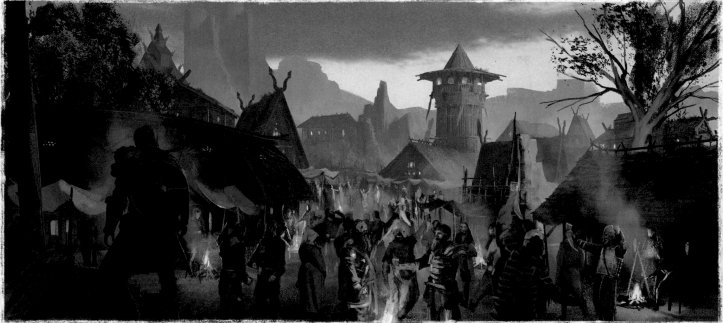

"The Vikings hold a celebration while Eivor must track a target in the throng of revelers."—DANN YEAU CHOONG YAP

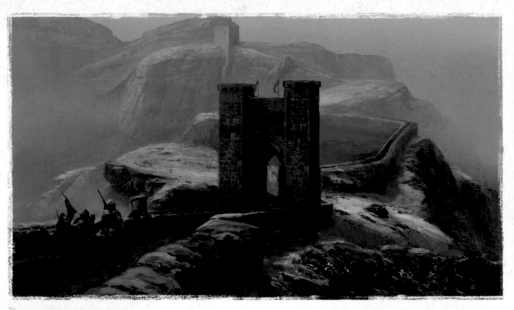

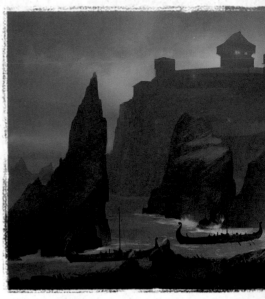

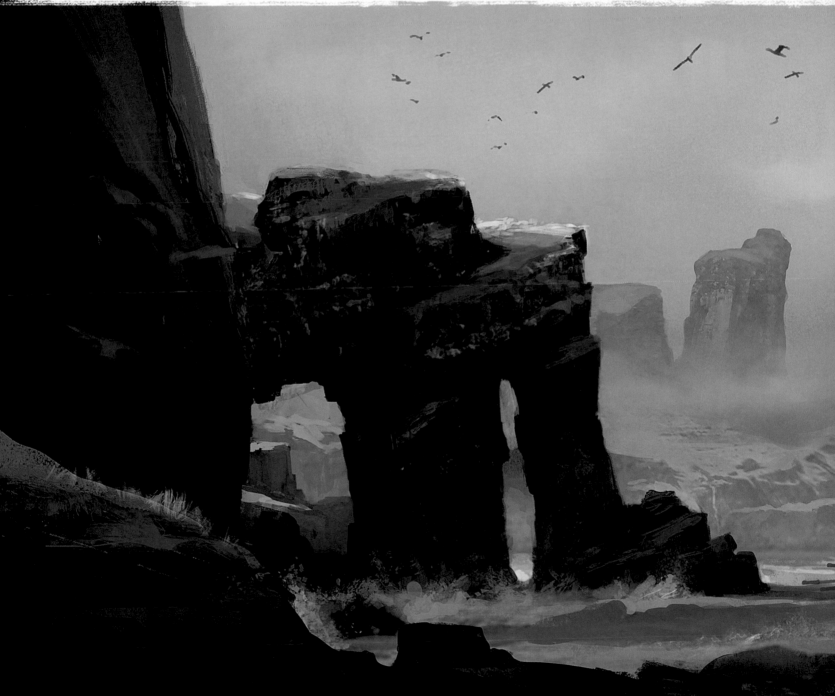

"The eastern coast of England offers a great variety of shorelines—from cliffs to coves, beaches, marshlands, and swamps. Navigating with a drakkar is always

THESE PAGES: ART BY MARTIN DESCHAMBAULT

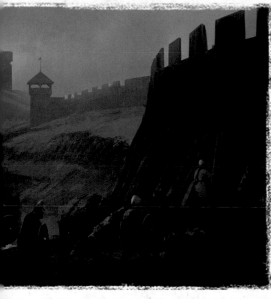

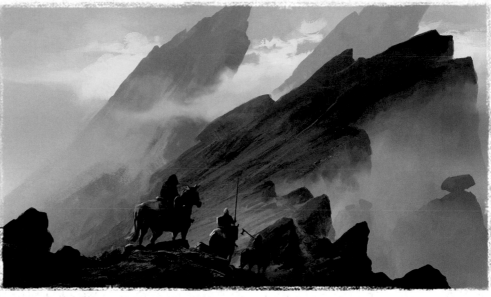

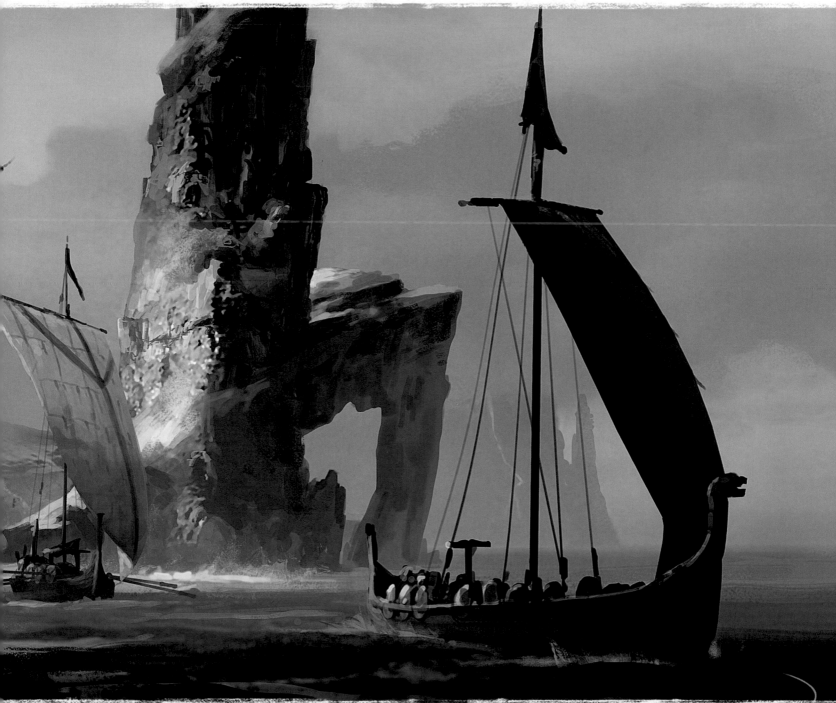

challenging and rewarding."—RAPHAËL LACOSTE

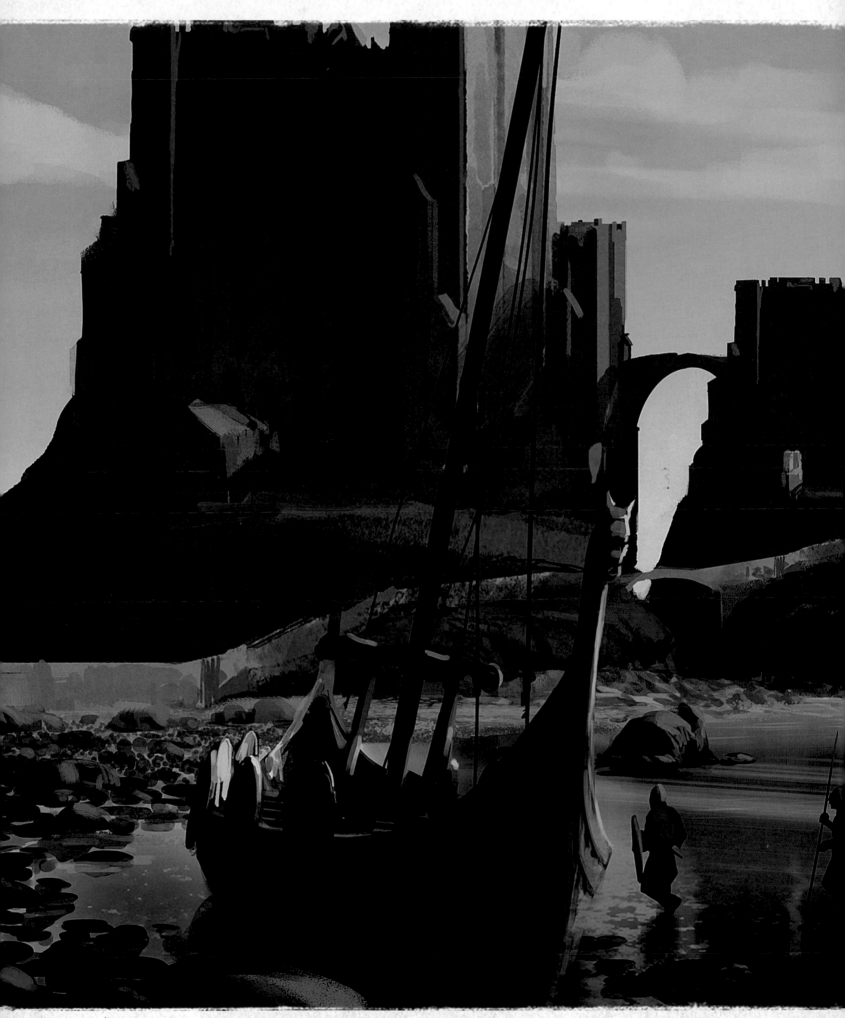

"Lots of locations can be raided in the game and are accessible by boat from rivers and shores. Our world offers plenty of opportunities to plunder like a

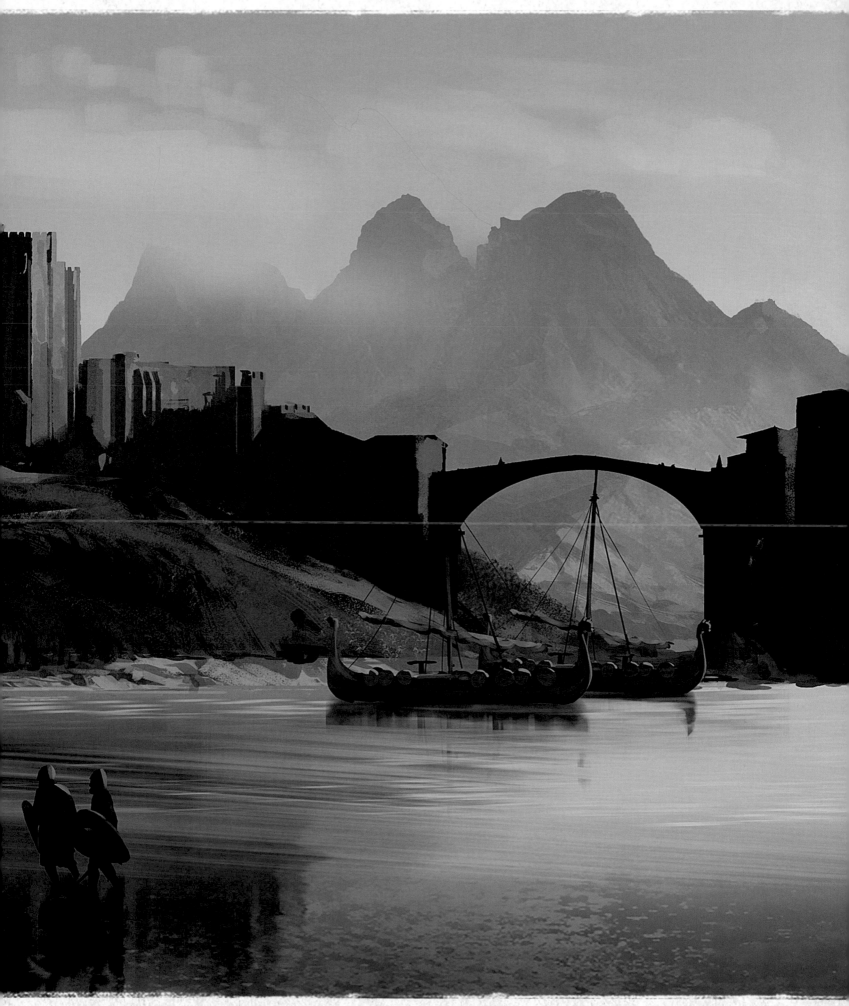

"Viking!"—RAPHAËL LACOSTE

ART BY MARTIN DESCHAMBAULT

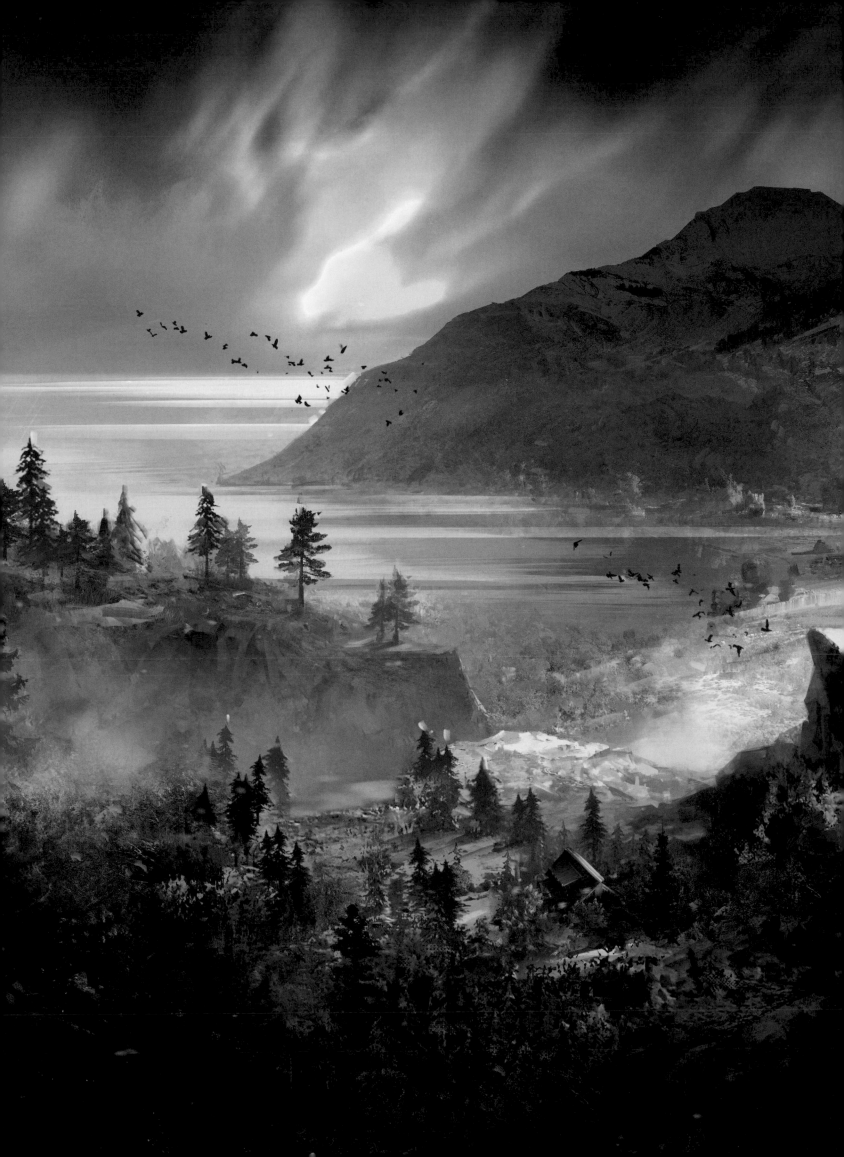

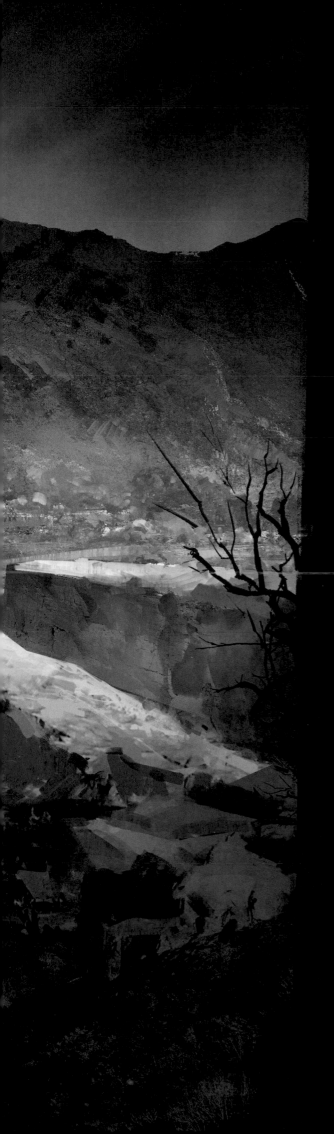

CHAPTER NINE

AMERICA AND PRESENT DAY

THE DISCOVERY OF VINLAND, AMERICA

After a long sea voyage, Eivor arrives in Vinland—to the Vikings, an unknown and untamed land. There, Eivor must track Gorm, Kjotve's son, who has taken his father's place in the order.

"These concepts highlight the wilderness and the mountainous qualities of the land," says Dann Yeau Choong Yap.

ART BY GUANG YU TAN
CHAPTER BREAK: ART BY DONGLU YU

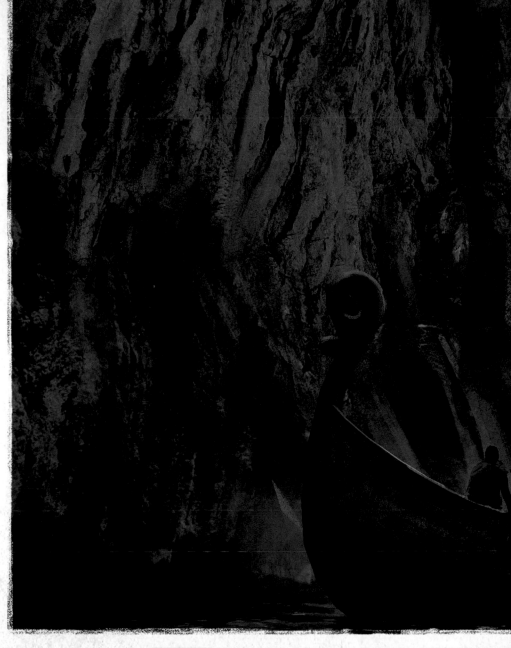

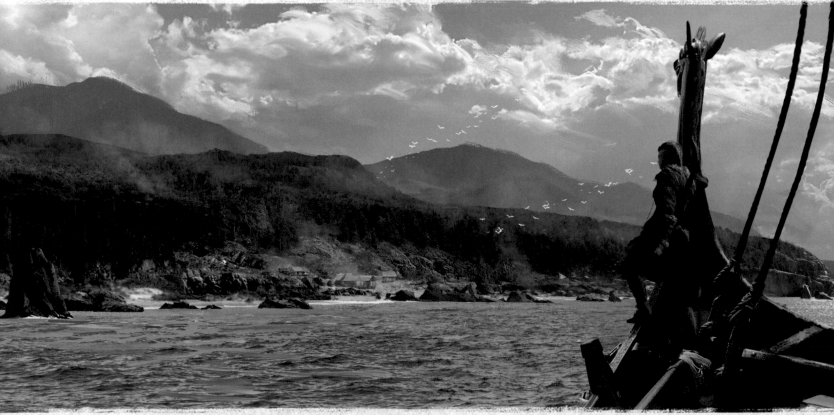

"Eivor's first sighting of land after a long journey at sea."—DANN YEAU CHOONG YAP

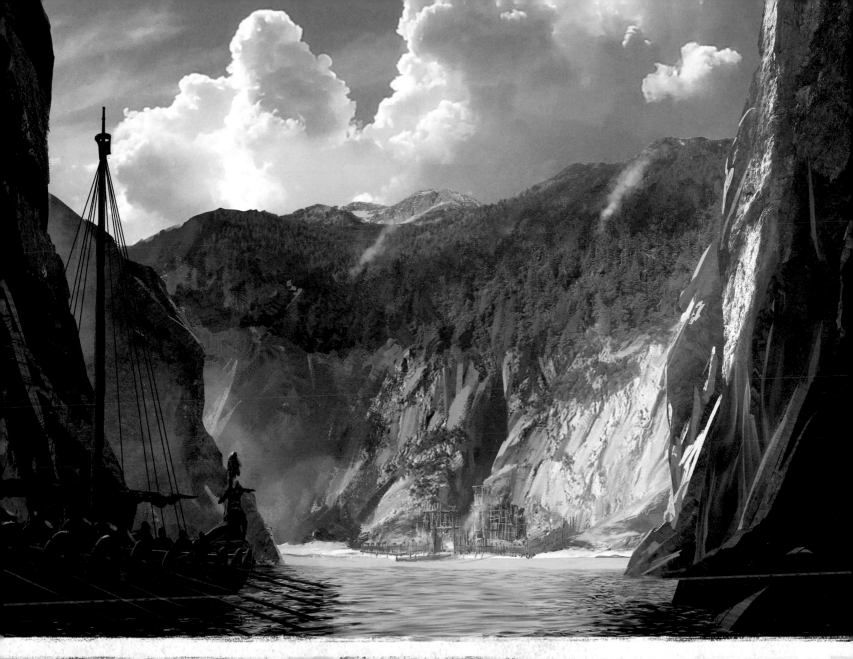

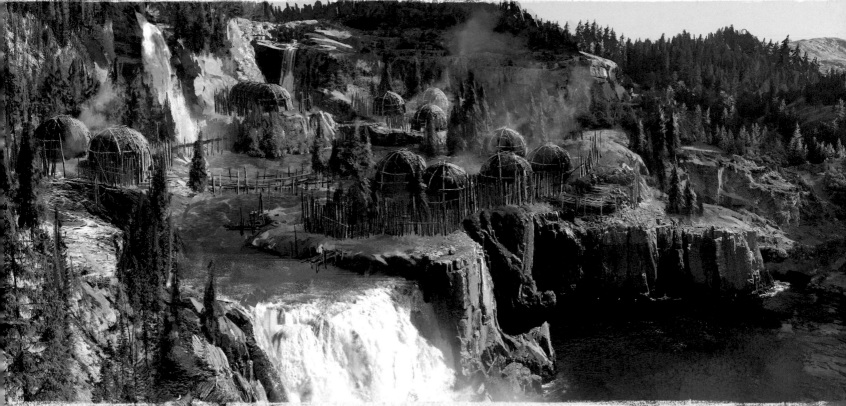

"As the Vikings explore the land of America, they find settlements like this one, which belongs to the native Iroquois people." —DANN YEAU CHOONG YAP

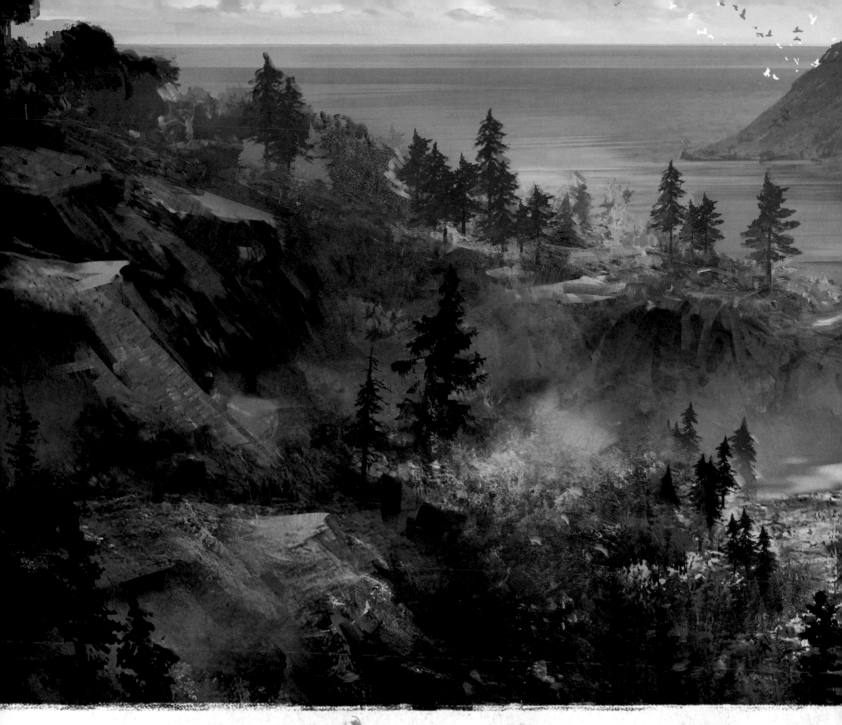

NATIVE AMERICANS

The artists worked with historians to ensure that the indigenous people's garments were represented authentically and accurately.

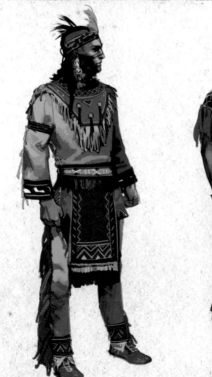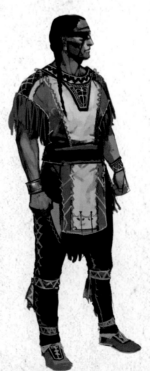

TOP: ART BY DONGLU YU
BOTTOM: ART BY YELIM KIM

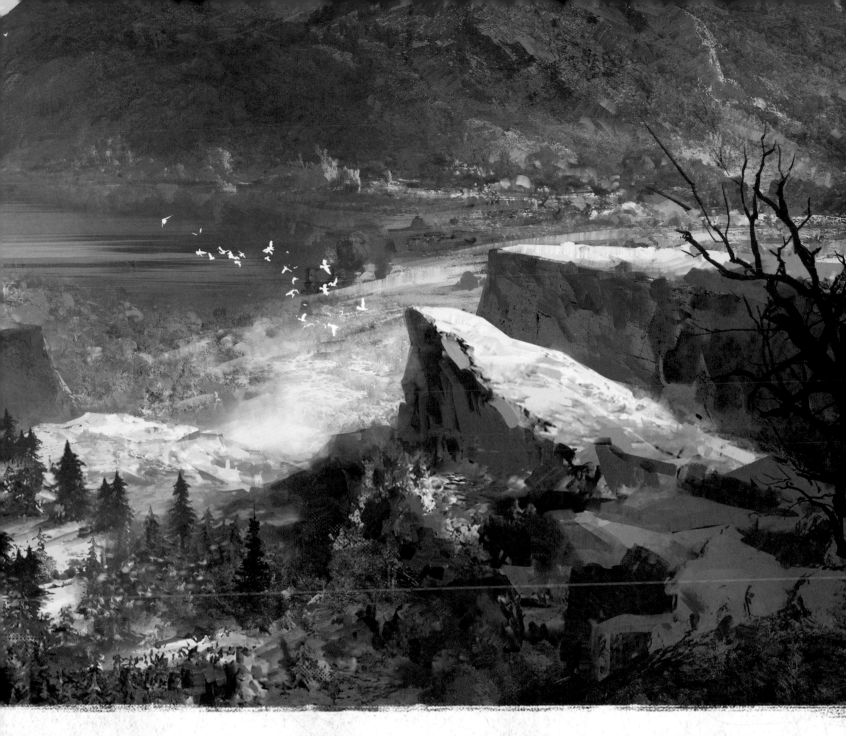

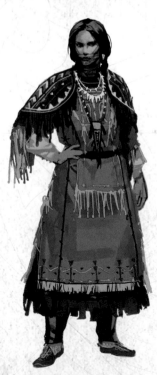

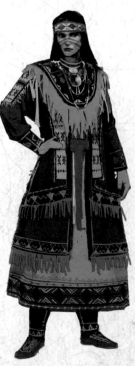

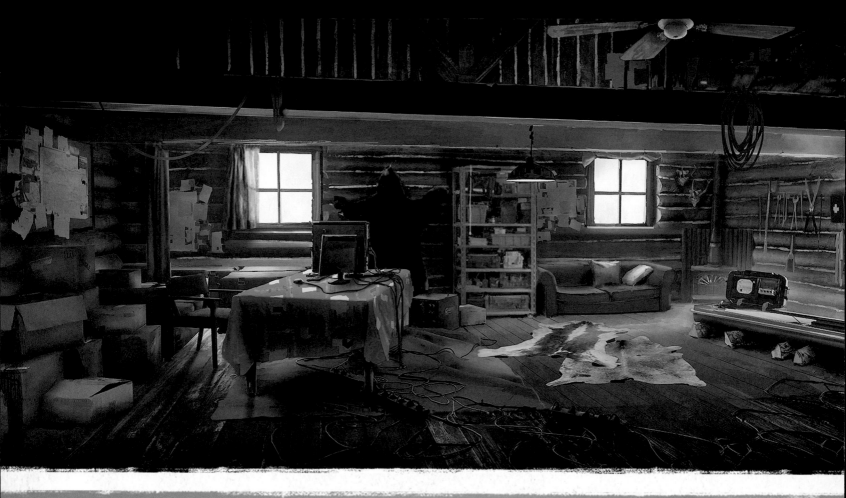

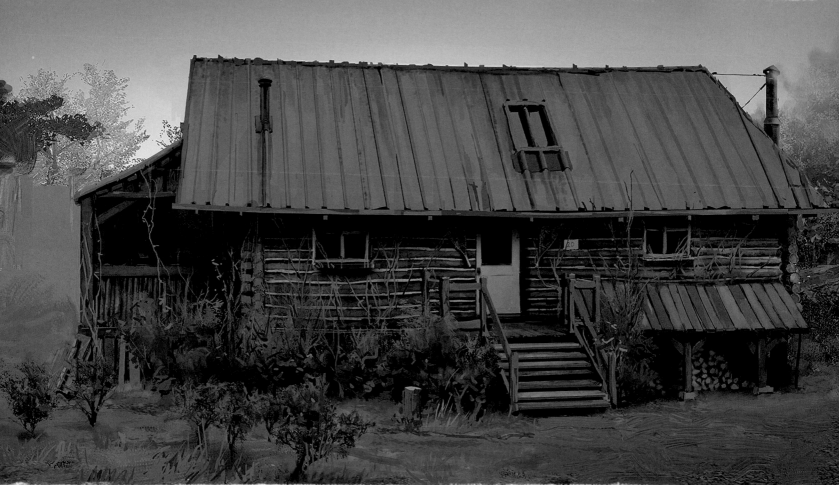

ASSASSINS HIDEOUT

The story in the present day begins with Assassins Shaun Hastings, Rebecca Crane, and Layla Hassan working together in a cabin in New England. "The log cabin is modest, decorated with only the bare minimum of furniture," says Gilles Beloeil. "This was far from straightforward to design, as we needed to make sure it stayed visually interesting, but it was a good challenge—especially

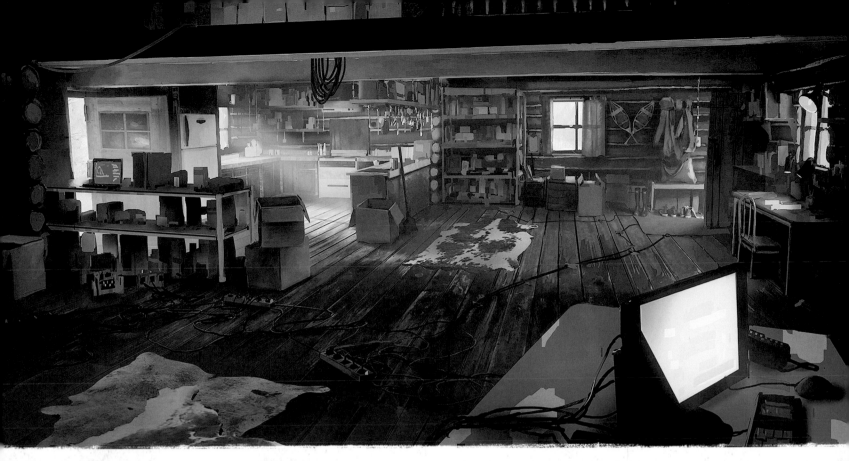

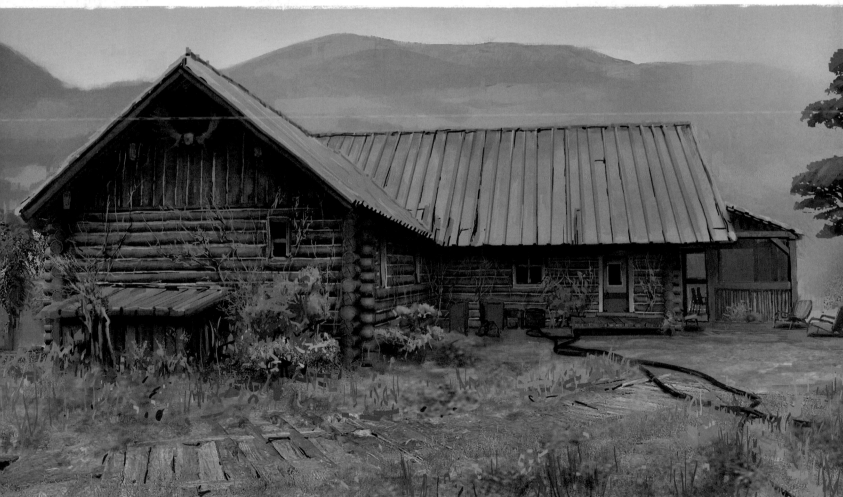

THESE PAGES: ART BY GILLES BELOEIL

when it came to choosing the correct color for the tablecloth!"

The cabin serves as home base to Shaun, Rebecca, and Layla as they investigate strange phenomena—including rapid fluctuations in the Earth's magnetic field and the remains of a ninth-century Viking recently uncovered in North America.

REBECCA CRANE AND SHAUN HASTINGS

The pair of Assassins have been working together for several years and are now a couple. They assist Layla while she experiences the simulations of Eivor's memories and help to operate the Animus. "For Rebecca, we wanted to preserve her previous aesthetic," says Kim. "A funny anecdote: her beanie is the same color as the one from Ubisoft Montréal's 2019 Christmas party!"

Kim says, regarding Shaun's revised design, "A few years have passed, so we gave Shaun a bit of gray hair, but he has not lost his confidence."

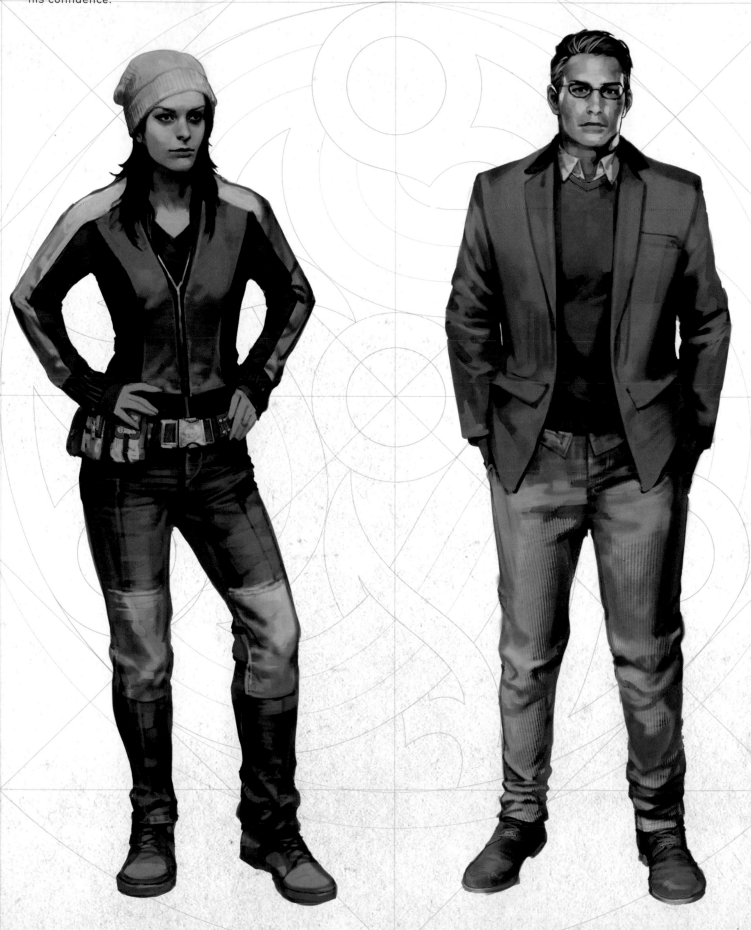

LAYLA HASSAN

The brilliant engineer Assassin looks different from the previous games. Her face is weathered after extended use of the Animus—the complex machine that enables her to read and project her genetic memory. "We made her look tired by giving her dark circles under her eyes and a worn-out jacket," says Yelim Kim.

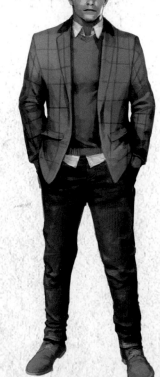

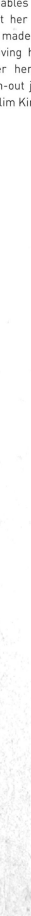

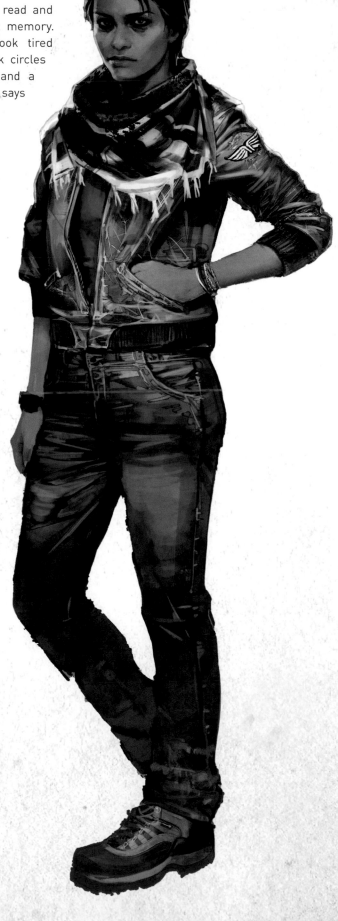

THESE PAGES:
ART BY YELIM KIM

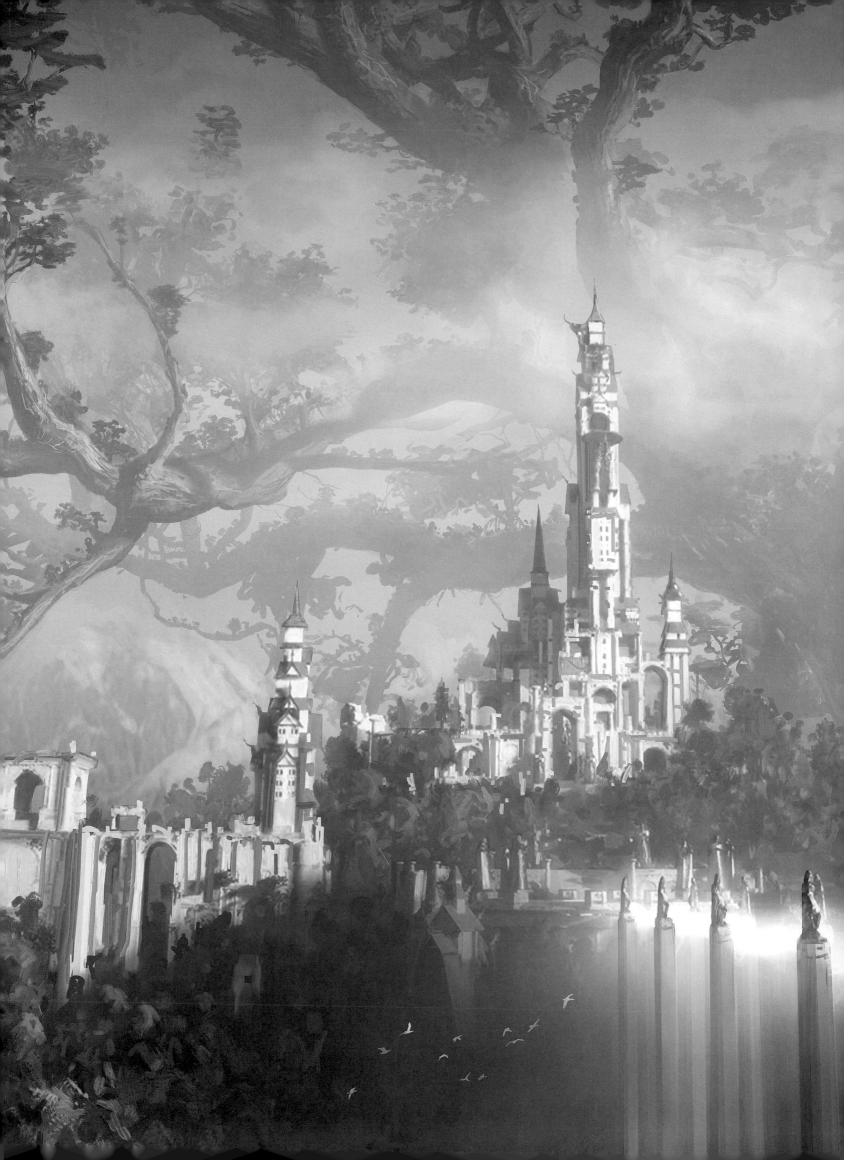

MYTHICAL WORLDS AND THE FIRST CIVILIZATION

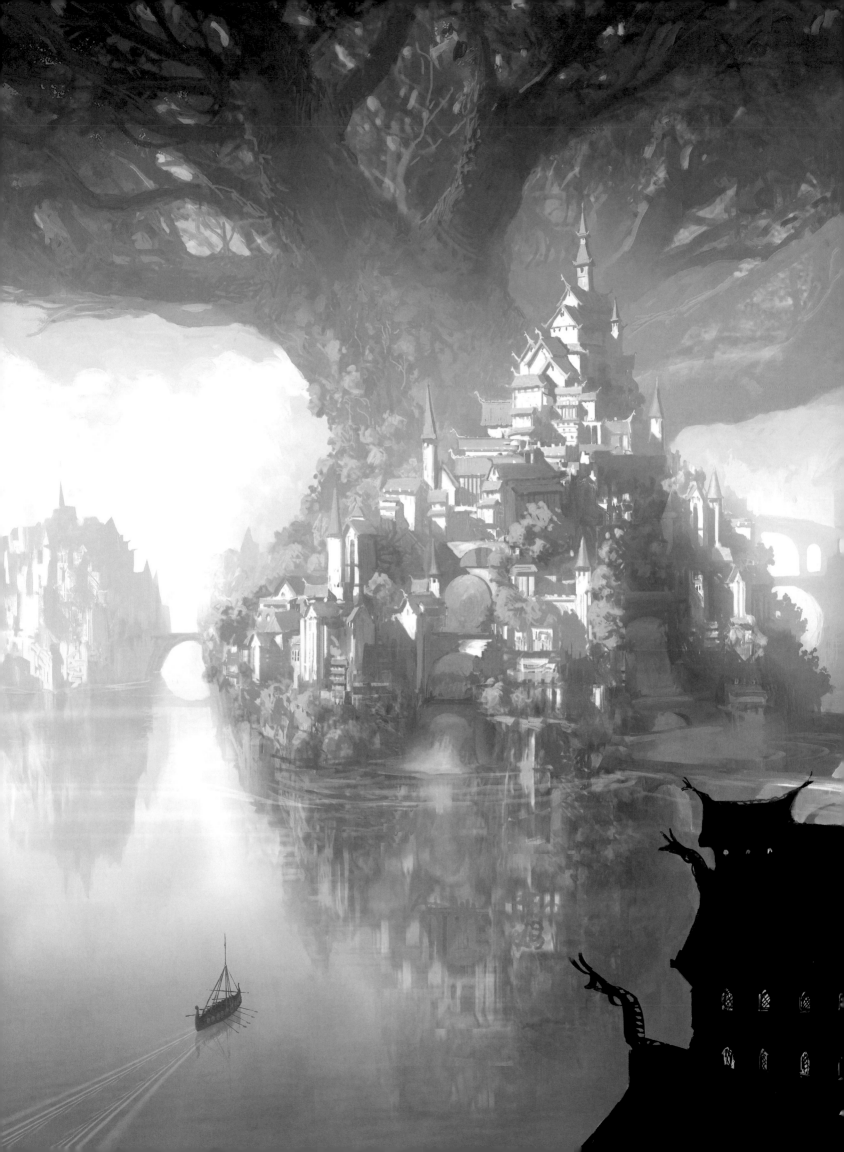

ASGARD

"It was creatively exciting to work on the otherwordly Asgard, one of the first mythical worlds our team created for *Assassin's Creed*," says Raphaël Lacoste. "Having the occasion to bring this large world to life was a nice challenge for the team." Lacoste and the other artists made it a priority in the concept art to interweave the natural elements of the huge Yggdrasil tree with the architecture of the Hall of Odin at the center of the island.

"We didn't want Asgard to look like a science-fiction world, but more like a dream," says Donglu Yu. "Realistic elements and distorted perception to make it feel like an otherwordly place . . ."

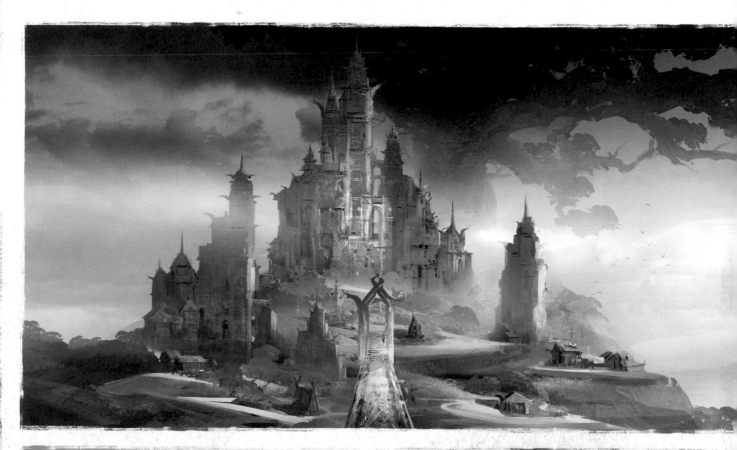

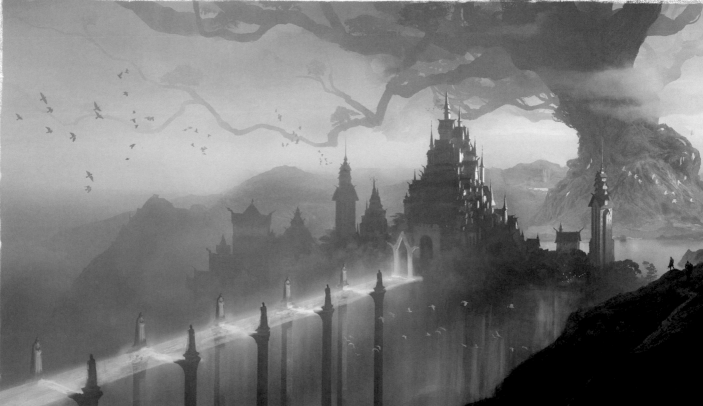

"This is the last concept art that I did for Asgard. It presents the final design for the Bifrost bridge, the tree, and the overall ambiance."—GILLES BELOEIL

CHAPTER BREAK, LEFT, AND BOTTOM RIGHT: ART BY GILLES BELOEIL; TOP RIGHT: ART BY DONGLU YU

THE HOME OF THE AESIR GODS

A diverse variety of props were designed to dress up the mystical world of Asgard—not only for aesthetic purposes, but for gameplay as well. "Lots of golden and red materials were used as accent colors on the objects," says Donglu Yu.

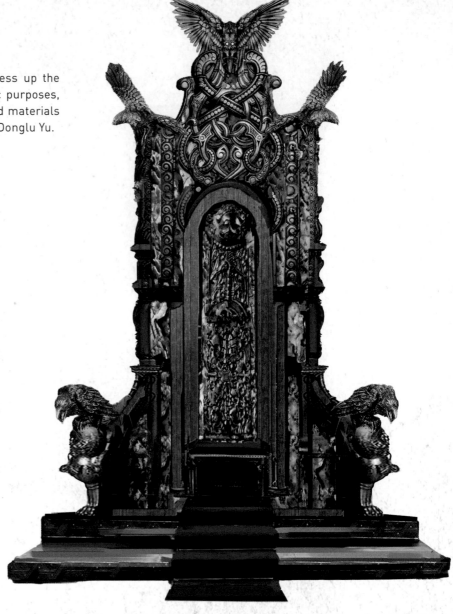

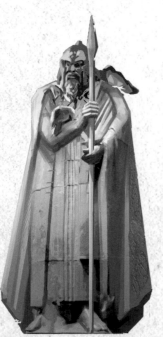

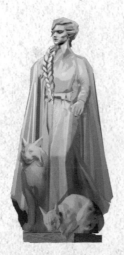

THIS PAGE: ART BY DONGLU YU

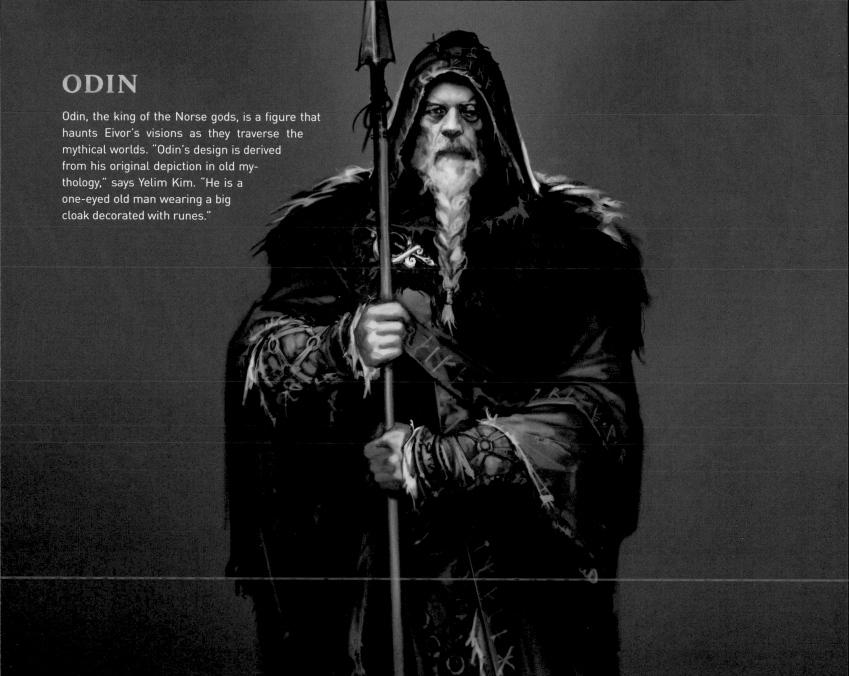

ODIN

Odin, the king of the Norse gods, is a figure that haunts Eivor's visions as they traverse the mythical worlds. "Odin's design is derived from his original depiction in old mythology," says Yelim Kim. "He is a one-eyed old man wearing a big cloak decorated with runes."

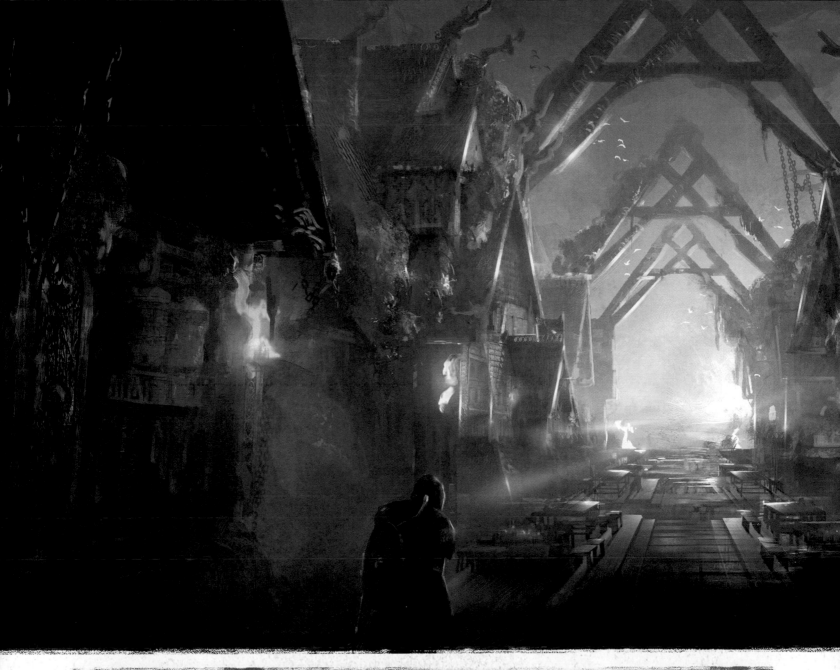

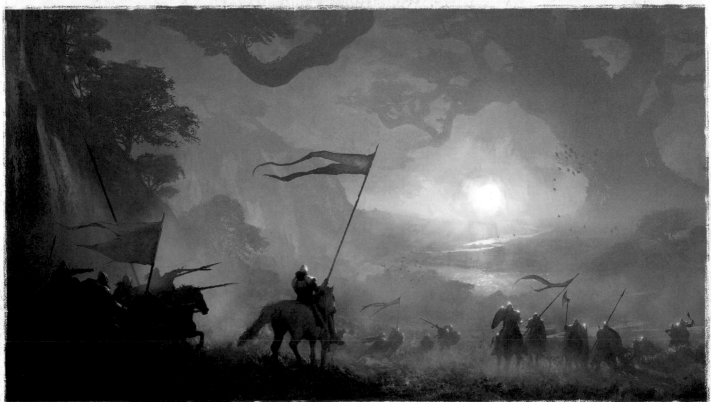

"This is a view of the Valhalla battlefield. We created an isolating mood with the tree's silhouette on the horizon. It's important to consider the various materials under this kind of backlighting, since each material reflects light differently. I also wanted the sun to have a blinding effect while still allowing the viewer to see the action in the scene."—GILLES BELOEIL

VALHALLA

Valhalla is the majestic hall in Asgard that is ruled by Odin. "I wanted to accentuate the red and gold color of the architecture, and the sunset backlight gives an omnipresent mystical and divine feeling to this place," says Donglu Yu.

TOP AND BOTTOM RIGHT: ART BY DONGLU YU
BOTTOM LEFT: ART BY GILLES BELOEIL

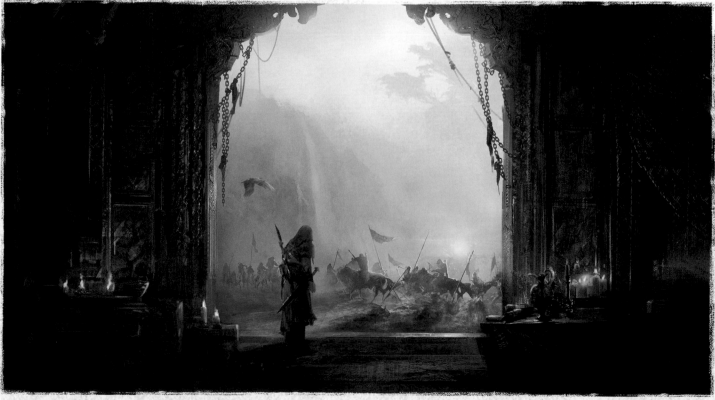

"The entrance to Valhalla, where Odin's dead warriors fiercely ride their horses, still engaged in divine combat."—DONGLU YU

JÖTUNHEIM

The homeland of the giants, Jötunheim, is a rugged and snowy world. The colossal twisted roots of Yggdrasil, the mystic World Tree, reach everywhere in the majestic icy land.

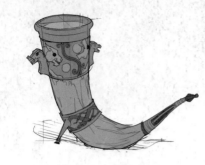
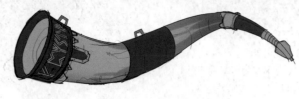
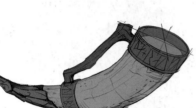

Explorations of drinking horns.

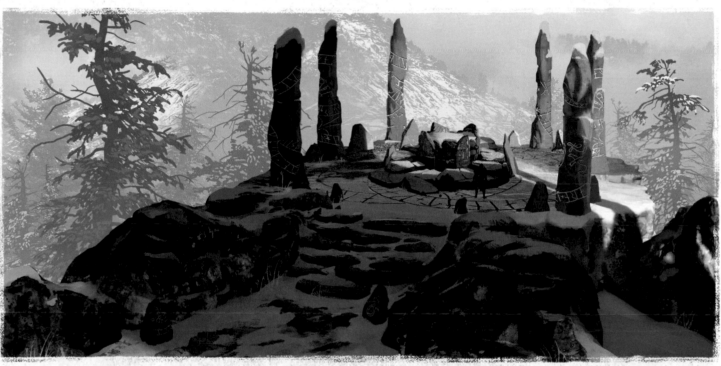

Concept art of Trymm's altar.

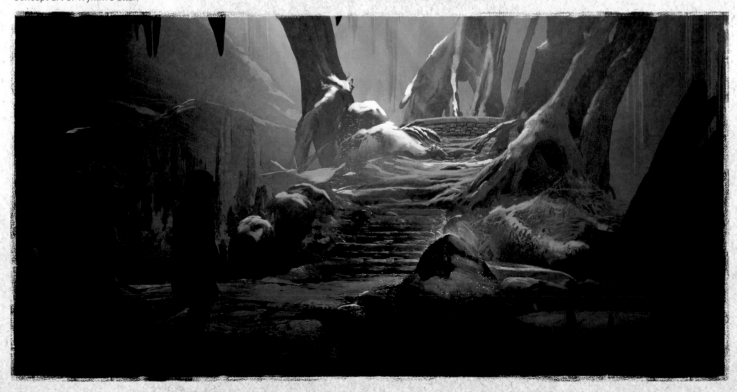

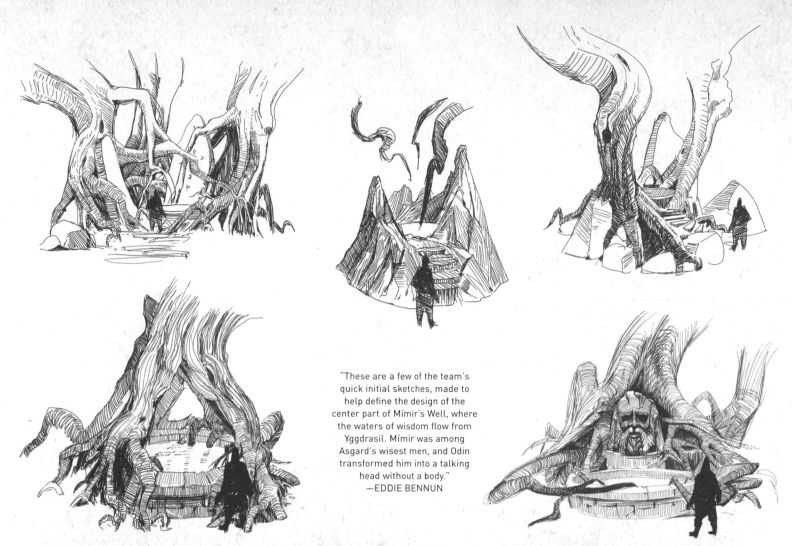

"These are a few of the team's quick initial sketches, made to help define the design of the center part of Mímir's Well, where the waters of wisdom flow from Yggdrasil. Mímir was among Asgard's wisest men, and Odin transformed him into a talking head without a body."
—EDDIE BENNUN

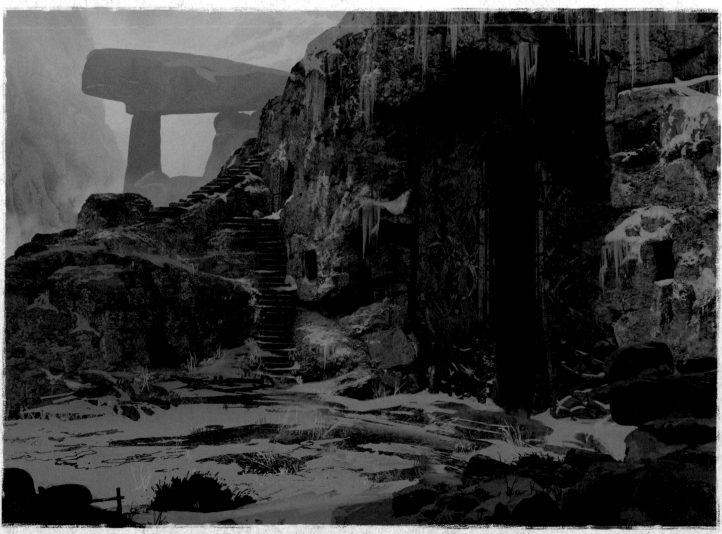

LEFT PAGE: TOP AND MIDDLE ART BY PHILIP VARBANOV, BOTTOM ART BY IGNAT KOMITOV; RIGHT PAGE : TOP ART BY IGNAT KOMITOV AND BOTTOM ART BY PHILIP VARBANOV

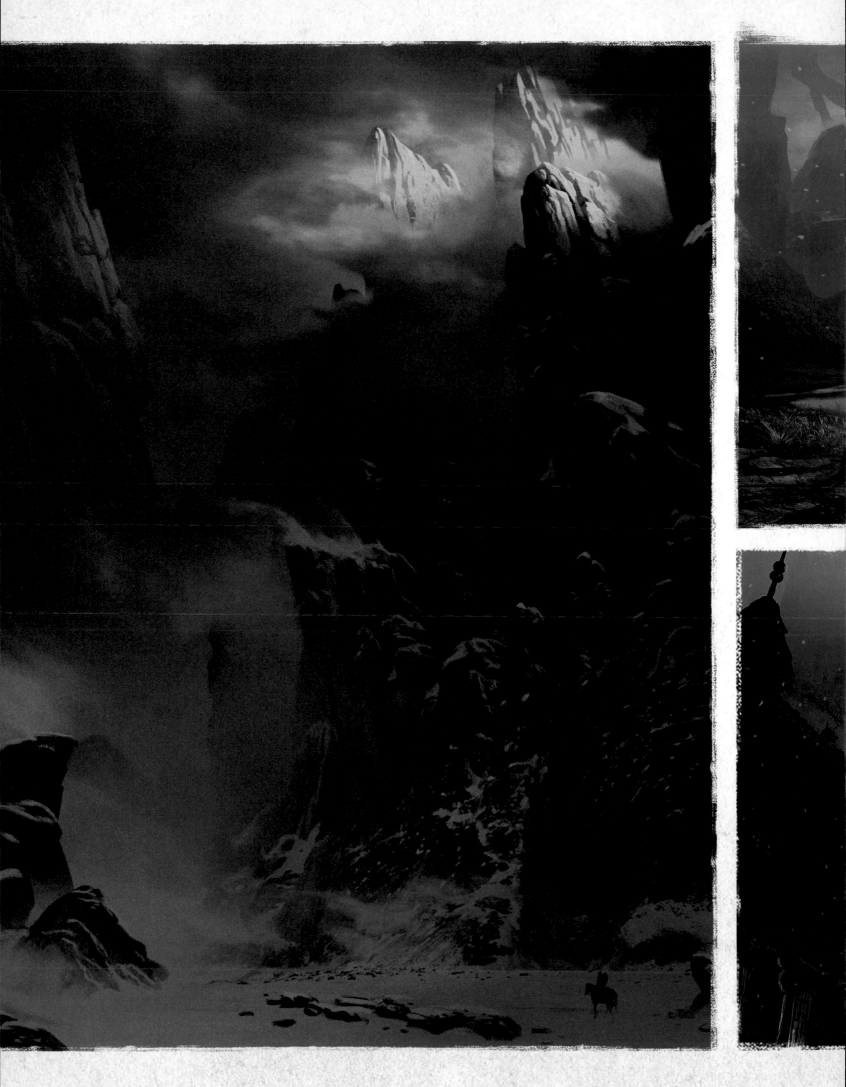

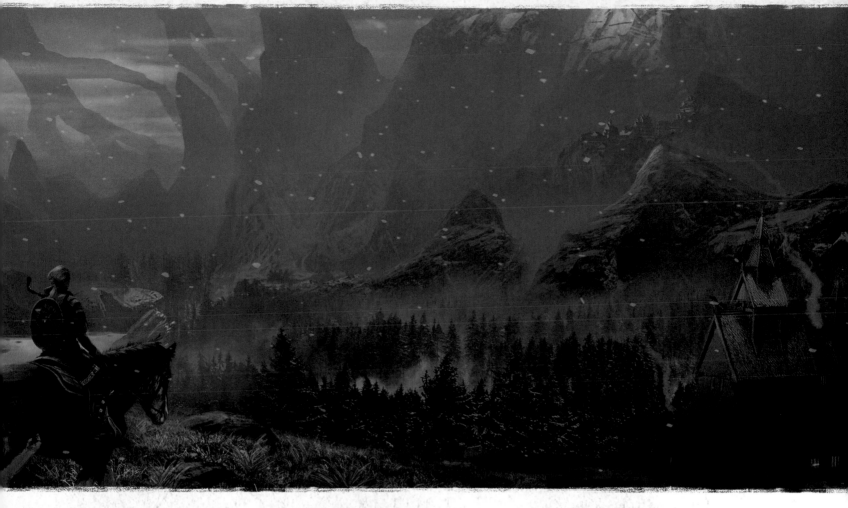

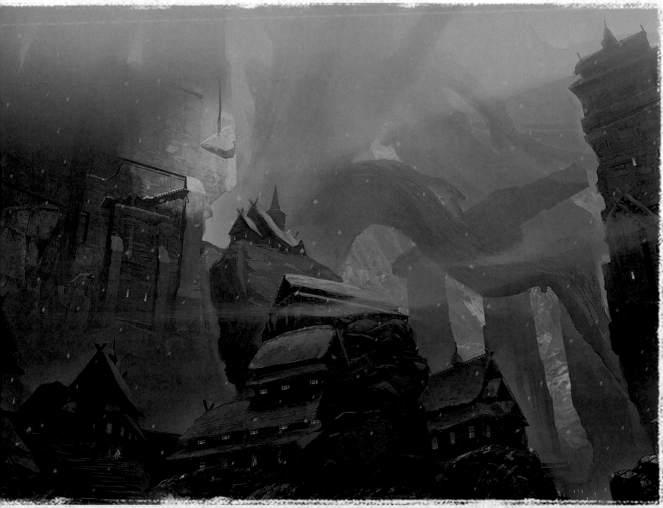

"Jötunheim is represented by beautiful, cold nature and the giant roots of Yggdrasil that wrap around the surreal shapes of the mighty mountains. Here, the player will also visit Útgarðar— the capital of the ancient civilization of the frozen giants."
—EDDIE BENNUN

LEFT: ART BY KONSTANTIN KOSTADINOV; TOP AND BOTTOM RIGHT: ART BY EDDIE BENNUN

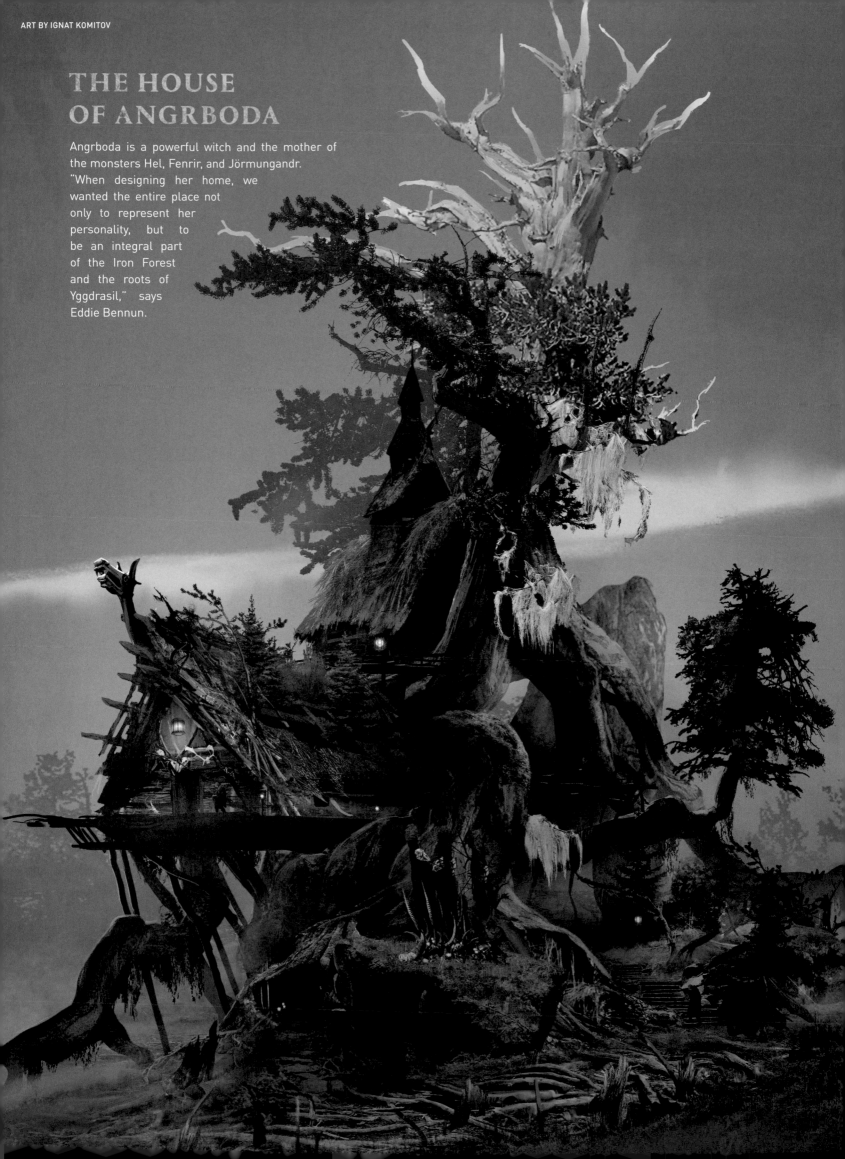

THE HOUSE OF ANGRBODA

Angrboda is a powerful witch and the mother of the monsters Hel, Fenrir, and Jörmungandr. "When designing her home, we wanted the entire place not only to represent her personality, but to be an integral part of the Iron Forest and the roots of Yggdrasil," says Eddie Bennun.

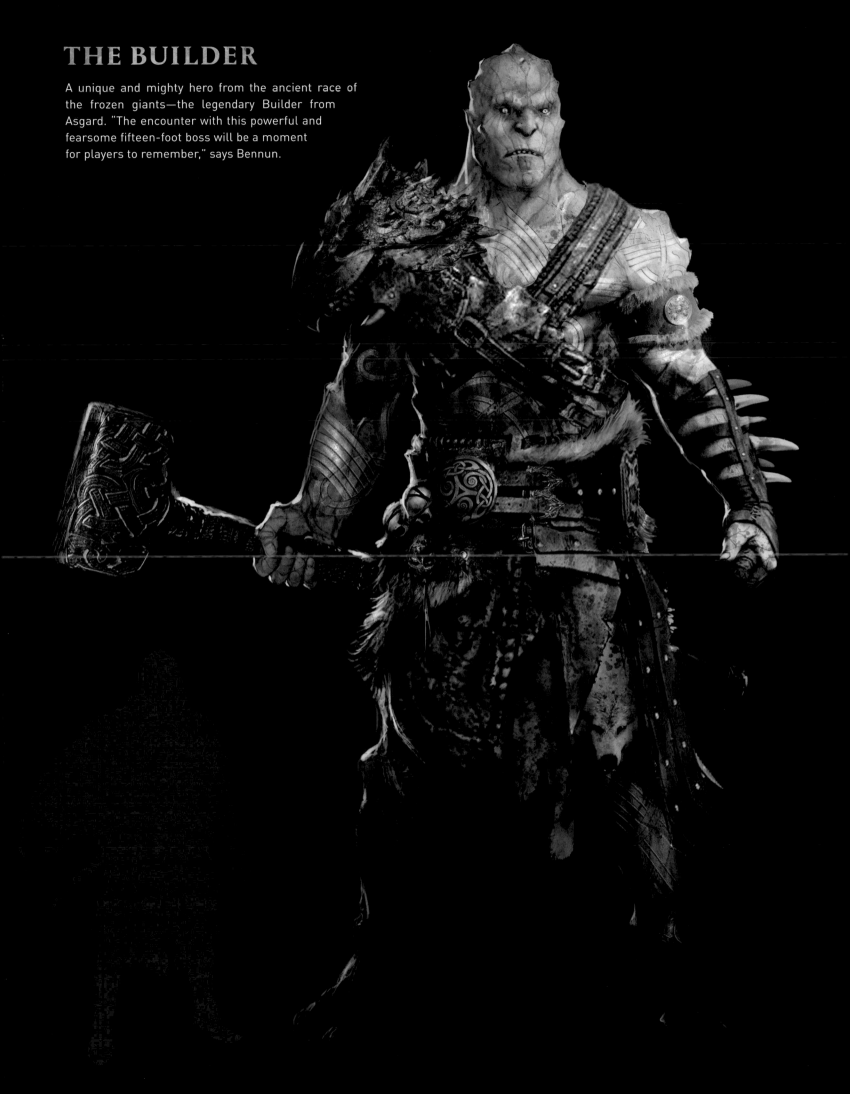

THE BUILDER

A unique and mighty hero from the ancient race of the frozen giants—the legendary Builder from Asgard. "The encounter with this powerful and fearsome fifteen-foot boss will be a moment for players to remember," says Bennun.

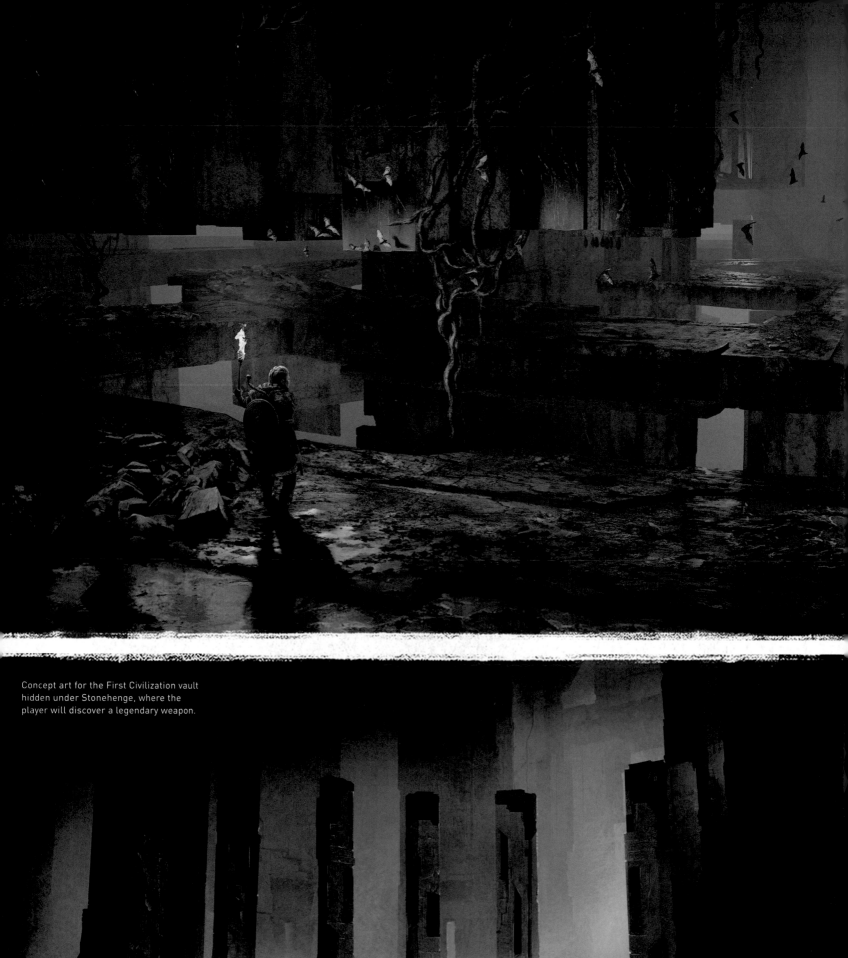

Concept art for the First Civilization vault
hidden under Stonehenge, where the
player will discover a legendary weapon.

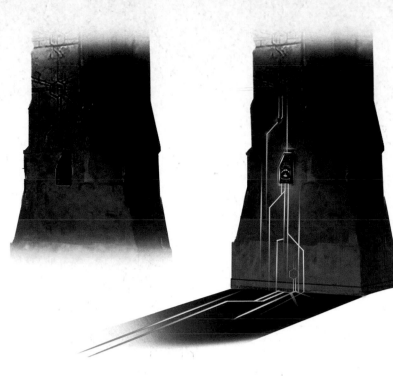

FIRST CIVILIZATION VAULT

"Our visual direction for Isu (or First Civilization) architecture is consistent throughout the franchise," says Raphaël Lacoste. This monolithic architecture makes use of limiting straight angles, obsidian-like materials, and sandstone with spectral light inlays. "It helps to maintain a mood of an otherworldly and mysterious ancient civilization in these places," says Lacoste.

LEFT: ART BY DIANA KALUGINA; TOP AND BOTTOM: ART BY DONGLU YU

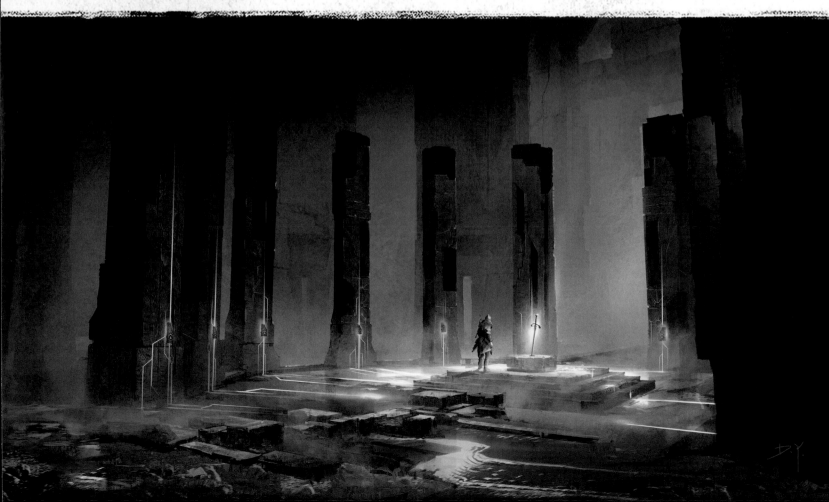

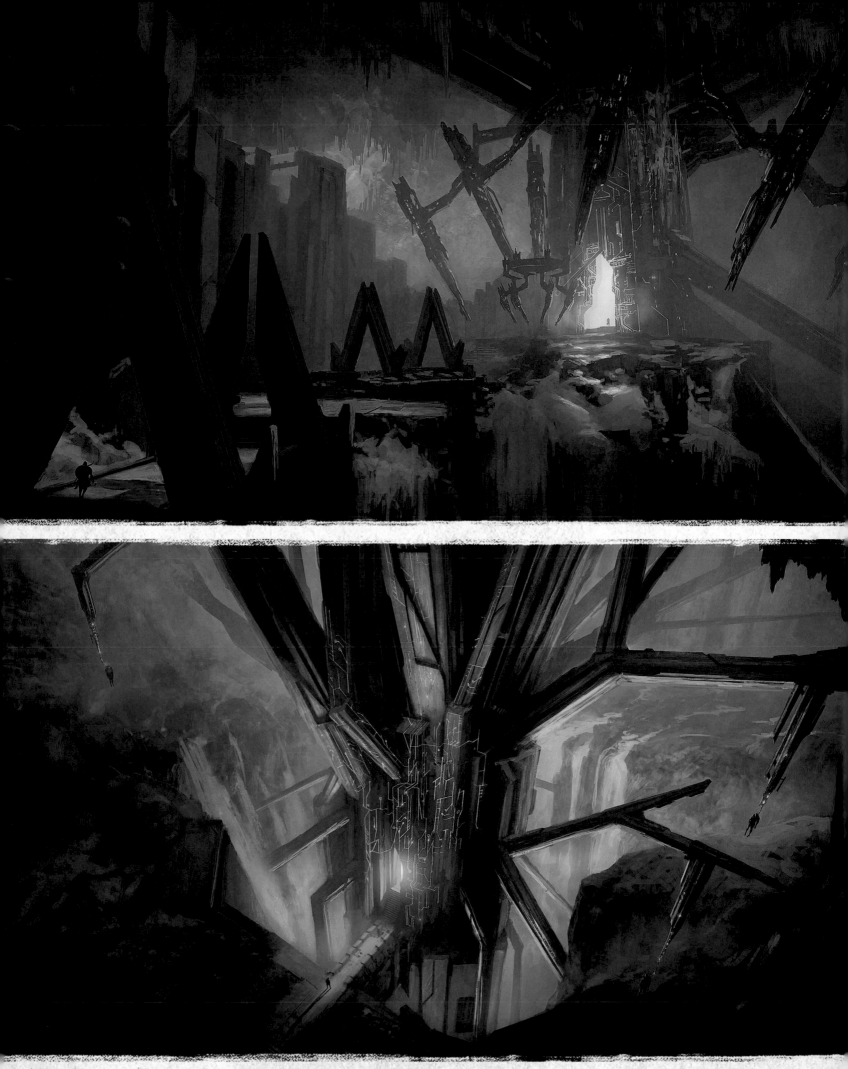

These concepts represent how the cave looked in the eighth century, when Yggdrasil was frozen in ice.

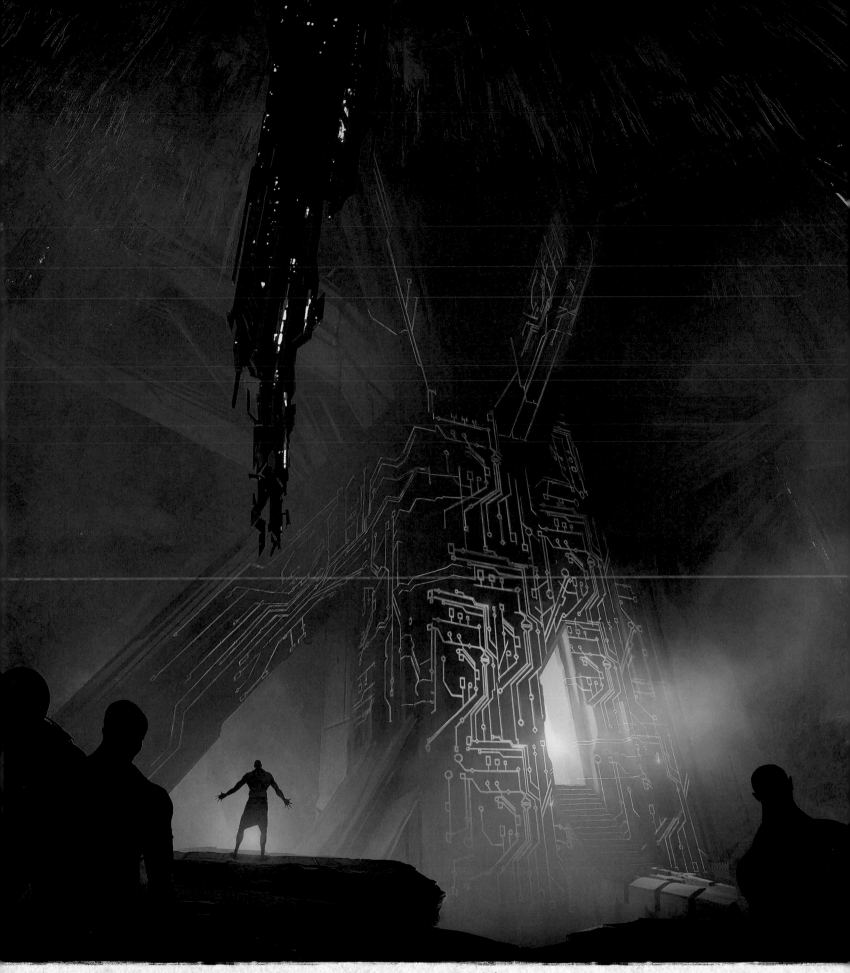

THESE PAGES: ART BY GILLES BELOEIL

YGGDRASIL, THE ISU SUPERCOMPUTER

"This concept art of Yggdrasil helped the world design teams to establish the general look of the supercomputer and render its massive scale."—GILLES BELOEIL

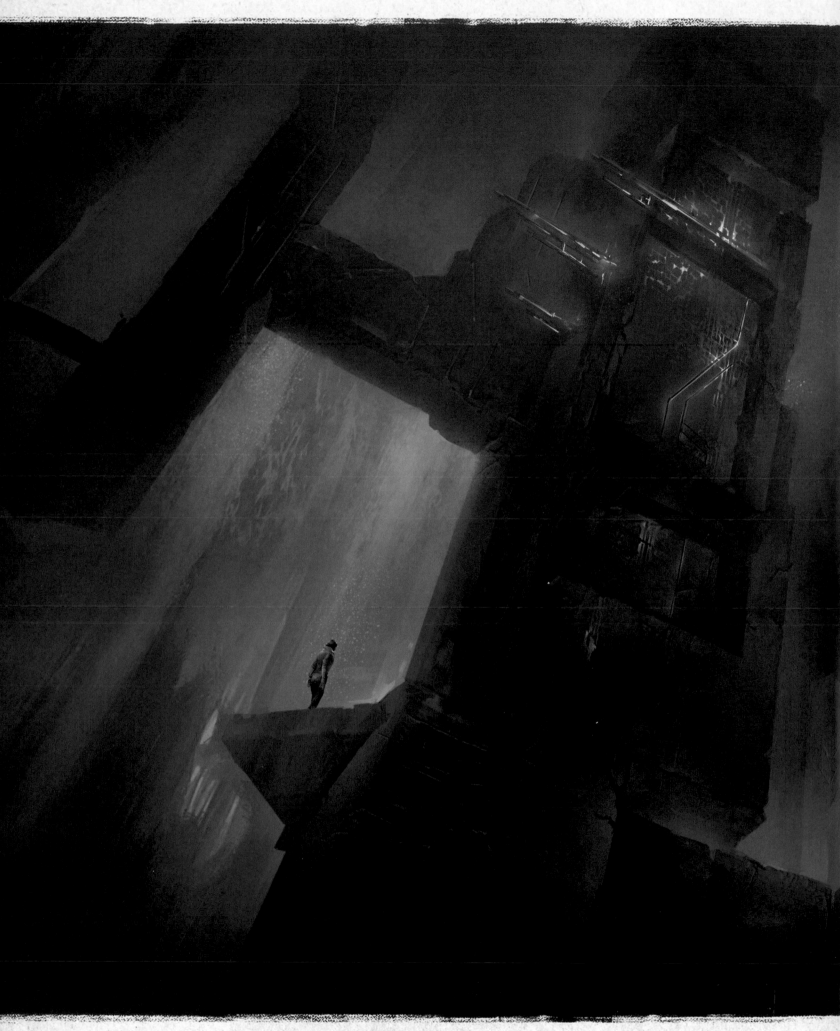

"This concept art represents the cave in the present-day story line, where the area is overheated by the giant supercomputer. The ancient structures of the First Civilization emit heat and sparks through the stone cracks." —DONGLU YU

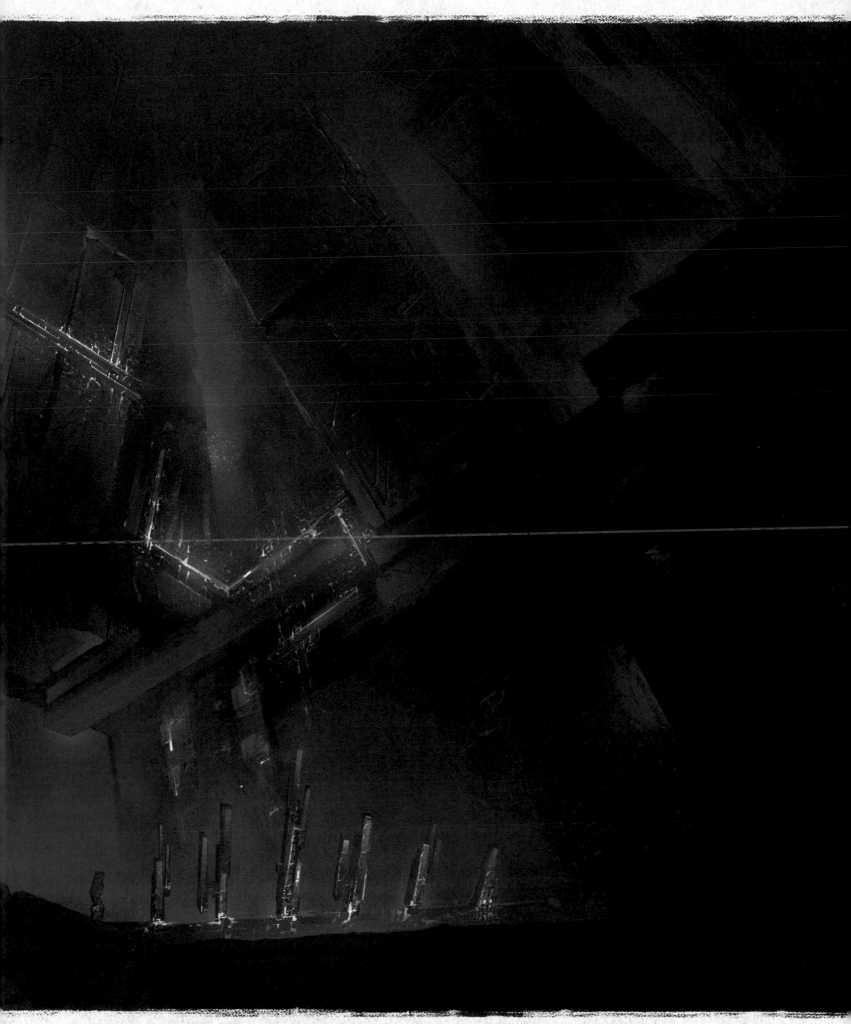

As the creative team formed the resolution of the modern day story arc, they carefully considered how to reconcile unsolved mysteries and disparate threads from over a decade of *Assassin's Creed* lore. "We asked ourselves how we could take a decade's worth of story and tie some of it together in one fitting resolution." says narrative director Darby McDevitt. "Many of these paths lead here, to this strange Isu temple . . . I think fans will be happy to see how it all comes together."

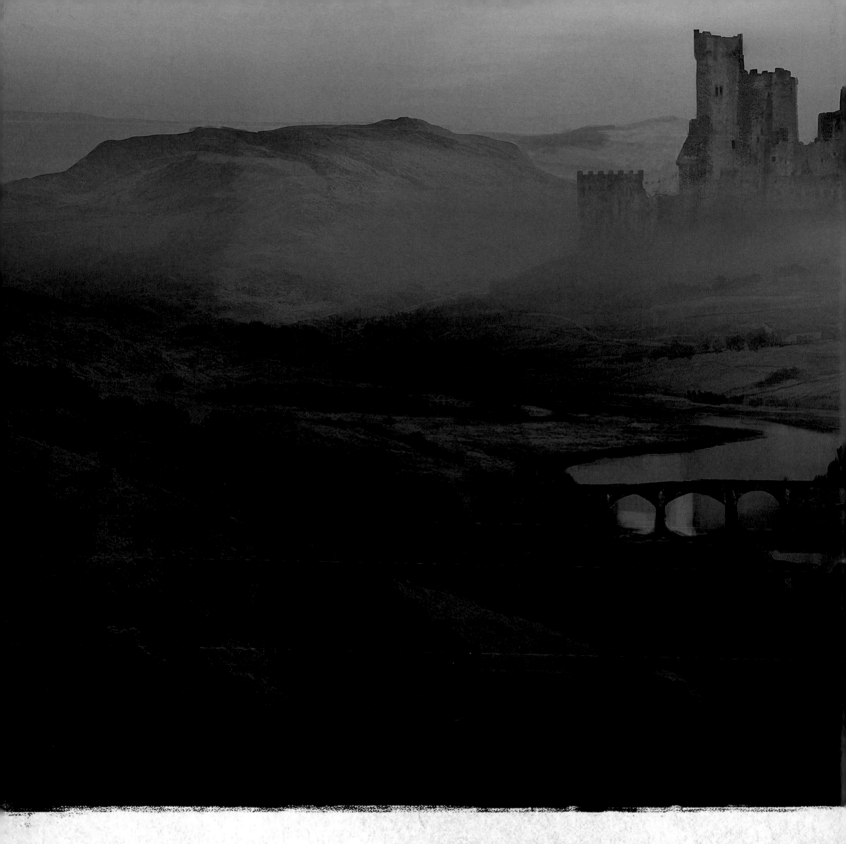

UBISOFT MONTRÉAL

RAPHAËL LACOSTE // Brand Art Director & Senior Concept Artist

DONGLU YU // Concept Artist

GILLES BELOEIL // Concept Artist

YELIM KIM // Concept Artist

PIERRE RAVENEAU // Concept Artist

REMKO TROOST // Concept Artist

MARTIN DESCHAMBAULT // Concept Artist

JEFF SIMPSON // Concept Artist

EVEN MEHL AMUNDSEN // Concept Artist

JEAN-CLAUDE GOLVIN // Historian and Illustrator

UBISOFT SINGAPORE

DANN YEAU CHOONG YAP // Art Director

FRANCO PEREZ // Associate Art Director

GUANG YU TAN // Senior Concept Artist

NATASHA TAN // Outsource Concept Artist

TONY ZHOU SHUO // Outsource Concept Artist

UBISOFT CHENGDU

SUN YU // Lead Artist

GABRIEL TAN // Concept Artist

WEI WEI // Concept Artist

TRAVIS QIU ZHIWEI // Concept Artist

UBISOFT PHILIPPINES

JOHN PAUL ELI TAN // Art Director

TEY BARTOLOME // Concept Artist

JOSE MARIA LORENZO GOMOS II // Concept Artist

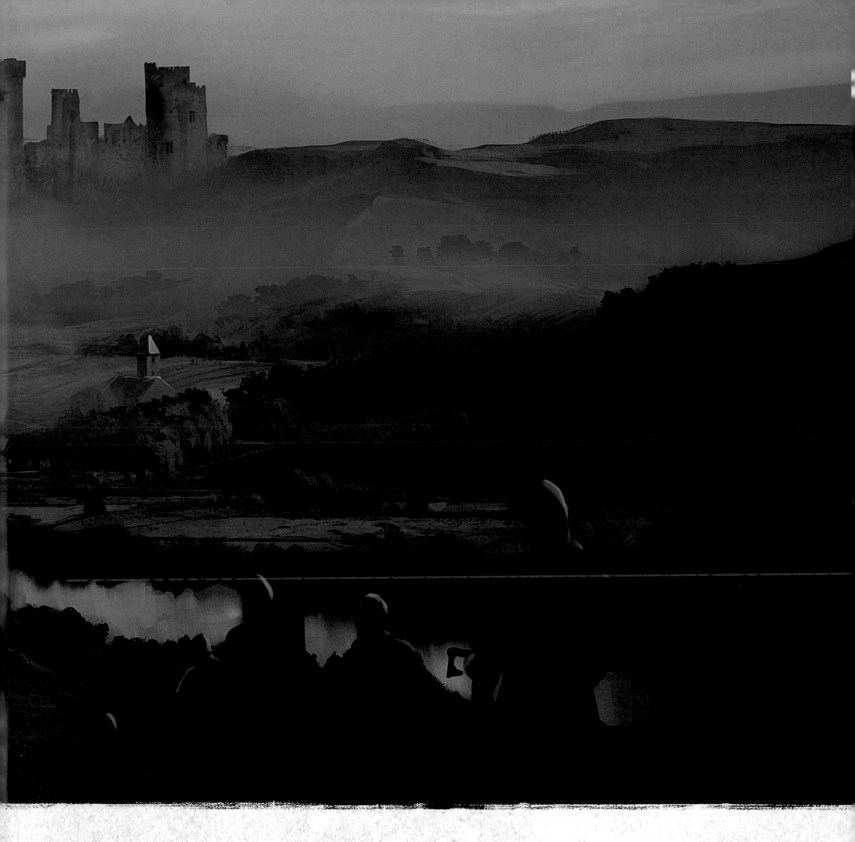

UBISOFT SOFIA
EDDIE BENNUN // Senior Art Director
NIKOLA STOYANOV // Associate Art Director
DANIEL ATANASOV // Senior Concept Artist
SABIN BOYKINOV // Senior Concept Artist
DIANA KALUGINA // Senior Concept Artist
IGNAT KOMITOV // Concept Artist
KONSTANTIN KOSTADINOV // Senior Concept Artist
PHILIP VARBANOV // Concept Artist

UBISOFT TRANSMEDIA TEAM—CANADA
AYMAR AZAÏZIA // Brand Content Director
ANTOINE CESZYNSKI // Brand Project Manager
FATIHA CHELLALI // Brand Project Manager

SPECIAL THANKS:

VLADIMIR ESKANDRI, SEBASTIEN PRIMEAU, MICHEL THIBAULT, VIRGINIE CINQ-MARS, ASHRAF ISMAIL, DARBY MCDEVITT, ALAIN MERCIECA, HOLLY HUA, YOUSSEF MAGUID, JULIEN FABRE, CAROLINE LAMACHE, ANTHONY MARCANTONIO, JUSTINE VILLENEUVE.

COVER IMAGE: HELIX MONTRÉAL & YELIM KIM
PRESENTATION AND COVER DESIGN: NICOLAS RIVARD
THIS PAGE: ART BY MARTIN DESCHAMBAULT

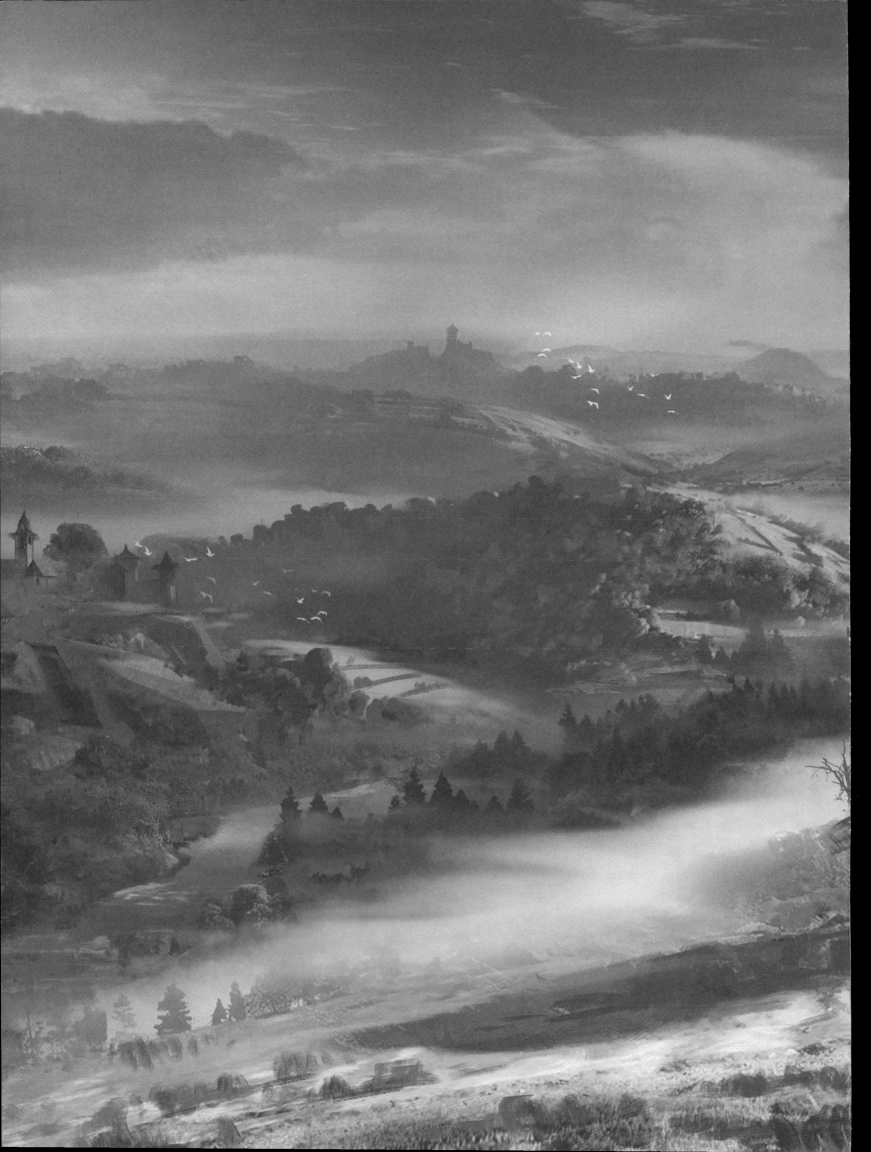